Art in a Turbulent Era

Contemporary American Art Critics, No. 6

Donald Kuspit, Series Editor
Professor of Art History
State University of New York at Stony Brook

Other Titles in This Series

Art in a Turbulent Era

by
Peter Selz

UMI RESEARCH PRESS
Ann Arbor, Michigan

Produced and distributed by
UMI Research Press
an imprint of
University Microfilms International
A Xerox Information Resources Company
Ann Arbor, Michigan 48106

Library of Congress Cataloging in Publication Data

Selz, Peter Howard, 1919-
Art in a turbulent era.

(Contemporary American art critics ; no. 6)
Includes bibliographical references and index.
1. Art, Modern—20th century. I. Title. II. Series.
N6490.S368 1985 709'.04 85-9068
ISBN 0-8357-1678-3 (alk. paper)

Contents

VII Pop and Funk

VIII Comments on Recent Artists

Foreword

This series offers a selection of the writings of master art critics. It does so on the basis of a proven track record. Lawrence Alloway, Joseph Masheck, Robert Pincus-Witten, Peter Selz, Dennis Adrian, and Nicolas Calas are important not only for their sophisticated treatment of complex art, but for the independence of their point of view, and their self-consciousness about it. They have all thought deeply about the nature and practice of art criticism. Working often within the limiting format of journalistic articles, they have all managed to expand the conception of criticism beyond that of journalistic reporting. That may have been their model, but they transcend it through their intellectuality. One cannot help thinking of Oscar Wilde's sense of the anti-intellectualism that pervades the relationship to art, and that indeed is prevalent in society. These critics have forged a solid, non-ideological, undogmatic criticism which shames conventional reporting of "newsworthy" art, promotional reporting of the artist stars of the moment. They offer us not hagiography, but analysis, functioning to sting us into consciousness. Even though they deal with the new, and can even be said to be obsessed with it, they never give in to sensationalism and parochial partisanship. They are passionate, but they also have the reserve and caution of reason. They reason hard to prove their points, rather than give in to opinion. They are the important critical minds of our day, and their work will last beyond it. Indeed, their conceptions have become the means by which art history assimilates the art they deal with, showing that art criticism at its best is the innovative cutting edge of art history. They show that art history can be a challenging intellectual adventure, as well as an account of documents and objects.

My prefaces were written without consultation with the critic in question. Each preface is my critical interpretation of his work, trying at once to give a conceptual overview of it as well as raise issues about it, continuing the dialogue it began. The only way to be in good faith with criticism is to continue to be critical. For what is finally at stake in all this writing is the survival of the critical spirit.

Donald Kuspit
New York, New York
April 1985

Preface

Peter Selz is among the most exemplary critic-historians working today. He is, in the best Baudelairean sense, an impassioned advocate of a particular kind of art, yet deliberately distanced—systematic, cognitive, analytic—in his approach to it. Where critics eager to announce trends might label the art they advocate an artistic breakthrough, conferring upon it the increasingly dubious dignity of stylistic novelty, Selz insists upon its slow historical unfolding and its world-historical role. It is inseparable from the life-history of the artist and the social history of his times—inseparable from the historical unfolding of humanity, in both a particular and general sense. In other words, Selz treats daring new art—the critic's first task—as though it already belonged to the past—the historian's assumption—even though it has contemporary impact, is emotionally as well as socially and artistically newsworthy, an important current event in the life-world. This critical strategy, which embodies both the cautiousness of the historian and the adventurousness of the critic, and which, far from incidentally, legitimizes the art (perhaps prematurely)—presumably only an art of self-evident, inherent value is awarded a detailed analysis of its genesis—not only adds intellectual credibility and depth to Selz's "emotional" advocacy of it, but precludes what could become a disaster for a critic who admires, as Selz does, "expressionistically" oriented art: mindless merger with the art, in which what began as a symbiotic relationship—the critical self's advocacy of an art that seems to highlight, within a single beam of illumination, its disintegrative and integrative tendencies—turns into naive submission to it. (I put "expressionistically" in quotation marks to indicate that for Selz the "self"-orientation of the art counts for more than any narrow stylistic definition of it, that the self-orientation, rather than any rigidly conceived set of stylistic features, is the heart of expressionism. Expressionism for Selz is not a matter of stylistic uniformity but of personal attitude, the attitude that creates the person.) For all the intensity of his advocacy, Selz does not blindly serve, ignorantly endorse the favored art. He refuses the naivete of enthusiasm; his humanistic sense of history is always a control on blind enthusiasm, his own form of "self"-protection.

Nonetheless, his endorsement, for all its generally intellectual and specifically historical self-consciousness, never loses a certain appreciative, "human" idealism, a certain sense of empathetic intimacy with the artist, verging

on identification with him. One senses something more than reportage when he writes that Ferdinand Hodler, "coming from the city of Bern, uneducated and poverty-stricken,... must have possessed potent inner resources and energies he could tap to overcome the inertia of the circumstances of his birth and upbringing." Selz identifies with the outcast artist, and especially with his "inner resources and energies"—with the self that struggles not for recognition in the world's eyes, but against the general inertia of the world, its smug sense of identity, of being "naturally" what it is. It is out of this struggle that the artist's personal integrity emerges, becomes manifest in his art, whatever its and his fate in the world. It is the achievement of solid identity that matters first and last to Selz, and the basis of this achievement: confrontation with the world, and "critically" transcending it. The art is the trace or residue of that human achievement, that achievement that guarantees humanity. More that anything else, Selz is interested in the humanity of the artists he deals with—chooses to deal with because of their humanity, of which their art is the most manifest, most decisive sign. His analysis of their art is an analysis of how they created their humanity, a search for the method of being human within the modern madness. To understand this is to begin to understand the full weight of calling Selz a "humanist critic," the kind of critic who advocates art that offers insight into the human condition, especially art that shows what it means to be human in modern times. There is something generally modern in Hodler's situation; Selz means to disclose the former through an exploration of the latter. In general, Selz wants to understand how what is fundamental to the human condition—he believes it makes itself felt particularly strongly in modern times, because of the mechanism of modernity itself, which aims to suppress consciousness of what is most pressing in life—informs modern artistic decision, especially the decision to work expressionistically. For Selz, the best modern art is unavoidably expressionistic in one way or another, for it is only an expressionistic orientation that can stand up to the rationalist mandate of modernity and defiantly express humanity—the suffering that makes for the humanity it would deny—to its face. Selz's determined interest in the tragic human condition gives him a critical perspective from which to judge art, and it is still the critic's first and last task to judge it from some universal perspective. This perspective transcends the art sufficiently to preclude Selz's "victimization" of it by becoming the instrument of its promotion, yet is sufficiently immanent within the art to allow its analytic revelation. In other words, it is neither a flattering nor arbitrary mode of interpretation, but one that allows a judicious appraisal of it in terms which are simultaneously artistic and extra-artistic.

What is the modern constitution of the tragic sensibility in art according to Selz? There is, inherent to it, an element of confrontation, that is, of conflict—of social and self-conflict. Expressionistic style is the manifestation of this conflict. The view that conflict logically precedes and represents itself, as it were, through style, is an important nuance of Selz's approach; any attempt to assert the priority

of style misses the existential conflict. There is really no such thing as stylistic integrity or stylistic novelty for Selz, no mechanically functioning "heroism of modern style" to assure the artist's development. The perspective of style, unlike the humanist perspective, does not so much afford an overview of art, on the basis of which one can determine the art's human use; it assumes the inevitability of art, its inherent goodness and desirability, even its ontological necessity. The humanist perspective assumes no such thing; the art must justify itself in terms other than strictly artistic terms. For Selz, there is implicitly no modernist mechanism for generating nonconformist art. Its nonconformity, its "difference," comes from its tragic implications, reflects a process of tragic individuation that occurs in response to personal and social realities. Esthetic "individuation" as such hardly interests Selz; even to acknowledge it as an end in itself is to falsify art because it is to ignore its psychosocial position. For all his sensibility, Selz's humanist approach is a militant refusal of estheticism of any sort.

Selz has a wide-ranging sensibility, as these collected articles show. Those on abstract painting and kinetic sculpture indicate that he is hardly bound by advocacy of figuration, as has often been thought. But his basic interest seems to be in the very particular way heroic artistic individualists became what they are, whether their individuality be that of the promoter Herwath Walden, originator of *Der Sturm*, or the artists Selz presented in the "New Images of Man" exhibition at the Museum of Modern Art (1959). Selz is less interested in the stylistic fact that the exhibition's artists "have been open to a great many influences," including that of "the art of the past"—although he pays the professional historian's due respect to it—than in the fact that they not only "have arrived at a highly interesting and perhaps significant imagery which is concomitant with their formal structures," but that "they are individuals affirming their personal identity as artists in a time of stereotypes and standardizations which have affected not only life in general but also many of our contemporary art exhibitions."

It is this sense of resistance not simply to conventionality but to hardened conventionality that constitutes the core of Selz's sense of modern tragic art, and informs his sense of artists worth discovering, his sense that the critic's curatorial mission involves not simply making hitherto invisible but potentially important artists visible, but arguing for the importance of the critical perspective from which they can best be understood and evaluated. It is because both their imagery and styles go against the grain of rigidly accepted social, rather than simply stylistic, conventions, because they refuse "common sense" and the order of art and the world it presupposes, that they are "revelations," and that the intricacies of their development are of great interest. Selz, then, is attracted to an art that "surprises" (not in any modern sense of novelty) because of the stereotypes and standardizations it disavows—an art which in effect recovers our basic ambivalence towards the given world, as well as the ambiguity with which the world seems given "in the first place." Stereotypes and standardizations exist to

obscure ambivalence and ambiguity, as though the world were given with such complete objectivity that its presence is impenetrable by the subject. Selz is most interested in an art that recovers the essentially "traumatic" sense of ambivalence and ambiguity inherent to the human condition—an art which makes its own private peace with this fundamental aspect of the human condition. For it is only through such "heroic" recovery of the irreducible doubleness of existence—expressionistic style (insofar as it is any one thing) reflects this doubleness directly—that it can be integrated into existence, grounding authentic individuality and integrity. Selz is interested in artists who experience and respond to this condition of fundamental dread, mediating it through their art in such a way that it seems immediate—"expressionist"—and achieving their selfhood through it. Simply to accept its reality is to be an outsider, for to be "inside" society is to accept the substantiality of its stereotypes and standardizations, and the security they give. Selz's preferred existential artists do not so much reject them, as deny their validity—this is part of these artists' "contrariness"—and, no doubt, seek to rid themselves of socially designed beliefs they involuntarily internalized as their social birthright. Their repudiation of these beliefs is the essence of their "expressionism," their "personalization" of art, their "opening" of the horizon of style.

Expressionism (Selz has written a major book about it) is an art in which the control afforded by (esthetic) stereotypes and standardizations seems lost, perhaps even impossible. Its artists use the threat of loss of control to once and for all purge themselves of socially designed perceptions. At root, expressionism is an epistemological revolution in the name of personally perceived truth, which quickly turns into a revolution against the order that denied the reality—because of its contradictoriness—as well as the general significance of personal perception. Loss of control, whether latent or manifest, implies a basic dissatisfaction with the untruth in the stereotypes and standardizations, which for Selz's preferred artists no longer afford existential comfort, and are experienced as disappointing and frustrating. It is through this severe discontent that a sense of humanity, the humanity informing the truth and "true" art, is affirmed.

Selz has always been known as an advocate of "humanist art," but what this means has been less clear. Its humanism involves the recovery of the fundamental trauma of being human, of facing the ambiguity of and ambivalence toward existence that is denied by the stereotypes that standardize it. Selz's search for a new image of man is really a search for the moment of man's emergence as man, a moment fraught with inalienable anxiety, the primitive anxiety inseparable from the experience of situational and emotional uncertainty that goes with becoming "civilized." It finally involves awareness of the unclear meaning of being human. It is the bringing to artistic consciousness of this meaning that is usually socially unconscious that engages Selz, and that is the source of his powerful humanism—his important role in developing a conception of a "new tragic humanism" in art,

which comprehends man in terms of his most elemental feeling of being, an unholy compound of self-assertive will to power and acceptance of the vulnerability of doubleness.

Selz moves from new humanist to new humanist artists, tracing the ups and downs of their conflict-ridden "self"-expression, extracting a modern paradigm of tragic humanity from an intimate examination of their artistic development. In a way, the most instructive part of this collection is one of the smallest, the section on "Pop and Funk." Succinctly and sharply, it shows the contrast that is the substance of Selz's critical position. Selz's courageous preference for funk art over the more fashionable pop art shows the strength of his convictions, the power and completeness of his conception of the critic as an advocate of art that "takes sides," that is "hot"—reflecting the critic's own taking sides (so essential to being a critic, so generative of his "heat"). (Needless to say, being "hot" in this context is quite the opposite of an art being "hot" because it is fashionable or trendy.) Selz writes: "Only in the Pop Artist's choice of subject matter is there an implicit taking of sides. Essentially he plays it cool. He makes no commitments; for a commitment in either love or anger might mean risking something.... What is so objectionable about Pop art is this extraordinary relaxation of effort, which implies a profound cowardice.... What we are dealing with then is an art that is easy to assimilate— much too easy; that requires neither sensibility nor intellectual effort on the part of either artist or audience; that has no more personal idiom than rock and roll music or the standard mystery story or soap opera. It is as easy to consume as it is to produce and, better yet, is easy to market, because it is loud, it is clean, and you can be fashionable and at the same time know what you're looking at." I've always thought that what a critic rejects is as revelatory, if not more, than the art he advocates: the force of the rejection is a measure of the strength of the conviction that led to the advocacy. In Selz's rejection of pop art, his whole ethos as humanist critic is summed up—his belief in an art that takes a stand in the world, that requires moral as well as artistic effort, whose stylistic and intellectual ambitions are not simply subsumed in a moral prerequisite but would not exist without it as a catalyst. Selz shows how criticism can itself be an act of moral decision, and a means of working towards a position that transcends art in the very act of illuminating it—that sees arts as a sublime stepping stone to a humanistic understanding of the world, which has as its substance not only repudiation of stereotypes and standardizations, but the vision of human integrity in the name of which that purgation is carried out.

In the end, for Selz the best modern art, humanistically oriented modern art, is an instrument in the major intellectual and moral effort of our time, namely, to redefine man without losing the sense of his still anxious emergence into a world which is always asking him to betray himself into its hands. It involves the recognition that what Selz, in the article on pop art, called "the ruined and isolated human beings of a disaffected society" portrayed by modern humanist artists,

bespeak the sedimented primordial tragedy of being human. Every modern moral art is an eternal return to, a rearticulation of, this tragic state, an attempt to reveal it as nakedly as possible, because the modern world denies the tragic through an increasingly powerful, and powerfully communicated—through media, which encourages the process—stereotyping and standardization of life. Selz is committed to modern tragic art; he implicitly believes that there is no world like the modern world that needs it, for modern rationalization of life through stereotyping and standardization denies it so completely. For Selz, there is no time like the present for art to reassert the awe that witnesses the inherent anxiety of the human condition. Art is privileged for him only to the extent it plays the role of tragic witness, a role it alone seems increasingly fit and willing to play in the modern world. It is this role that is the substance of the so-called "irrationality" of the expressionistic art Selz endorses.

Expressionism is the modern humanist tragic art for Selz because it is a hermeneutic of anxiety—the anxiety reflected in the refusal of conventional modes of understanding that is behind every moral commitment. For Selz, modern art must recover existential anxiety, the anxiety inherent in the human condition, to become humanly, critically, and artistically significant. Selz seems to suggest that the task of creating a tragic modern art—for him the only authentic art—has never been more pressing, because the mechanisms of stereotyping and standardization seek to enlist art itself in their ranks (the case of pop art). In general, they have never been so overwhelming, so repressive and destructive of the integrity, the very possibility, of the personal vision that can alone stand up to their fake truth—their truth that denies that the human dialectic with the world is the substance of truth.

—Donald Kuspit

Acknowledgments

The chapters in this book appeared originally as articles in the publications listed below. For permission to reprint these articles in this collection, I want to thank the following publications:

Chapter	Publication
1.	*Art Nouveau: Art and Design at the Turn of the Century,* Museum of Modern Art, New York, 1960.
2.	*Rodin,* by Albert E. Elsen, Museum of Modern Art, New York, 1963.
3.	*Ferdinand Hodler: Painter,* University Art Museum, Berkeley, 1972.
4.	*Art in a Turbulent Era: German and Austrian Expressioniam,* Museum of Contemporary Art, Chicago, 1978.
5.	*Art International,* Vol. 6, No. 9, November 1962.
6.	*Festschrift Ulrich Middeldorf,* Walter De Gruyter & Co., Berlin, 1968.
7.	*Art Bulletin,* Vol. 39, No. 2, 1957; reprinted in *Readings in Art History,* ed. Harold Spencer, Vol. 2, 2nd ed., Charles Scribner's Sons, New York, 1976.
8.	*Emil Nolde,* Museum of Modern Art, New York, 1963.
9.	*Lyonel Feininger,* Marlborough-Gerson Gallery, New York, 1969.
10.	*Max Beckmann: Retrospective,* ed. Carla Schulz-Hoffmann and Judith C. Weiss, Saint Louis Art Museum, Saint Louis, and Prestel Verlag, Munich, 1984.
11.	*The American Presidency in Political Cartoons, 1776-1976,* University Art Museum, Berkeley, 1976.
12.	*German Realism of the Twenties,* Minneapolis Institute of Arts, Minneapolis, 1980.
13.	*John Heartfield's Photomontages,* special publication of The Massachusetts Review, Winter 1963.
14.	Unpublished paper delivered at the College Art Association meeting, Toronto, 1984.

15. *New Images of Man,* Museum of Modern Art, New York, 1959.
16. *Alberto Giacometti,* Museum of Modern Art, New York, 1965.
17. *College Art Journal,* Summer 1956, Vol. 15, No. 4.
18. *Leonard Baskin: The Continuance of Tradition,* Museum Boymans-van Beumingen, Rotterdam, 1961.
19. *Rico Lebrun (1900–1964),* Los Angeles County Museum of Art, Los Angeles, 1967.
20. *Mark Rothko,* Museum of Modern Art, New York, 1961.
21. *Art International,* January 1973, Vol. 17, No. 1.
22. *Homage to New York: A Self-constructing and Self-destroying Work of Art Conceived and Built by Jean Tinguely,* Museum of Modern Art, New York, 1960.
23. *Directions in Kinetic Sculpture,* University Art Museum, Berkeley, 1966.
24. *Art and Artists,* February-March 1967, Vol. 1, pp. 7–12.
25. *George Rickey: Sixteen Years of Kinetic Sculpture,* Corcoran Gallery of Art, Washington, D.C., 1966.
26. *Interview with Pol Bury,* University Art Museum, Berkeley and Solomon R. Guggenheim Museum, New York, 1970.
27. *Partisan Review,* Summer 1963, Vol. 30, No. 3.
28. *Notes on Funk,* University Art Museum, Berkeley, 1967.
29. *Art International,* April 1972, Vol. 16, No. 4.
30. *Art in America,* July-August 1974, Vol. 62, No. 4.
31. *Art in America,* March-April 1975, Vol. 63, No. 2.
32. *Arts,* December 1976, Vol. 51, No. 4.
33. *Arts,* December 1978, Vol. 53, No. 4.
34. *Roger Herman,* Ulrike Kantor Gallery, Los Angeles, 1983.
35. *Arts,* February 1978, Vol. 52, No. 6.

I

Turn of the Century

Art Nouveau: Art and Design
at the Turn of the Century

Introduction

In February 1894 Claude Debussy's "Quartet in G Minor" and "La Damoiselle Elue" (after the poem "The Blessed Damozel" by Dante Gabriel Rossetti) were played at the opening of the first exhibition of *La Libre Esthétique* in Brussels. In the exhibition were paintings by Puvis de Chavannes as well as Camille Pissaro, Renoir, Gauguin, and Signac, and also Redon, Toorop, and Ensor. In addition to the paintings, selected with remarkable catholicity, there were shown—on the same level with "fine arts"—William Morris' illuminated books of the Kelmscott Press, Aubrey Beardsley's illustrations for Oscar Wilde's *Salome*, posters by Toulouse-Lautrec, Chéret, and Eugène Grasset, tapestries by Maillol, woodcuts by Vallotton, an interior designed by Gustave Serrurier-Bovy, spoons, cups, buckles, and bracelets which Charles Ashbee had designed for the Guild and School of Handicraft in London. The guests at this opening must have been struck by the diversity of the objects. Yet, listening to Debussy's music, gazing at Gauguin's paintings, and examining Ashbee's metal craft, they may also have perceived a purposeful attempt on the part of the exhibitors to manifest a relationship between all the arts, an effort which was soon to be spelled out in Henry van de Velde's lecture "L'art futur" scheduled during the exhibition.

Three years later, in May 1897, the German architect Alexander Koch called for "the need of a complete integration of all the artists, architects, sculptors, painters, and technical artists. They all belong intimately together in the same place, each thinking individually, yet working hand in hand for a larger whole."[1] This appeal was published in the first issue of the journal *Deutsche Kunst und Dekoration*, which almost immediately became the voice of a new movement in the visual arts. The statement using approximately the same wording as the First Proclamation of the Bauhaus,[2] which it preceded, however, by twenty-two years, was largely the outgrowth of Morris' Arts and Crafts movement, whose aim Walter Crane defined as "turning our artists into craftsmen and our craftsmen

into artists."[3] Indeed during the late eighties and nineties a good many painters, such as Henry van de Velde and Peter Behrens, turned from painting to architecture and design.

The Arts and Crafts Movement. William Morris, painter, poet, craftsman, lecturer, and militant pamphleteer, had been clamorous enough in his demand for a unification of all the arts and crafts to bring about important reforms in architecture, interior design, furniture, chintzes, carpets, wallpapers, and typography, to accomplish indeed such a unification in his workshop. Similarly, Arthur Mackmurdo, who founded the Century Guild in 1880-81, emphasized the indivisible unity of the arts and crafts, as did the Art Workers' Guild, established by Walter Crane and Lewis Day two years later. The Arts and Crafts Exhibition Society, founded in 1888 with Crane as president, brought a comprehensive program to the attention of a wide public by means of its exhibitions, lectures and demonstrations. An integral concept of the unity of art and life was the belief, first expressed by John Ruskin and constantly reiterated by Morris, that true art was the expression of man's pleasure in his work and that therefore the arts, when honest, were simultaneously beautiful and useful. So they seemed to have been in the Middle Ages, and from the medieval period the men of the nineteenth century learned that high artistic achievement might best be accomplished by communal effort. The men of the Arts and Crafts movement would have fully agreed with Tolstoy, who postulated in *What is Art?* (translated in 1899) that it is "a means of union among men, joining them together in the same feelings, and indispensible for the life and progress towards well-being of individuals and of humanity."[4]

The "Decadence." No greater contrast could be imagined than that between the old Tolstoy and the young Oscar Wilde. The latter had as little use for social reform as he had for utility. Artifice and affectation, perversity and egoism were the very essence of Wilde's world and of the whole movement known as The Decadence. To Wilde, brilliant conversationalist and cultivated dandy, the artful attitude was more desirable than the work of art itself. He had earlier announced the intention of living up to his blue-and-white china, and to him and his circle a doorknob could be as admirable as a painting; the necktie, the boutonniere, the chair, were of essential importance to the cult of living.

We find then a strange encounter in the 1890s: the socialists and moralists of the Arts and Crafts movement felt an ethical obligation to reconcile art and society and to create a better environment for themselves and for the working classes with objects of more honest design and production. The Decadents of the Aesthetic Movement of the *fin de siècle*, on the other hand, were eager to keep their sophistication far removed from popular culture by withdrawing into an esoteric world in which art was to become *the* way of life. *The Yellow Book*, that

great journal of the Decadence with Aubrey Beardsley as its art editor, seems, however, related to Mackmurdo's Arts and Crafts publication, *The Hobby Horse*, in its freshness of approach to typography, its use of original illustrative material, and in the combination of stories, drawings by new artists, advanced poetry, and essays on music and other cultural aspects catching the fancy of the editors. The two journals were strikingly different in purpose and appearance, but even so the Decadents seemed to agree with the moralists that a synthesis of the arts was utterly desirable.

Synthesis of the Arts. Motivated by this desire, both groups shared an admiration for Richard Wagner,[5] who combined a rather synthetic but nevertheless clearly pronounced belief in folk art with the actual creation of the *Gesamtkunstwerk*. Indeed the German composer's attempt at synesthesia of music and drama for the "total theatre" encouraged architects, painters, designers, and craftsmen to make similar efforts toward unifying all the arts of living. This unity of the arts was most evident in the comprehensive design of the house. There the wallpaper design is related to the light fixtures and the cutlery; and the design of the book carefully echoes that of the cabinet. For their predominantly decorative qualities murals, tapestries, and stained glass are preferred to paintings and sculpture which, when introduced, are intended to be seen as part of a larger whole. The jewelry corresponds to the furniture. Henry van de Velde and Hector Guimard followed William Morris by actually designing their wives' costumes so that the very gesture would become an integral part of the environment. It even went so far that when Toulouse-Lautrec was invited to a luncheon at van de Velde's house in Uccle, the choice of food, its color and consistency was harmonized with table-setting, curtains, and the whole interior.[6] Horta abolished any clear distinctions among floor, wall, and ceiling by creating a fluid baroque space based on plant ornament. The similarity between the composition of a printed page and the façade of a building is remarkable, and the title page of a book may easily be transposed into a portal.

The Search for the New. The 1890s was a period of boldness in experimentation, a time which not only tolerated new ideas but was eager for novelty, if not the sensational. Disgusted with the old naturalistic formulas—whether in the imitation of nature on canvas, or the imitation of craftsmanship in cheap, machine-produced furnishings—people seemed to have had their fill of the philistinism which characterized so much of the life and taste of the nineteenth century. The flagrantly inequitable social conditions made a great many artists and intellectuals turn toward socialism and anarchism. The success of technology as the great benefactor of the masses was questioned, and faith in materialism grew shaky.

There was also a move toward religion and mysticism. Both Beardsley and

Wilde were penitent converts to the Roman Catholic Church before their deaths. Some of the *Nabis* became ardent Catholics; Jan Verkade even joined a monastery. Others turned toward Buddhism; the Rosicrucians and Thesophists had many followers among the artists and writers.

Symbolism. Shunning narrative and disinterested in quotidian affairs, writers and soon other artists became more concerned with the veiled essence of reality, with the IDEA behind the shape. In 1886 Jean Moréas had published the Symbolist Manifesto,[7] summarizing concepts which permeated the poetry of Verlaine and Mallarmé and the prose of Huysmans. Realism in art and naturalism in poetry were rejected in innumerable "little reviews" of the avant garde. The aim of art was not to describe observed reality, but rather to suggest felt reality. "To name an object," said Mallarmé, "that is to suppress three-quarters of the enjoyment of the poem which comes from the delight of divining little by little: *to suggest it,* that's the dream."[8]

Verse dissociated itself from established patterns, and instead of describing nature it attempted to externalize ideas and sensations, to reveal the true meaning of life and nature by evoking a direct response through the use of sounds, rhythms and associations. The SYMBOL gives concrete form to the ideas—it is not didactic like the allegory; it addresses itself to the emotion, not the intellect; it does not stand for something else, it is close to myth; it is both the key to the meaning and the meaning itself.[9]

In France, Odilon Redon developed his personal dream world in close association with the Symbolist poets. Their program of expressing an idea subjectively by means of evocative and decorative form was adopted by a group of painters at Pont-Aven dominated by Paul Gauguin.[10] Soon this attitude found its expression in the painting of the *Nabis* in France, Ferdinand Hodler in Switzerland, Edvard Munch in Norway, Gustav Klimt in Austria, and in the drawings of Aubrey Beardsley in England and Jan Toorop in Holland. Almost at once it appeared in the applied arts: in the vases of Emile Gallé—significantly called *études*—in which shape, color, and texture created a Symbolist decor, underlined further by aphoristic phrases from Baudelaire, Verlaine, or Maeterlinck that were fired into the glaze. We see it in the whole poster movement of France, and it is noteworthy that the Symbolist periodical, *La Plume,* after devoting special issues to the work of Verlaine, Mallarmé, Huysmans, and Baudelaire, in 1894 inaugurated exhibitions sponsored by the *Salon des Cent,* and devoted a special issue to the work of Eugène Grasset, one of the chief exponents of the new poster movement.[11]

The personal relationship between Symbolist writers and artists was intimate. They published in the same journals in France, Belgium, Holland, England, and Germany. Frequently the artists illustrated the poetry and prose of their avant-garde companions.[12]

Symbolism of Line. The place occupied by sound in Symbolist poetry was now held by line in the new art. Line became melodious, agitated, undulating, flowing, flaming. The symbolic quality of line as an evocative force was expressed as early as 1889 by Walter Crane, whose work, although in the William Morris tradition, anticipated many of the characteristics of the new movement: "Line is all-important. Let the designer, therefore, in the adaptation of his art, lean upon the staff of line—line determinative, line emphatic, line delicate, line expressive, line controlling and uniting."[13] At the same time Seurat and Signac, following the researches of Charles Henry, spoke of complementary line as well as complementary color and then van de Velde, himself originally a Neo-impressionist painter, wrote of the line as "a force which is active like all elemental forces."[14]

This is the esthetic basis of Horta's abstractions of intricate linear loops in the Tassel House; it is the essential quality of the fantastic vegetative ornaments of Guimard's Métro stations, or of Endell's façade of the Atelier Elvira in Munich. Endell saw the ultimate meaning of the new Symbolism of form when he wrote in 1898: "We stand at the threshold of an altogether new art, an art with forms which mean or represent nothing, recall nothing, yet which can stimulate our souls as deeply as the tones of music have been able to do."[15]

Terminology. This was the ultimate formulation of the chief esthetic characteristic of a movement which developed simultaneously all over Europe. By the late nineties "Art Nouveau" had achieved a remarkable international success as *the* style of fashion and the avant garde. In the various countries it went by different names and was, in fact, ambivalently considered a national style or else an import from a foreign country, depending on a positive or negative attitude toward the mode. Only fairly recently has it been generally recognized as an international movement.

At first, nobody seemed to know where it originated. The English, not realizing the major contributions they themselves had made—especially in graphic design—and never really participating in the full-blown movement, called it Art Nouveau. In France, the country of the Symbolist movement, it was referred to occasionally as "Modern Style," and went under a great many names at first, such as the graphic "Style nouille," or, even more literally, "Style de bouche de Métro." Hector Guimard, the man responsible for these subway entrances—this odd-looking street furniture of Paris—preferred his own "Style Guimard." Edmond de Goncourt, aware of the streamlined elements, pejoratively called it "Yachting Style." Eventually the name Art Nouveau was adopted. In Germany it was at first variously called "Belgische" and "Veldesche" after the Belgian Henry van de Velde, who, upon coming to Germany in 1897, had assumed leadership of the movement there. Or it was referred to as "Studio-Stil" after the English publication which reflected the work of the Arts and Crafts

Exhibition Society. Other more whimsical names were "Schnörkelstil" (flourish-style) and "Bandwurmstil" (tapeworm style). It was, however, the term "Jugendstil," from the highly popular Munich magazine *Jugend*, which entered the vocabulary. The Austrians referred to it as "Secessionsstil" because of the Vienna Secession which, under the leadership of Klimt, Hoffmann, and Olbrich, was holding highly cosmopolitan exhibitions in Vienna. The Scots, who undoubtedly had a considerable influence on the Viennese, named their corollary "The Glasgow School." In Spain it was called "Modernismo," in Italy it went by the title of "Stile floreale" but generally, as "Stile Liberty" after Liberty's London store and the printed, often Oriental, textiles it offered for sale. The Italians, no doubt, were fully aware of the double meaning in this name. In Belgium it was called "Paling stijl" (*Paling*: Flemish for "eel") or "Le Style des Vingt" or "La Libre Esthétique" to identify it with the names of these exhibition groups which, under the brilliant guidance of Octave Maus, were the most advanced anywhere in Europe and were largely responsible for the leadership Brussels assumed in the new movement.

Maison de l'Art Nouveau. The term Art Nouveau, which was finally accepted in most countries, derives from S. Bing's shop Maison de l'Art Nouveau, at 22, rue de Provence in Paris. Bing, a native of Hamburg, had previously been primarily concerned with Japanese art as connoisseur, publisher, and dealer. Vincent van Gogh was one of his customers[16] and Louis C. Tiffany patronized the New York branch of his establishment.[17]

For his *Salon de l'Art Nouveau*, which opened in December 1895, Bing commissoned Bonnard, Grasset, Ibels, Roussel, Sérusier, Toulouse-Lautrec, Ranson, Vallotton, and Vuillard to make designs for stained glass executed by Louis C. Tiffany in the United States. The Salon itself included paintings by most of these artists as well as Carrière, Denis, and Khnopff, sculpture by Rodin, and—placing the applied arts on an equal basis—glass by Gallé and Tiffany, jewelry by Lalique, posters by Beardsley, Bradley, and Mackintosh. In 1896 Bing presented the first Paris exhibition of paintings by Edvard Munch. He also introduced van de Velde to Paris by inviting him to send four completely designed rooms to the establishment. Less than two years later Bing had van de Velde invited to Germany to participate in the large international art exhibition of 1897 in Dresden, which was acclaimed as "The trumpet call inaugurating a new time."[18] The special pavilion "Art Nouveau Bing" at the Paris *Exposition Universelle* of 1900 stressed the work of Colonna, de Feure, and Gaillard, and, though less epoch-making, showed a refined taste which seemed lacking in most of the exhibits.

Anti-Historicism. In an article which Bing wrote about the term Art Nouveau, he says that it was "simply the name of an establishment opened as a meeting

ground for all ardent young artists anxious to manifest the modernness of their tendencies,"[19] and, taking issue with the historicism still so prevalent at the time, he continued: "Amidst this universal upheaval of scientific discoveries the decoration of the day continued to be copied from what was in vogue in previous centuries, when different habits and different masters were current. What an astonishing anachronism!"[20]

The anti-historical attitude was as much an earmark of Art Nouveau as was its striving toward the synthesis of the arts. As early as 1885 Louis Sullivan, whose work predicted so many characteristics of Art Nouveau, proclaimed: "Our art if for the day, is suited to the day, and will also change as the day changes."[21] And Otto Wagner wrote ten years later in Vienna that the new style was not a renaissance, but a naissance, that modern life alone must be the sole starting point of our artistic creation, and that all else is archaeology.[22] Wagner's student, Joseph Maria Olbrich, inscribed in large letters on the building he designed for the Vienna Secession in 1898: *Der Zeit ihre Kunst,*[23] and the preface to the Munich periodical *Jugend,* which indeed gave the name to the style in Germany, reads in part: "We want to call the new weekly *Youth.* This really says all we have to say."[24] When in 1902 A. D. F. Hamlin published an article on Art Nouveau in the first critical series on the movement in the United States, he pointed out that there was little agreement among its adherents and that all they had in common was "an underlying character of protest against the traditional and the commonplace."[25]

Acceptance of Modern Technology. As part of this break with historicism and in contrast to the attitude of the Arts and Crafts movement, van de Velde defended the machine as an acceptable tool for the designer. He considered the engineer "the creator of the new architecture,"[26] whose boldness has surpassed even the daring of the builders of cathedrals, and who now works in metal and glass instead of stone and wood. His Belgian contemporaries, Hankar and Horta, made wide use of iron in their buildings, and Horta displayed the structural qualities of iron in his Tassel House with ornamental emphasis. This is not to say that iron construction was actually one of the sources of Art Nouveau.[27] It would seem more likely that Horta's sense of design and esthetic feeling—and possibly his familiarity with drawings and designs by Mackmurdo, Khnopff, Toorop, and Beardsley—determined his use of iron. But although the metal did not dictate his fluid, organic forms, iron was a fitting material for the architect's purpose. One of the essential aspects of Art Nouveau was the acceptance of technology and the machine as a means toward creating a new style, without, however, elevating functionalism to an esthetic principle.

In general, the Art Nouveau artists were convinced that they were evolving a new and contemporary style in which the flouting of convention—the attitude of *épater le bourgeois*—was "advanced" and desirable. The scathing social

accusations of Ibsen's plays found, in a certain sense, a parallel in the impudence of the unconventional Art Nouveau whiplash ornament that appeared in the theatre programs.

Historicism. Art Nouveau claimed to be the new art of the new time. Yet its avowed break with tradition was never complete. In certain ways Art Nouveau actually belongs with the nineteenth-century historical styles. The century had earlier run the gamut from the Egyptian revival of the first Empire to the baroque revival of the second. Now at the end followed Art Nouveau which, in France at least, often merged with a rococo revival. As Bing himself said: " . . . try to pick up the thread of . . . grace, elegance, sound logic, and purity, and give it new developments just as if the thread [of the French tradition] had not been broken. . . . "[28]

Rococo. Art Nouveau shared with the rococo a desire to make painting part of the general decor. Painters and decorators showed a preference for a light, high-keyed color scheme. Rococo characteristics can be observed in Horta's flowing space, in his asymmetrical ornamentation, his vigorous curves which, however, have substituted a more abrupt termination for the easy, elegant flow of the eighteenth century. Aubrey Beardsley in his last drawings culled quite consciously from eighteenth-century draftsmen like Saint-Aubin and Debucourt. Gallé, Majorelle, and Vallin, however, probably came closest to the gracefulness of rococo design, working in Nancy with its magnificent eighteenth-century Place Stanislas.

Celtic Art. The marked individuality of Art Nouveau in different countries is partly due to revivals of specific traditions. If the Nancy School seemed inspired by the rococo, the cult of the Celt attracted the Glasgow designers of the nineties in their search for an independent national culture. The flat patterns of Celtic manuscript pages, brooches and chalices in which intricate linear design of tangled interlace and coiled spirals is rigidly controlled by geometry is echoed in the early drawings and repoussé designs by Mackintosh and the Macdonald sisters and appears again in the murals of the Buchanan Street Tearooms of 1897 and in the wrought-iron ornament of the Glasgow School of Art.

Gothic. The fascination with the Celtic is part of the more comprehensive interest in the Middle Ages which spanned the nineteenth century. The Gothic Revival had begun in the 1750s with Sir Horace Walpole's Strawberry Hill, and continued to flourish under the aegis of A. W. N. Pugin, Ruskin, Morris, and Viollet-le-Duc. The latter, indeed, advocated the use of iron as a new building material, and the unconcealed display of structural members in the Gothic may well have inspired Horta's daring use of iron, while van de Velde was proud to

admit his conscious use of Gothic space concepts.[29] But in addition to their admiration for the rational nature of Gothic architecture, Art Nouveau artists were also intrigued by the ornament, especially in the late manifestations of the Gothic. These late buildings with their observations of natural growth, their flamelike and leaflike tracery, double curved ogee arches and flowing shapes, are called Curvilinear in England and Flamboyant in France, and even their names are descriptive of the very elements which appealed to the Art Nouveau. Guimard's Castel Béranger and Horta's Hotel Solvay, for instance, exemplify the relationship of Art Nouveau to the Flamboyant Gothic.

Blake. A similar flowing, undulating Gothic linearity appears in the book illuminations and temperas of William Blake, and there is no doubt that he exerted a major influence on Art Nouveau,[30] although the fervent feelings, conditioned by his visions, are not reflected. There is in *The Songs of Innocence*, for example, not only the smoothly flowing line, but also a comprehension of the page: the interrelationship of typography and ornament. Mackmurdo's *Hobby Horse* had a good many references to Blake, and the frontispiece of the first issue is "obviously a pastiche of Blake motifs."[31] It was Mackmurdo, the admirer of Blake, who produced the first work which combined all the characteristics of Art Nouveau: the chair designed in 1881,[32] and the second, the title page of his book *Wren's City Churches* published in 1883.[33]

Exotic Art. The nineteenth century, having managed to exhaust nearly all sources of inspiration in the Western past, turned at last beyond Europe and the Near East. Art Nouveau designers, for example, became interested in the flat batiks introduced by Dutch importers from Java. African sculpture was first reproduced as "art" when *Dekorative Kunst* published a number of Benin bronzes in 1899[34]—some five years prior to its discovery by the Expressionists in Dresden and the *Fauves* in Paris.

Japanese Art. But of greatest importance especially in painting and the graphic arts was the impact of the Japanese art.[35] Here was a completely new esthetic expression in which each Western artist could find inspiration for his own individual style. Whistler was the first major painter to show the direct influence of Japanese art. Japanese motifs are used in *La Princesse du Pays de la Porcelaine* of 1863-64; the famous Peacock Room of 1876-77 is entirely decorated in a design inspired by Japanese interiors. Moreover, Whistler also often placed his models against plain light walls and showed a similar preference for sophisticated simplicity in contrast to the burly heaviness of the arts and crafts of the day. Whistler was extremely important to men like Beardsley and was perhaps the chief intermediary between Japanese art and Art Nouveau.

Whistler was followed in his interest in Japanese art by Manet, Monet,

Renoir, Degas, Gauguin, van Gogh, and Toulouse-Lautrec; each took what he needed. Japanese textiles, fans, lacquers, and prints began entering collections, and it is noteworthy that men as intimately connected with Art Nouveau as S. Bing, Arthur L. Liberty, Louis C. Tiffany, Aubrey Beardsley, Otto Eckmann, and Toulouse-Lautrec are to be counted among the important early collectors of Japanese art.

Most significant for Art Nouveau was the two-dimensional planar aspect of the Japanese color woodblock, itself an expression of a late cultural phase: its absence of central perspective in favor of broad, homogenous, receding planes; the division of the picture space into large, unified areas; the evocative quality of the line in establishing a linear rhythm; the expressive contour; the use of color for flat pattern effect instead of illusionistic modeling; the asymmetry of the composition and energetic diagonal movement of linear design, frequently originating in the corner of the picture; and the simplification of natural forms for the sake of the picture.

Art Nouveau and Nature. The Japanese were able to deal intimately with nature without ever copying its surface appearance. The whole nineteenth century, of course, had great faith in the world of nature and the Art Nouveau artist, going to nature for a major source of inspiration, found in Japanese art a way to re-experience the very forces of nature in energetic, rhythmic line. Unlike the Impressionist, he was no longer concerned with momentary visual stimuli on the retina. Nature was still "the infallible code of all laws of beauty,"[36] but he wished to explore the forces of growth and to represent them symbolically. Art Nouveau artists were often careful students of botany: Gallé wrote scientific articles on horticulture, Grasset realized the applications of plant study for the new ornament,[37] Obrist started his career as a natural scientist. Ernst Haeckel, the German biologist and explorer who contributed significantly to the theory of evolution and who wrote a great many monographs on lower forms of life, published in 1899 his epoch-making *Kunstformen der Natur*.[38] This work consisted mainly of greatly enlarged color drawings of amoebae, jellyfish, medusae, and polyps. Forms in nature which had never really been seen before were suddenly made available to the artist and were furthermore presented in a layout and graphic style that was very much in the visual idiom of the period. Haeckel says in his introduction that esthetic considerations played a major role in the compilation of the book, and he expresses the desire to be able to contribute motifs to the arts and crafts of his time.

Indeed, the Art Nouveau interior at its culmination—Horta's house for Baron van Eetvelde, Mackintosh's Willow Tearoom, Guimard's Humbert de Romans Building, Endell's Atelier Elvira, with their sinuous shapes of iron, wood, stone and plaster, suggesting climbing stalks and clinging tendrils—produces the effect of a suddenly fossilized conservatory.

Iconography. It was nature in its most unexpected aspects which appealed to the Art Nouveau artist. He welcomed motifs of creatures found at the bottom of the sea, especially if the shapes of their tentacles or general contours corresponded to his own feeling for the flowing curves. If he used a flower, it was not the ordinary garden or field variety but rather the languid, exotic hothouse plant, whose long stalks and pale blossoms he found exquisite. Certain motifs keep recurring in Art Nouveau iconography: the lily, peacock and sunflower are adopted from the Aesthetic Movement, but the sunflower with its regular, radial form is less frequent, the peacock's tail feathers occur more often than the whole bird, and soon the lily pad and stem take precedence over the flower. The tendril of the vine is more interesting than its leaves, the bud more interesting than the blossom. The swan surpasses the peacock in popularity. Equally a symbol of pride, he is also capable of gliding with the utmost grace, and now everything begins to flow, partakes of constant movement. Almost to the exclusion of men, it is the woman who dominates the Art Nouveau world and the aspect of woman which pre-occupies the artist is her hair—long, flowing hair which may merge with the drapery or become part of a general wavy configuration. Loïe Fuller's serpentine dances—"The Butterfly," "The Orchid," "The Fire," "The Lily"—enjoyed the highest popularity and can be seen as the most apt expression of certain art impulses at the time. Her veils performed the same erotic function as the flowing tresses of the Art Nouveau female. This girl-woman, to a great extent descended from the hothouse creature of the Pre-Raphaelites, has the same ambivalent eroticism of a small-breasted, narrow-shouldered, virginal, indeed often boyish creature. Almost emaciated, her body is yet extremely languorous in its sexually suggestive poses. This is the woman who appears in different disguises in the world of Beardsley, Toorop, Thorn Prikker, Bernard, Denis, Grasset, Macdonald, Mackintosh, and Klimt.

The interest in the bud and the young girl suggests that the ideal world of the Art Nouveau artist was far removed from what is usually thought of as the "Gay Nineties." He seemed to prefer a melancholy, nostalgic expression to unbridled gaiety or joy. Everything remains in a state of unfulfillment; there is perhaps eager expectation, but it never seems to go beyond the threshold. And indeed the whole movement only makes beginnings. Toulouse-Lautrec, Beardsley, and Eckmann died early. Horta and Mackintosh, Toorop and Thorn Prikker, Bernard and Denis, even Edvard Munch, reverted to a conservative style and were never able to follow through on the brilliant promise of their youth. Hector Guimard continued in his Art Nouveau style, but his buildings of the twenties and thirties are anachronisms. Some of the architects, like Hoffmann, Behrens, and van de Velde, were able to develop beyond Art Nouveau to become important in the "Modern Movement" which followed, while painters such as Bonnard, Vuillard, Kandinsky, and Picasso found their own unique expressive forms after their Art Nouveau apprenticeship.

By 1900 the style had become generally accepted, even fashionably chic among the elite. Within the next two years it filtered down, and the international exhibition of decorative arts held in Turin in 1902 showed the popular triumph and the concomitant decline in taste. Art Nouveau was always an ornamental style, but at its best its ornament grew from a desire for symbolic-organic structure. But when it was merely applied, it tried to make up in ornateness for what it lacked in conviction.

Having been able to create a unified style and to shake off the heavy hand of nineteenth-century imitative compulsion, the avant-garde designers began to look in a different direction. With almost sudden deliberation the inventiveness of ornament, the playfulness, the organic feeling comes to a halt. "Organic" will now refer to the nature of the material, to fitness and to the function of the object rather than to vegetative growth. Whenever used, ornament becomes geometric: the right angle takes the place of the sinuous curve; the square, the circle, the rhomboid, the oval are preferred to the stalk, the wave, the hair. But buildings such as Mackintosh's House of a Connoisseur or Hoffmann's Palais Stoclet, while partially abandoning the wavy line for a more rectangular ornamentation, still adhere to the Art Nouveau principle of a two-dimensional decoration whose evocative power rests on its linear rhythm.

Historically, Art Nouveau fulfilled the liberating function of an "anti" movement. It discarded the old, outworn conventions and set the stage for the developments which followed with such extraordinary rapidity in the twentieth century.

Painting and Sculpture, Prints and Drawings

"Art Nouveau," "Jugendstil," "Secessionsstil," "Stile floreale"—whatever one calls the style, it belongs to the decorative arts. It was largely a way of *designing*, not of painting, sculpting, or building. Yet many Art Nouveau elements—the emphasis on the evocative power of an undulating line, the insistence on creating a two-dimensional decorative surface, the affinity to Symbolism in the artist's desire to suggest rather than to describe—were anticipated in painting before being used in the applied arts. Moreover, if there was no Art Nouveau painting as such, the style was so encompassing that it did have a great impact on a good many painters born in the sixties and seventies, no matter what direction their work was ultimately to take.

Impressionism was no longer the unchallenged protagonist of the avant garde when in 1884 two highly consequential exhibition societies were formed: *Les Vingt* in Brussels and the *Société des Artistes Indépendants* in Paris. The *Indépendants* was broad enough to include both Odilon Redon and Georges Seurat in its leadership. Redon was on intimate terms with the Symbolist poets and, like them, used the dream for inspiration. While still working with the visible world, he endowed his reality with fantasy, proposing to "use the logic of

the visible in the service of the invisible."[1] Redon felt that the Impressionists were "parasites of the object." As Mallarmé was concerned with the "mysterious meaning of life" and Lautréamont and Rimbaud with the exploration of the irrational world, so Redon was fascinated by the "little door opening on mystery."[2] Still in touch with Romantic sensibility, he created a visionary imagery in his graphic work. There he introduced black as an essential color and established his form by definite contour. His drawings and lithographs, on the frontier of reality and fantasy with their combination of the precise and the vague, were to lead him to the glowing colored pastels of his maturity. They no longer narrated but evoked a mood: in this they became important precursors of the style of the nineties.

Less evident but equally important was the contribution of Seurat, who exhibited his first masterpiece, *The Bathers*, at the *Indépendants* in 1884. In this as in his later work he used a quasi-scientific method to investigate the structural elements of color and line for the sake of constructing pictures which, instead of producing an effect of verisimilitude, would make the viewer conscious of a deliberately tectonic organization. Impressionism, the sensitive but literal recording of visual data, was transformed by the application of these analytic theories into a more rational investigation of visual experience. Art was no longer Zola's "corner of nature seen by a temperament," but a conscious attempt to stimulate a predetermined emotion by the direction of lines and the juxtaposition of color. This deliberate use of line and color and the geometric arrangement of forms in a flattened space in Seurat's late canvases—*La Parade, Le Chahut, Le Cirque*—seemed to provide a solution to the prevalent search for a new style.

In 1884, the same year as the foundation of the *Indépendants*, *Les Vingt* was formed in Brussels under the perceptive leadership of the lawyer Octave Maus, who sought out advanced work in all countries of western Europe. The exhibitions of *Les XX* provided meeting places for the innovators of the time. Ensor, Toorop, and Khnopff were charter members who exhibited regularly. Seurat's *A Sunday Afternoon on the Island of La Grande Jatte* had been shown as early as 1887, arousing violent opposition from the public but an enthusiastic response from the artists. The adoption of the Neo-Impressionist technique by Theo van Rysselberghe and Henry van de Velde dates from this event. Redon's drawings and lithographs had appeared in 1886; Toulouse-Lautrec exhibited in Brussels in 1888. In 1889 Gauguin showed twelve canvases, including his Symbolist *Vision after the Sermon*. The following year Cézanne, who had not shown in Paris since 1877, sent pictures to Brussels, and van Gogh had the one important show of his lifetime at *Les XX*. In 1892 and 1893 the decorative arts were shown, probably for the first time, on equal terms with painting and sculpture, a policy which was emphasized even more strongly by *La Libre Esthétique*, the successor to *Les XX*.

The enterprising spirit of these exhibitions, together with the process of

industrialization then sweeping Belgium and the accompanying awareness of new building needs and materials, was largely responsible for Brussels taking the lead in the Art Nouveau movement. It was there, indeed, that in 1893 the first full-fledged Art Nouveau building, Victor Horta's Tassel House, was erected.

Developments in France

Paul Gauguin, whose *Vision after the Sermon* had made such a strong impression on the Belgian public in the *Les XX* exhibition of 1889, had the great advantage—rare in the nineteenth century—of having never suffered an academic training. Starting to paint at a mature age, he had worked in the most advanced style, Impressionism, almost from the beginning. Early in 1888 he returned from Martinique to Pont-Aven in Brittany where the rural surroundings allowed him to work in comparative isolation from the Paris art world and where it was possible for him to indulge in his romantic craving for a more primitive way of life. In the summer, he was joined by the youthful Emile Bernard who, together with his friend Anquetin, had been working in a rigorously simplified and boldly patterned style, called "Cloisonisme" after the medieval enamel technique. Bernard was in close touch with the Symbolist poets and critics and familiar with their artistic program as it was expressed, for instance, in the *Revue Wagnérienne,* founded and edited by Edouard Dujardin, writer, musician, Aesthete, and close friend of Mallarmé and Debussy. The whole period points in many aspects toward an integration of all the arts.

Bernard's painting and probably even more his ability for theoretical formulation made a great impression on the older Gauguin, who was moving in the same direction. The two men admired each other's work. Like the Symbolist poets they believed that ideas and emotional experiences could be suggested by "equivalents" or "correspondences" in sound and rhythm, or in color and line, respectively. They evolved a style of painting which was first called Synthetism but became known as Symbolism after 1890 and which must be recognized as one of the most important components of the Art Nouveau movement.

Among Gauguin's paintings, the *Still Life with Three Puppies* shows the transition from his earlier style to his Symbolist manner of this period. The fruit and tablecloth in the lower part of the canvas with the visible brushmarks and the use of advancing and receding color still show Cézanne's influence, whereas in the upper part of the painting, the three goblets, three apples, three puppies, set against the steep plane of the tablecloth, are simplified in a child-like fashion. In a disarmingly naive way a flower on the tablecloth is repeated in the head of a dog. Gauguin and his friends developed an art of bold, abstract outline. They abandoned local colors in favor of naturalistic color harmonies. They allowed no foreshortening, no modeling, and when shadows were used, they were employed for their ornamental interest. They reduced depth of composition to a flat plane

on which a decorative pattern was applied in rhythmic lines. "Don't copy nature too much," Gauguin wrote to his friend Schuffenecker, "Art is an abstraction; derive this abstraction from nature while dreaming before it, but think more of creating than of actual result. The only way to rise towards God is by doing as our divine Master does, create...."[3]

In 1888 and 1889 Gauguin affirmed the principle of two-dimensionality in the Symbolist *Vision after the Sermon* and the *Yellow Christ*. It becomes even more evident in the *Decorative Landscape*, originally a door panel in Gauguin's studio at Le Pouldu and probably painted by himself. Here decorative flatness is carried to an extreme. There is no horizon, the surface is piled up with tree trunks, outlined trees and houses, and the seemingly arbitrary choice of colors helps to emphasize the effect of the plane, relating the whole to Art Nouveau in spirit. At this time Gauguin made, in fact, designs for decorative plates and painted bucolic scenes on vases, among them the one made by the famous ceramist Ernest Chaplet, whom he knew well. A convincing argument has been advanced that Gauguin's work in this field, where the simplification of form was conditioned by the technique, may have affirmed in him the wish to extend this new style into his painting.[4]

In his woodcuts, too, he abandoned the conventional method of making prints and began to cut and gouge his blocks to give them a coarse, hard-hewn appearance, resulting in designs of unusual expressive power. Gauguin's craftsman-like preoccupation with the material in these prints relates them as closely to Art Nouveau as does his starkly formalized stylization.

There was a tendency among the painters at Pont-Aven to extend their activities beyond easel painting. Emile Bernard, for instance, was designing glass windows and carved polychrome furniture. Often the subject matter for the decoration of these objects was derived from local peasant motifs. By redesigning their physical environment and distorting figures and landscapes, the artists responded to their inner need of expressing states of mind. Bernard's painting, *Bathers*, of 1889 reminds us of the sixteenth-century Florentine Mannerists with its piling up of figures whose stance is not defined in space; with the repoussoir of cut-off figures in the frontal planes; with the elongation of bodies, the use of the lost profile, the erotic symbolism. Objects change their meaning in this picture: a root or garment becomes an erotic symbol. We observe in amazement that the lawn on which the nudes stand or recline suddenly becomes a wall for the figure in the upper margin of the painting. A similar flattening of space takes place in Gauguin's *Still Life with Three Puppies* in which the tablecloth is interchangeable with wallpaper. There is an ambiguity, or rather, a conscious desire on the part of Bernard to play with dichotomies of depth and flatness, horizontality and verticality, lightness and darkness; a tendency to suspend definition of an object in order to express the purely decorative value of its two-dimensional shape. These factors become extremely important in Art Nouveau

decoration, while figures like the seated woman in the upper right make their reappearance in the early work of Matisse who will, however, recast the scene in a more joyous, less constrained manner.

The esthetics of Gauguin and Bernard were carried on by Paul Sérusier, to whom the purpose of art was the "evocation of an idea without expressing it."[5] He did not arrive at this concept independently. In the summer of 1888 he returned from Brittany with a landscape painted on a cigar box lid, which he called his "talisman." It represented for him the product of a lesson by Gauguin who had demonstrated to him the importance of the free reign of the artist's thought in which emotions and impressions were translated into constructions of simplified forms, eloquent outlines, structural color, slow movement. The pictures painted following these rules, rather than repeat visual impressions, evoked the spectator's quiet contemplation and led to what Gauguin called "the mysterious centers of thought."

Sérusier, who, together with Denis, Bonnard, Ibels, and Ranson, had been a student of Bouguereau at the Académie Julian, was instrumental in forming upon his return to Paris a group which called itself the *Nabis*. They were soon to be joined by Vuillard, Roussel, Séguin, Vallotton, and Maillol. *Nabi* is derived from the Hebrew word for Prophet, and the *Nabis* considered themselves a pure brotherhood of initiated artists who felt the need to renew art in their time. In the beginning they deliberately courted the influence of Gauguin. They also admired Redon, Cézanne, and the Japanese printmakers. In the famous formulation by Denis, "a picture—before being a battle horse, a female nude or some anecdote—is essentially a flat surface covered with colors assembled in a certain order."[6]

It is true that a painting like *April* is still very close to the allegorical symbolism of Puvis de Chavannes, and Puvis was indeed greatly admired by the younger generation. But Denis, whose importance as a theorist for the new style has already been pointed out, went beyond the literal allegory of the older master by composing a scene which expressed a major mood through a decorative equivalent. White-clad ladies walk quietly, bending, gathering flowers—restful white shapes set against a joyous yellow-green lawn—along a broad, amply curved path. A contrast is created by the complementary orange color of the horizontal fence, zigzagging sharply across the painting, and by the linear agitation of the bush in the lower left. But these are only minor disturbances that point up more effectively the essential meaning of the painting, which is pastoral, measured harmony.

Denis stressed the primacy of the flat surface, and it actually mattered little whether this was a canvas or a screen, a low relief, designs for stained glass, mosaics, tapestry, posters or stage sets. In fact, most of the *Nabis* made stained glass designs for S. Bing's *L'Art Nouveau*, which were executed by Louis C. Tiffany in 1895. Whenever possible, they wished to go beyond the limitations of

easel painting in their endeavor to make painting part of a total environment. This desire was vividly expressed by one of the *Nabis*, Jan Verkade: "About the beginning of the year 1890, a war cry was issued from one studio to the other. No more easel paintings! Down with these useless objects! Painting must not usurp the freedom which isolates it from the other arts.... Walls, walls to decorate.... There are no paintings, there are only decorations."[7]

Largely because of their close connection with the Symbolist writers, most of the *Nabis* were passionately involved in the small, experimental theater of their time. They made marionettes for the avant-garde puppet theatres and they designed scenery and programs for plays by Rimbaud and Maeterlinck, Ibsen and Strindberg, Hauptmann, Wilde, and Gide. Perhaps the climax of their concern with the stage was the performance of Alfred Jarry's *Ubu Roi* with Claude Terrasse's music at Lugné-Poë's Théâtre de l'Oeuvre in 1886; Sérusier, Bonnard, Ranson, Vuillard and Toulouse-Lautrec—all worked on the decor and costumes of this extraordinary play.[8]

Bonnard, in his activities as a painter, sculptor, book illustrator, lithographer, and designer of decorative screens and posters, is perhaps typical of the all-embracing attitude towards the arts of this period. An early painting such as *Le Peignoir* is primarily a piece of wall decoration, painted thinly on heavy cloth. The gold robe is embellished with a repeat pattern of brown crescents, which merge at the top of the garment into the background, suggesting lily pads floating on water. Its sumptuous jewel-like execution, held to the plane without any depth, and the motif of the white flower petals are close to Japanese decoration. The *Nabis* had nicknames for their members—Denis was called the "Nabis aux Belles Icônes" and Bonnard was the "Nabi Japonard." Bonnard, following a long line of painters since the 1860s to come under Japanese influence, had a profound understanding of the esthetic sense of Japan. While his first poster for *France Champagne* still shows Chéret's influence, the famous one for the *Revue Blanche* of 1894 is closely related to Japanese woodcuts. In the decorative screen (published in 1899), which is composed of four mounted color lithographs, the geometrically ordered design is sparse and leaves large areas blank. Color is subdued and spaced with incredible sensitivity. The verticality comes to a subtle but definite stop with the horizontal frieze of the carriages. This screen no longer relates to a single Japanese print, but in its restraint and understatement it gives the viewer the effect of an entire Japanese interior.

A close kinship to the earlier work by Bonnard is found in the four decorative panels which Armand Séguin painted for the inn at Le Pouldu. These panels are especially interesting in this context because here Art Nouveau characteristics are pronounced so emphatically. A free arabesque is the essential element: the figures of the women, the skaters on the ice, the sheet of music, the fowl, leaves, lampshade, hats. Flowing water and cigarette smoke, usually associated with fleeting transparency, have become curvilinear shapes, firmly

embedded in the decorative scheme. All forms relate to each other much like the wildly indented, yet carefully cut out pieces of a picture puzzle. Within these contours, Séguin has applied bright and strong colors in a rather improvised fashion. A few years after these panels were painted, on the occasion of an exhibition of Séguin's work in 1895, Paul Gauguin wrote in the preface to the catalogue that Séguin "is above all a cerebral—I do not say 'literary'—artist, that he expresses not what he sees but what he thinks by means of an original harmony of line which becomes part of an over-all arabesque."[9]

The arabesque is also the predominant factor in Paul Ranson's work, but here the curves move more slowly, are less nervous, and suggest a perpetual serpentine movement which extends beyond the picture frame. These undulating lines, like running water or burning flames, keep moving apart and coming together again, but never rest. Fully conscious of the decorative quality of his work, Ranson as early as 1890 made cartoons for tapestries which were executed in embroidery by his wife, France Ranson.

Maillol, who was also primarily engaged in tapestry design before 1895, achieved the desired flatness but gave his wall hangings a richer surface with more resonant color. His space, much more complex than Ranson's, consists of a series of overlapping and autonomous planes. Much like late medieval *mille-fleurs* tapestries which he must have studied, he assigns his figures to a space quite separate from the flowered background and relies on color and texture for his unifying effect.

Trouble with his eyes forced Maillol to abandon tapestry design and painting. His first sculptures—reliefs carved in wood—were similar to his tapestries. When he began modeling in the round at the turn of the century, he radically simplified his forms. His small bronze *Washerwoman* is conceived in large, basic planes. These planes with their definite curvature and undulating rhythm recall Art Nouveau, but even more important is the stress on the clearly outlined, negative space enclosed by the girl's arms, head, and garment which becomes as essential an element in the sculpture as the solid mass, acting as its necessary complement. The firm but swinging curve of the contour formed by the back and skirt of the kneeling woman seems to have been particularly dear to Maillol since it also occurs almost identically in a painting of the same year.

Sculpture of a very different kind was produced by Georges Lacombe, known as "Nabi sculpteur." Also eager to extend his activities beyond the confines of *l'art pour l'art*, he carved, around 1892, four decorative reliefs for a bed with human life as its symbolic theme. Birth forms the subject of the footboard, copulation and death the sides, while the headboard provides a "dream," indicating, no doubt, the belief that the irrational and mysterious preside over life. *The Dream* is represented by the ancient metaphor of the serpent biting its own tail. The serpent rolls itself into a face by forming the eyes in a great double loop. Nose and mouth are fitted in below to complete the monster face, which is

surrounded by linear and wavy decorations. Influenced directly by Gauguin— particularly Gauguin's sculpture—this low relief is one of the earliest pieces of sculpture which shows the awakening interest in primitive art during the last decade of the nineteenth century. We know that the Councillor Coulon, close friend and patron of the *Nabis*, had brought a collection of Pre-Columbian art from South America as early as 1880.[10] Pre-Columbian art was again seen—still as a curiosity, to be sure—at the Paris World's Fair of 1889. All this confirmed the anti-classical attitude of Gauguin and his friends; the exotic forms are used in a decorative way almost immediately—they become part of a feeling for flat and linear ornament which, although very different in style, is yet related to Art Nouveau.

The undulating movement of Art Nouveau appears again in Vallotton's *Waltz*. Félix Vallotton, who was born in Lausanne in 1865 and came to Paris in 1882, was drawn into the *Nabi* circle around 1890. This painting of 1892, done in a pointillist technique of rather large dots, abstracts the dancers into rhythmic S-curves, which keep gyrating in a continuous whirl. The head, placed off center in the lower right-hand corner, as well as the dancing couple sliced off by the right margin, proves again the strong hold which Japanese composition had on these artists.

Never a *Nabi*, Toulouse-Lautrec was studying in 1887 in the private studio of Fernand Cormon together with van Gogh, Bernard, and Anquetin. The four painters had a small joint exhibition in a little restaurant on the Avenue Clichy during that year and referred to themselves as the "Ecole du Petit Boulevard." The following year van Gogh left for Arles and Bernard for Brittany, while Lautrec steeped himself ever more deeply in the life of Paris, more interesting to him than earnest discussions about the purpose of art and the language of form. His unprejudiced mind and incisive eye cut through taboos and depict the life of this period which gave birth to Art Nouveau.

Like his friends, like most of the important painters of his generation, Lautrec became absorbed by the expressive possibilities of line. Indeed he went further than most of his contemporaries. In his *At the Nouveau Cirque: The Dancer and the Five Stiff Shirts* he yields completely to an Art Nouveau arabesque, which moves here with a spirited and vivacious flow. Hat, hair, and dress of the lady have taken on bizarre shapes, as has the dancer bending her body backwards to create a sharply exaggerated curve. The broad handling of the flat areas and the highly decorative pattern of this painting lead us to the conclusion that it was probably a design for a stained glass window or for a poster. In his paintings, Lautrec modeled his figures more solidly than in his posters and lithographs, and the paintings usually retain a more tonal quality.

In his graphic work he was able to suggest the total character of an individual, or the quickest gesture, by the slightest modulation of line. Here the line, precise and delicate, becomes an almost independent carrier of the emotion.

The lithograph of Loïe Fuller indicates her dance by a contour which is distilled to the essence of movement. At first glance the viewer seems to be looking at a flame or a puff of smoke rather than at a dancer. Indeed, Loïe Fuller in her long iridescent veils, which she would swing while multicolored lights played on their serpentine movements, must have appeared to be a phantom of the dance rather than an actual performer. Loïe Fuller's phenomenal success on every European stage during the nineties may be due to the fact that in her performances the dance seems no longer a physical act, but the embodiment of arabesque, of sinuous decoration. When she danced, "sculptured by the air, the cloth rose and fell, swelled and contracted... recalling the fluid, tenuous lines of *art nouveau* designers with their predilection for goblets shaped like tulips, grills like ramblers, and frames of desks and screens like espaliered trees."[11]

Soon the sculptor Pierre Roche was to make a small bronze of La Fuller in which her scarfs pour upward in an irregular billowing rush, transforming the object into a symbol of movement.

The world of Loïe Fuller and the art of Toulouse-Lautrec were no surprise to Picasso when he arrived in Paris in 1900. He had been part of the Barcelona avant garde which discussed Nietzsche and Wagner, recited French Symbolist poetry, and was familiar with the most progressive art of the time. Gaudí had been working on the Church of the Sagrada Familia since 1884. Picasso's first drawings were published in *Joventut*, a magazine modeled after the Munich *Jugend*, and he was a friend of Ramón Casas, the man who successively edited *Quatre Gats*, *Pel y Ploma*, and *Forma*, and whose portraits resembled those by Lautrec and especially Steinlen. Picasso's friends, Isidor Nonell and Carlos Casagemas, worked in this manner and it is not surprising that Picasso pinned Lautrec's poster of Jane Avril to the wall of his Paris studio in 1901.

His *Courtesan with Jeweled Collar* has this bold, linear, decorative character and shows the great interest in the play of positive and negative areas typical of Art Nouveau. Yet we can consider this early work as being only peripheral to Art Nouveau. The form is still the same but the purpose, it seems, has changed. While he must have enjoyed the daring curve of the feather, Picasso was also occupied with the human solitude of the woman and with the statuesque, plastic forms of her head, shoulder, and arms.

The earlier *End of the Road*, however, is in the full spirit of the Art Nouveau movement with its steep two-dimensional plane, its great emphasis on the curvilinear contour, and its heavy symbolic content. It is out of this feeling for universal tragedy, expressed here before the end of the century, that the somber figures of Picasso's Blue Period were to grow.

The British Contribution

England lacked the brilliant expressions of French Symbolist poetry and painting. The Aesthetic Movement in London occurred later, was less original

and certainly less virile. Yet, there is no minimizing the influence of the English Pre-Raphaelites after their first exhibition in Paris at the World's Fair of 1855. The Symbolists, and especially Mallarmé and Verlaine, showed much interest in their work, while Huysmans was most enthusiastic. They most admired Edward Burne-Jones, who had discarded the minute naturalism of the early Pre-Raphaelites in favor of an elaborated surface design. His gentle melancholy and languid silences were esteemed on both sides of the Channel, and as late as 1911 Burne-Jones and his teacher Dante Gabriel Rossetti are mentioned by such an advanced artist as Wassily Kandinsky as "searchers for the inner life by way of the external."[12]

Burne-Jones was the outstanding connecting link between the Pre-Raphaelites and the new style. Life-long friend and collaborator of William Morris and partner of Morris & Co., he was a painter who, in the spirit of the time, made cartoons for stained glass and designs for tapestry and needlework, painted wall panels, did mosaic decorations and illustrated books, the most important of which was the Kelmscott Chaucer.

In 1892, Aubrey Beardsley, then a nineteen-year old insurance clerk, showed a series of drawings to Sir Edward Burne-Jones and was so delighted by the older artist's encouragement that he referred to him as "the greatest living artist in Europe."[13] He then managed to complete 350 illustrations for Sir Thomas Malory's *Morte d'Arthur*, which were still to some extent in the medievalist style of Morris and Burne-Jones. Yet the liberating influence of the Japanese print is already visible. Soon Beardsley was also to see and use the most recent work of Whistler and Lautrec.

By 1893 when he did the drawings for Oscar Wilde's *Salome* he had matured into an accomplished draftsman in complete command of both line and concept. His drawings no longer illustrate specific scenes in the play but are commentaries which start where the text ends. His cold, biting line no longer delineates realistic forms, but leads a life of its own. The disposition of the white areas of the paper in relation to the filled-in black areas creates a most intriguing interrelationship of negative and positive shape. This formal meaning of the voids, creating an abstract pattern of black and white as a vital part of the composition, had never before been so important. Its significance in Art Nouveau typography has already been noted, and it was an essential phenomenon of Art Nouveau prints beginning with the woodcuts of Félix Vallotton.

Beardsley's work, like that of his French contemporaries, consists primarily of flat decorative patterns, but it differs in content. Beardsley was a satirist who loved the grotesque. Preoccupied with eroticism, he unmasked the suppressed aspects of late Victorian culture, not exposing its corruption so much as entering more fully into the intellectual indulgence of the *fin de siècle*. And, as his contemporary Arthur Symonds had already recognized, Beardsley transfigured "sin" by the abstract beauty of his line. He intellectualized evil and made

degradation seem attractive in these sardonic drawings where a stunning facility and a penetrating archness act to exclude emotion.

In 1894 the young artist became successively art editor of *The Yellow Book,* which he left after one year because of the tensions resulting from the Wilde trial, and the newly founded *Savoy,* contributing drawings to these brilliant and sophisticated journals of Aesthetes, Symbolists, and Decadents.

His style underwent several more changes. Always an eclectic, he continued to incorporate elements of past styles such as Greek vase painting or eighteenth-century illustrations into his work, which by the time of his early death in 1898 had already become less typically Art Nouveau.

Beardsley's illustrations were quickly known throughout Europe and the Western world. He had given visual definition to The Decadence, or, as Max Beerbohm called it, "The Beardsley Period." Almost simultaneously the impact of his drawings was felt by Klimt in Vienna, Bradley in Chicago, Horta in Brussels, Toorop in Antwerp, Vallotton in Paris, Bakst in St. Petersburg, and by a few adventurous young men and women in Glasgow.

This latter group, "The Four," as Charles Rennie Mackintosh, Herbert MacNair, and their future wives, the MacDonald sisters, were called, were evidently also familiar with the work Toorop was doing in Holland, and the illustrations by Carloz Schwabe for Zola, besides sharing the current interest in Celtic and Japanese art. All these elements had repercussions in their work which, however, develops a remarkably independent and original character. Their drawings, book plates, gesso panels, repoussoir metal work, murals, all show a stylized linear pattern which must be seen as an integral part of a total ensemble.[14] The Beardsley line recurs in their work, but while it is virulent with Beardsley, it has become coolly sophisticated in the work of the Scots. The line is stretched vertically, making the figures quite abstract; indeed, it seems that the female figures themselves often derive from the ornamental line. The attenuation is due to a strong sense of verticality within the rectilinear design. The same elongation appears in Mackintosh's furniture, and a representation of the human figure becomes simply a part of the linear pattern.

When Mackintosh designed the first of a series of tearooms—in themselves nuclei of the Reform Movement—for Miss Cranston on Buchanan Street in Glasgow, he stenciled on the wall large murals in which tall, stern women, with roses and other conventionalized flowers as their attributes, are surrounded by an *entrelac* line and carefully spaced so as to leave a major part of the wall blank. Identical figures appear at regular intervals in a rhythmic repeat pattern which reminds us of the "parallelism" developed by Ferdinand Hodler.

The light colors—"The Four" preferred pale olive, mauve, and especially white—are an essential part of the delicacy of the murals and the whole interior, an ensemble which arouses a feeling that can best be described as a measured austerity. A visitor to one of Miss Cranston's tearooms designed by Mackintosh

must have responded also to the extraordinary grace and refinement of the space—a total decorative effect of the kind alluded to by another contemporary Glasgow designer, Jessie Newbery, who wrote in 1898: "I believe in everything being beautiful, pleasant, and if need be, useful."[15]

Belgium and Holland

Henry van de Velde, who, more than any other single individual, was responsible for both the theory of the Art Nouveau style and for its dissemination throughout Europe, began his career as a painter. After a brief period of study at the academy of his native Antwerp, where Vincent van Gogh was his fellow student, he went to Paris. There he studied painting with the academic portraitist Carolus-Duran but established personal contact with the Symbolist poets and the Impressionist painters. When, after his return to Antwerp in 1885, he began painting on his own, he followed the most recent trend of Neo-Impressionism. No doubt this style appealed to him because it seemed to be based on a rational system, and while van Gogh's dynamic line did impress him, he tried to reconcile it with his own rational outlook. All his life van de Velde believed in the power of reason and man's ability to solve the problems of creating a better environment by applying his logical mind to the creation of better forms.

A prodigious reader, van de Velde was undoubtedly familiar with Charles Henry's hypotheses on the direct psychological effects of color and line. He soon abandoned the demanding technique of pointillism, and as early as 1892 he seems to have arrived at almost total abstraction. The *Abstract Composition* in the Kröller-Müller Museum still appears to derive from nature and suggests gourd and bulb motifs. It is a pastel in strong shades of orange-yellow, purple, green, black, blue, and pink, yet these colors have no descriptive function. The relationship of elliptical planes and sinuous rootlike forms creates a picture suggesting organic growth. Abstract shapes shift in an ambiguous space. Here, as in the almost totally non-objective woodcuts he contributed to the Flemish periodical *Van Nu en Straks* in 1893, van de Velde achieves the culmination of the Symbolist attitude of evoking an emotion without resorting to literal statements or allegorical description, and indeed, this was the furthest the Art Nouveau group moved toward non-objective art. In his theoretical writings, also, he declared his opposition to naturalistic decoration and championed a new abstract ornament, which he felt to be intellectually and emotionally invigorating.[16]

While almost totally abstract, the *Abstract Composition* and certainly the vignettes for *Van Nu en Straks* still belong in the realm of decoration rather than of pure painting. "Little by little," he recalls, "I came to the conclusion that the reason why the fine arts had fallen into such a lamentable state of decay was because they were being more and more exploited by self-interest or prostituted

to the satisfaction of human vanity. In the form of 'easel pictures' and 'salon statuary,' both were now being executed as often as not without the least regard to their eventual destination as with any other kind of consumer goods."[17]

As a matter of fact, it was not long before van de Velde gave up easel painting altogether. A social moralist, he followed the example of William Morris and entered the field of the industrial arts in almost all its aspects. He worked as architect, educator, writer, and designer. His importance as the international ambassador and spokesman for the new style (van de Velde preferred not to call it Art Nouveau) cannot be overestimated. Working in Belgium, France, Germany, and later also in Switzerland and Holland, he devoted his life to designing objects, or rather an environment, which would lead to a more liberal and a more rational life.

When in 1900-02 van de Velde designed the interior for the Folkwang Museum for Karl Ernst Osthaus in Hagen, he had Georges Minne's *Fountain with Kneeling Boys* installed in the main gallery where the attenuated lines and geometric structure form an integral part of van de Velde's design.

A comparison of one of these kneeling figures of 1898 with an earlier bronze by Auguste Rodin, *The Sirens* of 1889, dramatically points at two seemingly opposite aspects of Art Nouveau: the earlier, curvilinear and the slightly later rectilinear or "counter-Art Nouveau."[18] The almost rigid angularity of Minne's figure seems to be in complete contrast to the fluid, light-reflecting bronze of Rodin. Yet both sculptures share an essential linearity, a great emphasis on the contour which outlines an unbroken mass. It is precisely this linearity which evokes a specific emotional response in the viewer. Both Rodin and Minne left the naturalism of their predecessors in their concern for expressing a symbolic idea. While this may be sensuousness in Rodin's group and ascetic austerity in Minne's adolescent boy, they do share a mood of weariness and passivity, so typical of the *fin de siècle*.

Minne, who illustrated plays by Maeterlinck and poetry by Verhaeren, was, like his compatriot van de Velde, intimately connected with the Symbolist movement emanating from Paris. In contrast, the Dutch painters of the period owe their greatest debt to England: the work of Toorop and Thorn Prikker would be unthinkable without Blake, the Pre-Raphaelites, and Beardsley.

Jan Toorop, who was born in Java in 1858, divided his time in the eighties between London, where he was subject to the same influences as Aubrey Beardsley, and Brussels, where he exhibited with *Les XX* as early as 1884 and became a friend of Maurice Maeterlinck, who inspired him to work in a Symbolist manner.

His drawings of the early nineties—perhaps his greatest contribution and certainly the most important in this context—suggest the mood of melancholy mystery achieved by ambiguously combining an elaborate literary metaphor with evocative form. Renouncing color almost entirely, his powerful drawings might almost be a programmatic illustration of Symbolism. In the most significant of

these, the large *Three Brides* of 1893, in chalk and pencil on brown paper, line is used not only to delineate the figures but also to denote sound and at the same time to express its own abstract force. In order to read the mystic content of this picture, representing the contrast between good and evil, an almost literal analysis is necessary:

The three brides stand for the nun bride of Christ on the left, the lilies as attribute; the human, innocent, virgin bride in the center, surrounded by roses; and the bride of Satan on the right with a collar of skulls and a basin of blood. Below, female figures with closed eyes—clearly derived from Javanese shadow puppets—are shown as if floating around a stylized chrysanthemum. Above in the background a frieze is formed by heads of young girls—a chorus of disembodied spirits—and in the corner the ringing bells, from which long skeins of maidens' hair are flowing, seem to allude to the prophetic tolling of the bells in the writings of Maeterlinck and Poe, whose work Toorop was illustrating at the time. But the hair strains translate into visual terms the waves of sound: softly rounded and rising on the left they indicate "the good," while on the right the dropping, shrill, angular "noise lines" embody "the evil" in an apparently downward falling movement. The iconography of a medieval Last Judgment representation clearly finds its echo in this pedantic Symbolist composition.

The picture as a whole—which certainly strikes us today as both too sentimental and too literal, particularly when contrasted with the simple directness of van de Velde's *Abstract Composition*—had, however, an immediate influence on its time. Its strictly symmetrical composition, attenuated curves, all-over pattern, sparse use of color, slender bodies, unrealistic grouping of figures and objects, and mysterious mood corresponded well with the demands of the Art Nouveau movement. It was illustrated in the first volume of *The Studio*,[19] and the early drawings of Frances Macdonald and C. R. Mackintosh are directly traceable to this source.[20]

Thorn Prikker, who painted in a dark Impressionist vein before turning to religious symbolism, in the winter of 1892-93 painted *The Bride*, which relies considerably less on figurative allegory than did Toorop's painting and depends upon the suggestive use of form. The clustered shapes in the background are not actually candles, but suggest them; there is no bridal wreath, but twining lines infer it. There are no facial expressions, and the bride herself is implied by a long shape in a veil-like garment patterned with decorative forms derived from flowers. A spiral line connects her on the one hand with the larger form symbolizing the crucified Christ and on the other with the flanking group of oversized bud shapes. The picture is painted in soft greys and greens and light violets, and a gentle sensuality is evoked by the melodiously curving lines and budding shapes. Its undefined growing forms, its rotating motion, subdued color, and general mood, suggest the paintings which Marcel Duchamp was to do some twenty years later.

There were strong cross-influences among Thorn Prikker, Toorop, and van

de Velde. Thorn Prikker was the last of these artists to exhibit with *Les XX* in 1893, when he first met van de Velde and contributed drawings to *Van Nu en Straks*. Van de Velde also stimulated him to engage in the applied arts: he did batik designs as well as wallpapers and furniture. In his paintings and drawings at the turn of the century, however, he renounced what he considered the Symbolist fallacy. In 1904 he moved to Germany and began to devote himself primarily to work for the Catholic Church, designing stained-glass windows and painting murals. Jan Toorop also became more conservative in his later work, was converted to Catholicism in 1905, and turned to more conventional liturgical painting.

Hodler, Klimt, and Munch

The general revival in religious feeling and the turn toward mysticism in the nineties account for the success of the Rosicrucian movement under the leadership of the Sar Péladan. With the financial backing of the Count de la Rochefoucauld, the Sar Péladan brought together transcendentalists and Aesthetes, spiritualists and charlatans, and succeeded in holding his *Salon de la Rose-Croix* at Durand-Ruel's in 1892, mingling paintings by the *Nabis* and Symbolists with more academic exercises. Ferdinand Hodler, born of Swiss peasant stock in Bern and active in Geneva, painted, after naturalistic beginnings, the large Symbolist composition *The Night* in 1890. When he followed his canvas to Paris in 1891, he was greatly admired and fêted by the Rosicrucians for his allegory of sleep, love, and death, and, in turn, came briefly under their spell. Philosophically inclined, Hodler strove for a transcendental art that, he felt, should express his mystical feelings of pantheism in the universe.

Hodler created several large figure compositions, such as *The Chosen One*, which may be interpreted as a cryptic commentary on the "Adoration of the Child." As in van de Velde's earlier tapestry, *Angel's Guard*, which was on the same theme, Hodler wanted to avoid any reference to a specific time or place, even to the Biblical event. A small nude boy is seen kneeling in a symbolic garden, planting a small tree and praying for its growth. He is fenced in by a group of angels, standing sturdily on the air, who seem almost to be fastened to their columnar garments. They hold tender flowers as if in answer to the supplication of the "chosen" boy before the leafless tree.

The ritualistic figures and their garments are simplified to the utmost, eliminating everything that is accessory, transitory, or accidental. The landscape background elicits no feeling of atmosphere, avoids all naturalistic space concepts, and is used only as a foil to set off the rhythmic pattern of the figures. The light color serves merely to fill in the clearly delineated contour which again puts supreme emphasis on the repeat pattern of the stylized figures. Hodler saw in man and nature a constant recurrence of the same phenomena which led him

to develop his theory of "parallelism." According to this concept, the repetition of forms serves to intensify emotion by creating a unified rhythm and thus give an image to his idea of human solidarity within a pantheist cosmos. "We know and we all feel in certain moments that that which unifies us human beings is stronger than that which separates us."[21]

Often Hodler's large figure compositions strike us as overburdened with rhetorical, passive gestures. The idealist purpose and allegoric imagery still relate Hodler to the world of the Pre-Raphaelites. They are essentially an expression of a philosophy of life, rather than an intensely felt visual experience. Yet, like his Art Nouveau contemporaries, Hodler worked in terms of the plane enriched with a decorative pattern, where a tense line becomes the important carrier of emotion. *The Chosen One* was placed in the Hohenhof,[22] which van de Velde designed for Karl Ernst Osthaus in Hagen, where it acted as an integral part of a unified Art Nouveau composition. His large, mural-like compositions with their severe symmetry and precise linear structure tried, in fact, to transpose Art Nouveau from the realm of the decorative into that of the monumental.

A retrospective exhibition of Hodler's large figure pieces at the Vienna Secession in 1904 was so successful that thereafter his fame was assured. The way for his great triumph in Vienna had been prepared for him by Gustav Klimt and his other friends of the Secession. The Vienna Secession was founded in 1897, and the following year its brilliant and colorful official organ, *Ver Sacrum*, began publication. From then on developments in Austria, starting later than in Western Europe, succeeded one another with great rapidity. In the mid-nineties Austrian design was still in the grip of heavy-handed eclecticism. A few years later, at the Universal Exposition in Paris in 1900, the Austrian pavilion, designed by Hoffmann and Olbrich, was the best example of the new style and in itself a remarkably elegant structure. Klimt, the president of the Secession, had worked originally in the fashionable academic manner of Hans Makart and had not become familiar with contemporary European art until 1895. The foundation of the Secession immediately opened the doors to advanced European artists. Klimt was especially impressed by Jan Toorop, the Belgian Symbolist Fernand Khnopff, and Franz von Stuck, who worked in a similar vein in Munich. Most important, however, was the influence from Britain: Burne-Jones, Beardsley, and especially Mackintosh.

By 1900 Klimt had established his own style. He was "famous well beyond the borders of his own country . . . an artist so typical of *art nouveau* that a more characteristic example of that international style could hardly be found. If *art nouveau* was an art of the surface—and a beautifully ornamental surface—of flowing curves and delicate figures, of ephemeral beauty and rich ornamentation of poetical, sometimes symbolic subjects, a feminine and decadent art—Klimt was its quintessence."[23]

Klimt was in great demand as a painter of mutedly elegant portraits; and he

painted allegorical pictures of voluptuous young women set off against richly textured backgrounds, often applying gold and silver sequins to the canvas. This application of metal to the picture plane was probably inspired by Byzantine mosaics, but in some ways it anticipates the modern collage. He did landscapes and flower pieces, covering the picture with a linear, strongly colored carpet in which representational elements are interwoven with freely invented geometric ornaments—the whole canvas being executed with a festive ornateness suggestive of the handicraft products of the other Secessionists.

Klimt had ambitions for making large wall decorations. Between 1900 and 1903 he created imposing murals for the faculties of philosophy, medicine, and jurisprudence at the University of Vienna, which met with severe popular disapproval because of the radical character of their symbolism. Then, to surround Klinger's Beethoven Monument at the Secession in 1902, Klimt made an allegorical frieze whose sentimentality is as refined as Klinger's is bombastic. His most successful work, however, was the frieze he designed for Josef Hoffmann's Palais Stoclet. In keeping with the quiet elegance of Hoffmann's designs, Klimt's murals for the dining room possess a restrained and graceful repose achieved through a rhythmic repetition of geometric forms. To stress the value of the wall as wall, Hoffmann framed his plain white surfaces with a heavy gold border. Similarly, there is no longer any three-dimensional illusion in Klimt's mural. The motifs—tree of life, dancer, lovers—are subordinated to a flat, ornamental structure of triangles, ovals, curves, volutes, and free arabesques. The designs were executed in a mosaic of glass and semi-precious stones, majolica, white marble, metal, and enamel. They approach the decorative splendor of Byzantine mosaics and, indeed, the stylized tree with its spirals brings to mind the work of the Orthodox Baptistry in Ravenna. But compared with the majestic dignity of the Ravenna mosaics, Klimt's beautiful and delicate frieze hardly rises beyond arts-and-crafts embellishment.

The decorative nature of Art Nouveau was not truly conducive to a monumental conception. However, there were examples in which the emotional quality of the whiplash line could rise beyond the purely decorative to a genuine expression of deep psychological involvement. This was true of the work of Edvard Munch.

As a young man, Munch was part of the intellectual fermentation and libertine radicalism of Oslo's bohemia. Then, coming to Paris in 1889, he made contact with the most advanced painting in France. He saw the work of Seurat and Lautrec and at Theo van Gogh's gallery he looked at van Gogh's paintings, and was especially impressed by Gauguin. He began working on a series of paintings—the *Frieze of Life*—dealing with man's emotional life and his suffering. In 1892 he traveled to Berlin for an exhibition of these paintings, only to see the show close within a few days after precipitating one of the great controversies of this period which is notorious for the number and the intensity of its art scandals. Munch, however, remained to become a central figure of the

progressive cultural life of Berlin. His paintings and prints express not only the general melancholy of the *fin de siècle*, but an additional intense anxiety, whether of man-woman relationships fraught with desire and suffering, or of individual figures threatened by the forces of life and confronted by the terror of death.

"Perhaps Edvard Munch came closest to a pictorial realization of the symbolist's endeavor to evoke an immediate response through the use of the plastic form itself without the intermediary factor of didactic allegory. *The Cry* of 1893 uses a minimum of descriptive or narrative elements. A writhing figure emerges from the picture plane, and its convoluted form is repeated throughout the landscape in the sinuous line of the shore and the equivalent rhythm of the clouds. The curved line is strongly emphasized by its contrast to the straight, rapid diagonal cutting through the imaginary space of the painting. The cry that the central figure seems to be uttering pervades the landscape like a stone creating centrifugal ripples in water. Munch has painted what might be called sound waves, and these lines make the human figure merge with the landscape to express a total anxiety that evokes an immediate response from the observer."[24]

Unlike Toorop's *Three Brides* of the same year, *The Cry* was able to communicate emotion through the visual elements themselves. Munch then proceeded to exploit these elements by repeating the same themes in various painted versions or by turning to graphic reproduction. He began experimenting with the different print media in 1894 and, impressed by Séguin's prints, he made drypoint and aquatint etchings in which he managed to recapture the atmospheric quality of his oils. In his woodcuts he profited by the pioneer work of Vallotton and Gauguin, became greatly intrigued by the nature of the medium itself, and, stressing the grain of the woodblock, he reached a remarkable virtuosity. The breadth and freedom of lithography, however, permitted him the closest approach to recasting the flowing qualities of his paintings.

The *Madonna*—certainly a startling title for the languid nude painted in 1894—was repeated in a color lithograph the following year. But in the lithograph a border is added in which a foetus and spermatozoa appear shockingly to allude to the role of the Madonna as the creator of life. The sperms, while resembling the cells seen under the microscope, serve to form the decorative border and have assumed the sinuous line of Art Nouveau. When Munch returned to Paris in 1896, it was S. Bing who exhibited his paintings at his new gallery, *L'Art Nouveau*, and it seems significant that Munch's friend August Strindberg wrote a review of the show in the most important organ of the *Nabis*, the *Revue Blanche*.[25]

The Situation in Germany

Germany produced no truly outstanding painting or sculpture during its Jugendstil period. This is probably because the Germans took certain principles of Art Nouveau too literally and too seriously. Much in the manner of the earlier

Arts and Crafts Movement in England, the German artists in the nineties felt a great moral responsibility for the creation of objects of fine workmanship and individual value to counteract the cheap products of a debased mass culture. Historicism, which had remained firmly entrenched in Germany so much longer than it had across the Rhine, was finally rejected and academic convention repudiated. Functional and beautiful objects were made which would carry the personal imprint of the artist's hand. The arts and crafts, therefore, became the center of interest for some of the best German artists—Peter Behrens, Otto Eckmann, August Endell, Hermann Obrist, Bernhard Pankok, Richard Riemerschmid—most of whom had begun their careers as painters. The level of the applied arts, to which they devoted most of their activities, was raised to meet the highest standards. Painting itself was to become mostly embellishment of a well-appointed space, and was to "fit into a room like a gem into a ring."[26]

Periodicals which covered literature, politics, and social satire as well as art became the rallying points of the new movement. The erudite vanguard quarterly *Pan*, which Julius Meier-Graefe founded in Berlin in 1895, was followed in 1896 by the more popular Munich weeklies *Jugend* and *Simplicissimus*. These magazines sponsored a whole group of extraordinary illustrators, among whom Thomas Theodor Heine, Olaf Gulbranson, Bruno Paul, and Rudolf Wilke produced some of the most vigorous work. Many of the talented artists of the time contributed cartoons, illustrations, and ornaments, and it was in *Jugend*, for example, that Ernst Barlach began his career. Soon after his Jugendstil drawings and covers for *Jugend*, Barlach began doing sculpture, designing plaques, small fountains, and decorative ceramics. His *Cleopatra* of 1904, with its typical Art Nouveau kidney shape, is a sensuous nude completely surrounded by a sweeping cloak in which the busy movement of its delicate ripples opposes the smooth surface of the figure. These early decorative Art Nouveau sculptures, however, bear little resemblance to the monumental carvings of archetypes for which Barlach is remembered and which began after his trip to Russia in 1906.

Many of the German painters who like Barlach became leading figures in the German Expressionist movement had their start in Jugendstil. For example, Ernst Ludwig Kirchner's early woodcuts—which he later refused to acknowledge—were typically Art Nouveau. In his *Before the People* the man and woman are dancing on a ridge above the crowd. This scene finds a symbolic linear equivalent on the left side of the print in the abstract forms suggesting dance movement and a group of staring eyes.

Isolated in the artists' colony of Worpswede, yet in close contact with the art of Paris, Paula Modersohn-Becker evolved her own personal Art Nouveau forms in this German Pont-Aven. In her *Still Life* of ca. 1900, she had already gone far beyond the regional lyric naturalism of Worpswede and was describing objects with what she referred to as "runic writing." In her enthusiastic treatment of the decorated tablecloth, the convoluted curves of the embroidery take on an organic

life of their own. Later she simplified her forms and hardened her structure but never lost her understanding of symbolically decorative form.

Typical of the Jugendstil artists of Munich, which had become the center of the movement, was the tendency to restrict every form to a two-dimensional plane, reducing even the human figure to nothing but an ornamental design. The *Kiss* by Behrens of 1898 is a good example of this. The two severe, almost classical profiles, surounded by a dense arabesque of hair, are drawn in a delicate rhythm of dynamic balance. Nothing of the warm, life-like embrace of Rodin's *Kiss* of 1886 remains; all that is left is an intricate interlace of lines in which the pointed meeting of the mouths forms the abstraction of a kiss.

It was in Munich in the nineties that the philosopher Theodor Lipps, advocate of the theory of empathy, held lectures at the University on the evocative meaning of line and performed experiments on the effect of linear movements on the human psyche. There Hermann Obrist, who had been trained as a natural scientist, used organic forms abstractly in his embroideries, like *The Whiplash*, and then again in his sculpture designs for fountains and funerary monuments. He made the declaration, revolutionary for 1901, that the human form is no longer the end-all of sculpture and urged sculptors to parallel nature in creating growing forms. His *Design for a Monument* is a diagonally rising wedge with a swift continuous spiraling movement. The figures—the angel on the summit of the spiral, for instance—are banal literary vestiges which the next generation (cf. Tatlin) could easily eliminate.

August Endell, a student of Lipps in philosophy and under Obrist's influence as an artist, designed the imaginative relief on his Atelier Elvira. Based on a dragon motif, the purple form floats with exuberant fury on its green wall. It is still architectural decoration—not yet free abstract sculpture—but Endell already foresaw the development of a new non-representational art form.

"It was a great time of artistic renewal when I came to Munich to study in 1901," Gabriele Münter remembers. "Jugendstil began in its own way to destroy the old naturalism and to devote itself to pure line."[27]

Gabriele Münter's friend and teacher, Wassily Kandinsky, made a series of woodcuts based on romantic, medieval fairy-tales. In these he must have been influenced by the ballet design and stage décor of Bakst, Benois, and Somov, whose work he saw on his frequent return visits to Russia. In *The Mirror* of 1903, the two-dimensionality of the picture plane is predominant; almost all vestiges of perspective are eliminated. But an intricate play between foreground and background is stressed by the use of positive and negative forms. The white of the paper, for instance, serves at the same time to shape the clouds in the sky behind the fairy-queen and the long veil floating down in a zigzag line advancing in front of the figure. Yet the small broken-up curvilinear forms of its folds tie up with the grey ones on the hanging sleeves, located somewhere between veil and clouds. Again, an all-over pattern of white flowers spreads evenly over skirt and

lawn; it is only by means of these flowers that the shape of the skirt is recognizable since no line separates its black from the black of the sky. It is this interpenetration of multiple space values creating suspension of space and tension of surface which is so characteristic of Art Nouveau design from Vallotton to Kandinsky. This was one of the means of visual expression which Kandinsky was to explore further in his breakthrough from Art Nouveau to Non-Objectivism.

Many of the Art Nouveau artists from Germany made contributions to this unified style. As in the rest of Europe, there were those who came to their peak during their participation in the movement, but sank again into mediocrity, after the hold which the vital elements of the new style had on their talents had weakened. But there were also those who, beginning their careers, took aspects of Art Nouveau as a starting point, to leave the movement itself far behind them on their way to artistic maturity.

Notes

Introduction

1. Alexander Koch, "Aufruf an die Deutschen Künstler und Kunstfreunde," *Deutsche Kunst und Dekoration*, Vol. 1, 1897-1898, p. 1.

2. First Proclamation of the Weimar Bauhaus, in Bayer, Gropius and Gropius, *Bauhaus*, New York, Museum of Modern Art, 1938, p. 16.

3. Walter Crane, *Transaction of the National Association for the Advancement of Art and Its Application to Industry*, Liverpool, 1888, p. 216.

4. Leo Tolstoy, *What is Art?*, Translation from Russian by Aylmer Maude, New York, Crowell, 1899, p. 43.

5. One of the important Symbolist reviews in Paris was the *Revue Wagnérienne*, founded in 1885 by Edouard Dujardin. Among its famous contributors were Stéphane Mallarmé, Stuart Merrill, and Theodor de Wyzewa.

6. Gerstle Mack, *Toulouse-Lautrec*, New York, Knopf, 1938, p. 319-320.

7. Jean Moréas, "Le Symbolisme," *Figaro Littéraire*, Sept. 18, 1886.

8. Stéphane Mallarmé, "Réponse à une enquête," in J. Huret, *Enquête sur l'évolution littéraire*, Paris, 1891, reprinted in *L'Art moderne*, Aug. 9, 1891.

9. For a more thorough discussion of Symbolist theory see Guy Michaud, *La Doctrine Symboliste* (Documents), Paris, 1947 and Jacques Lethève, *Impressionistes et Symbolistes devant la presse*, Paris, Armand Colin, 1959.

10. G. Albert Aurier, "Symbolisme en peinture: Paul Gauguin," *Mercure de France*, March 1891.

11. Robert Koch, "The Poster Movement and 'Art Nouveau,'" *Gazette des Beaux-Arts*, Ser. 6, Vol. 50, November 1957, p. 285-296.

12. For a discussion of the relationship of Symbolist literature and painting: John Rewald, *Post-Impressionism from van Gogh to Gauguin*, New York, Museum of Modern Art, 1956, and Peter Selz, *German Expressionist Painting*, Berkeley and Los Angeles, University of California Press, 1957, Ch. VI.

13. Crane, lecture delivered before the National Association for the Advancement of Art, 1889, *Transaction of the Art Congress*, Edinburgh, 1889, p. 202-220.

14. Henry van de Velde, "Prinzipielle Erklärungen," *Kunstgewerbliche Laienpredigten*, Leipzig, Hermann Seemann, 1902, p. 188. Van de Velde's theory of the expressive forces and emotional values of the line is preceded by the researches and the 1885 Sorbonne lectures of Charles Henry. The paintings of Seurat and Gauguin also antedate van de Velde.

15. August Endell, quoted in Selz, op. cit., p. 55-56.

16. Van Gogh "was permitted to roam through Bing's entire building, including cellar and attic, and his enthusiasm knew no limits." Rewald, op. cit., p. 72.

17. Robert Koch, "Art Nouveau Bing," *Gazette des Beaux-Arts*, Ser. 6, Vol. 53, March 1959, p. 179-190.

18. Karl Ernst Osthaus, *Van de Velde*, Hagen, Folkwang Verlag, 1920, p. 19.

19. S. Bing, "L'Art Nouveau," *The Architectural Record*, Vol. 12, No. 3, August 1902, p. 281.

20. Ibid., p. 283.

21. Louis Sullivan, "Characteristics and Tendencies of American Architecture," *Inland Architect and Builder*, 6, Nov. 1885, p. 58.

22. Otto Wagner, *Moderne Architektur*, Vienna, 1895 (4th edition published as *Die Baukunst unserer Zeit*, Vienna, 1914).

23. "Each time its art."

24. Preface to Vol. 1, No. 1 of *Jugend*, 1896.

25. A. D. F. Hamlin, "L'Art Nouveau: Its Origin and Development," *The Craftsman*, Vol. 3, Dec. 1902, p. 129. The other articles in this series are: Irene Sargent, "The Wavy Line," *The Craftsman*, Vol. 2, June 1902, p. 131-142; Jean Schopfer, "L'Art Nouveau: An Argument and Defence," *The Craftsman*, Vol. 4, July 1903, p. 229-238; S. Bing, "L'Art Nouveau," *The Craftsman*, Vol. 5, Oct. 1903, p. 1-15; see also Hector Guimard, "An Architect's Opinion of L'Art Nouveau," *The Architectural Record*, Vol. 12, June 1902, p. 127-133.

26. Van de Velde, "Die Rolle der Ingenieure in der Modernen Architektur," *Die Renaissance im modernen Kunstgewerbe*, Berlin, Cassirer, 1903, p. 111.

27. Cf. to the contrary: Sigfried Giedion, *Space, Time and Architecture*, Cambridge, Harvard University Press, 1946, p. 224-225.

28. S. Bing, "L'Art Nouveau," *Architectural Record*, op. cit., p. 285.

29. Van de Velde, "Das Ornament als Symbol," *Die Renaissance im modernen Kunstgewerbe*, op. cit., p. 94-96.

30. The spirit of Blake's work was carried on by Samuel Palmer. Blake's illuminated books were exhibited in the Print Room of the British Museum from the 1850s on. Dante Gabriel Rossetti acquired Blake's Notebook (formerly in Palmer's possession) in 1847, and prints by Blake were reproduced in Alexander Gilchrist's *Life of William Blake* (2 vols., London, 1863). Swinburne's *William Blake* (London, 1868) must also have had a considerable influence on writers and

artists of the time. The influence of Blake on Art Nouveau is clearly traced in a recent article by Robert Schmutzler, "Blake and Art Nouveau," *Architectural Review*, Vol. 118, No. 704, August 1955, p. 90-92.

31. Schmutzler, op. cit., p. 92.

32. Reproduced in Stephan Tschudi Madsen, *Sources of Art Nouveau*, New York, Wittenborn, 1956, p. 276, fig. 151.

33. Nikolaus Pevsner, *Pioneers of Modern Design*, New York, The Museum of Modern Art, 1949, p. 55, and other scholars following Pevsner, such as Henry-Russell Hitchcock, *Architecture: Nineteenth and Twentieth Centuries*, Baltimore, Penguin Books, 1958, p. 285, and R. Schmutzler, op. cit., seem to indicate that the book, rather than the earlier chair, is the first Art Nouveau object.

34. *Dekorative Kunst*, Vol. 4, No. 8, 1899, p. 81 ff.

35. For an early treatment of the Japanese influence on Art Nouveau see Ernst Michalski, "Die entwicklungsgeschichtliche Bedeutung des Jugendstils," *Repertorium für Kunstwissenschaft*, Vol. 46, 1925, p. 133-149. For a more recent and thorough treatment: Clay Lancaster, "Oriental Contributions to Art Nouveau," *Art Bulletin*, Vol. 34, No. 4, 1952, p. 297-310.

36. S. Bing, "L'Art Nouveau," *The Craftsman*, Vol. 5, Oct. 1903, p. 3.

37. Eugène Grasset, *La Plante et ses applications ornamentales*, Paris, Librairie Centrale des Beaux-Arts, 1897-1899.

38. Ernst Haeckel, *Kunstformen der Natur*, Leipzig and Vienna, Bibliographisches Institut, 1899-1904.

Painting and Sculpture, Prints and Drawings

1. Odilon Redon, *A Soi-Même*, Paris, Floury, 1922, p. 30.

2. Ibid., p. 89.

3. Paul Gauguin to Schuffenecker, August 14, 1888. Quoted in John Rewald, *Post-Impressionism from Van Gogh to Gauguin*, New York, The Museum of Modern Art, 1956, p. 196.

4. Merete Bodelsen, "The Missing Link in Gauguin's Cloisonism," *Gazette des Beaux Arts*, Vol. 53, May 1959, p. 329-344.

5. Paul Sérusier, *ABC de la peinture, correspondance*, 3rd ed., Paris, Floury, 1950, p. 164.

6. Maurice Denis, *Théories 1890-1910*, Paris, Bibliothèque de l'Occident, 1913, p. 1.

7. Jan Verkade, *Le Tourment de Dieu*, Paris, Librairie de l'Art Catholique, 1923, p. 94.

8. Agnès Humbert in her book, *Les Nabis et leur époque*, Geneva, Cailler, 1954, evokes the life of the artists in a vivid manner.

9. Gauguin, Preface to exhibition catalogue, *Armand Séguin*, Paris, Barc de Boutteville, February-March 1895, p. 9-10.

10. Humbert, op. cit., p. 106.

11. Lincoln F. Johnson, Jr., "The Light and Shape of Loie Fuller," *The Baltimore Museum of Art News*, Vol. 20, No. 1, October 1956, p. 13.

12. Wassily Kandinsky, *Über das Geistige in der Kunst*, Munich, Piper, 1912, p. 30.

13. Letter by Aubrey Beardsley to A. W. King. Quoted by Robin Ironside, "Aubrey Beardsley," *Horizon*, Vol. 14, No. 81, September 1946, p. 193.

14. For an excellent recent analysis see Thomas Howarth, *Charles Rennie Mackintosh and the Modern Movement*, London, Routledge and Kegan Paul, 1952.

15. Quoted by Gleason White, "Some Glasgow Designers and Their Work," Part III, *The Studio*, Vol. 12, 1898, p. 48.

16. Van de Velde, "Prinzipielle Erklärungen," in *Kunstgewerbliche Laienpredigten*, Leipzig, 1902.

17. Van de Velde, "Extract from His Memoirs: 1891-1901," *Architectural Review*, Vol. 112, No. 669, September 1952, p. 146.

18. The term "counter-Art Nouveau" was suggested by John M. Jacobus, Jr. in his review of Madsen's *Sources of Art Nouveau* (*The Art Bulletin*, Vol. 40, No. 4, 1958, p. 371). It seems to be a very useful term for the rectilinear and later aspects of the style, especially the work coming from Glasgow and Vienna, but it would also refer to a sculptor like Minne.

19. W. S. Sparrow, "Herr Toorop's: The Three Brides," *The Studio*, Vol. 1, 1893, p. 247-248.

20. Thomas Howarth, op. cit., p. 228. Toorop himself, as well as the Scots, were probably also influenced by Carloz Schwabe's illustrations to Zola's *Le Rêve*, which appeared in Paris in 1892.

21. Ferdinand Hodler, quoted in Fritz Burger, *Cézanne und Hodler*, Munich, Delphin, 1919, Vol. 1, p. 50.

22. *The Chosen One* was completed in 1894 and shown at the *Champ de Mars* in Paris that year. It was exhibited again in Vienna in 1901 where it was greatly admired, and as the original version, now in the Kunstmuseum in Berne, was then in poor repair, Hodler made a replica for a Vienna patron about 1903, which soon reached the Osthaus collection and now belongs to the Karl-Ernst-Osthaus Museum in Hagen.

23. Edith Hoffmann, *Kokoschka*, Boston, Boston Book and Art Shop, 1947, p. 30.

24. Peter Selz, *German Expressionist Painting*, Berkeley and Los Angeles, University of California Press, 1957, p. 52.

25. August Strindberg, "L'Exposition d'Edward Munch," *Revue Blanche*, Vol. 10, 1896, p. 525-526.

26. Arthur Rössler, *Neu-Dachau*, Bielefeld and Leipzig, Velhagen & Klasing, 1905, p. 85.

27. Gabriele Münter, from "Bekenntnisse und Erinnerungen," quoted in *München 1869-1958 Aufbruch zur Modernen Kunst*, Munich, Haus der Kunst, 1958, p. 304.

Rodin and America

Visitors to the United States Centennial Exhibition in Philadelphia's Fairmount Park in 1876 could hardly have been impressed with the sculptures of Auguste Rodin.[1] The young artist, who had been working on decorative architectural commissions for the new Stock Exchange in Brussels, was represented by eight works among the Belgian entries. Except for the bust of a child, *Alsatian Orphan*, these have long since vanished, but their names—*Loving Thoughts, The Rose, Field Flowers*—give enough indication of their academic style and saccharine content. Yet they were made by the great genius who was to renew sculpture; who, after sculpture's position of despair in the nineteenth century, "succeeded in transforming everything," as Brancusi said; thanks to whom "sculpture became human again, both in its dimensions and spiritual content";[2] and who was to become the most celebrated artist since Bernini.

One year after this exhibition took place, Rodin's first great masterpiece, *The Age of Bronze*, was shown in Paris. It shocked academic sculptors by its naturalism much as his later work was to arouse their antagonism for its audacity of form. A few Americans, however, recognized rather early the presence of a truly great artist. The now-obscure Boston sculptor, Truman H. Bartlett, visited Rodin in the mid-'80s and in 1889 published a detailed interview with him in some ten installments in the influential *American Architect and Building News*,[3] which has remained a principal source of biographical material on the artist. Wealthy business men and their wives had their portraits done by Rodin, though much of his other work offended the "prurient prudery of our puritanism."[4]

In fact, when the French government sent a number of Rodin's sculptures to Chicago's World Columbian Exposition in 1893, *The Kiss* and *Paolo and Francesca* were considered too lewd for public view, and in order to protect American morality the Fair officials isolated them in a special room where they could be seen only on individual application. The Art Institute of Chicago, however, acquired an important work at that time: the plaster of the magnificent *Jean d'Aire* from *The Burghers of Calais*. It was also in 1893 that the Metropolitan Museum of Art in New York acquired Rodin's *Head of St. John the Baptist*, the first of its large and significant collection of works by the sculptor.

Rodin gained recognition by his special pavilion at the Paris Exposition Universelle in 1900. Whereas an American correspondent for a San Francisco newspaper considered the work she saw there *"cochonnerie"* and "degraded examples of the decadence of French art," calling the *Balzac* a "monstrous thing, ogre, devil and deformity in one,"[5] most American critics were aware of the significance of Rodin's work. They saw in it a combination of Phidias' heroic chisel and Dante's dramatic fantasy in a new sculptural form that continued the Renaissance-baroque tradition and simultaneously showed the possibilities of new development in sculpture "at the dawn of a new century."

The celebrated American dancer Loïe Fuller, whom Rodin admired because she had "awakened the spirit of antiquity, showing the Tanagra figurines in action,"[6] visited him in his "Temple" at Meudon and bought so much of his work that in September 1903 the National Arts Club in New York was able to hold the first sizable exhibition of Rodin's sculpture in the United States, relying entirely on Miss Fuller's collection. It included plasters of the large *Age of Bronze, Adam, Eve,* and *The Thinker,* bronze heads of *Victor Hugo* and *Balzac,* as well as Edward Steichen's photograph of *Rodin—Le Penseur. The New York Times* in an unsigned review quite rightly pointed out that "Rodin's work has a great deal of the quality of Wagner's music: it seizes one and carries one along despite all protests, it excites and disquiets one."[7]

Two years later the Copley Society of Boston combined the sculpture of Rodin with the painting of his contemporary Claude Monet (both artists were born in 1840) in an exhibition, as had been done by the Galerie Georges Petit in Paris in 1880. Eleven of Rodin's important works from four private collections were shown with considerable critical acclaim.

When the young American photographer Edward Steichen went to Paris in 1900, he made straight for the Rodin pavilion at the Exposition Universelle: "Rodin was the focal point of my trip."[8] It made a profound impression on him, and he was happy when the following year Fritz Thaulow, "the Norwegian painter of waterfalls,"[9] offered to take him to Meudon to meet the great artist. Steichen still remembers with pride Rodin's comments about his portfolio and the master's invitation for Steichen to come to his studio whenever he wanted. Every Saturday for a year Steichen then bicycled from Paris up to Meudon where he "came under the inspiration of his grand and independent mentality and his extraordinary subtle perception of beauty."[10] In 1902 he photographed Rodin confronting his *Thinker* against the central background of the great marble *Victor Hugo.* This photograph, this "masterpiece of portraiture, an allegory, a document, virile, tender, a marching song without words,"[11] was, upon Rodin's suggestion, submitted with several others to the Salon at the Champ de Mars and accepted by the jury. If it had not been rejected by the more conservative Hanging Committee it would have been the first photograph ever to be shown in a Paris Salon.[12] In any case, it was immediately and widely shown all over Europe and America.

In 1905 Alfred Stieglitz together with Steichen established the Photo-Secession Gallery in Steichen's old studio at 291 Fifth Avenue. In keeping with the principle of showing not only photographs but all the arts, Steichen with the master's co-operation selected fifty-eight of Rodin's wash drawings for exhibition in New York. When they were shown at "291" in January 1908, a new aspect of Rodin's genius became apparent. Stieglitz' avant-garde journal *Camera Work* quotes from eight reviews in New York newspapers. J. N. Laurvik in the *Times*, who saw in the wash drawings a challenge to American prudery, also considers the show "a hopeful sign of the changing order of things, when work such as this can be shown here in New York."[13] If the order did indeed change, it was largely due to Stieglitz and Steichen. Within a few years the Photo-Secession Gallery at "291" followed the Rodin show with the first American exhibitions of Matisse, Henri Rousseau, Cézanne, Picasso, and Brancusi.

Not all the critics responded favorably to the Rodin drawings. Most of them were impressed with their vitality and spontaneity; the influential critic of the *Tribune*, Royal Cortissoz, remained skeptical, and a W. B. McCormick in the *Press* was offended: "Stripped of all 'art atmosphere' they stand as drawings of nude women in attitudes that may interest the artist who drew them, but which are not for public exhibition... they are most decidedly not the sort of thing to offer to public view in a gallery devoted even to preciosity in artistic things."[14]

Steichen returned to Paris and Meudon, and in September 1908, Rodin had his plaster cast of the *Monument to Balzac* moved into the field overlooking the valley of Meudon during the full moon so that Steichen could photograph it with the moon as the sole source of light. Until dawn he photographed the great sculpture from all positions. Rodin paid Steichen the unheard-of sum of 1,000 francs (then $400) for the photograph, began calling him *"mon fils"* and gave him a bronze cast of the original version of *The Walking Man*, as "an admonition to keep on marching."[15] In 1910 the Little Galleries at "291" mounted a second exhibition of Rodin drawings—this time including the more carefully composed early line drawings—and in the following year *Camera Work* published a special Rodin issue illustrated with Steichen's photographs and superb collotype reproductions of the drawings. When Rodin was buried in Meudon in 1917, General Pershing appointed Edward Steichen to represent him at the funeral.

In 1906 Mrs. John W. Simpson, a friend of Steichen's, gave a fine cast of *The Age of Bronze* to the Metropolitan Museum of Art through its curator of painting, Roger Fry, a gift which was acknowledged with pleasure by Daniel Chester French, chairman of the museum's Committee on Sculpture. A plaster cast of *The Thinker* had been presented to the museum by the French government two years earlier, after its showing at the Louisiana Purchase Exposition in St. Louis, and eventually *The Thinker* became a sort of trade-mark for the American art museum from coast to coast. In 1908 the Metropolitan's European agent advised its director, Edward Robinson, to purchase important pieces—especially marbles—from the artist before his death. In the ensuing

correspondence between Robinson and Rodin, many of the letters from Paris were written for Rodin by his intimate friend and "muse," the Duchesse de Choiseul—originally Miss Coudert of New York. When in 1909 the American millionaire, Thomas Fortune Ryan, had his portrait made by Rodin, the Duchesse de Choiseul persuaded him "to do something really worth-while for his country" by donating funds to the Metropolitan Museum for the purchase of works by Rodin. "By bringing over such works as those of Rodin and other masters," the duchess suggested, "the young American artists could have the best examples of Europe's greatest works amidst their own surroundings, and this would tend to build up a great American art,"[16] an opinion confirmed a few years later by the great collector John Quinn.[17]

Mr. Robinson and Daniel Chester French then set out to select the work, and "in the summer of 1910, with the assistance of the sculptor, a choice was made at Rodin's studios in Paris and Meudon."[18] In 1912 the collection of sculptures by Rodin was opened officially by the museum; it totaled thirty-two pieces, including eighteen signed plaster casts, made especially for the Metropolitan Museum by the sculptor from various clay studies, and donated by him to the museum. Rodin himself was made an honorary fellow for life by the Metropolitan Museum and from that time on he referred to America's "Rodin Museum" and "Rodin Gallery"[19] in New York. Charles Newton Smiley began his review of this Rodin collection in the scholarly *Art and Archaeology:* "Since 1900 the art world has been learning to say Phidias, Michelangelo, Rodin...."[20]

It was also in 1912 that the States of New York and Vermont, in celebration of the tercentenary of the discovery of Lake Champlain, unveiled a monument to the great French explorer whose name it bears. At the base of the monument, as a gift of a French committee to the people of America on this occasion, was placed a bronze cast of Rodin's *France*, originally modeled in plaster in 1904 after Camille Claudel (and which had sometimes borne the alternative titles of *Byzantine Empress* and *Empress of the Roman Empire*).

At the Armory Show in 1913 Rodin was represented by seven drawings, lent by Gertrude Käsebier, who had made some fine portrait photographs of him in 1906 and 1907.[21] These drawings caused the academic painter and pompous critic Kenyon Cox, to lump him with Matisse, the Cubists, and the Futurists as one of the men "making insanity pay."[22] A few years later another critic considered the *Balzac* a "grotesque with a ghoulish, animalistic head" and the "appearance of a lewd and cruel ghost,"[23] which was, after all, the feeling of the Société des Gens de Lettres when it refused to accept the monument in 1898. An anonymous writer in 1917 seemed to anticipate Hitlerian criticism when he published a brief article entitled "A Degenerate Work of Art," in which he expressed a most vociferous hostility to Rodin and the "brutal excrescence of his followers, many of whom are insane."[24] And as late as 1925, one of the founders of the National

Sculpture Society speaks of Rodin as a "moral sot" and cites the fact that the head and arms of *The Walking Man* were missing—or "hacked off"—as clear proof that the sculptor's mind was "tainted with sadism."[25] His view typifies that of this reactionary group of American sculptors.

A less belligerent attitude was expressed in an article in the *Metropolitan Museum of Art Bulletin* on the American sculpture of the day, which had nothing but praise for pieces by other artists, entitled *Duck-Baby, Happy Tiger*, and *End of the Trail*. The author's conclusions were probably quite typical of conservative American opinion: "However deeply our sculptors have felt Rodin's power, the fact remains that for the most part they have been touched by the characteristic beauties of his style rather than by his equally characteristic ugliness. These last were, of course, part and parcel of his living faith, but as articles of creed, they are not wholly convincing to our sculptors. Our art has no harvest of *Vieilles Heaulmières*, not because we deny Villon and Rodin, but because such a crop is foreign to the genius of our soil."[26] We may wonder today whether Theodore Dreiser and Thomas Eakins were also "foreign to our soil," but critics like Miss Adeline Adams preferred to concentrate on the positive side of life on the new continent. One of America's most noted sculptors of the day, Lorado Taft, reviewing Rodin's contributions in a lecture at the Art Institute of Chicago, spoke with great admiration for the sculptor, though he perceived "childish and senile fancies" in his more "extravagant work."[27] Actually, the conservative Taft utilized Rodin's formal innovations in his own works, but substituted flamboyant sentimentality for Rodin's genuine feeling.

It was shortly before the outbreak of the First World War that Mrs. Alma de Bretteville Spreckels of San Francisco met Loïe Fuller in New York, initiating a friendship which was to last until the latter's death in 1928. Later in the summer of 1914 the veil dancer took Mrs. Spreckels to meet Rodin in Meudon, where, according to his American student Malvina Hoffmann, who was present at that meeting, the two ladies tried to persuade Rodin to come to America. While the seventy-four-year-old sculptor refused to make this long trip, he was happy to sell important pieces of sculpture to Mrs. Spreckels, including casts of *St. John the Baptist Preaching, The Prodigal Son, The Age of Bronze*, and the bust of Rochefort. At about this time Rodin also had his *Thinker* shown at the Panama-Pacific International Exposition of 1915 (it seems that no international fair was complete without this imposing sitter); the sculpture was promptly bought by Mrs. Spreckels and sent to Maybeck's romantic Palace of Fine Arts together with other large bronzes. By the time Rodin died in 1917, Mrs. Spreckels owned eighteen of his works, undoubtedly constituting the largest private collection of his sculpture on this side of the ocean. She and Loïe Fuller[28] then decided that an appropriate museum should be built, and during a ride through the magnificent Lincoln Park overlooking the Golden Gate, they selected a beautiful site in which

a replica of the Paris building of the Legion of Honor was to be erected. *The Thinker* was placed as the centerpiece for the Court of Honor of the new building. Between 1932 and 1950 Mr. and Mrs. Spreckels donated to the new California Palace of the Legion of Honor thirty-six bronzes, all cast before the master's death, as well as thirty-four plasters, five marbles, one terra cotta, and nine drawings.

In the early '20s Rodin's impressive *Three Shades* was placed across the road from the California Palace of the Legion of Honor as a memorial to Raphael Weill. Years later this monumental sculpture was selected by San Francisco Republican leaders to be reproduced on the cover of the program for their 1956 Presidential Convention, to illustrate Peace, Progress, and Prosperity. The program cover was abandoned very quickly when it was discovered that the figures were originally the guardians who stand over the lintel of *The Gates of Hell.*

Jules E. Mastbaum of Philadelphia had a small collection of bronzes, including some works by Rodin's teacher Barye, before he went to Paris in 1924. There the Michigan-born painter Gilbert White took him to the Musée Rodin at the Hôtel Biron. Mastbaum persuaded a curator to allow him to buy a small bronze bust which he took back to Philadelphia.

Mastbaum's enthusiasm for Rodin grew quickly and, being a highly civic-minded individual, he proposed to build a Rodin Museum for the City of Philadelphia. The French Art Commission allowed the most important pieces, representing every phase of Rodin's work, to be cast by the firm of Alexis Rudier, who had worked with Rodin during his lifetime. The architect Jacques Gréber of Paris, who had originally studied painting with Redon and Emile Bernard, collaborated with Paul P. Cret of Philadelphia in designing a building inspired by the Château d'Issy, whose doorway Rodin had bought and removed to his studio at Meudon; the white limestone for the Rodin Museum in Philadelphia was shipped from the Ile de France.

His friend Gilbert White related that "Mr. Mastbaum made arrangements... for the building of Rodin's studio in Meudon, which is falling into ruin from neglect. He is also presenting a museum to be built there, which will contain the maquettes and sketches which at present are not on view."[29] As hundreds of original plasters and drawings had been inadequately protected, Mr. Mastbaum presented the government of France with a securely restored building to house the treasures at Meudon; it is regrettable that his family has never received proper acknowledgment of his generosity from the French authorities. He also ordered the first two bronze casts to be made from the plaster *Gates of Hell,* one for the Musée Rodin in Paris and one to be installed in front of the Rodin Museum on the Parkway in Philadelphia. On November 29, 1929, three years after Mastbaum's death, the Rodin Museum of Philadelphia opened to the public. At the dedication New York's mayor, Jimmy Walker, shared the platform

with Paul Claudel, the French ambassador to the United States. The museum houses a great collection of eighty-five bronzes, thirty-nine plasters, sixty-four drawings, and two paintings, as well as important letters and ephemera.

On the occasion of the opening of the Rodin Museum in Philadelphia, Francis Henry Taylor, then curator of medieval art at the Pennsylvania Museum,[30] felt that the *Gates of Hell* belonged in "the category of conscious classics of 1900."[31] Indeed Rodin was already considered passé. The museum itself suffered a temporary decline in attendance: "now only a handful of persons, fewer than fifty a day, and only an occasional Philadelphian, visit the beautiful Rodin Museum,"[32] reads a newspaper report of 1936.

Artists and critics in the '20s, '30s, and '40s no longer felt threatened by Rodin's violence and expressionist audacity, nor did they significantly respond to his work. Except for an occasional nod in the direction of "the originator of modern sculpture," he was ignored, although the general public continued to admire *The Thinker, The Hand of God,* and especially *The Kiss.* From 1929 until 1942 the *Art Index* shows no critical article on Rodin in any American publication. The sculptor who had placed such great emphasis on the interaction of his hands and tools with the clay that they modeled gave rise to a generation of artists who made such a fetish of "truth to the material" that they expected the material "to speak for itself." They no longer had much use for Rodin's complex bronze casts, and even less for his marbles, many of which, to be sure, had been carved by assistants. The fact that thought and emotion—rather than the material itself—inspired his work caused the new generation to denigrate him as a "literary" artist. Joseph Hudnut, who was later to become Dean of Architecture at Harvard, typically misinterpreted *The Burghers of Calais* as "the supreme example of this literature-sculpture. To convey an intense emotional feeling Rodin is literal in his description of the effects of emotion upon body and face. But without the story the group is meaningless, is without power.... Thought and feeling...shatter in Rodin all formal beauty," Hudnut goes on to observe, and "the extreme example of this destructive effect of thought and feeling on form is in the *Balzac,* " where "even the stone [*sic*] disappears in the intense variety of light."[33]

Clive Bell had taught that the essence of art lies in "significant form"; his followers mistook this for "simple form" and looking at Rodin's sculpture, where each inch of nervous surface has the life of a passionate gesture, these purists were bewildered. They found neither stable structure nor structural stability. Searching for new principles of plastic form, they found too much individualism. Longing for the severity of archaic sculpture, they were ashamed to be descendants of the baroque. And the purists agreed with an older generation of moralists in condemning Rodin's sensuous nudes: if they were dangerous morally for the older generation, they were too cluttered with irrelevant

associations for the younger one, who wanted their form "pure and simple." But, while structural form is truly significant in Rodin, his sculptures are never mere arrangements of formal elements.

In 1949, Albert E. Elsen began intensive historical research on Rodin under the guidance of Professor Meyer Schapiro at Columbia University, resulting in a preliminary article in *Magazine of Art* in 1952 and his probing and extensive study of the sources and evolution of *The Gates of Hell*,[34] as well as in the present essay. Now new scholarly research is under way by American students of Rodin's work. It is to be hoped that the essential archival material at the Hôtel Biron and the actual sculptural studies at Meudon may soon become fully accessible to scholars throughout the world.

Surely the most important contribution to the new appreciation of Rodin in America was made by Jacques Lipchitz and his friend Curt Valentin, the gallery director who introduced modern sculpture to a broad American public. Not long after coming to the United States in 1937 as director of the New York branch of Berlin's Buchholz Gallery, Curt Valentin at Lipchitz' suggestion showed work by Rodin in his exhibitions entitled "From Rodin to Brancusi" (1941) and "Homage to Rodin" (1942), as well as in shows of his drawings and watercolors.[35] Now that sculpture was at last beginning to be widely recognized as a major art form in this country, Valentin felt that it was time to introduce the public to one of the major sources of modern sculpture itself. In May 1954 the Curt Valentin Gallery opened a major Rodin exhibition of forty-four sculptures and thirty-seven drawings, a show which had been in preparation for many years. The gallery was crowded with visitors, many of whom experienced their first encounter with the work of the great master. Lipchitz, Jean Arp, and André Masson wrote contribution for the catalog, which included excerpts from Rodin's own writings and from a perceptive letter by Rilke.

Howard Devree began his review of the exhibition in *The New York Times* by stating: "As time adds perspective to our view it may well be that those critics will be justified who have called Cézanne and Rodin the two giants of the nineteenth century."[36] A few years earlier, Andrew Carnduff Ritchie, in his book *Sculpture of the Twentieth Century*, written to accompany the Museum of Modern Art's exhibition which included five of the artist's sculptures, had asserted: "Rodin is the father of modern sculpture, and probably the greatest sculptor of our day. While his principal work was done in the last quarter of the nineteenth century his influence on modern sculpture has probably been more profound than any other."[37] Leo Steinberg, reviewing this book, reveals one important aspect of this influence: "Rodin does belong to us; not by virtue of his light-trap modelling, but because in him, for the first time, we see firm flesh resolve itself into a symbol of perpetual flux.... The sculptor studying not states of being, but forms of transition—this is the common factor that unites Rodin's

Defense, Picasso's cubist *Head,* Gabo's *Spiral Theme,* and Roszak's *Spectre of Kitty Hawk.*"[38] Although Rodin's work had been around for half a century, it began to be seen with fresh eyes in the '50s. There was now a general predisposition in the direction of his freedom of form, his exuberance of content, and even his "painterly" sculpture, so dependent upon effects of light. And new artists no longer considered thought and feeling destructive of form.[39]

In January 1955 the first sculpture by Rodin, his *St. John the Baptist Preaching,* entered the permanent collection of the Museum of Modern Art,[40] serving "both as a fundamental basis for comparison and point of departure"[41] for modern sculpture. A few months later the *Monument to Balzac* was formally presented to the Museum of Modern Art as a memorial to Curt Valentin, who had died the previous August. One hundred and thirty friends had raised the funds for this monumental nine-foot-high sculpture which was installed permanently in the museum's Sculpture Garden. In accepting the *Monument to Balzac* for the museum, Alfred H. Barr, Jr., called it "the unique climax of (Rodin's) mature style. With the bold modeling, dramatic pose and overwhelming power of the *Balzac,* Rodin may be said to have initiated expressionist tradition in modern sculpture. And quite aside from its importance as a pioneer work, the *Balzac* should take its rightful place as one of the very great sculptures in the entire history of Western art."[42]

Edward Steichen, then Director of the museum's Department of Photography, photographed the great bronze a second time. But unlike the famous pictures he had taken at Meudon forty-seven years earlier, this one was taken in the full light of the day.

Notes

This essay was published in the catalogue on Auguste Rodin on the occasion of the extensive retrospective Rodin exhibition directed by Mr. Selz at the Museum of Modern Art in 1963.

1. I wish to express my gratitude to those who have helped to unearth material on Rodin and America: Thomas C. Howe, Lucy Lippard, Henri Marceau, Grace M. Mayer, John Goldsmith Phillips, Gaillard F. Ravenal, Mrs. Charles J. Solomon, Capt. Edward Steichen, Mrs. Jane Wade Lombard, Mrs. Acey Wolgin.

2. Constantin Brancusi, "Hommage à Rodin," Quatrième Salon de la Jeune Sculpture, Paris, Gizard, 1952.

3. See bibliography in Albert E. Elsen, *Rodin,* The Museum of Modern Art, New York, 1963.

4. J. N. Laurvik in *The New York Times,* quoted in *Camera Work,* no. 22, April, 1908, p. 36.

5. Quoted in Frederick Lawton, *The Life of Auguste Rodin,* New York, Scribner, 1907, p. 235.

6. Loïe Fuller, *Fifteen Years of a Dancer's Life,* Boston, Small Maynard & Co., 1913, p. 127.

7. *The New York Times*, September 5, 1903.

8. Edward Steichen, interview with the author, July 25, 1962.

9. Ibid.

10. Charles H. Caffin, *Camera Work*, no. 2, 1903, pp. 22-23.

11. Carl Sandburg in *Steichen the Photographer*, texts by Carl Sandburg, Alexander Liberman, Edward Steichen and René d'Harnoncourt, biographical outline by Grace M. Mayer, New York, The Museum of Modern Art, 1961, p. 25.

12. Ibid., p. 70.

13. J. N. Laurvik, loc. cit.

14. Quoted in *Camera Work*, no. 22, April, 1908, p. 40.

15. Steichen, interview with the author, November 29, 1962.

16. Herman Bernstein, *Celebrities for Our Time*, New York, Lawren, 1924, pp. 122-23.

17. John Quinn, "Sculpture of the Exhibition," *Arts and Decoration*, Nov., 1913, p. 17.

18. Joseph Breck, *The Collection of Sculptures by Auguste Rodin*, New York, The Metropolitan Museum of Art, 1913, p. 3.

19. Bernstein, loc. cit.

20. "Rodin in The Metropolitan Museum," *Art and Archaeology*, vol. III, no. 2, February, 1916, p. 107.

21. The catalog of the Armory Show also lists a bronze "Figure of a Man," but Walt Kuhn wrote in a letter that no sculpture by Rodin was in the exhibition.

22. *The New York Times*, March 16, 1913.

23. Charles L. Borgmeyer, "Among Sculptures—Auguste Rodin," *Fine Art Journal*, vol. XXXII, 1915, p. 190.

24. "A Degenerate Work of Art—A Woman in Contortion by Rodin," *The Art World*, Nov., 1917, p. 130.

25. Elsen, *Rodin*, pp. 180, 189, n. 12.

26. Adeline Adams, "Contemporary American Sculpture," *Metropolitan Museum of Art Bulletin*, vol. XIII, no. 4, April, 1918.

27. Lorado Taft, *The Scammon Lectures*, The Art Institute of Chicago, 1917, p. 21.

28. Loïe Fuller was also instrumental in indroducing Samuel Hill to Auguste Rodin, and Mr. Hill was unquestionably encouraged further by Mrs. Spreckels in his enthusiasm for the sculptor's work. Between 1915 and 1922 Samuel Hill bought a great many plasters, some fine bronzes, terra cottas and drawings from Rodin, and after the artist's death from Loïe Fuller. This considerable collection was donated by Mr. Hill to the Maryhill Museum of Fine Arts in Maryhill, Washington, of which he was the founder and of which Mrs. Alma de Bretteville Spreckels is still Honorary Chairman.

29. "Musée Rodin de Philadelphie, Fondation Mastbaum," *Renaissance de l'Art Français*, vol. 9, no. 10, November, 1926, p. 600.

30. The Pennsylvania Museum of Art was until 1938 the name of the Philadelphia Museum of Art, which administers the Rodin Museum.

31. "Rodin," *Parnassus*, Feb., 1930, p. 10.

32. Robert Reiss in the *Philadelphia Record*, June 14, 1936.

33. Joseph Hudnut, *Modern Sculpture*, New York, Norton, 1929, pp. 24-25.

34. Albert E. Elsen, "Genesis of Rodin's Gates of Hell," *Magazine of Art*, vol. 45, March, 1952, pp. 110-19; *Rodin's Gates of Hell*, Minneapolis, University of Minnesota Press, 1960.

35. The name of the Buchholz Gallery was officially changed to Curt Valentin Gallery in 1951. Works by Rodin were included in the following exhibitions at this gallery: "From Rodin to Brancusi: European Sculpture of the Twentieth Century," February 11-March 8, 1941 (6 works by Rodin); "Homage to Rodin: European Sculpture of Our Time," Nov. 10-Dec. 5, 1942 (9 works by Rodin); "Auguste Rodin. Watercolors and Drawings," Oct. 2-26, 1946 (60 works); "The Heritage of Auguste Rodin. An Exhibition Assembled in Honor of the Diamond Jubilee of the Philadelphia Museum of Art," Dec. 6, 1950-Jan. 6, 1951 (6 works by Rodin); "Auguste Rodin," May 4-29, 1954.

36. "The Giant Rodin," *The New York Times*, May 9, 1954.

37. *Sculpture of the Twentieth Century*, New York, The Museum of Modern Art, 1953, p. 14.

38. "Sculpture Since Rodin," *Art Digest*, August, 1953, p. 22.

39. Hudnut, loc. cit.

40. From 1941 to 1945 another cast of this sculpture from the collection of Dr. Michael Berolzheimer had been on loan to The Museum of Modern Art. This cast was acquired by the City Art Museum of St. Louis in 1945.

41. Alfred H. Barr, Jr., quoted in a Museum of Modern Art press release, January 18, 1955.

42. Idem, release dated March 4, 1955.

Ferdinand Hodler

In 1913, just before the outbreak of World War I, President Poincaré of France personally decorated Ferdinand Hodler with the "Légion d'Honneur" when he exhibited at the Salon d'Automne in Paris. During the same year the German Kaiser was present for the unveiling of the Swiss painter's large mural in Hannover. Hodler had met Rodin and Degas; he was celebrated in Vienna when he was the featured artist of the Vienna Secession exhibition in 1904. He was acclaimed by Gustav Klimt and exerted a certain influence on Egon Schiele. Emil Nolde, Alexej von Jawlensky, and the German Expressionists in general acknowledged their debt to the Swiss master. Indeed, he was compared to Cézanne as one of the giants of early twentieth-century art. More recently, Alberto Giacometti paid homage to his great Swiss predecessor.

Hodler is unique among the artists of the late nineteenth century. He came from a very isolated place, he was never part of any artistic community, had little tradition to continue or even to rebel against. He was not only a self-taught artist, but also a self-generated individual, who would follow his own vision of his mission and managed, quite fortuitously, to meet individuals who willingly would help him. Coming from the city of Bern, uneducated and poverty-stricken, he must have possessed potent inner resources and energies he could tap to overcome the inertia of the circumstances of his birth and upbringing.

Ferdinand Hodler was born into the Swiss proletariat in the poorest quarter of Bern in 1853. His father, an impecunious carpenter, died when the artist was still a child, and was eventually followed in death by his mother, who was remarried to Gottlieb Schüpbach, a widowed house and sign painter. Of the twelve children in these combined households, Ferdinand and five others survived; the rest died in infancy and youth, most of them of tuberculosis. The image of death was ingrained in Hodler's mind and vision: he was to paint it in many versions throughout his life.

From his eighth year, Ferdinand helped Schüpbach in his work. At about the age of fifteen, in 1868, he was apprenticed to Ferdinand Sommer, a painter of mountain views—perhaps not as unusual a transition from the stepfather's paint

shop as it might seem at first glance: paintings of landscape for sale to tourists were the precursors of the landscape photographs of today. During the three years of Hodler's apprenticeship, Sommer conveyed to the young artist the rudiments of painting. But Hodler, despite the deprivation of his childhood, was eager to learn about art, science, religion, and life. Hoping to leave humdrum provincial existence behind him, he decided in 1872 to leave the Swiss countryside near Bern. He walked to Geneva without money, without education, with the slightest knowledge of French, and without a friend to greet him at his destination. He knew only that Geneva was a cultural center of considerable importance and that it might be a place where, having left behind the sadness of his childhood, he could hope to enter a new life, perhaps as a new person. (It is interesting to note that Gottlieb Schüpbach had left Switzerland in 1871 after the death of Hodler's mother, and settled in Boston.)

When Hodler came to Geneva, it was the only city in nineteenth-century Switzerland boasting an active contemporary artistic culture, animated mainly by François Diday and Alexandre Calame, Swiss landscape painters active in Geneva in the early half of the century but renowned throughout Switzerland. But Hodler was more drawn to Karl Vogt, whom he knew by reputation, a great naturalist who taught geology, paleontology, and zoology at the University of Geneva and who ultimately became its rector. Vogt, who before emigrating to Switzerland had been active in liberal politics in pre-1848 Germany, was able to give the young Hodler some contact with the world of the mind.

While engaged in making copies at the Musée Rath, Hodler encountered Barthélemy Menn, an accomplished painter who really became the artist's teacher. Menn, born in Geneva in 1815 and very influential in the artistic culture there, had studied with Ingres and had gone to Rome with the master. Later on, he also became a friend of Delacroix, Corot, and Daubigny. Menn painted carefully balanced, intimate landscapes with soft contours and high tonalities. Menn, like his teacher Ingres, believed in the primacy of line and structural form. Hodler, coming from a rural environment, was able to enter the great French classic tradition thanks to the six years he worked with Menn as a student in the Ecole des Beaux-Arts in Geneva.

While a student with Menn, Hodler painted one of his earliest self-portraits, *The Student*. In the course of his life Hodler painted at least forty self-portraits, constantly exploring his own image, searching for the key to the deeper meaning of his face and gesture. This self-portrait, done when he was twenty-one, is remarkable for its clear construction: the tall figure occupies the center of the narrow, vertical space; all the parts of the body are based on linear directions and their relationships. A contemporary critic, seeing this painting in an exhibition of the Société Suisse des Beaux-Arts in Geneva in 1876, made the acute observation that "Hodler makes us aware of the epidermis, the weight and the cubic form of his subjects."[1] In this portrait the artist sees himself as a young

student with books and canvases in the background. In his left hand he holds a T-square in perfect balance which must signify the interest he took in science and construction. His right hand is raised in an oath and his earnest countenance speaks cogently of his dedication to his life as an artist. But the oath also seems tenuous, the young man's posture is questioning, the expression is still uncertain. Hodler painted his image down to above the knees, probably in order to achieve the desired verticality of the composition; but what a strange place to truncate the figure!

Soon after he painted *The Student* Hodler's interest in linear structures, the placement of the figure, and balanced composition was reinforced by his encounter with Holbein's work during a visit to Basel. Holbein and Dürer, whose works he was to copy and whose theories were to occupy his mind, were the artists of the North whom Hodler admired most throughout his life. Yet he had equal regard for Michelangelo, Leonardo, and Raphael, whose *Miraculous Draft of the Fishes* he considered "perhaps the most beautiful composition an artist ever made."[2] Although his Symbolist work must be counted among the major breakthroughs of Post-Impressionism, Hodler, like the somewhat older Cézanne, was firmly grounded in tradition, creating a new present with the values of the past.

Hodler continued working with no tangible success. In 1878 he was impelled to move, and suddenly left Geneva for Madrid. Although Florentine masters of the Italian Renaissance remained Hodler's heroes, rather than Titian, Velázquez, and Ribera whose work he encountered in the Prado, the sheer physical dimensions of their paintings must have had great impact on the artist, who, having begun with small landscapes, was to become one of the great muralists of his time.

Watchmaker Workshop Madrid, made during his stay in Madrid, is a very small painting. Here he put three men carefully into a room, placing all objects and figures along a perpendicular structure. This rigorously constructed simple interior, facing the light of a window whose rectangular transparent panes give a view of a bright outside world, relates the Swiss painter to the tradition of German Romantic painting, going back to such artists as Caspar David Friedrich and Georg Kersting, who also created moods of silent intimacy in their Biedermeier interiors. It is fascinating that during a trip to Spain Hodler should relate to North German artists of the early nineteenth century.

Hodler's style was by no means crystallized at this time. In *On the Shore of the Manzanares River near Madrid*, also painted during the first half of 1879, he achieved a fresh, unfinished quality, in complete contrast to that demonstrated in *Watchmaker Workshop Madrid*. This outdoor scene, willow trees on the banks of the small Manzanares River outside Madrid, is filled with sunlight and transmits the airy experience of a bright spring morning. Hodler's knowledge of Corot's landscapes (the rough, airy, and light quality of a painting like *The Bridge*

at Narni comes to mind) was transmitted to him by Menn, and suffices, together with the actual experience of the river on this particular day, to explain the seeming influence of Sisley and the Impressionists—work that Hodler had not yet necessarily seen.[3] The Manzanares landscape is the first to break with more traditional ties. Hodler tells us that Menn freed him from conventional ties and "made it his task to restore me to a state of nature and to make me capable of seeing."[4]

In the summer of 1879 Hodler left Madrid to return to Geneva. Two years later his visage, marked by anger and energy, confronts us in another self-portrait, *The Angry One.* The artist shows himself as having been interrupted, having just turned about to query the intruding viewer with surprise, but also with a speculating and suspicious glance. His glance is direct and seems to emphasize the importance of his own being, and his search for it. In this painting Hodler seems to insist on two aspects of his personality. The left eye in the portrait is startled, terrified, frightened, while the right seems to be threatening and angry, asking the interloper to leave the room. *The Angry One* was the first painting Hodler sent to the Paris Salon (where it was ignored) and also his first work to enter a public collection. The Bern Art Association bought it in 1887 for the city's museum.

During the ensuing years Hodler participated in all sorts of competitions and managed to win occasional prizes. Yet his financial situation remained desperate, and in Geneva the critical reception of his work was generally negative. He rented a studio in a garret on the Grand'Rue in the oldest quarter of the city and enjoyed the friendship of a number of fellow painters and writers. During the summers he would go back to the Bernese Oberland to paint landscapes which retained the high key of the Spanish interlude and developed an ever greater clarity of structure. In 1885 he painted the superb *Portrait of Louise-Delphine Duchosal,* the young sister of his friend, the poet Louis Duchosal. The composition with the girl sitting straight as a rail in her chair, the placement of the figure against a neutral background of grays, the empty shape created between the girl and the chair, the gesture of tenderly holding a white narcissus, her magnificently painted face, all make this an extraordinary painting. This small canvas, done under the conscious influence of Manet,[5] is infinitely superior to Hodler's ambitious allegorical portrayals in minute detail of athletic festivals or to the historical subject of Calvin and other religious reformers walking the cloisters of the College of Geneva.

In 1885 Hodler also painted a landscape, *Beech Forest,*[6] which must be regarded as the first example of his Parallelism. Parallelism as seen in Hodler's work was a compositional device based on the repetition of similar elements and their relationship to each other. As Hodler explains Parallelism, it is a "principle of order," inherent in nature, reflecting the underlying harmony of creation.

Hodler was less concerned with diversity than with universality and unity. Human beings, trees, mountains, are more alike than they are different. "We know and we all feel at times that what unites us is stronger than what divides us."[7]

In his lecture, "Mission of the Artist," delivered at the University of Fribourg in 1897, he explained:

> If I go for a walk in a forest of very high fir trees, I can see ahead of me, to the right and to the left, those innumerable columns formed by the tree trunks. I am surrounded by the same vertical line repeated an infinite number of times. Whether those tree trunks stand out clear against a darker background or whether they are silhouetted against a deep blue sky, the main note, causing that impression of unity, is the parallelism of the trunks.[8]

The painting of the beech forest seems to embody Hodler's statement articulated twelve years later in his Fribourg lecture. In great contrast to the contemporary French Impressionists, fascinated with the accidental quality of their corner of reality, Hodler selected details of nature which limited and in fact delineated his principle. And having found his perfect model, as it were, he emphasized the alignment of the tree trunks, placing them as parallel vertical lines to demonstrate a categorical quality of rhythmic repetition.

In 1884 Hodler met Augustine Dupin, his close companion for several years, who bore his son Hector in 1887. Hodler painted a number of intimate pictures of mother and child in their home surroundings, small-scale paintings which, unlike his more ambitious compositions, continued the kind of work he did in the portrait of Mlle. Duchosal. *Mother and Child* is a sensitive painting of the mother feeding her little son. Almost like a traditional madonna and child, this painting is very self-contained in its triangular structure. The relationship of color areas such as Hector's red dress, the mother's gray shirt, the nearly black areas of her skirt, hair, and the firescreen, the flesh-colored sections of both figures as well as the brown semi-ellipse of the table, make an abstract pattern of interacting shapes that is not accidental but which helps create the feeling of closeness between mother and child. The treatment of color and composition in this painting recalls the portraits by Degas.

It is very likely that by this time Hodler was familiar with Degas' work, probably through Marcellin Desboutin, who had been Degas' close friend and who was on familiar terms with the French cultural elite, including Degas' friends, the Viscount Lepic and Henri Rouart, as well as Puvis de Chavannes, Courbet, Renoir, Morisot, George Sand, Emile Zola, and Dumas fils. Desboutin was a playwright, collector, and etcher of portraits, and, while carefully maintaining his contacts in Paris, settled in Geneva in the early 1870s. Hodler's contact with Desboutin must have been important, because it enabled him to become familiar with French artists whom his teacher, Barthélemy Menn, could not have known. Walter Hugelshofer points out: "In Desboutin, Paris came to

Hodler."[9] It was conceivable that due to Desboutin's encouragement Hodler sent more of his work to exhibitions in Paris. At the World's Fair of 1889 he received an honorable mention for his large, ponderous composition, *Procession of Wrestlers.*

The painting that gained him international recognition, however, was *Night*, which he began with few prior studies in 1889 and completed in 1890. Here for the first time Hodler uses the human figure, as well as color and light, to create a symbolic Parallelist painting. The Parallelism created by the extended horizontal figures is clearly emphasized by areas of light and dark—bodies and their garments—that form a domino pattern throughout the painting. Leaving narrative painting behind, Hodler achieves a work which no longer describes an event but rather evokes a feeling. *Night* suggests a unique fusion of eros, sleep, and death.

Six of the eight figures in the composition are asleep. As in a dream, the stagelike space is crowded. Some of the figures are modeled after people close to Hodler's life, while others are related more directly to art. The woman who sleeps alone on the lower left with her body covered and her knees, feet, and elbows crossed in a position of closure is his friend Augustine Dupin. The sensuous and seductive nude embracing a young man on the lower right is not his new wife, Berta Stucki, with whom Hodler lived only about as long as he worked on this major composition. The figure on the upper right, which certainly appears to be another self-portrait, resembles the lying Diogenes in the center of Raphael's *School of Athens* (a point also made by von Tavel in his book on *Night*). It is highly significant that in the very painting which marks the turning point in Hodler's work toward the future, the "most important painting, in which I reveal myself in a new light,"[10] Hodler reaches back to the world of the Italian Renaissance. It is not only Raphael, but also Michelangelo's Medici tombs and Signorelli's *Pan* which come to mind when we are confronted by this major work. The central figure is the artist, who had known death so well throughout his early life, suddenly awakened and terrified by a black hooded figure. The message is clear. To make it even more so, Hodler wrote on the frame: "Plus d'un qui s'est couché tranquillement le soir, ne s'éveillera pas le lendemain matin." Yet what a strange image of death: it appears here as a seducer, crouched implacably on the artist's genitals. His attempt to push this threatening figure away from him seems to be of no avail. This painting clearly recalls the eighteenth-century Swiss canvas, Fuseli's famous *Nightmare*,[11] in which an incubus, a sneering demon, crouches on the chest of the sleeping figure of a sensuously entranced girl. But instead of the enigmatic, provocative, and feverish eroticism of Fuseli's pantomime, Hodler, a century later, deals with the nightmare of sex and death in measured rhythm and symmetry.

In 1891 *Night* was withdrawn from the municipal exhibition at the order of Geneva's mayor. Hodler then exhibited the painting most successfully at his own

expense, in a space he rented elsewhere in the city. Hodler sent it to the Salon du Champ-de-Mars, where it was received enthusiastically and admired by Puvis de Chavannes. The artist himself traveled to Paris and was elected a member of the Société Nationale des Artistes Français. Joséphin (Sar) Péladan, founder of the Rose†Croix Esthétique and for a brief time very influential in cultural matters, called the picture "unforgettable, a work of art which bespeaks a great future."[12] In 1892 the painting was shown officially in Bern and in 1897 it (along with Hodler's *Eurythmy*) was awarded the coveted gold medal at the VII International Art Exhibition in Munich. In 1899 it was sent to the III Biennale in Venice and the following year it was again in Paris, this time at the World's Fair, where it (with *Eurythmy* and *Day*) received a gold medal, and Hodler's reputation as a modern master was established. In 1901 *Night* was finally purchased, together with three other major works, by the Bern Kunstmuseum.

One of these works was another large symbolic canvas, *The Disillusioned*, which was sent to Paris almost immediately upon its completion in 1892. In fact, Count Antoine de La Rochefoucauld, financial backer of the Rose†Croix Esthétique, traveled to Geneva to invite Hodler to exhibit this new work in Paris in the first salon of this heterogeneous group of painters, at Durand-Ruel's in March 1892. Although Péladan's pronouncements were very doctrinaire, the many divergent talents exhibited in the Salon included not only followers of Puvis, Moreau, and Gauguin, but also Redon and Toorop, all of whom shared an anti-Impressionist and anti-contemporary point of view and were perhaps in some sort of agreement with the Sâr's neo-Catholic metaphysics. Certainly Hodler belonged to a new group of artists who considered nature only a source which would help to symbolize emotion. Like his great contemporaries Gauguin, Van Gogh, Munch, or Ensor, Ferdinand Hodler saw in art a means toward edification rather than mere delectation.

The Disillusioned represents five old men sitting on a bench, having renounced their struggle, accepting the inevitable fate of old age in silent despair. Although this painting may be based on sketches Hodler made of men sitting on the benches of the parks of Geneva, these figures in their timeless garments are an allegory of human despondency and desolation rather than a realistic rendition. Two darkly garbed figures on the left correspond to two on the right, while the central figure differs in dress and posture. The repetition and axial symmetry carry the message that this is not a fortuitous grouping of men, but a carefully arranged symbolic representation of man's fate. The repetition frees these men from solitude and creates a symbolic human community. The clear and emphatic contour lines, the vertical lines of the men, the horizontal one of the bench—everything is placed on a shallow, stagelike space. Although the figures are copied from nature (Hodler must have had his models seated in the positions in which they are portrayed), he joined the leading post-Impressionist painters in emphasis on the picture plane, in free and symbolic use of color and line, and

above all in the identity of form and idea. No wonder, then, that Hodler was taken up with enthusiasm by the Symbolists and *Nabis* of Paris. Félix Vallotton, a younger Swiss compatriot and a member of the Rose†Croix Esthétique, reported from Paris in the *Gazette de Lausanne* of March 18, 1892, that he found the five figures "powerfully restrained in black and white against the rose-colored background of a hill truly unforgettable" and commented further that it would be necessary to go "far back into the past, to the frescoes of Orcagna and Signorelli, to find such power of drawing, such dignity of form."

The rhythmic arrangement of parallel figures, with a central one differentiated from the pairs on left and right in a shallow frontal plane, is repeated in *Eurythmy* (1894–1895). This was one of Hodler's favorite paintings, "because of its simplicity, its large parallels, its white garments with their simple folds that make delicate ornaments at the man's feet."[13] In this picture, Hodler breaks the stasis of his former large figural compositions and introduces rhythmic movements by the motion of the figures themselves. Five old men, whose faces recall those of Dürer's *Four Apostles* in Munich (a likeness pointed out by Ewald Bender), are dressed in festive, white loose-fitting robes. They move fluidly from left to right, from life toward death.[14] The figures, consuming almost all of the space, are monumental in appearance. Hodler's Parallelism, which expresses his metaphysical vision, may remind us of the hieratic frieze of saints in Sant'Apollinare Nuovo, with the measured rhythms created by the procession of saints and virgins. Yet the fluidity of the movement is distinct from the static ritual enacted at Ravenna. In his Fribourg lecture, Hodler speaks of the artist "searching for the linear beauty of a contour," "stressing the movements and the parts of the human body," "expressing its rhythm," and he explains further that "the outline of the human body changes according to its movements and is in itself an element of beauty."[15]

In this attitude Hodler closely approaches new ideas in dance which developed during his lifetime. The figures in a great many of Hodler's large symbolic compositions after 1890 assume the stance of modern dancers.[16] (His biographer and student, Stephanie Guerzoni, tells how he worked directly from dancing models.)[17] During the last decade of the century, it must be remembered, art increasingly moved toward the non-discursive condition of music and dance. In this respect, his later friendship with Emile Jacques Dalcroze, a distinguished musicologist, choreographer, and professor at the Geneva conservatory of music, was also important. One of the great innovators of the modern dance movement, Dalcroze was indebted to Loïe Fuller and Isadora Duncan and taught eurythmics long before Rudolf Steiner. There is little doubt that Hodler saw Dalcroze's performances, that he supported the younger man's work and was, in turn, inspired by it, particularly by Dalcroze's exercises with successive movements. When Hodler died Dalcroze wrote a moving obituary; ten years later in an article entitled "Ferdinand Hodler et le Rythme," he stated that "the principal

inspiration in Hodler's work was rhythm,...his painting appears eminently musical in the Greek sense of the word." Seeing "rhythm and meter as the foundation of art," Dalcroze continues: "This continuous preoccupation with movement is just made to interest musicians. Hodler is certainly one of them. None of them better than he possesses the art of associating and disassociating movements, of accenting unisons, of creating counterpoint, of treating human sentiments symphonically, of choosing for their expression the gestures and positions appropriate for their orchestration."[18]

But long before Hodler's acquaintance with Dalcroze, we find that dream-like movements and ritual gestures animate his figures and give them their symbolic significance and psychological content. Even seated figures—the five old men in *The Disillusioned* or the five young women in *Day*, indeed even recumbent figures like the couples in *Love*—are articulated by the heightened stage gestures of mimes or dancers. Frequently Hodler's large figures, whether standing, sitting, or lying, are static and at complete rest, but even the walking men in *Eurythmy* move in measured steps through frozen time and space. It is certainly this use of the seemingly static and over-stated gesture that over the years has been the source of much critical objection to Hodler's stylizations. But it is precisely the measured gestures of his hieratic figures which evoke the viewer's reaction along the lines determined by this Symbolist painter.

Symbolism and Art Nouveau, movements in which Hodler participated at the turn of the century, are characterized in painting by the evocative use of flat linear form and, "Like his Art Nouveau contemporaries, Hodler worked in terms of the plane enriched with a decorative pattern, where a tense line becomes the important carrier of emotion."[19] This trend becomes most apparent in *Day* of 1899–1900. Here the five figures are seated on a flatly patterned mountain meadow in a linear dancelike movement. Again the Parallelist composition consists of a central figure flanked symmetrically by two figures on each side. Their gestures are repeated in the rising hill in the background, if indeed we can still speak of a background in so flat a composition. The young women are nude, and the theme of daybreak is developed in their bodies and movements. The two on the outer edge of the painting have their legs in a guarded and closed position while their arms are folded as in prayer. They are introverted figures. The two women next to them turn more directly toward the viewer, but while their thighs are more open, their arms almost hide their faces in an averting gesture. The severe central figure with her arms in a gesture of open prayer appears like a priestess who channels the emotion of the group toward the light of day. If *Night* was a painting to symbolize the threat of death, *Day* is a hymn to awakening and light.

Truth, painted in 1903, when Hodler spent six weeks in Vienna and became a friend and admirer of Gustav Klimt and the Jugendstil artists of the Vienna Secession, combines the decorative arabesque with allegorical meaning. Strained

and contorted figures standing on a stylized meadow fuse with the surface of the picture. A nude woman with arms outstretched symmetrically stands in the center, banishing the six half-draped demons at her side. Unlike Klimt and many of his Art Nouveau contemporaries, Hodler does not treat woman as a languidly sensuous decorative object. The slender young girl here is seen as the liberator, the symbol of the good and the true, while the men with faces covered and averted are unable to bear the vision of naked Truth which stands before them. It is the male figures who are partly draped in an almost provocative manner, while Truth herself—we are reminded somehow of Titian's allegory of love—is completely naked and pure. Color is used to emphasize the meaning, which is surely the victory of light and day over the dark and morbid forces of the night.

A few years later, in his magnificent composition, *Love*, the artist has moved beyond the allegorical decoration of Jugendstil. Stylizations and mannerisms are rejected in favor of a deeply felt realistic rendition of the human form. On a long, ribbon-like, horizontal canvas three couples are stretched out like waves at the edge of the sea. Rarely has his use of color been more forceful and meaningful, and never has he painted the human body more masterfully. It seems as if all the problems and threats and fears of *Night* have been resolved in this painting of frankly assertive physical love. If the couples in *Night* were meant to symbolize death, the three couples in this large mural are images of life, of the completion of passion and love. This painting has an elemental power lacking in his more symbolic compositions. Parallelism is no longer a matter of doctrine at this point, but appears in the natural and easy flow of three couples embracing at the edge of the sea.

With the exception of *Love*, there is generally a heavy and didactic element in Hodler's large compositions symbolizing the human condition. They seem to be done by a painter different from Hodler the landscapist. His landscapes, mostly pictures of mountains, are done with much greater freedom and spontaneity. Yet, especially in his landscapes executed before the turn of the century, we find similar uses of parallel structure and similar attitudes toward the meaning of color. "Color has a penetrating, harmonious charm, independent of form. It influences emotions..." and Hodler goes on to explain that we associate certain colors with certain feelings. White, for instance, "usually means purity."[20] *Eurythmy* is predominantly a white painting. His beautiful landscape of 1892, *Autumn Evening*, is composed of golden browns. The painting is unified in its color scheme; there is no aerial perspective, but instead a completely even color intensity. In order to give the landscape a universal and motionless aspect, he has suppressed the presence of figures and painted over the original female figure walking on the road. In his search for parallel structure in nature, Hodler now rejects totally the transitory quality of the Impressionist landscape. The composition is symmetrical. The chestnut trees, moreover, are not shown

growing naturally and at random, but have been arranged so as to infuse man's order into nature. The absence of shadows adds to the austere quality of this structural landscape. The avenue is greatly foreshortened, moving rapidly to its vanishing point. Yet for all its measure and structure—and this is perhaps the essential aspect of this fine landscape—the road itself not only goes into the sunset, it leads into infinity, to the immeasurable. The leaves fall aimlessly, announcing the approach of winter.

Hodler's desire for measure within his pantheist awe of the boundless universe seems almost analogous to the sentiment of the great Symbolist poet Rainer Maria Rilke:

> Fall
>
> The leaves are falling from afar
> as though far gardens withered in the skies;
> they fall with constantly denying gestures.
>
> And in the night the heavy earth is falling
> from all the stars into its loneliness.
>
> We are all falling. This hand falls,
> and look at others: it is in them all.
>
> And yet there is One, who holds this falling
> in his own hands with timeless tenderness.[21]

The symmetry of *Autumn Evening* is a quality Hodler retained in landscapes for some time. Often, instead of using a vertical axis, he orients his landscapes on a horizontal one. For the remainder of his life, he painted many views of Lake Geneva, often as seen from Chexbres or Vevey. He would look down at the expanse of the lake and make a large oval form in which the near shore is echoed by the sweep of the mountains on the far side, while clouds in the sky are reflected in the waters of the lake. In *Lake Geneva from Chexbres* of 1895, a high sweeping cloud formation repeats the defining curve of the near shoreline. Hodler combines a sense of realism and place with his theoretical principle of Parallelism. The numerous variations of the wide view of Lake Geneva attest the constant refinement of his vision.

During the summer months Hodler also often returned to Lake Thun, where he had worked with Ferdinand Sommer when he was a very young man, to paint a series of landscapes. One of the later of these is *Lake Thun* of 1909. This painting is almost a schematic example of double axial symmetry with the far shoreline again serving as the central horizontal axis, while the waves in the lake create a repeat pattern of parallel lines. In addition, the mountains beyond the lake rise in a symmetrical manner around an invisible vertical axis. To an eye accustomed to the charming random quality of an Impressionist landscape, this painting may appear too stylized and theoretical, but Hodler was well aware of

his purpose. In 1904, during his great triumph in Vienna, he remarked that "when I began, I turned toward Impressionism. Slowly, however, due to study and years of observation, I came into my current trend: *clear form, simple representation, repetition of motifs.*"[22] Similarly, Heinrich Wölfflin, a great admirer of Hodler, felt that "to a certain extent he brought the accidental together into a universal order."[23]

On a trip to the Engadin in 1907, Hodler painted *Lake Silvaplana* on a bright, crystal-clear day. To achieve harmony and unity in this painting of the high mountain lake, he again paints the image of the mountains reflected perfectly in the water. The banks, which in actuality are more parallel, seem to run together in a horizontal line, forming the wide shoreline across the lake. The mountains on the left side are echoed on the right, but this painting goes far beyond the scheme of double symmetry. The colors in *Lake Silvaplana*, the reddish brown of the mountains, the emerald green of the meadows, the clear blue of sky and water make this painting a superb image of nature.

Perhaps the crowning achievement of Hodler's landscapes at the turn of the century is *Eiger, Mönch, and Jungfrau in Moonlight* of 1908. Here, in this painting, kept almost entirely in blues, the three great peaks emerge majestically from night fog. The mood is set by the color, the drama is created by light and the relationships of the shapes. Two dark clouds float in the center of the painting and are outlined by cold bright rings of moonlight. They relate to each other as if there were a cosmic charge between them, and they are embraced by a great crescent of clouds high above them. A sense of heavy mystery infuses this nightscape above the partially veiled mountains. The painting suggests a pantheist concept, comparable to that expressed a half-century later by Mark Rothko, who often dealt similarly with floating, luminous shapes impinging on each other. The rhythms created by Hodler's visionary painting seem to correspond to the rhythmic feelings of the artist's innermost self, and are communicated to the viewer. Having abandoned the more dogmatic scheme of Parallelism, Hodler expresses the magical experience and sense of the mountain night more directly. We know that the mountain landscape itself, no matter how beautiful, can never equal the strength of feeling expressed—now almost unconsciously—by the artist's sense of formal structure.

Hodler frequently went high up into the mountains to come close to the Alpine giants. He would go to the Schynige Platte, to Grindelwald or Mürren to be as close as possible to the great Jungfrau massif so he could study and paint the grandiose quality of the mountains, or he would paint the solitary Niesen, which stands like a pyramid against the sky. *Niesen* of 1910 was painted in broad brushstrokes; Hodler was interested in the flat decorative pattern of convoluted clouds above the equilateral triangle of the peak. A year later, discarding Art Nouveau ornamentation, he painted a monumental picture, the *Breithorn*, in pure blues, whites and browns. The mountain is outlined in hard, defined contour

lines, the masses are carefully balanced. The rocks beneath the snow are brought out in very sharp and clear relief. In fact, Hodler uses somewhat lighter tones for the foreground of these pictures and darker values for the distance, reversing the traditional means of treating landscapes. Thus, by denying aerial perspective, he achieves the two-dimensional effect he wants and brings the mountain close to the viewer. In these pictures he reveals the architectural structure of the object— and this is the essence of his modernity here. His friend, the noted Swiss painter Cuno Amiet, expressed it thus: "Hodler seems to me to be more of an architect than a painter."[24]

The artist himself underplayed the importance of his magnificent landscapes, viewing them as a summer relaxation from the work he considered truly significant, and, since there was now an enormous demand for these pictures, as a means to make money. This is clear from the following remark: "People think I'm all out for money. If that were so, I'd have to paint only landscapes, which sell like hot cakes. The figures are the only important things for me."[25] Contemporary criticism, however, did not agree: "The landscapes of Hodler are as significant and independent as the landscapes by Cézanne and Van Gogh. It could easily happen that the history of art of the future will elevate Hodler the landscapist above the master of monumental style."[26]

This has indeed happened to a considerable extent. Hodler's feeling for the monumental seemed to a good many critics more suited to the depiction of the mountain than to the representation of man, perhaps because Hodler's sense of the stasis and immobility with which he endows his large figure compositions disturbs critics possessed of a more realistic sensibility. And mountains, after all, are about as solid and permanent as anything can be. In his paintings of lone summits or Alpine massifs, Hodler went far beyond depicting individual mountains; he came close to creating a universal symbol of the concept MOUNTAIN. It is astonishingly true that nobody had ever painted the Alps with such deep understanding of the solitude that reigns among the peaks or of the powerful quality of rock and ravine, gorge and glacier. Earlier painters of mountains might offer a sublime, romantic, inner-directed vision like that of Caspar David Friedrich, or they might idealize the Alps with a sense of classical order and Arcadian nostalgia, as did Josef Anton Koch and his followers. The Impressionists painted mountains with a soft lyricism. Hodler's Swiss predecessors and contemporaries (with a few exceptions, such as Giovanni Giacometti, Cuno Amiet, and Giovanni Segantini) were generally satisfied with sentimentally picturesque views of the Alps.

In his late landscapes Hodler becomes increasingly free. A painting like *Landscape near Caux with Rising Clouds* of 1917 no longer has any sharp contours and there is little structured composition. Everything is dissolved into light and color in this remarkable painting from the summits. Years later René Daumal in a visionary novel, *Mount Analogue*, tells about a mountain painter:

"She understands that the view one has from a high peak is not registered in the same perceptive range as a still life or an ordinary landscape. The paintings admirably express the circular structure of space in the upper regions."[27]

Aware of the special feeling he achieved with his late landscapes, Hodler himself referred to them, perhaps jokingly, as "paysages planétaires." During the last months of his life, no longer able to go up to his retreat at Montreux, he finally could not even leave his apartment to go to his studio. He then stood at his window at the Quai de Mont Blanc in Geneva and painted a series of landscapes, at all times of day and in all weather, of the wide lake, the Mont Blanc massif, and the sky.

Painted with loose brushwork, these pictures are mostly in blue and gold. They are small; some are bright and crisp in color, others dark and glowing. They are very horizontal and emphasize the width of the lake flowing by like a river, the mountains, and the sky—the three elements so important to Hodler's experience. They symbolize the visible world, and they become increasingly abstract. Shortly before he died, Hodler stood on the banks of Lake Geneva with Johannes Widmer and said: "I want to paint different landscapes now, or paint my landscapes differently. Do you see how over there everything is dissolved into lines and space? Don't you feel as if you were standing at the edge of the earth and were able to communicate freely with the universe? That's how I want to paint from now on."[28]

In many ways Hodler felt as if he were "standing at the edge." When he was seven years old his father died. At fourteen he experienced the slow dying of his mother, also of tuberculosis. "We were miserably poor then and the funeral was as paltry as possible," Hodler recalls. "The raw wooden coffin was put on a simple pushcart and the funeral cortege consisted of us children, my brothers, sister and myself stumbling behind it. This picture has remained light and clear in front of my eyes during my whole life."[29]

The deaths of both parents were followed in rapid succession by the deaths of most of his brothers and his sister. "In the family there was constant dying. It seemed to me as if Death were always in the house, as if this is how it had to be,"[30] Hodler remembers, speaking also of the permanence of death.

After his arrival in Geneva as a young man, he was permitted by Karl Vogt to draw and study corpses in the dissecting room of the University, and in 1876, soon after seeing Hans Holbein's great *Dead Christ* in Basel, he painted two intense canvases: *Woman on Her Deathbed* and *Dead Man*. Years later, when his ideas crystallized, he painted *Night*, the most decisive work of his career; it is an allegory of death. Many of the symbolic compositions that followed dealt with termination of life. *The Disillusioned* have reached the end of existence. *Eurythmy* deals with the inevitable walk toward oblivion. In this respect Hodler's sensitivity relates him closely to his contemporary, Edvard Munch, who

had similar early experiences with death in his family. Moreover, at the *fin de siècle* a preoccupation with death and the meaning of life was general among painters, sculptors, poets, playwrights, and novelists, and Hodler was very much a man of his time.

Even in his historic compositions, paintings often meant to celebrate heroic exploits of Swiss warriors, Hodler chooses to deal with tragedy, defeat, and death: the mural, *The Retreat from Marignano*, was commissioned for the Hall of Armor at the Schweizerisches Landesmuseum in Zurich. It commemorates the retreat of the Swiss army at Marignano early in the sixteenth century. *The Wounded Warrior* of 1897 is a full-scale color sketch for the Zurich mural. The standard-bearer has rescued the flag on which he still leans, about to succumb to the wounds of battle. The greatest of his historical compositions, and probably Hodler's chef d'oeuvre—the large mural celebrating *The Departure of the Volunteers in 1813* at the University of Jena—depicts the steady march of soldiers, moving irresistibly into battle, facing inevitable death.

Beginning with the portrait *The Poet Louis Duchosal on His Deathbed* in 1901, Hodler recorded the death of those close to him with agonizing precision. In 1909 Augustine Dupin, his former mistress and mother of his son Hector, became seriously ill, and the artist went to her, stayed with her, and recorded her sickness and death, always adding the exact date to his signature. The final painting, *Augustine Dupin on Her Deathbed*, painted the day after she died, has the name "Hodler" added to hers: Augustine was finally acknowledged by her lover. The thin woman in black with hands folded is stretched out, stiff and immobile. Death is expressed by prostrate horizontality, which is reiterated by three parallel blue lines painted high on the ochre wall above the dead woman. Hodler told Hans Mühlestein that they stood for the soul of the deceased.[31] They certainly bring the concept of Parallelism into the realm of abstract symbolism. To Hodler, the permanence and universality of death were the final manifestation of unity among all people.

In an excellent essay on Hodler's Augustine Dupin death cycle, Jura Brüschweiler comments on this last of the four paintings:

> ...Now the body is totally collapsed and stiffened in its definitive horizontality. It lies like a wave that becomes immobile before disappearing at the shore of destiny. "Mountains become lower and more rounded by the centuries until they become as flat as the surface of water," Hodler said about nature. By dramatically foreshortening Augustine's corpse, the painter rediscovers this tendency of forms to dissolve into horizontality. The corpse, clothed in a black dress which sparkles with specks of royal blue and bottle green that are reminiscent of life, lies on a white bed streaked with bluish-gray and olive-gray. Enclosed between the lateral edges of the painting, Augustine seems smaller. Her rigid hands have been crossed over her stomach and her feet point upward in a grotesquely maladroit fashion. Hooded by her green-black hair, in curls now tipped white, Augustine's relaxed face has been finely modeled in tones of white, ochre and yellow chalk. Death, in one of its pitiless paradoxes, has restored an air of youth to her, only to petrify it in an inanimate mask. The wall in back of Augustine not only occupies

three-fourths of the painting: it suggests infinite space. It is given rhythm by three large, tormented strokes; these appear as the emanation of the soul, which is exhaled and condensed into three nocturnal clouds. In this elevated echo of the horizontal rhythm of death, Hodler's Parallelism goes beyond all decorative intention to attain a cosmic significance. This final vision of Augustine is the masterpiece of the cycle.[32]

Several years later Hodler once more became completely absorbed in the theme of death, or, as he called it, "the permanence of absence."[33] He was about fifty-five when he met the woman to whom he came closest in his life: Valentine Godé-Darel, a well-educated woman from Paris who came to Geneva in her thirties and became Hodler's model, his intimate friend, and the mother of his daughter, Pauline. In 1913 Valentine became ill with cancer and from that point to her death in 1915, Hodler went to her sickbed near Lausanne, day after day. There he made a great many drawings and paintings as well as his only sculpture of the sick, the dying, and the dead Mme. Godé-Darel, whose dignity he compared to that of a Byzantine empress.[34] This cycle is fully documented and analyzed by Phyllis Hattis on the basis of nine drawings. Among the paintings, *The Sick Valentine Godé-Darel*, created in December of 1914, is the most poignant in its eloquence. Here she is stretched out on her bed, her head still at right angles (eventually she will become entirely horizontal), her features finely chiseled, her face clearly defined by pain, her mouth slightly opened, almost as if in the breath of expiration. Her body under the sheets flows on, wavelike. The watch, undoubtedly Hodler's, which is placed against the wall indicates that her time has almost reached its end. And, as if to indicate their close relationship, the artist paints three roses on the wall, a motif he uses in that extraordinary self-portrait of 1914 with the raised eyebrows and cynical glance in the Schaffhausen museum.

We have already mentioned that Hodler observed his own countenance and produced a large number of self-portraits. These are concentrated primarily in his early and late years—the years of self-doubt and trouble. They rarely occur during his middle period. But in 1891, fresh from his success in Paris with *Night*, and probably after his trip to the French capital, he painted his own image in the most affirmative and almost aggressive manner. This is an extraordinarily clean, fresh, and direct portrait. The painter turns around to look at the viewer not with the angry and threatened expression seen in *The Angry One*, done ten years earlier, but open and bright. The most remarkable aspect of this forceful self-portrait is the clear, observing eyes—of which Johannes Brahms remarked to the Bern writer Joseph Viktor Widmann: "Have you seen these wonderful eyes glowing with energy and talent? You better go there. Certainly something significant can be expected."[35]

Some twenty years later in the frontal *Self-portrait* in the Winterthur museum, we see the artist still with penetrating and wide open eyes, but now

fatigued, confused, and troubled. This self-portrait was created in 1912 at the very peak of his career. Hodler was now invited to participate in almost every major international exhibition, he had one-man shows in Germany, and many important mural commissions from Zurich to Hannover. He was certainly one of the most sought-after artists of his time and had all the financial rewards that come with success. But Augustine Dupin had died, and 1912 marked the beginning of their son Hector's chronic illness. Despite outward success, Hodler seems to look at the mirror with an expression of disappointment as if to say: "Is this all there is?"

Two years later in the *Self-portrait* now in Schaffhausen the expression of disillusionment has given way to a skeptical, cynical, almost suspicious one. Hodler's style has also changed again: instead of the loose brushwork of the 1912 portrait, he works in a much more linear manner, emphasizing the deep folds in his brow, which like an arc relate to the decorative, abstract flowers in the background. The mouth is tightly shut, the whole face has become thinner. As the question of life and its meaning seems to occupy Hodler more profoundly, he searched his own face more intensely and painted no fewer than twenty-three self-portraits during the remaining five years of his life.

In one of the many self-portraits of 1916, Hodler looks at us again with a questioning demeanor, his shirt front and necktie are disheveled now, and there is a look of sadness in the old man's face. Yet—perhaps because he changed the composition of the head—there appears a light halo or nimbus around the distinct contour of the head which adds to this painting's icon-like quality.

Finally in the self-portrait of 1917–1918, also in the Geneva museum, he has become a broken man. His friends have died, his financial and artistic success, which had been won with such difficulty, came to an end as his German patrons boycotted him because of his protest against the shelling and partial destruction of Reims Cathedral by the German artillery. He painted his images with a light and loose brush, because his illness no longer left him the strength for more solid painting. Much as in the landscapes of Lake Geneva done at the same time, the color is applied in a thin film of marks and stains instead of in his former, more conventional brushwork. The result is an unfinished, calligraphic, and abstractly vital appearance. But if there appears to be vitality in the brushwork, the face itself with its almost ritual stare and expression of awe has an incorporeal aspect: the artist facing death.

Notes

1. B. in *Le Petit Genevois*, April 17, 1876, quoted in Jura Brüschweiler, *Ferdinand Hodler*, Lausanne, 1971, p. 16.

2. Fritz Widmann, *Erinnerungen an Ferdinand Hodler*, Zurich, 1918, p. 28.

3. This is suggested by Walter Hugelshofer in his important monograph *Ferdinand Hodler*, Zurich, 1952, pp. 17–18.

4. Hodler, "Barthélemy Menn," Bibliothèque Publique et Universitaire, Geneva, Ms. fr. 1984/273-274 (no title, no date).

5. *Ferdinand Hodler*, exhibition catalogue, Wiener Secession, Vienna, 1962, pp. 37–38 (documentation by Jura Brüschweiler).

6. This painting has always been dated 1890. In fact this date which appears on the canvas is in Hodler's hand. Recent research by Jura Brüschweiler ("La datation du 'Bois des Frères' de F. Hodler et la naissance du parallélisme" in *Musées de Genève*, Nos. 103 and 105, Geneva, March/May 1970) makes it clear, however, that it was actually done in 1885 for the Concours Calame of that year and signed and dated incorrectly by Hodler at a later time.

7. Hodler, "The Mission of the Artist," Fribourg, 1897.

8. *Ibid.*

9. Walter Hugelshofer, *Ferdinand Hodler*, Zurich, 1952.

10. Hodler, "Mes tendances actuelles—'La Nuit,' " (1891), Bibliothèque Publique et Universitaire, Geneva, Ms. fr. 2984/361-366.

11. John Henry Fuseli's *Nightmare*, painted in 1781 a few years after his arrival in London from Zurich, enjoyed tremendous fame all over Europe. Professor Gert Schiff tells me that "although none of the extant copies of this painting were in Switzerland during Hodler's lifetime, the painting was fairly popular on the grounds of innumerable engravings of which Hodler could certainly have seen one" (Schiff, letter to the author, April 4, 1972). The visual evidence certainly makes this familiarity very likely, and it is known that Hodler saw and admired a drawing by the Swiss-English painter. Arnold Federmann, in his earlier monograph of Fuseli, sees "a secret thread connecting Fuseli's work with Hodler's" (*Johann Heinrich Füssli*, Zurich and Leipzig, 1927, p. 70).

12. Joséphin Péladan, *Le Salon (Dixième Année)*, Paris, 1891, pp. 32–33.

13. Hodler in D. Baud-Bovy, "L'Oeuvre de Ferdinand Hodler," *La Tribune*, Geneva, May 27, 1918.

14. Hodler, "*Eurythmy*: Five men representing humanity, marching toward death," in "Notes Ultimes" (notebook of F. Hodler), 1917–1918, Geneva, Musée d'Art et d'Histoire, Ms. no. 1958/176–234.

15. Hodler, "The Mission of the Artist," Fribourg, 1897.

16. I am indebted to Marilyn Kaye Hodson for some of the research on the relationship of Hodler to modern dance, which she carried out in a research paper at the University of California, Berkeley, in 1971.

17. Stephanie Guerzoni, *Ferdinand Hodler*, Geneva, 1957.

18. Quoted from researched documentation provided by Jura Brüschweiler.

19. Peter Selz, in Selz and Constantine (eds.), *Art Nouveau*, The Museum of Modern Art, New York, 1959, p. 74.

20. Hodler, "The Mission of the Artist," Fribourg, 1897.

21. Rainer Maria Rilke, "Herbst," from *Das Buch der Bilder*. Translation by the author.

22. Hodler, interview with Else Spiegel, in *Wiener Feuilletons- und Notizen-Correspondenz,* January 21, 1904.

23. "Uber Hodlers Tektonik," *Die Kunst in der Schweiz,* May, 1928, p. 97.

24. "Ferdinand Hodler wie ich ihn erlebt habe," *Die Ernte,* Basel, 1943.

25. Hodler quoted by Arnold Kübler, *Du,* August, 1953, p. 9.

26. Carl Gebart in *Frankfurter Zeitung,* August 3, 1910.

27. René Daumal, *Mount Analogue,* San Francisco, p. 28.

28. Johannes Widmer, *Von Hodlers Letztem Lebensjahr,* Zurich, 1919, pp. 8–9.

29. Hodler to C. A. Loosli, in C. A. Loosli, *Ferdinand Hodler* (4 vols.), Vol. I, Bern, 1921, p. 11.

30. *Ibid.,* p. 5.

31. Ibid., p. 472.

32. Jura Brüschweiler, "Ferdinand Hodler: Le cycle de la mort d'Augustine Dupin (1909)," translated by Jane Nicholson, in Institut Suisse pour l'Étude de l'Art, *Jahresbericht und Jahrbuch,* Zurich, 1966, p. 167.

33. Hodler in his notebooks, cf. C. A. Loosli, *Hodler,* Bern, 1924, IV, p. 223.

34. Hans Mühlestein and Georg Schmidt, *op. cit.,* pp. 484, 487–488.

35. Johannes Brahms in Fritz Widmann, *Erinnerungen an Ferdinand Hodler,* Zurich, 1918, p. 6.

The Era of German Expressionism

Art in a Turbulent Era:
German and Austrian Expressionism

The world in its present state is not the only possible world.

Paul Klee

Emerging from relative obscurity to wide recognition in the past twenty-odd years, the movement known as German/Austrian Expressionist art has revealed itself to be so protean in nature that it has rendered its label as a singular, art-historical category, little better than a term of convenience. The cultural climate that surrounded what we have come to call Expressionist art gave rise to artistic phenomena which assumed separate and distinct forms in Dresden, Vienna, and Munich. These artistic centers served as background to the production of a number of works that ultimately have only their diversity in common. In these three cities and in Berlin, where many Expressionist artists were eventually to establish residence and gain recognition, Expressionism was elaborated and enriched by artists generally more concerned with spiritual vitality, emotional content, and passion, than with purely formal problems. This emphasis on content, particularly in painting, was carried to a degree almost unparalleled in western art.

It is my contention then that German Expressionism lacks the formal coherence which could justify its being called a "style." The reader of these pages and the viewer of this exhibition will find ready evidence of the unique qualities of personal expression for which the so-called Expressionist artists searched at the beginning of the 20th century, the qualities which above all justified the shock and outrage with which a complacent Europe received their first works.

If there is an Expressionist "style," it resides not in the collective nature of the works themselves but in the character of the underlying ferment—social, aesthetic, philosophical, political—that called them into being. During the first decade of this century, life in Europe appeared to be attaining an apogee of

security. A long period of peace and colonial and industrial expansion had seemingly brought with it the promise of full prosperity; "civilized" man could look forward to the uninterrupted continuation of a well-established social order, to ever-increasing production of goods and services, and to decreasing human want and toil. In Central Europe the long reign of Kaiser Franz Josef—benign, remote, exceedingly oppressive—seemed to ensure the tradition and continuity of the prevailing social and political systems. Even a relative upstart like Kaiser Wilhelm II, it was thought, could eventually be absorbed into the fabric of this linear cultural evolution. Science and reason, it was generally assumed, would soon explain whatever remained of the inexplicable: Progress was Man's fate.

All of these premises were ephemeral. Many were false. But Nietzsche's announcement of God's demise was not heard by leaders of church and state; missionary Christianity continued to be implanted with imperialist fervor among the heathen of Africa and Asia. Darwin's theory of biological evolution was misapplied to human culture. His genetic model of survival of the fittest was cunningly employed to rationalize prevailing social injustices.

In these few pages it is impossible either to document the complex illusion that comprised the maquillage of *fin-de-siècle* European institutions, or to report in detail the events that undermined them and brought them crashing to ruin. But to understand the implication and inherent strength of the currents running counter to established social norms is prerequisite to understanding why creative individuals at large, and the German Expressionist artists in particular, made their art.

In 1913, the French poet Charles Péguy wrote: " ... the world has changed less since Jesus Christ than it has in the last thirty years."[1] Indeed, at the end of the 19th century profound changes of thought and attitude were sweeping through European intellectual and artistic circles. The structure of the old world was not nearly so secure as its surface appearance misled many to believe. It was, in fact, breaking asunder, and the Expressionists were among the animators of this fracture, along with many other intellectuals who had become painfully aware of the degree of alienation that permeated all aspects of western life beneath its masks of progress and prosperity. Writers, philosophers, poets, composers, painters, and sculptors throughout Europe had for some time been possessed by the need to shatter the complacencies of their age. Some turned their creative energies to seeking renewed cultural authenticity in the realms of myth, ritual, the non-rational, a congeries of esoteric religions and spiritualism. Images of utopian communities inhabited by noble savages living in simplicity and purity once again piqued the imaginations and zeal of philosophers and artists. None of this was new under the long sun of Europe, where revolution in other times had always been nurtured by the intelligentsia and eventually emerged upon its own barricades with its own spokesmen, and with its arts redemptive of mankind.

But this time, the false visions of an entire social fabrication evaporated in worldwide holocaust. The outbreak of World War I and the slaughter of at least ten million human beings between 1914 and 1918 finally brought home the fallacy of holding continued faith in the securities and comforts that had seemed to prevail at the start of the 20th century.

Few generalizations are effective in discussing the independent and individualistic artists who have been gathered under the label "Expressionist." By and large, the German Expressionists were strongly aware of their heritage in the German Romantic tradition. Many of them placed the highest value on the late medieval art of Northern Europe. Artists as different as Kirchner and Beckmann admired the Gothic, which seemed to them to be the last artistic manifestation of the Northern spirit. They opposed what they considered to be the Impressionists' shallow preoccupation with surface, and would have agreed with Odilon Redon, who accused his *plein-air* contemporaries of being "parasites of the object." The Expressionists found immediate sources in *Jugendstil* and in the work of painters who stressed the symbolic and emotional aspects of art. Gauguin and Redon, Cézanne and Hodler, Van Gogh, Munch and Ensor were important to them.

The Expressionist artists, driven by an inner need to utter their personal feelings and emotions and to project unresolved conflicts with society, saw their work as a meaningful declaration about life, not merely a well composed and formal artistic statement. They searched incessantly for their own identity, while simultaneously maintaining a fervent dialogue with the viewer. In 1899 during his first trip to Paris Edvard Munch, the Norwegian painter who exerted such a substantial impact on the German movement, wrote in his notebooks: "No longer should you paint interiors with men reading and women knitting. There must be living beings who breathe and feel and love and suffer."[2] And years later, in his eulogy to Munch, Oskar Kokoschka described Expressionist art as "form-giving to the experience, thus mediator and message from self to fellow human. As in love two individuals are necessary. Expressionism does not live in an ivory tower, it calls upon a fellow human whom it awakens."[3]

The Expressionist artist sought to understand him or herself, and then hoped to establish the I-Thou relationship of a Martin Buber. The artist's relationship to the spectator was both intimate and urgent. Some of the artists, indeed, pursued their art with a truly religious fervor, dreaming of a brotherhood of man, or, beyond that, fulfillment of the Romantics' yearning for a fusion of man and universe. They saw themselves as the prophets of a new social order which they announced in their art or poetry. They idolized the poet Georg Heym, who wrote in his diary in 1910: "In waking dreams I see myself as a Danton or a man on the barricades. Without my Jacobin bonnet I can't even think."[4]

Dresden

Jugendstil or Art Nouveau, the movement that immediately preceded the Expressionist generation, was still imbued with a utopian faith in art as that factor which could effect a harmonious design for living. As late as 1908 Joseph A. Lux, the Viennese *Jugendstil* critic, could still affirm that every person is a born artist (a concept, which to be sure, has recurred with predictable frequency throughout the century). By contrast the Expressionists saw the artist as a uniquely endowed being, as a genius, or indeed a prophet. Men of the earlier generation like Henry van de Velde, August Endell, Peter Behrens, turned from painting to the crafts and eventually to architecture. By complete contrast the artists who founded Die Brücke in Dresden in 1905—Ernst Ludwig Kirchner, Erich Heckel, Karl Schmidt-Rottluff, and Fritz Bleyl—were all originally students of architecture, a profession to which only Bleyl returned later. The Brücke artists turned their backs on their more utilitarian training and decided to become painters. In so doing they could achieve the sense of personal freedom they desired. They felt that only by means of complete personal affirmation and total liberty could an authentic new art be achieved. Against the *Jugendstil* idea of artists and craftsmen, designers and architects working for the common good of a bourgeois society, the Expressionists postulated a different community, consisting of free and audacious artists "to carry the future." The contrast between community and society, between the authentic, nurturing and often *völkisch Gemeinschaft* and the rootless, mechanical, urban and rational *Gesellschaft*—first postulated by the sociologist Ferdinand Tönnies[5] and later on used by the Nazi Party—is of great importance here. Certainly, the young painters who formed their close commune in Dresden felt that a genuine and authentic self-expression, and not decoration, was the essence of art.

The Brücke painters entered their thoughts in an ephemeral and now vanished manuscript which was significantly entitled *Odi profanum* after Horace's ode "I hate the uninitiated crowd." But this is not to imply that the Brücke painter or other Expressionist artists subscribed to a *l'art pour l'art* point of view. On the contrary, they wanted to find an authentic contact with the *Volk* and looked to late medieval German art and to the art of "primitive people" in the hope that their own often irrational art would regain the emotional and primordial power of the iconic object.

At the same time, they felt themselves a part of a new wave of European art. Partly through exhibitions that they saw in Dresden and on their travels, partly through reproductions in the art press, they were familiar with the work of the giants of the older generation in Paris. In addition, Hodler was a major influence, as was Munch who exhibited twenty paintings at the Saxon Art Association in Dresden in 1908.[6] A year later they may have seen Matisse's 1909 one-man show at the Cassirer Gallery in Berlin. If Kirchner denied these influences, it must be

remembered that the artistic purpose of the Brücke painters was quite different from that of the older Norwegian artist or their great French contemporary.

The Brücke artists lived in a closely knit community, worked together with exorbitant intensity, discussed their problems, severely criticized each other's work, and were far more embroiled in the excitement of creation than with the finished product. Kirchner probably had the most inventive ideas; Schmidt-Rottluff coined their name and was the most stable member of the group; and Heckel was its most active agent. The furniture in their workshop—benches, stools, and chests—was created by the artists themselves. The distinctions between fine and applied arts were eliminated and an almost primitive unity between art and life—quite different again from the more sophisticated Art Nouveau interior—was achieved in their abandoned cobbler shop in Dresden. "Their canvases, frequently painted on both sides, were hung on the walls (or piled on the floor) along with their murals, and their painted burlap and batik."[7] Their erotic wood carvings stood in the corners.

The first Brücke exhibition took place in 1906 in a lampshade factory in a suburb of Dresden. Few people paid any attention to it. The group, however, felt the need to expand to be a "bridge to attract all the revolutionary surging elements" to itself.[8] Emil Nolde was asked to join the group. He was a significant member for a short time (1906-07) and developed his own characteristic style— his own visionary and religious fantasies and paintings of the land, his masks, his exotic heroes, his deeply felt flower pieces and paintings of the ocean—all rendered in sonorous symbolic colors. It was also in 1906 that Max Pechstein joined the group and remained a very active member for its duration. Cuno Amiet, the Swiss Symbolist painter, became a member, as did the Finnish Symbolist Alex Gallén-Kallela; and Kees van Dongen who was in close touch with Matisse and the Fauves. Edvard Munch was actually asked to participate in the first graphic exhibition of the group that was held in 1906, but refused.[9] Finally, in 1910 Otto Mueller became a member. This gentle painter from Silesia may have brought a softening influence to bear on the work of his tougher companions.

The landscapes of the Brücke painters, such as Schmidt-Rottluff's *Blossoming Trees*, 1911, or Heckel's *Forest Interior*, 1911, are wildly exuberant. Often they are peopled by nudes. In their search for direct and immediate expression, the Brücke painters rejected the posed nude professional model—set up much like a still life—employed by the Academy. They found their models in their own neighborhood and on the streets and studied the nude in natural movement or lying erotically about on couches in their living studios. Or they would take their women companions to the countryside where they depicted their bodies freely moving in natural surroundings as an integral part of the landscape of trees, lakes, and hills. They affirmed the Dionysian sensuality which Nietzsche had celebrated in his writings. But when they were impelled to paint

city scenes, they portrayed streets inhabited by individuals trapped in the nervous surroundings of the urban environment which Spengler described as "deserts of daemonic stone." Clearly the Brücke painters preferred the freedom of the countryside and searched romantically for roots in the soil and the land, roots which were not to be found in the urban environment. Yet around 1910 most of these painters relocated in the metropolitan world of Berlin. By 1913 the group broke apart, largely due to Kirchner's somewhat self-glorifying publication of the *Chronik der Brücke* and the ensuing controversies.

Vienna

Dresden, although it was the residence of the kings of Saxony and could boast a great art museum, theatres and opera, remained a provincial city in Central Europe. Vienna, on the other hand, was one of the great centers of European civilization and a cradle of new ideas. In the early years of the century it was a place of unequaled intellectual and artistic energy and ferment. Traditionally the center of music, Vienna now produced Gustav Mahler's *Eighth Symphony*, the "Symphony for 1000," which indicates the gigantic ambitions prevalent among artists and intellectuals in the capital of Dual Monarchy. Soon Arnold Schoenberg would radically alter the history of western music. This was the period in which Arthur Schnitzler had pinpointed the decadence of the *fin de siècle* in his brilliant series of plays, enveloping his accusations of a hypocritical bourgeoisie in a diaphanous veil of satire. The poet Peter Altenberg wrote brief "photographic" poems, commenting on the intellectual and moral life of his time, and more significant, Karl Kraus, the brilliant cultural critic and polemicist, became the literary and political conscience of an era, communicating his thought about language, culture and politics in his unique magazine, *Die Fackel.* Hugo von Hofmannsthal developed a visionary romanticism with a melancholy evocation of an idealized 18th-century grace. Eventually he became the collaborator and librettist for Richard Strauss. Franz Werfel concerned himself in his early poems with the problem of man's relationship to God and the liberation of the soul. Stefan Zweig, writing in a highly civilized prose style, was one of the innovators of the 20th-century historical novel at its finest.

Sigmund Freud and his Viennese collaborator Alfred Adler developed the theory of psychoanalysis, delving into heretofore little-explored realms of dream and fantasy and penetrating basic human desires and needs which an overcivilized society forced man—and, even more, woman—to conceal and suppress. Freud's theories of the unconscious self and his interpretation of art as the successful exploitation of the libido toward creative pursuits are highly important to an understanding of the art of his time.

In philosophy we find such divergent approaches as Ernst Mach's scientific investigations, Ludwig Wittgenstein's analysis of linguistic forms and Martin

Buber's philosophy based on the spiritual and often mystic beliefs of the Hasid. Art historians like Franz Wickhoff, Alois Riegl, Max Dvorak, and Hans and Erica Tietze broke with previous biographical and formalistic practices and related the discipline more intimately to the broader history of culture, thus opening the art of the past to a much deeper understanding.

A new kind of architecture, related to Art Nouveau, followed the precept of the towering figure of Otto Wagner and was practiced by his disciple Joseph Maria Olbrich, who had designed the boldly geometric exhibition hall for the Vienna Secession, and by Joseph Hoffmann, a man of extraordinary design sensibility. They were followed immediately by the more radical anti-Secessionist Adolf Loos, who propounded a total simplification of architectural form. Following his dictum that "ornament is crime," Loos' buildings were among the first examples of the new rationalism and functionalism in European architecture which were ultimately to change the appearance of the human environment.

The cause for the unparalleled outburst of energies may very well lie partly in the highly divergent cultures which fused in the Hapsburg capital, the city on the Danube that reigned over ethnic groups that spoke German, Hungarian, Czech, Slovak, Polish, Rumanian, Slovenian, Croatian, Serb, Yiddish, Italian, Ruthenian, etc. But the ferment was undoubtedly also partly due to the number of brilliant and cultivated Jews who rebelled against the austerity of Orthodox Judaism as well as the repressive hypocritical moral code of a worn out aristocracy to which they had no access. They were also subjected to the constantly rising wave of anti-Semitism among the populace, exemplified by Karl Lueger, mayor of Vienna from 1897 until 1910. We must remember that it was in Vienna that Hitler developed his political polemics; and also that Theodor Herzl, journalist for the *Neue Freie Presse*, formulated his ideology of Zionism, based on the belief that the true emancipation—so deeply longed for by his intellectual confreres—was neither possible nor desirable.

Vienna was a city which did not have a truly great tradition in painting. At the turn of the century Gustav Klimt, president of the Vienna Secession, moved from elaborate decorative paintings toward evocative symbolist murals and sumptuous portraits of Viennese ladies. He became the most sought-after portraitist for depictions of women who were almost imprisoned in their luxurious environment. His women relate to characters who in the plays of Schnitzler and Hofmannsthal are part of an illusory stage world without a power of their own. These women seem to live a life of luxuriant futility, part of an overripe civilization far gone towards its decline.

Klimt, Austria's first modern painter, was of great importance to the younger Austrian artists, Oskar Kokoschka, Max Oppenheimer, Richard Gerstl, and Egon Schiele. These men, coming of age slightly later than the Dresden group, no longer believed in the idea of a "community of artists," but saw

themselves as separate, indeed isolated and lonely artists entirely alone in their search for artistic and personal identity. Indeed, Adolf Loos spoke about a "monstrously powerful individuality." Their highly introspective portraits—and portraiture was the prime subject matter of the Viennese Expressionists—depict the anxiety and pain of Vienna's intellectuals and are indeed mirrors of that unquiet sensibility.

Typical of Oskar Kokoschka's series of analytical portraits is that of his friend, the architect Loos, the man who very early on recognized the young painter's great talent and introduced him to the realm of Vienna's intelligentsia. Kokoschka, who had come to Vienna from a small town on the Danube near the Czech border in order to study painting, had achieved full maturity as an artist when he did this painting at age twenty-three. In these early portraits the artist projected himself into the painting, while simultaneously showing deep psychological insight into the personality and character of his sitter. The artist painted this canvas fluidly with nervous rapidity by means of brush, hands, and rags. He used a flickering light to emphasize the essential elements, head and hands, and renounced the world of bright color for the darkness he needed to give substance to his vision of anxiety. Although not a friend of modern art, Sir Ernst Gombrich, who himself grew up in pre-war Vienna, recognized the depth of insight and radical breakthrough of these portraits, and wrote that "It is the intensity of the artist's personal involvement which made him sweep aside the protective covering of conventional 'decorum' to reveal his compassion with a lonely and tormented human being. No wonder, perhaps, that the sitters and the public felt at first uneasy and shocked by this exposure."[10]

After a difficult period and serious injury in the war, Kokoschka settled in Dresden for a brief time, long after the Brücke painters had left the Saxon capital. His work slowly became less imbued with tragedy and he could do a fresh watercolor such as *Lovers with Cat* in 1917 in which the movement of the brush has become of even greater importance and in itself carries the psychological message. This is a painting of the actress Käthe Richter and the poet and playwright Walter Hasenclever in a composition based on Lucas Cranach's *Apollo and Daphne*. Hasenclever, like the early Kokoschka and so many other Expressionist writers and artists, was concerned with the utopian emergence of the "New Man" in the turbulent post-war period.

Beginning in 1924 Kokoschka set out to paint his *Orbis Pictus* of the great cities of Europe and the Middle East, such as *Jerusalem*, 1929. These cityscapes are generally seen from a distant vantage point and infused with light. They are more related to Impressionist painting as well as Kokoschka's own native Baroque heritage and move away from his early restless Expressionist visions.

Max Oppenheimer, known as Mopp, was a member of the Viennese avant-garde. He also painted emotionally charged, incisive portraits during the first decade of the century. In 1911 he began working with Franz Pfemfert for the

vanguard left-wing periodical *Die Aktion* in Berlin, while Kokoschka became for a time the collaborator and art advisor to Herwarth Walden's *Der Sturm*. By 1916 when Mopp painted *The World War* he had clearly absorbed the impact of Cubism and Futurism and used typography to carry his anti-war message by using French, English, Italian, and American newspapers, envelopes, and cigarette wrappers for his *trompe l'oeil* picture.

Richard Gerstl, too, painted several psychological portraits—mostly self-portraits—of sexual torment. At the same time he painted pictures in bright Fauve colors, applied with vigorous brushstrokes, of the Schoenberg family who were his friends. Arnold Schoenberg himself was entirely self-taught as a painter, but took his painting very seriously and often turned to it for the experimentation with ideas that he could not work out musically. He has suggested that the almost hallucinatory color visions that he made around 1910 may have been done in some kind of trance. Wassily Kandinsky, whose own creation of a new and radical kind of painting was parallel in many ways to Schoenberg's essential contribution to the history of music, appreciated the composer's painted apparitions and pointed out that "Schoenberg does not really think of the picture while painting. Renouncing the objective result, he seeks solely to ascertain his subjective emotion and needs therefore only those means which appear to him unavoidable at the moment."[11]

Schoenberg, Kokoschka, and Mopp, realizing that the focal point of the Central European avant-garde was moving to Berlin, went there before the outbreak of World War I; Gerstl had committed suicide in 1908, at twenty-five. "There remained only one artist capable of producing a valid version of Expressionism out of the indulgent sensuousness of the Secession style: Egon Schiele, who reached maturity only a few years before he died in 1918."[12]

Schiele's *Self-Portrait* of 1910 shows the young twenty-year-old artist in a rigidly frontal pose. The flat, two-dimensionality of the painting and the emphasis on the evocative quality of line clearly derive from the older Gustav Klimt, who in many ways was Schiele's teacher. But, where Klimt's line is subtle, languid, and passive, Schiele's contour is hard, brittle, and angular; it has become an active agent, which, instead of flowing like water, pushes hard over obstacles. Klimt's patterned decorative background has been eliminated and there is only the isolated figure, stark and austere, framed by wavy lines.

Schiele, preoccupied with his own identity, painted many searching portraits of himself; but perhaps his most important work revolves around the female figure, which he often explored in its most intimate aspects. He revealed women and girls in the most unexpected erotic poses. He painted and drew them in various states of undress, singly or in lesbian embrace as in *Friendship*, 1913; in half-dressed, seductive poses; or naked and pointedly exposed. Although he was incarcerated in 1912 on a charge of immorality and seduction, Schiele advanced beyond pornography by the very intensity of his artistic expression, by

the vitality of line and the seriousness of his conception. The viewer can feel that Schiele drawing his nudes was even more passionately engage in the act of drawing than in the erotic content. His adolescent and pre-adolescent girls are not Lolitas, but highly neurotic creatures with odd, oversized heads who display a guilt over their exhibitionism, their masturbation, the lesbianism to which they seem driven. Schiele's women do not enjoy themselves. Rather, like Bosch's creatures, they seem to be compelled to engage in their sexual activities.

Schiele even more than Kokoschka exemplifies the strange combination of erotic hedonism and anguish which characterized the febrile state of pre-war Vienna, likened by Karl Kraus to an "isolation cell in which one is allowed to scream." The artists pointed at the symptoms, as artists often do. The civilization to which they belonged was not to last.

Munich

"If I had a son who wanted to be a painter I would not keep him in Spain for a moment, and do not imagine I would send him to Paris (where I would gladly be myself), but to Munik (sic)...as it is a city where painting is studied seriously without regard to a fixed idea of any sort such as pointillism and all the rest."[13]

Unlike Vienna, a city which seemed to excel in just about every intellectual pursuit but had a relatively minor tradition in the visual arts, Munich was the European art center, second only to Paris at the turn of the century. It was the center of *Jugendstil*; it was the city where important international exhibitions of modern art were held with regularity, including one-man shows of Munch, Hodler, and Van Gogh. Artists from all over Europe and America came to Munich to study, to work, to meet colleagues and even to sell their work.

The attitude prevailing in Munich was much more form conscious than in other German centers. It was there that the sculptor Adolf von Hildebrand worked and published his influential book, *The Problem of Form in Painting and Sculpture* in 1893. At the University, Theodor Lipps formulated his theory of empathy and his student, the *Jugendstil* architect August Endell, announced his totally abstract art—at least in theory—as early as 1897, writing: "We stand at the threshold of an altogether new art, an art with forms which mean or represent nothing, recall nothing, yet which can stimulate our souls as deeply as only the tones of music have been able to do."[14] In 1904 Julius Meier-Graefe issued the first critical history of modern art in which formal values, as manifested chiefly in French painting, form the main criterion. Perhaps the most consequential book was Wilhelm Worringer's *Abstraction and Empathy*, published in 1908.

In 1909 a group of advanced artists formed their own art association, the *Neue Künstlervereinigung* (New Artists' Association), a loosely organized group of painters and sculptors, as well as musicians, dancers, and poets. Their

exhibitions were characterized by the very absence of a specific style. From the beginning their work differed sharply from the vehement Expressionism of the Brücke and from the compulsively introspective art which was so characteristic of their Viennese contemporaries.

The membership of the group included artists from France, Italy, and Austria as well as Germany. Its chairman and most influential force was the Russian Wassily Kandinsky who had come from Moscow to study in Munich with Anton Azbé, and then Franz von Stuck, an artist who painted fantastic subjects in an academic style. In Stuck's atelier, Kandinsky had his first encounter with Paul Klee, who had come from Bern, and with Alexej von Jawlensky and Marianne von Werefkin, both of whom had been students of Russia's fine Symbolist painter, Ilya Repin in St. Petersburg. Gabriele Münter arrived from Berlin to study at the Phalanx School which Kandinsky established in 1902. Most of the artists had experimented with Impressionism and rejected it in favor of a more definite form, imbued with evocative thought. Their ideas can be compared with those of the Symbolists. In their early gatherings at Werefkin's studio they were, in fact, joined by Gauguin's disciples Paul Sérusier and Jan Verkade, the latter now in habit and known as Father Willibrod of the abbey Beuron.

Soon, in the third year of its existence, controversies about the nature of modernism caused the New Artists' Association to split; Kandinsky and Franz Marc formed *Der Blaue Reiter*. The name itself had many associations with tradition from the medieval and romantic periods. The legendary first Blue Rider exhibition in December 1911 included work by Kandinsky and Marc, Münter, and Kubin, the artists who had seceded from the earlier group, as well as paintings by Henri Rousseau, Robert Delaunay, August Macke, Albert Bloch, David and Vladimir Burliuk, and others. It was to travel to Cologne where it was shown under the sponsorship of Emmy Worringer, sister of the young Munich art historian, and then to Berlin where it helped inaugurate the phenomenal series of avant-garde exhibitions in Herwarth Walden's Sturm gallery.

At the same time Kandinsky and Marc assembled material for the first (and only) almanac *Der Blaue Reiter*, a book which in retrospect appears to be the most important printed document of early 20th-century art, precisely because it was *not* a compendium of aesthetic theories and was consequently neither didactic nor formalist. It proposed a program of modern art by finding relevant links to the past—links, not traditions. "Traditions," Marc declared, "are lovely things—to create traditions, that is, not to live off them."[15]

For the first time, works of art that seemed totally unrelated were placed together: Egyptian shadow puppets, children's drawings, Bavarian glass and mirror paintings, Gothic, African and Pacific sculpture, paintings by the *douanier* Rousseau and Baldung Grien, by Matisse and Cézanne and El Greco, by Picasso, Delaunay, and Kandinsky, Russian folk prints and Chinese paintings as well as Byzantine mosaics. The book, like the exhibitions of the group,

established connections among artists in all countries working in new directions and broke through periods and genres, searching solely for the inner spirit that motivated the result. For the first time, as Klee stated later, the personal commitment, the concept and attitude of the artist were more important than the actual result. Franz Marc explained: "We went with a divining rod through the art of the past and present. We showed only that art which lives untouched by constraint and convention. Our devoted love was extended to all artistic expression which was born of itself, lives on its own merit and does not walk on the crutches of habit. Whenever we saw a crack in the crust of convention we hoped to find an underlying force that will someday come to light."[16]

In their search for the basic organic rhythm underlying all of man's artistic, religious and philosophical expressions, they also hoped to bring about a synthesis of all the arts. Frequent references were made to poetry (e.g., Maeterlinck), and Kandinsky was very close to mystical religious ideas, especially as synthesized by Mme. Blavatsky and Rudolf Steiner. Above all, a close relationship was established to music. The almanac contains scores of the new music, rejecting traditional harmonic passages: there are contributions of scores by Schoenberg, Webern, and Berg. While these scores were written prior to the full development of the twelve-tone scale, they were characterized by sustained intensity, complex tonality, and the expression of "inner necessity." Kandinsky himself, in fact, published the "script" for a "total stage composition," *Der Gelbe Klang* (The Yellow Sound), in the almanac. Here he tried to realize the idea that drama, like music and painting, must discard naturalism and return to its mystic-religious origin. It attempts to communicate a total aesthetic, indeed a synaesthetic experience, extending the paradigm of Wagner's *Gesamtkunstwerk*. The action in this "mystery play" consists largely of changes in color and light as well as movement of gigantic pantomime figures which are more like live marionettes than actors. There is no narrative commentary but there are random sounds and phrases, as Kandinsky felt that the human voice should not be obscured by words. The final aim of this color spectacle—much like Scriabin's earlier experiments with the color organ—was to elicit inner responses from the audience, to reach the spirit, or as Kandinsky would have it, "to cause vibrations in the soul." This, then, was the incredibly ambitious purpose of the new kind of art which brought about totally abstract painting on the part of Kandinsky. The Blue Rider indeed travelled into mysterious and unexplored territory, into dreams, into fantasies and toward the creation of new artistic formulations, which were often based on a total identification of the artist with nature itself. Paul Klee who had a small drawing reproduced in the almanac noted in his diary in Tunisia in 1914: "I myself am the moonrise of the South."[17]

In a painting by Kandinsky such as *Winter Study with Church* of 1911 we experience this feeling of empathy with nature, in this case the snowy Murnau landscape, expressed in enhanced color and more concerned with the feeling

inspired by the subject than the subject itself. By 1913 and 1914 the painter had left the realm of representation behind. The secure barriers of the known world are abandoned as the artist, following his "inner necessity," explores the world of the unknown. The pictorial cosmos of these paintings has become independent and autonomous; a new and free world has been unveiled.

Kandinsky and Marc—as well as Paul Klee—believed that art follows nature in its spiritual inner laws, not in its external manifestations. Franz Marc sought to paint pictures that would recreate the internal rhythms of nature: "We will no longer paint the forest or the horse as they please us or appear to us, but as they really are, as the forest or the horse feel themselves—their absolute being—which lives behind the appearance which we see."[18] He uses the expressive force of strong color for his evocation of the power of nature and eventually, under the influence of Kandinsky's oceanic abstractions and Delaunay's cosmic visions, Marc created what he referred to as his "inner mystical constructions." *Stables*, 1913–14, is a painting in which form, color, and light are transparent and pervade each other, a painting which, unlike the work of the Expressionists of the North, establishes a lucid sense of order, but an order that has been reached by a pure sense of intuition.

It was August Macke who had introduced his friend Franz Marc to the joy of color. Macke himself knew about Fauvist color and Cubist structure and shared Kandinsky's and Marc's thoughts on the spiritual possibilities of color. Never a mystic, however, Macke painted some of the most truly enchanting pictures of the period in which even the people in the parks are part of the visual joy. Macke, like his friend Franz Marc, was killed in the trenches of World War I.

Among the painters who followed the lead of Kandinsky and Marc were Heinrich Campendonk, who like Macke came to Munich from the Rhineland and painted imaginative semi-Cubist paintings, and the American Albert Bloch, who had come from St. Louis and did charming carnival-like paintings of dancers, harlequins, and pierrots. After considerable success in Germany, Bloch returned to the United States where he was head of the art department of the University of Kansas for almost thirty years.

The deep mystical longing for a new religiosity of the Blue Rider, however, was to find its protagonist in Alexej von Jawlensky. Jawlensky, originally a Russian officer, felt the need to become an artist and studied in Munich and travelled a great deal. He had come under the influence of Gauguin—he even painted in Pont-Aven for a while—and then found his own way to sonorous color compositions by way of Matisse and Kandinsky. In the pre-war years in Munich Jawlensky painted heavily outlined landscapes in powerful contours, and strong heads such as *Spanish Woman*, 1912, where the features have solidified into a hieratic painted idol. The solidity of form in this head and the emphasis on definite shapes—the lines of the eyes, the line of the nose, the lines of the mouth—and the resonant palette led Jawlensky eventually to his iconic meditative heads of the post-war period.

Berlin, Frankfurt, Weimar

Where Paris and London had for centuries been centers of cultural activity, Germany had no such single focal point. Instead, largely because of the late political unification of the country, Germany sustained its tradition of small but important cultural centers in various principalities and semi-independent kingdoms, such as Bavaria and Saxony.

After the unification of Germany in 1871, however, Berlin grew into a cultural center of considerable significance in spite of the Kaiser's bellicose attitude toward all arts but those of war. The new capital of the Reich began to emerge as the point of cultural focus for the entire country. First performances of revolutionary plays by Ibsen, Strindberg, Hauptmann, and Wedekind had put Berlin stage drama in the forefront of the development of a new theatre. Max Reinhardt converted the traditional stage into a magic world of symbols. Replacing the scene painter with the "stage architect," he created a stage "at once tribune, pulpit and altar." Reinhardt in turn was soon to be replaced by the daring constructivist Erwin Piscator as the leader of the avant-garde. Playwrights, actors, poets, novelists from all over Germany settled in Berlin.

In the visual arts, the Berlin Secession, founded in 1892 under the leadership of Max Liebermann in protest against the closing of an exhibition of paintings by Edvard Munch, assumed a position of leadership in German art and grew into the rallying center of German Impressionists. The galleries of progressive art dealers such as Paul Cassirer, Alfred Flechtheim, and later Fritz Gurlitt, I.B. Neumann, and Herwarth Walden, became meeting places for appreciators and collectors of modern German and foreign art. Artists and intellectuals of all descriptions lived in an environment mingling Prussian respectability with Bohemian cosmopolitanism. The name of the cafe where many of these people congregated—*Grössenwahn* (Megalomania)—is typical of the self-conscious cynicism of Berlin's bohemia. After the war, Berlin, capital of the Weimar Republic, became the vortex of a country in turmoil, the focal point of political, social and cultural ferment, the fabulous, depressing and exuberant stage of Bertold Brecht's plays.

Around 1910 most of the Brücke painters moved to Berlin where they rallied once more with the foundation of the New Secession, in response to the refusal by the old Berlin Secession to show the work of the avant-garde. It was in Berlin, in fact, during the remaining years of peace, that the Brücke artists created what may very well be their finest works. Otto Mueller, an artist who in many ways was more traditional than the original Brücke group, had moved to Berlin as early as 1908 where he was close to Wilhelm Lehmbruck whose sculpture of the human figure is also characterized by restrained, sensitive elongation. Mueller's thinly painted distemper pictures were in significant contrast to the heavy brush favored by his more impetuous friends from Dresden. Mueller's are

quiet, lyrical, idyllic works, such as the intimate *Woman in Boat*, 1911, a painting of gentle curvilinear rhythm in blue and beige. The motif is similar to Pechstein's nudes in the forest; it is also based on a liberated attitude toward nudity and nature, but the mood is quiet and meditative. Some of the nature of Mueller's personality is evident in Kirchner's portrait of his friend, painted in 1913, but Kirchner's painting is highly dramatic, owing to the strong contrast of light and dark, the heavy brushwork and the angular V-shapes, so characteristic of his work after his move to Berlin in 1910.

Kirchner, a highly sensitive individual, was drafted into the German army, which brought about his physical and emotional collapse. The malaise of his military service is represented in his *Artillerymen*, 1915, in which a large number of emaciated naked men are presented together in a small shower room under the surveillance of one of the officers. The painting expresses the extreme constraint and confinement of life in the barracks. In his *Self-Portrait as Soldier* of the same year, he appears in a pose similar to that used to depict Otto Mueller. He envisages himself with an amputated painting arm. His thin, drawn face stares out at the viewer without expression. In the background is the full-front figure of a nude woman and an unfinished painting hangs on the wall. The picture clearly symbolizes impotence and frustration. "Seen historically, *Self-Portrait as Soldier* expresses metaphorically that state of siege between private life and public death that the bitter war with its sluggish front and fruitless sacrifices had by now become. Unresolvable conflicts are unresolvable: this work is one of the great war paintings of the twentieth century because it so clearly and matter-of-factly indicts Wilhelminian Germany and chauvinistic Europe."[19]

It is revealing to compare two portraits by two Brücke painters: Max Pechstein's *Portrait of Louise Mendelsohn* of 1912 is a very positive statement. His likeness of Louise Mendelsohn, the beautiful young wife of Germany's great architect, is represented in vivid color in one of Pechstein's truly flawless compositions. Schmidt-Rottluff's *Portrait of Emy*, 1919, painted after the war is fraught with tragedy, due to the pensive pose, and primarily the frightening round left eye which seems to float disembodied in front of the model's face.

This troubled mood, however, prevails as early as 1913 in a painting such as Ludwig Meidner's *Apocalyptic Landscape*. A presentiment of the coming catastrophe seems to be expressed by the distorted perspective, compressed forms, and exploding earth and sky. The heaving streets, the toppling houses, all painted with a vehement brushstroke, evoke a sense of terror. Many years later, at the end of another world war, Berlin assumed an appearance not unlike Meidner's prophetic cityscape of doom.

Nolde settled in Berlin in 1905 and painted highly charged messianic paintings of biblical subjects—totally personal visions, often painted as if the artist were in a trance—and also paintings of masks, undoubtedly inspired by his visit to James Ensor in Ostend in 1911. *Masks*, 1911, evokes a feeling of terror not

only by the grotesque expressions, but also by the unexpected color and contrast between defined angular masks and others that seem to be almost evanescent. Nolde's own sense of magic is often transmitted in his work. And in far-away exotic countries he could find man in a primordial condition open to magic and mystical experiences. In 1914 Nolde sailed to the South Pacific as pictorial reporter of an expedition, organized by the German Colonial office. Nolde completed a number of remarkable canvases of the Melanesian islands, such as *Nusa Lik*, painted in New Ireland (Germany's colony of New Mecklenburg at the time) in 1914. The whole vast lonely scene with its little boats in the small bay and the green sea under a bank of clouds has been transformed into large and decorative rhythms of blues and greens.

In a watercolor, *South Sea Island Chief*, Nolde offers evidence of his admiration for pure native stock, the Noble Savage, whom he imagined he would encounter in the South Seas. In his diaries he spoke with romantic adulation of the unspoiled races he encountered there. Imbued with a belief in racial purity and a blood-and-soil mystique as necessary preconditions for the creation of pure and good art, Nolde joined the Nazi party very early. When the National Socialists came to power, however, Nolde was ironically smeared as a "degenerate artist" like all the other modernist painters and sculptors, and was prohibited from painting. It was during that time that he made a large number of watercolors, which he called "Unpainted Pictures," in his lonely house in the marshes on the northern border of Germany. In these visionary paintings by a true colorist, "Nolde's private world has been transfigured into a serene realm of human actors, whose chief function is their subservience to the color which gave them birth."[20]

Christian Rohlfs was the oldest of the painters identified with German Expressionism. Born in 1849, only a year after Gauguin, he was at least a generation older than the painters of the Brücke or the Blue Rider. His background, like Nolde's, was the ancient peasantry of Holstein. Rohlfs, artist in residence at the Folkwang Museum in Hagen, Westphalia, saw the art of his friends and German contemporaries and responded to their experiments in a highly personal way. The dynamic landscapes he painted early in the century were influenced by Van Gogh's agitated canvases. Later, Rohlfs turned to religious subject matter with a totally personal cast as in *The Return of the Prodigal Son*. In his old age, he painted delicate landscapes, cityscapes, flower pieces and occasional portraits in oils, watercolor, and crayon, paintings in which objects are mysteriously dematerialized and dissolved into veils of color.

By the war's end Expressionism had really run its course. In the presence of political reality, confronted with the brutality of post-war conditions, the Expressionists with their introverted attitudes were largely at a loss as to how to respond. The Berlin Dada group, with its engagement in political action (emphasis on action!) and its vilification of middle class culture and patronage,

directed some of its manifestos against "bourgeois decomposition, lunatic Expressionism and every kind of false emotionalism."[21] The Expressionist group did, however, join in the utopian *Novembergruppe* which, in fact, was co-founded by Max Pechstein, and soon included practically every avant-garde painter, sculptor, architect, composer, poet, and playwright. Their utopian programs for the arts would bring about a better future and a new society. Pechstein announced in a revolutionary pamphlet of the Worker's Council for Art the "desire to achieve through the socialist republic not only the recovery of the conditions of art, but also the beginning of a unified artistic era."[22] It seems ironic but it is an indication of the total confusion of post-war Berlin that such faith in the "socialist republic" could still prevail a short time after the Social Democratic regime had been implicated in the murder of the radical leaders Karl Liebknecht and Rosa Luxemburg, but the Expressionists had become close to being the official artists of the Weimar Republic and the artists were eager to put their work at the disposal of the government. "For the first time the artist was deprived not of his social acceptance but of his isolation."[23]

The heightened emotion of the pre-war years could not be sustained and the Expressionist artists themselves now worked in a less amorphous, a more defined form, clearer delineation, a return to illusionist space, and more attention to detail. In other words, a generally more conservative art came to the fore in Germany as it did in the rest of Europe. The New Objectivity movement of the 1920s was often sober and neutral in its reportage of the urban environment. It gained strength and patronage after the economic consolidation in 1924 following the catastrophic Inflation. The radical left wing of this group consisted of men such as George Grosz and Otto Dix who were politically engaged and painted savage pictures of accusation and used art as a weapon of revolution. Max Beckmann was included in the first exhibition of the New Objectivity in 1924, but he belonged neither to that nor to any Expressionistic group. In his twenties Beckmann had been a highly successful conservative painter. After his first experience in the war, where he "looked horror in the face," his style changed quite abruptly and gained inner depth. He announced his goal clearly when he said: "Just now, even more than before the War, I feel the need to be in the cities among my fellow men. This is where our place is. We must take part in the whole misery that is to come. We must surrender our heart and our nerves to the dreadful screams of pain of the poor disillusioned people... Our superfluous self-filled existence can now be activated only if you love them."[24]

Settling in Frankfurt after the war, Beckmann tossed out all the academic craft that he had mastered and turned to eloquent depictions of the human tragedy, cramming figures into the "dark black hole" of space. Finding affirmation in late medieval German panel painting, he turned toward religious subject matter as in *Christ and the Woman Taken in Adultery*, 1917. The strangely pale color, the pointed angularity of his linear forms, the crowded

figures moving in their restricted Mannerist space, carry his dramatic message. The action of many of Beckmann's paintings seems to unfold on a stage and here, the biblical scene is enacted by distorted figures through a silent conversation of hands. There is an existential absence of human contact. A similar detachment exists in *Family Picture*, 1920. Six desperate people are compressed into a small, crowded, low-ceilinged room. The artist himself, surrounded by his family, lies on a narrow piano bench, clutching a horn. Again there is no communication, no contact among the members of the family in this picture, which is one of Beckmann's cogent images of the great anxiety prevailing at the time of his "resolve to rationalize the horrible vision of the ravaged world."[25]

The Bauhaus, founded by Walter Gropius in Weimar in 1910, was a very different attempt at finding a rational solution to the turbulence of the time. It was to signal a new union of the arts and crafts and eventually of art technology. It created a new language of form. It was to alter art, design, and art education throughout the western world. One of the first painters whom Gropius appointed to be a master at the Bauhaus was Lyonel Feininger, whose woodcut, *The Cathedral of Socialism*, was the cover of the first Bauhaus Manifesto. As early as 1912 Schmidt-Rottluff had asked Feininger to join the Brücke and a year later he accepted Franz Marc's invitation to exhibit with the Blue Rider at Der Sturm in Berlin.

When Feininger first came to Germany from his native New York in 1887, he was still undecided whether to follow a career in art or music. The severe structure of music remains visible in all his painting. He felt that his work should come close to the "synthesis of the figure" and this is precisely what he accomplished. The painting *Side Wheeler at the Landing*, 1913, is an example of his early Cubist fragmentation of form into visionary synthesis. As time went on, Feininger created a crystalline world, whether he painted bridges, medieval churches, or vast skies and ocean beaches. In his clearly articulated paintings he dealt with his personal fantasy with the precision of a scientist.

Paul Klee became a Bauhaus master in 1920. His transparent *Death in the Garden*, 1919, may be read as a metaphor for the troubled times, but it may just as well be personal experience or excursion into the realm of the dream. Klee was to continue ceaselessly to experiment with forms, ideas, techniques, finding his sources in nature, in music, in poetry, in the study of biology and philosophy, in the art of children and the less traditional art of the European tradition, in his thought and dreams. Whether he painted people out walking or flowers that bloom in the dunes or a Sicilian September, Klee's eye and mind penetrated deeply into all aspects of creation, and his brush knew that the world "in its present shape is not the only possible world."[26]

This statement, made by Klee in his famous Jena lecture in 1924, sums up the goal of the Expressionist artists, even if most of them did not reach the heights and depths of Klee's own painting. But Klee, teaching at the Bauhaus,

was also aware of the problems of the avant-garde artist in society, and concluded that lecture on a note of pessimism: "The people are not with us."

Even so, almost every Expressionist artist was eventually elected to the Prussian Academy of Arts, and the "style" was quite readily accepted; it became semi-official to such an extent that even Joseph Goebbels was willing—for a short time—to adopt it as the German and Nordic art, but it could not conform. The essence of Expressionist painting and sculpture, literature and theatre, was its totally individualistic and thoroughly anti-authoritarian attitude. In spite of the Expressionists' search for a true community, a spiritual *Gemeinschaft*, their very subjectivity did not permit them such social coherence except in theory.

Furthermore, most of the artists—former members of the Brücke, some of the adherents of the Blue Rider, or Oskar Kokoschka—could not sustain the almost feverish, anxious and tense quality of their early work and turned toward more traditional forms in their mature years. So far as the Expressionist movement was concerned, Wilhelm Hausenstein, the art historian, announced as early as 1920: "Expressionism, artistically has long since danced itself out...Expressionism has its *Glaspalast*. It has its Salon."[27]

The Expressionist phenomenon was, then, in nature transitory. Very few artists in Germany continued the Expressionist legacy and made major contributions to artistic creativity in the inter-war period. Kandinsky in his Bauhaus years (1922-33) moved into a realm of carefully conceptualized painting concerned with the meaning of form. Max Beckmann and Paul Klee however advanced the Expressionist spirit in their unique, personal ways. They also verbally articulated their artistic purposes. Beckmann declared, "What I want to show in my work is the idea which conceals itself behind so-called reality. I am seeking for the bridge that leads from the visible to the invisible."[28]

Notes

1. Charles Péguy, *Oeuvres en prose*, Vol. II, Paris, 1947, p. 299.

2. Edvard Munch, St. Cloud Diaries, quoted in Frederick Deknatel, *Edvard Munch*, New York, 1950, p. 18.

3. Oskar Kokoschka, "Edvard Munch's Expressionism," *College Art Journal*, XII, 1953, p. 32.

4. Georg Heym, quoted in *Expressionismus*, Marbach, Schiller-National Museum, 1960.

5. Ferdinand Tönnies, *Gemeinschaft und Gesellschaft*.

6. Donald E. Gordon, *Ernst Ludwig Kirchner*, Cambridge, 1968, p. 20.

7. Peter Selz, *German Expressionist Painting*, Berkeley and Los Angeles, 1957, p. 78.

8. Karl Schmidt-Rottluff, Letter to Emil Nolde, February 4, 1906, quoted in Selz, op. cit., p. 84.

9. Gerhard Wieteck, "Der finnische Maler Alex Gallén-Kaellela als Mitglied der Brücke," *Brücke-Archiv*, Heft 2/3, 1968-69, p. 4.

10. E. H. Gombrich, *Oskar Kokoschka*, London, 1962, p. 14.

11. Kandinsky, quoted in Josef Rufer, "Schönberg-Kandinsky; zur Funktion der Farbe in Musik und Malerei," in *Hommage à Schönberg*, Berlin, 1974, p. 74.

12. Frank Whitford, "Arnold Schoenberg as Painter," *Times Literary Supplement*, July 13, 1973, p. 801.

13. Pablo Picasso, letter of 1897, quoted in Anthony Blunt and Phoebe Pool, *Picasso, The Formative Years*, New York, 1962, p. 8.

14. August Endell, in *Deutsche Kunst und Dekoration*, Vol. I (1897), p. 141.

15. Franz Marc, *Briefe, Aufzeichnunger und Aphorismen*, Berlin, 1920, Vol. I, #31.

16. Marc, "Vorwort zur zweiten Auflage," *Der Blaue Reiter*, Munich, 1914.

17. Paul Klee, in Felix Klee (ed.), *The Diaries of Paul Klee*, Berkeley and Los Angeles, 1968, p. 260.

18. Marc, *Briefe, Aufzeichnunger und Aphorismen*, Vol. I, p. 121.

19. Donald E. Gordon, *Ernst Ludwig Kirchner*, Cambridge, 1968, p. 102.

20. Selz, *Emil Nolde*, New York, 1963, pp. 71-72.

21. Hans Richter, *Dada Art and Anti-Art*, New York, 1965, p. 129.

22. Max Pechstein, "Was Wir Wollen," *An Alle Künstler*, Berlin, 1919, p. 19.

23. Sibil Moholy-Nagy, quoted in Wolf von Eckhardt and Sander L. Gilman, *Bertold Brecht's Berlin*, New York, 1975, p. 69.

24. Max Beckmann, *Schöpferische Konfession*, Berlin, 1920, pp. 63-64.

25. Stephan Lackner, *Max Beckmann*, New York, 1977, p. 17.

26. Paul Klee, *On Modern Art*, London, 1949, p. 45.

27. Wilhelm Hausenstein, quoted in Ida Katherine Rigby, "The Third Reich," in Orrel P. Reed, Jr., *German Expressionistic Art: The Robert Gore Rifkind Collection*, Los Angeles, 1977, p. 354.

28. Max Beckmann, "Meine Theorie der Malerei," Lecture at Burlington Gallery, London, 1938, in Benno Reifenberg and Wilhelm Hausenstein, *Max Beckmann*, Munich, 1949, p. 47.

Der Sturm: The Modern Movement Unfolds

Last fall in Berlin the fiftieth anniversary of *Der Sturm* was celebrated with a large memorial exhibition. This, together with recent research, made it possible to re-evaluate one of the major events in the history of 20th-century painting and sculpture. At the time of *Der Sturm* itself, 50 years ago in pre-war Berlin, there were only tempestuous eulogies and annihilating criticism.

Paris and the School of Paris have preoccupied the thinking of scholars as well as the public (to say nothing of collectors) to such extent that still little else is generally mentioned in discussions of 20th-century painting and sculpture. Yet, during those critical years preceding the First World War, *Der Sturm* was a powerful magnet for a great number of artists and movements and simultaneously their vociferous mouthpiece.

Only Alfred Stieglitz' 291 gallery in New York was a similar point of focus for modern painting. The photographer Stieglitz, himself a dedicated artist, began his important international exhibits as early as 1908, but his showing of Rodin, Matisse, Lautrec, Rousseau, Cézanne, and Brancusi was not of the same polemical avant-garde nature as Walden's exhibition, and Stieglitz' magazine, *Camera Work*, was altogether esoteric compared to Walden's aggressive *Der Sturm*.

Let me quote from the publication, *Der Sturm*, itself: In 1924 Lothar Schreyer, staff-member of the magazine, wrote an essay about its brief history in which he pointed out that the Sturm—periodical, publishing house, gallery, school, theatre—was not an organization of artists, not a bolshevik band, not a capitalist cartel, not a clique of Jews, and not an exclusive club, but rather that "Der Sturm is Herwarth Walden."

Walden, whose original name was Georg Lewin, was a remarkable man. He started out as a not very successful pianist and composer. He wrote poetry and prose and published a biography of Richard Strauss as early as 1908. He was active as a critic of music, literature, and art. In addition he was a business man, an impressario, a great publicist and propagator of novel ideas, a man who through

his own prodigious energy and enthusiasm and the hydra-headed organization he created became the catalyst of the modern movement, the focal point of Expressionism, a term he rendered popular. He was fascinated by the new, intrigued by the different and the provocative, but he also had a most astounding sensitivity for *quality* so that for a number of years, at least during the pre-war period, his choice closely coincided with the truly significant currents in art.

In January 1910 Walden was dismissed as editor of the theatre magazine, *Der neue Weg,* perhaps because his ideas were too radical, perhaps because his personality was too aggressive, probably both. At once he started his own publication, *Der Sturm.* The first issue appeared in March 1910. It was a weekly periodical devoted to literature and criticism. Its format was that of a newspaper. In order to insure the widest circulation it was kept very cheap and published both in Vienna and Berlin during the first year.

The list of contributors is impressive: August Strindberg, Richard Dehmel, Max Brod, René Schickele, Adolf Loos, Heinrich Mann, Frank Wedekind, as well as the fine poet Else Lasker-Schüler, who was Walden's first wife. The fact that almost from the start this weekly had a circulation of about 30,000 was a great attraction for many of the leading writers of the time.

Visual material, like a portrait of Max Liebermann, appears in *Der Sturm* from the beginning. When the 24 year old Oskar Kokoschka joined the staff as the regular illustrator in May 1910 the visual aspect started to take direction. His first portrait was of Karl Kraus, the brilliant Viennese poet, critic and journalist whose magazine *Die Fackel* may well have been the model of *Der Sturm* together with Papini's *La Voce* in Florence, a journal which soon thereafter was to become the mouthpiece of the Futurists. Kokoschka's second portrait was of Adolf Loos, his closest friend and patron, and one of the first exponents of functional architecture. Regularly Kokoschka contributed his "portrait of the week," a series that seems like a parade of leading intellectuals and artists of his broad circle. He published a drawing of Yvette Guilbert, who had become an old woman since Toulouse-Lautrec interpreted her, and Kokoschka's essentially tragic approach accentuates her decline. There is also his portrait of Walden himself. In these pen and ink drawings, Kokoschka, young as he was, showed a most remarkable understanding of the calligraphic possibilities of line and an extraordinary power to reveal the often hidden character of his sitter.

It was at this time that Kokoschka painted Walden's portrait, which must be reckoned among the most distinguished works of the painter's early years— subjective renditions of groping, often tortured individuals, psychological interpretations which have set the mark for Expressionist portraiture.

Walden also published Kokoschka's controversial play, *Mörder, Hoffnung der Frauen,* which had caused a public riot in Vienna in the previous year. Kokoschka here added illustrations to the play—savage drawings which his biographer, Edith Hoffmann, correctly compared to work by Picasso in the '30s,

not only for their barbaric expressiveness, but also for the divided faces containing profile and full face in one.

It remains doubtful whether Picasso had been familiar with Kokoschka's work, for his so-called double portraits have a different origin and serve a different purpose. But a very fruitful interchange resulted when Kokoschka met the Brücke painters in Berlin.

Between 1908 and 1911 the Brücke artists had deserted the provincial capital of Saxony for Berlin, which was rapidly climbing the cultural ladder to become an important, intellectual metropolis. The Brücke was searching for the kind of stimulus a vast city would offer and they also hoped to find a better market. Although the group was hardly known at the time, Walden saw some of their work, and almost as soon as they arrived he provided them with the broad audience they wanted when he asked first Pechstein, then Heckel, Kirchner, and Schmidt-Rottluff to contribute drawings and woodcuts to his magazine.

The Brücke contributions to *Der Sturm* share the urgent and subjective aspects of Kokoschka's portraits: they are also representative of man lonely in the crowded city, denunciations of the human condition in a time of crisis. The approach of the Brücke artists is less intellectual, however, than Kokoschka's, their technique even less traditional: Kirchner's woodcuts, for example, gain character from the direct interaction between the artist and his material. Much of the positive strength of Brücke work was also derived from the discovery of African and Oceanic art, as well as from the frank affirmation of erotic subject matter.

The Brücke artists and Nolde were, like Kokoschka, largely responsible for the visual material published in *Der Sturm* during 1911. But at the very height of their artistic careers, Walden lost interest in their work when he discovered new and even more avant-garde artists.

Before this happened, however, a new term had appeared in the art vocabulary: Expressionism. The original source of the term "Expressionism" is still uncertain. It is variously attributed to Hervé's exhibition of paintings in the Salon des Indépendants of 1901, called "Expressionismes," to Matisse, and to that fertile coiner of terms: Vauxcelles.

When the term first appeared in Germany during the spring of 1911 in reviews of the international exhibition of the Berlin *Sezession* it was not applied to any German painters, but to the Fauves who exhibited there. *Der Sturm* also first used it in this way.

Several scholars in the field maintain that *Der Sturm* originated the term Expressionism. But while earlier usage of the word can be found in other journals, it is important that *Der Sturm* both popularized and expanded its meaning. During the summer of 1911 Wilhelm Worringer, for example, published a provocative essay in the magazine in which he maintained that Expressionism was a historic necessity of the time in which the artist, rejecting

merely rational art forms, seeks a return to the irrational abstraction of primitive and elemental forms. Slightly later Paul Ferdinand Schmidt published an article in *Der Sturm*, called "Die Expressionisten," in which he characterized such different artists as Vlaminck, Herbin, Pechstein, and Nolde as being concerned with the direct evocative power of plane, color, and space, and with inner truth rather than external verisimilitude.

Still later, Walden and his group used the term "Expressionism" for anyone whom their hyperbolic criticism blessed with recognition, as when Walden with typical grandiloquence stated in his article, "Kunst und Leben":

> We call the art of this century Expressionism, in order to distinguish it from what is not art. We are thoroughly familiar with the fact that artists of previous centuries also sought expression: Only they did not know how to formulate it.

When, in March 1912, Walden decided to arrange the first of what were to be hundreds of *Sturm* exhibitions he invited "The Expressionists," which at that time still meant the French Fauve painters. But in this first show he included paintings by Kokoschka and, significantly, by Edvard Munch. He also included the material from the epoch-making First *Blaue Reiter* Exhibition. This was the first manifestation of Walden's talent for pulling together many diverse and important personalities and trends in modern art.

The *Blaue Reiter* exhibition was assembled four months earlier by Franz Marc and Kandinsky in Munich, where it set one of the milestones in the history of 20th-century art. It had its origin in Marc's and Kandinsky's activity as editors of the book, *Der Blaue Reiter,* and included paintings by August Macke, Gabriele Münter, and Robert Delaunay among others.

Probably the most important of Franz Marc's canvases in the show was his *Yellow Cow,* a painting in which color, rhythm and treatment of subject are highly symbolic, in which the animal is integrated in the landscape as the very embodiment of cosmic rhythm.

But possibly the most significant inclusion in this show for succeeding art movements was a group of Kandinsky's early non-objective paintings, like *Composition IV* of 1911—an organization of energetic lines, shifting planes, and intense colors which are freed from their contours. While this painting still suggests certain forms in nature, it is essentially abstract—that is to say: it avoids figurative imagery and communicates on a primary visual level in a manner quite similar to that adopted by the Abstract Expressionists over 30 years later.

Even before this first and highly important Sturm exhibition was installed, Walden made a new and to him still more exciting discovery when he saw the first Futurist exhibition at Bernheim Jeune in Paris. Immediately after it was shown at the Marlborough Gallery in London he ordered it shipped to Berlin where it opened in April 1912. At the same time he published in *Der Sturm* the

famous *Technical Manifesto of Futurist Painting,* signed by the five innovators: Balla, Boccioni, Carrà, Russolo, and Severini (first published in the U.S. almost 50 years later in the Museum of Modern Art's book on Futurism).

Here Walden found a movement most suited to his own inclinations: aggressive in its opposition to the past, insistent on the most active participation of the spectator, who is transposed into the action of the painting—demanding that the modern artist concern himself with the 20th-century world of velocity and consciousness of molecular movement and simultaneous sense impressions. The next issue of *Der Sturm* brought the readers Marinetti's original Futurist Manifesto, which frantically denounced tradition and extolled the virtues of racing cars, militarism and war and a violent—if nebulous—future.

The first April issue of *Der Sturm* announcing the opening of the exhibition brought an article written for the public by the five original Futurists. Here the Italian painters attack their French contemporaries—artists like Picasso, Braque, Derain, Léger—for only giving new pictorial form to the static world of Poussin and Ingres and returning to pre-Impressionist concepts instead of adhering to the precepts of the contemporary world.

Force lines, indicating velocity and movement, simultaneously break up objects and link forms. The constant motion of all matter is expressed by simultaneity—that is to say, by the simultaneous representation of various aspects of an object *plus* the sensation which the object arouses in the artist's emotion. In opposition to what they considered a formalist disengagement on the part of the Cubists, the Futurists demanded a moral and personal commitment by the artist.

Walden, who actually thought of himself as the prophet of a renewal of life through art, became their clamorous spokesman. He publicized the first German Futurist show so widely that in spite of furious newspaper denunciations there were days when a thousand visitors paid to see the exhibition. A great deal of the work was sold. Walden brought Marinetti and Boccioni to Berlin to lecture at the galleries and he published postcards of paintings by Boccioni, Russolo, and Severini as well as reproductions of their work in his magazine.

The Futurist exhibition had an immediate effect on the German painters themselves. Franz Marc, for example, wrote a eulogy on the Futurists in *Der Sturm,* saying that "Carrà, Boccioni, and Severini will become milestones in the history of modern art. We will yet envy Italy its sons and hang their work in our galleries." A woodcut by Marc, like *Riding School,* done during the winter of 1912–13, clearly reveals the Futurist force lines and compels the spectator to take part in the dynamic movement of interlinked forces, as, for example, in Boccioni's and Balla's paintings.

The impact of Futurism is also found in the drawings of Paul Klee, published by Walden. One of these, for example, *Suicide on the Bridge,* dated 1913, shows a little man with a big top hat, on top of a fragile bridge. A large clock

in the linear framework of the bridge indicates the decisive hour while weird faces and cogwheels surround the clock. Klee indicates the simultaneous activities of the man's mind, including the big splash caused by his drop into the water.

Many other painters from Walden's circle, Lyonel Feininger for instance, experienced a similar influence from the Italians whom *Der Sturm* brought to Berlin. Their work in turn became increasingly abstract, perhaps due to Kandinsky's impact.

But while Walden became the convinced champion of Futurism—at least for a while—his interests continued to expand in many directions. In May 1912 he commissioned Picasso to do the cover for the magazine while the third Sturm exhibition of French graphic art, featuring Gauguin, Picasso, and Herbin, was installed. This, incidentally, was the first time that Gauguin's color woodcuts from Tahiti were seen in Germany, and here Walden displayed work that was an affirmation of the Brücke artists, whose prints had developed in similar directions.

During the fall season of 1912 Walden's gallery introduced James Ensor to Germany, arranged the first retrospective exhibition of Kandinsky's work surveying his development from 1901 to 1912 and thus showed the origins of non-objective painting, and arranged a one-man show for Gabriele Münter, one of the original members of the *Blaue Reiter* group.

In January 1913 Walden opened his first Delaunay exhibition. Delaunay, who had already exhibited in the First Blaue Reiter show, was of central importance in the development of its painters, especially Marc, Macke, and Klee, who had gone to Paris to visit him, to look at his work, and to discuss the significance of color and light in post-Cubist painting. Now Delaunay returned their visit, coming to Germany with his friend Apollinaire. In Bonn they stopped with Delaunay's closest friend among the Germans, August Macke, and then the three continued to Berlin where Delaunay and Apollinaire gave lectures at *Der Sturm*. A translation by Paul Klee of Delaunay's essay *Sur la lumière* introduced the exhibition in the journal.

The interaction between Delaunay and the *Blaue Reiter* painters was most productive. While Delaunay exerted perhaps the most important single influence on the development of Macke, Klee, and Marc, he was in turn stimulated by Kandinsky's non-objective work and began experimenting with the elimination of subject-matter.

In the spring and summer of 1913 Walden presented a retrospective exhibition of Franz Marc, a show of *Der Moderne Bund,* an avant-garde organization of Swiss artists including Paul Klee and the Alsatian Hans Arp, and one-man shows of Gino Severini and finally of Alexander Archipenko, including his first essays in Cubist sculpture. Walden, in fact, discovered Archipenko and published a book on him in 1913.

During all these varied exhibiting and publishing activities Herwath Walden travelled with frantic speed through most European centers from Budapest to Paris in preparation for his great exhibition, the First German Autumn Salon of 1913. Here Walden set out, as he wrote, to "present a survey of the new movement in the visual arts in all countries, a survey which was to enlarge the scope of all contemporary artists."

This exhibition was the climax of Walden's activities and at the same time it pinpointed the unfolding of the modern movement in its numerous diversified and international aspects. The exhibit consisted of 366 paintings and sculpture by some 85 artists. It was truly international, including work from America, Russia, and India.

The scope and the quality of the work shown at Walden's First German Autumn Salon are truly astonishing! Unlike the *Sonderbund* exhibition held in Cologne the previous year, or the New York Armory Show held earlier in 1913, the First German Autumn Salon did not include large sections of the precursors of the modern movement but was much more radical in its composition. Only the douanier Rousseau was shown (with 22 entries) among painters no longer living.

There was, of course, a great deal of Futurist work, such as Balla's well-known *Dog on Leash* . Balla had by that time completed his set of totally abstract paintings, the *Iridescent Interpenetrations,* on which he had probably worked in Düsseldorf in 1912. There was Severini's great *Dynamic Hieroglyphic of the Bal Tabarin,* one of the first collages using sequins, words, and letters as parts of the painting related to each other in a rhythmic swirl. Boccioni exhibited his *Unique Forms of Continuity in Space,* his Futurist version of the *Victory of Samothrace,* in which the striding figure—now on two pedestals—is opened up and fused with the surrounding space. Among the sculptures there was also new work by Archipenko, less aggressive than Boccioni's but just as dynamic.

Picasso and Braque were not included in this exhibition. Walden was generally more interested in the Montparnasse group of Cubists, that is to say, Delaunay, Villon, Léger, Picabia, Metzinger, and Gleizes. He preferred the greater interest in color orchestration on the part of the group, soon to be called the *Section d'or,* to the monochrome analysis of the Montmartre Cubists. Léger worked in bright pure colors and achieved a dynamic effect by their intensity and the rhythmic relationship of the simple geometric forms. There were no less than 22 of Delaunay's orphic color compositions—many of color disks floating in open space. There were also several of Picabia's early inventive non-objective paintings. In other words, among the three painters who in Paris were just then experimenting with non-objective painting, Delaunay, Picabia, and Kupka, the former two were shown. Marc Chagall, who held his first one-man show in the Sturm Gallery in Berlin after being introduced to Walden by Apollinaire, was

represented by a group of his important Cubist fantasies, including the great *I and the Village* now in the Museum of Modern Art.

There was a full series of Blue Rider pictures, with several of Kandinsky's non-objective compositions and improvisations such as the *White Edge,* now at the Guggenheim Museum. There was Marc's masterpiece, the now lost *Tower of Blue Horses,* and his stunning premonition of the approaching war, the *Fate of the Beasts* and *Tirol.*

In a gayer mood, there were Macke's paintings, sparkling in their prismatic color and enjoyment of life, and Gabriele Münter's portrait of Paul Klee with its witty rectangularity.

Klee, who had been represented with only a few works in the Blue Rider show, now exhibited 22 watercolors and drawings, done with penetrating irony. Klee was not alone among young artists still relatively unknown in the art world of the time. Walden also exhibited five of Marsden Hartley's evocative abstractions, some of the energetic drawings of the youthful Hans Arp, as well as two of Mondrian's abstract Cubist paintings which indicated the direction he was shortly to take.

Despite much adverse criticism by press and public the Autumn Salon encouraged Walden to sponsor further exhibitions. In addition to the Berlin show he now circulated exhibits through many cities and towns of Germany and as far afield as London, Stockholm, Helsinki, and Tokyo. He founded the Sturm school of art, a Sturm bookstore on the Potsdamerstrasse, and the experimental Sturm Theatre. But the earlier dynamic direction seemed to be lacking and the time was no longer so favorable after the war. Publication of the magazine continued until 1932, but the activity of Walden and *Der Sturm* had reached its culmination in the turbulent years of 1910–1913 when Walden served as catalyst of an unfolding of the modern movement.

The Influence of Cubism and Orphism on the "Blue Rider"

For Ulrich Middeldorf

The Germans took account of Cubism almost from its inception. Many of the German critics saw their own painter, Hans von Marées, as an important precursor of Cubism, second only to Cézanne. Paul Erich Küppers, in his book *Der Kubismus,* published in 1920, remarks that Marées not only constructed his heads as spheres, legs and necks as columns, and the chest as a basket hung on the spine, but conceived of pictorial space no longer in terms of perspective and illusory depth, but rather as a function of carefully structured figures who interact with it.[1] Paul Fechter, who brought out his book *Der Expressionismus* in Munich in 1919, incorporated a speculative essay on Cubism. He also see Marées as an important prototype of the Cubists because he unveils the mysterious laws of existence by the lucidity of his spatial construction.[2]

In 1891, four years after his death, a consequential memorial exhibition of Marées took place in Munich's Crystal Palace. The influential francophile critic, Meier-Graefe, extolled his work,[3] and Heinrich Wölfflin, who adopted many of his schemes of visual perception from Marées' thoughts, wrote a panegyric on the painter.[4] And in Munich, Marées' old friend, the sculptor Adolf von Hildebrand, wrote his *Das Problem der Form in der bildenden Kunst* with its emphasis on formal—not illusionist—values.[5]

But if Wölfflin's interest tended to be historical and Hildebrand's academic, Munich was also a place of direct innovations in art. It was Germany's center of *Jugendstil*—the periodical *Jugend* was published there—and in 1898 one of Jugendstil's prime practitioners, the architect and designer August Endell, formulated a prophetic theory of abstract art.[6]

The Marées exhibition was followed by one-man shows of Munch, Hodler, Cézanne, Van Gogh, and Matisse. No other city was as *au courant* in European art. Paintings by Braque and Picasso were shown in the shop windows of the

Goltz gallery. In 1909, Picasso's first major exhibition outside France was held at the progressive Moderne Galerie Thannhauser. A few months later in the same space the *Neue Künstlervereinigung München* held its first show under the leadership of two Russians, Wassily Kandinsky and Alexej von Jawlensky. In their second exhibition in the fall of 1910 they invited a French contingent, consisting of Picasso, Derain, Braque, and Le Fauconnier. This was actually before the Cubists showed for the first time in force in Paris in the famous Salle 41 in the *Salon des Indépendants* in the spring of 1911.

Picasso's *Head of a Woman*, a crayon and gouache on paper of 1909, now in the Art Institute of Chicago, is illustrated in the catalogue of the second exhibition of the *Neue Künstlervereinigung München*.[7] This head, influenced by African carvings, has a barbaric force and sculptural structure similar to the earlier *Demoiselles d'Avignon*. While contemporaneous German critics in their discussion of Cubism rejected what they considered Cubism's intellectual and scientific reasoning, Picasso's *Head of a Woman* has a highly expressive, not to say expressionist, subjective power. The head has been taken apart structurally and re-assembled according to the artist's personal conception. The diamond-shaped hypnotic eyes emit radiating linear beams and the planes of the face seem to push and pull with dynamic energy.

Derain, whose post-Fauve works were considered proto-Cubist by French and German critics alike, was represented with four works, including one of his Cézannesque *Cagnes* landscapes, which had an immediate impact on the more conservative members of the NKV, such as Alexander Kanoldt.

When Daniel-Henry Kahnweiler published *Der Weg zum Kubismus* in Munich, he correctly distinguished between Derain's attempt to remain close to nature and Braque's much bolder departure from the physical aspects of the natural scene—especially in terms of space.[8] This is evident in his *L'Estaque* landscapes of 1908, such as the one now in the Basel museum, which was shown in the same historic exhibition in Munich in 1910.[9] It was landscapes such as these "avec des petits cubes" which made Louis Vauxcelles hit on the word Cubism in 1908.[10] But the term Cubism was not originally reserved for Picasso, Braque, and Gris, and it is no longer valid to perpetuate Kahnweiler's misleading writing of history—perhaps not unbiased in favor of his own stable—as Robert Rosenblum does when brushing aside the contributions of artists such as Delaunay, Gleizes, Villon, and Le Fauconnier, by saying that "by 1910 the style had begun to attract the attention of an increasing number of Parisian artists,"[11] nor can one with any justification refer to painters of the significance of Delaunay and Duchamp as "Parisian satellites."[12] Instead of being adapters or satellites, these painters made highly important contributions in a direction different from those of Montmartre Cubists and were perhaps even more influential on other artists because they pushed the formal innovations of Picasso and Braque into epic, visionary and universal themes, ultimately leading to abstraction.[13]

Le Fauconnier—whom Apollinaire had described as the creator of Physical Cubism—was represented in the Munich exhibition of 1912 with *Abundance* which had been completed in 1910 under the very eyes of Metzinger, Gleizes, Delaunay, and Léger and the critic Roger Allard, all of whom had frequently met in Le Fauconnier's studio to watch the development of this monumental canvas which summarized so many of their ideas about a new plastic form for new social ideas.[14] Le Fauconnier's essay, translated—probably by Kandinsky—as "Das Kunstwerk," dealing with Cubist composition in space and the importance of volitional structure, appeared in the catalogue of the exhibition.[15] Thereafter *Abundance* was prominently reproduced in *Der Blaue Reiter*; Le Fauconnier was given his first one-man show not in Paris but at the Folkwang Museum in Hagen in 1912 and his influence on the Germans, especially on August Macke, was almost immediate.

Le Fauconnier and the others gathering in Jacques Villon's house in Puteaux were clearly dissatisfied with the purely visual analysis of neutral subject matter such as guitars, pipes, bowls of fruit, newspapers, and water jugs—by the more orthodox Cubists of Montmartre. They discussed Nietzsche and Bergson, Poincaré's mathematical theories and Non-Euclidean geometry. Some of these painters, such as Delaunay and Gleizes, could become completely abstract precisely because they were not primarily concerned with the analysis of visual reality but searched for grand epic themes and universal order. The outstanding artist among them was Robert Delaunay, and it was he who was to have the greatest impact abroad—not only on the Germans, but also on the Italians and the Americans. I shall, however, limit myself to Munich. The impact of Cubism on the Munich painters was varied and manifold, each artist responding to it according to his own stylistic needs.

After the more radical painters split off from the NKV in the fall of 1911 under the leadership of Kandinsky and Franz Marc, Kandinsky invited Delaunay to join the first *Blaue Reiter* exhibition at the Thannhauser gallery in December.[16] Delaunay complied by sending one drawing and four paintings, one of the St. Séverin series, one of the Eiffel Tower, and two of the City group. Erwin von Busse in his essay on Delaunay's composition, which was soon to appear in the famous yearbook *Der Blaue Reiter*, analyzes these pictures and points out that whereas in *St. Séverin* the painter still adheres to nature and depicts the actual ambulatory of a church, the object is dissolved into small segments in *The Tower*, particles whose size, color and order are determined solely by the dynamic needs of the space, while in *Window on the City* all reference to the external world is abandoned in favor of a concentric movement created by both form and color,[17] a development which was carried to its cosmic climax in the *Sun Disks* of 1912–13. Von Busse in this article manifests extraordinary insight into the work of Delaunay and the trend of ideas. Delaunay, who had studied Chevreul's treatise on the harmony and contrasts of color, rejected his theories of optical mixture, and created his rhythms and movements in space by this

simultaneous use of pure and autonomous spectral colors. This eventually led him to "bid goodbye to Eiffel towers, views of streets, the outside world...toward the heartbeat of man himself."[18] Where Picasso and Braque implied movement by their analytical examination of the representational elements, Delaunay evoked a sense of movement by the use of light and color itself. For him, "the breaking up of form by light creates colored planes. These colored planes are the structure of the picture, and nature is no longer a subject for description but a pretext"[19] "Color alone is both form and subject."[20]

Coining the word "Orphism" primarily for Delaunay's poetic and musical painting, Apollinaire defined it as "the act of painting new structure out of elements which have not been borrowed from the visual sphere...pure painting."[21] Apollinaire was soon to publish an article on Delaunay for Herwarth Walden's *avant-garde* Berlin journal, *Der Sturm*. This, "Réalité, peinture pure," is a eulogy on Delaunay and includes important quotations from Delaunay himself in which he developed his theory of abstract art.[22] Soon thereafter, at the time of his one-man exhibition at *Der Sturm* galleries, Delaunay himself contributed a brief essay to the magazine, "Sur la lumière," which was translated by his new friend Paul Klee.[23] Both Delaunay and Apollinaire travelled to Berlin for the occasion of this exhibition, and the French poet earned enthusiastic response when addressing the public in German at the opening. Seeing the new development in painting explored by Delaunay and the parallel roads on which Mondrian and Kandinsky had embarked, Apollinaire now went beyond the limitations of Cubism. And Delaunay's visual simultaneism was the direct inspiration for Apollinaire's calligrammatic poems.[24] Delaunay's work— together with his wife Sonia's—was featured in a large special Salon of Orphism in Walden's First German Autumn Salon in 1913.

Cubism in general and Delaunay in particular were the decisive influences on Franz Marc's development. Close to the German Romanticists in feeling and approach, Marc felt that through the animal he could establish a pantheist empathy with the organic rhythm of God's creation. "Is there a more mysterious idea for an artist," he wrote, "than to imagine how nature is reflected in the eyes of an animal?"[25] In 1911, when painting his famous *Blue Horses,* he has discarded local color as well as realistic form in favor of a spiritual rhythmic relationship of echoing curves between horses and landscape.

But the merging of animal with landscape, the total cosmic unification for which he was striving, could be achieved only with the organizational means obtained from Orphism and Futurism. In the spring of 1912, at the time of the Futurist show in Berlin, Marc wrote a eulogy on Carrà, Severini, and Boccioni in *Der Sturm*[26] and before long, rays, not to say lines of force, made their appearance in a number of his dynamic compositions of dramatic tension.[27]

The energetic rhythms of the Futurists were almost at once fused by Marc with his experiences of Orphist painting, of the simultaneous contrasts of pure

color. After his pictures had hung next to Delaunay's in the first *Blaue Reiter* exhibition in December 1911, Marc and August Macke went to visit Delaunay in Paris in the summer of 1912, and soon thereafter Marc quotes the Frenchman's color disks almost literally in a picture such as *House with Trees*. Using the new fullness of color and prismatic form, he is now able to return to his beloved animal theme and truly fuse a deer with the surrounding forest in the *Deer in a Flower Garden* of 1913. Shapes and colors are now transparent, pervading each other, and physical form is truly de-materialized into the new world of a pantheist spirit which Marc so ardently desired. Toward the end of his brief life (at 36 he was killed at Verdun in 1916) and surely under the inspiration of his two mentors, Delaunay and Kandinsky, Marc abandoned objective images altogether in an attempt to penetrate to the pure cosmic energy and flux he felt lay behind the veil of appearances.[28] If the language of Cubism set out to define and analyze a tangible object in space, Franz Marc now uses many of the elements of this vocabulary for an entirely contradictory purpose: to reject the object and to find expression for the intangible.

It was the young Rhenish painter, August Macke, who had first introduced Marc to the world of bright and strong color when they met in Munich in 1910. Unlike most of the *Blaue Reiter* painters, however, Macke was no theorist, and for him art did not serve any metaphysical purpose. If Marc used the Cubist and Orphist vocabulary for his own spiritual ends, Macke derived from the identical stimulus new means to realize his optical sensations: he was the most French among the German painters.

Macke was also much impressed by the Futurists when he first witnessed their work, seeing in it a vital realism so profoundly different from naturalism, but later on he observes that the Futurists only illustrated movement while Delaunay created it.[29]

The visit of Marc and Macke to Delaunay in Paris in 1912 resulted in a deep personal friendship and fertile correspondence between Macke and Delaunay. In January 1913 Delaunay, accompanied by Apollinaire, visited Macke in Bonn on his way to his *Sturm* exhibition in Berlin and Macke's work for the two remaining years of his life—he too was killed in action in the war—was greatly indebted to the Orphist painter. In a joyously happy picture like *Sunny Path*,[30] saturated colors, with complementaries in dominance, create the figures and tree as well as the space occupied by them. We begin to understand what he meant when he said that Delaunay created movement, when we observe how Macke himself has used color to evoke a feeling of constant flux by painting the foliage and the lady's jacket in rhythms of yellow and green, the water in alternations of blue and green and the path in red and yellow. One of Macke's favorite themes was ladies looking into the windows of dress shops or milliners', and in *The Dress Shop* the large window pane which Delaunay has used in his abstract *Fenêtres* is placed back into the real world of daily life as a shop window. The

crystalline sensations of the play of light in Delaunay are substantiated into the much more tangible shapes of colorful dresses. Or a landscape like *Garden on Lake Thun,* also of 1913,[31] is made up of rectangles and triangles, rhomboids and trapezoids, but while the painting depends on the weightless interaction of the color planes, the objects are not nearly as radically transformed into geometric configurations as in Delaunay's *Windows.*

When in April of 1914 Macke and his friend Paul Klee set out for a joint trip to Tunisia, Macke continued to work in geometric color patches whose brightness and clarity communicate the atmosphere of the North African spring. Macke's profound feeling for color was, I believe, transmitted to Paul Klee, who had been principally a draftsman before the Tunisian journey and who was to bring Macke's testimony to a new and magnificent fulfillment.

Color was the last element to be added to Klee's vocabulary. Painting for him was a synthesis toward which he developed slowly and he showed only drawings in the *Blaue Reiter* exhibitions. But in his graphic work he had achieved a free autonomy of line, "an absolute spirituality without analytic accessories," as he wrote in his diary.[32]

Then when Klee saw Cubist pictures in Munich and at the collection of Hermann Rupf in Bern, he began to realize that the artist is not only free to use line as he wishes, but that the composition as a whole was up to his will. When studying the graphic works of Picasso, Derain, and Braque in the 2nd *Blaue Reiter* exhibition—this is the one in which he was also included—he decided to visit Paris again and went there in April 1912. He saw paintings of Picasso and Braque at Wilhelm Uhde's and at Kahnweiler's. He visited Le Fauconnier, but the first studio at which he called was Delaunay's and he must also have seen the work of Albert Gleizes.[33]

During these impressionable years Klee also admired the Futurists, especially Carrà, and their aim of showing simultaneous events and sensations, but again Delaunay is of central importance. He was using color with the same freedom that Klee himself achieved with line, without the apparently chaotic results which Klee rejected in Kandinsky. Klee's foremost critic, Werner Haftmann, observes that "if we attach any importance to establishing a source for Klee's work, then we must assign the major share to Orphic cubism, as the movement associated with Delaunay has been called."[34] Klee, like Macke, was to carry on a lively correspondence with Delaunay; he translated his essay "Sur la lumière," and it was the Cubists and Delaunay who helped him realize that, as he put it, "art is a harmony parallel to nature." This becomes evident in the paintings done after his Tunisian journey when Klee opened up a world of color for himself. He expressed his debt to Delaunay quite directly in the little watercolor *Laughing Gothic* of 1914. Delaunay's painting of 1909, still solidly three-dimensional, has now in the Klee been flattened out into planes of simultaneous color almost the way Delaunay himself might have done it these six

years later. But Klee has also created a little magic, whimsical world of his own, as he did in the delicate *Hommage à Picasso* of the same year, surely reminiscent of the Picassos he saw at Uhde's and Kahnweiler's.[35] But the closer we look, the less this oval picture resembles Picasso. Klee does not analyze an object in the Cubist manner, nor does he use their tonality. Instead he assembles a rich fabric of color for its own sake.

His debt to Delaunay persists. Even the marvelous *Senecio* can be seen as an Orphist color disk with just enough childish whimsy added to make a face. But it is a face which stares at us with an ironical gaze. In place of Delaunay's theoretical investigation into the nature of color, Klee presents a metaphor on life. As early as 1905 in his diary he answered the question "Do you like nature?" with an unequivocal: "Yes, my own."[36]

Kandinsky, who had invited Delaunay to participate in the *Blaue Reiter* exhibition, developed his unique style relatively untouched by Cubism. It may have been Matisse, as Alfred Barr wrote, "with the brilliant singing color and organic curving fluid form of the *Joy of Life*" who "opened the way to Kandinsky"[37] and Kandinsky's *Parc de St. Cloud* of 1906 certainly shows, as Kenneth Lindsay has indicated, his debt to the great Matisse canvas, although it is much more conservative in style.[38] When Kandinsky wrote his consequential essay *Concerning the Spiritual in Art,* he acknowledged his appreciation of Matisse, yet found that in his work true spiritual beauty was still inter-mixed with conventional charm. "But," he continues, "in the work of another great young artist in Paris, the Spaniard Picasso, there is never any suspicion of conventional beauty. Torn by the need for self-expression, Picasso hurries from means to means. A gulf appears between consecutive modes of expression, because Picasso leaps; he is continually found by his bewildered followers at a point different from that where they last saw him. No sooner do they think they have caught him then he has changed once more. Thus cubism arose, the latest of the French movements." This, we must admit, is quite an acute observation to be made in 1911. Kandinsky then continues to say that Picasso in his latest works "reaches through logic an annihilation of materiality, not, however, by dissolution of it, but through a kind of fragmentation of its separate parts and a constructive dispersal of these fragments over the canvas...." "Matisse—color. Picasso—form. Two great signposts pointing toward a great end."[39]

Toward the end of the essay, however, he returns to Cubism and sees it as a transitory stage because it still relies on natural forms. "A transition is cubism," he explains, "in which natural form being forcibly subjected to constructional ends, becomes an impediment."[40] He himself, as we well know, took the leap by discarding this impediment.

When we compare an important work of 1911, such as *Composition IV,* with one of 1912, say, *With the Black Arc,* we notice that precisely during the time when Cubism and Orphism made their strongest impact in Munich,

Kandinsky did renounce all the vestiges of illusionist space. In this respect he is indebted to Cubism. But in no way did he adopt Cubist space with its relative flatness or two-dimensional quality. By transcending Cubism, Kandinsky prophesies the development in painting after World War II. Whereas Cubist space is created by interlocking and shifting planes, Kandinsky's space no longer admits any planes at all. Here forms, like Wagnerian chords, are no longer anchored, but float freely and irrationally in a fluid void, creating their own indeterminate universe.

Notes

1. P.E. Küppers, *Der Kubismus,* Leipzig, 1920, pp. 20–21.

2. P. Fechter, *Der Expressionismus,* Munich, 1919, p. 40.

3. J. Meier-Graefe, *Hans von Marées,* Munich, 1910.

4. H. Wölfflin, *Kleine Schriften,* Basel, 1946, pp. 75–83.

5. A. von Hildebrand, *Das Problem der Form in der bildenden Kunst,* Strassburg, 1893.

6. A. Endell, "Gedanken: Formkunst," *Dekorative Kunst,* I, 1898, p. 280; idem, "Formenschönheit und dekorative Kunst," ibid., II, 1898, pp. 119-125.

7. *Neue Künstlervereinigung München, II. Ausstellung* (Moderne Galerie Thannhäuser) [catalogue], Munich, 1910, no. 84.

8. Daniel Henry [pseud.], *Der Weg zum Kubismus,* Munich, 1920, pp. 14–16.

9. *Neue Künstlervereinigung,* op. cit., no. 12.

10. L. Vauxcelles, in *Gil Blas,* November 14, 1908.

11. R. Rosenblum, *Cubism and Twentieth Century Art,* New York, 1960, p. 149.

12. Ibid.

13. D. Robbins, *Albert Gleizes, 1881-1953* (The Solomon R. Guggenheim Museum) [exhibition catalogue], New York, 1964; idem, unpublished Ph.D. dissertation, New York University.

14. J. Golding, *Cubism, A History and Analysis, 1907-14,* London, 1959, p. 24.

15. H. Le Fauconnier, "Das Kunstwerk," *Neue Künstlervereinigung,* op. cit. This exhibition catalogue contains additional essays by David and Vladimir Burliuk, Kandinsky, Redon, and an unsigned piece on Rouault. The catalogue lists 115 works by 31 artists.

16. Kandinsky's attention was drawn to the work of Delaunay by the painter Elizabeth Epstein; cf. P. Selz, *German Expressionist Painting,* Berkeley-Los Angeles, 1957, p. 210.

17. E. von Busse, "Die Kompositionsmittel bei Robert Delaunay," in Kandinsky and Marc, *Der Blaue Reiter,* Munich, 1914, pp. 48–52.

18. R. Delaunay, quoted in W. Haftmann, *Painting in the Twentieth Century,* New York, 1960, I, p. 113.

19. Delaunay, quoted in G. de la Tourette, *Robert Delaunay*, Paris, 1950, p. 39; cf. H.B. Chipp, "Orphism and Color Theory," *The Art Bulletin*, XL, 1958, pp. 55-63.

20. Delaunay, in G. de la Tourette, op. cit., p. 37.

21. G. Apollinaire, *The Cubist Painters*, New York, 1949, pp. 17-18.

22. *Idem*, "Réalité, peinture pure," *Der Sturm*, III, 1912, pp. 224-225.

23. Delaunay, "Uber das Licht" [translated by Paul Klee], ibid., III, 1913, pp. 255-256.

24. R. Shattuck, *The Banquet Years*, New York, 1961, p. 286.

25. F. Marc, *Briefe, Aufzeichnungen und Aphorismen*, Berlin, 1920, I, p. 121.

26. *Idem*, "Die Futuristen," *Der Sturm*, III, 1912, p. 187.

27. Cf. Selz, op. cit., fig. 33.

28. Cf. G. Schmidt, *Franz Marc*, Berlin, 1957, pl. VI.

29. G. Vriesen, *August Macke*, Stuttgart, 1953, p. 119.

30. Ibid., p. 121, and Selz, op. cit., pl. 171.

31. Macke, *Garten am Thuner See* (Städtische Kunstsammlungen, Bonn), in Vriesen, op. cit., p. 101.

32. P. Klee, diary entry no. 920, in *The Diaries of Paul Klee*, Berkeley-Los Angeles, 1964, p. 278.

33. Klee, diary entry no. 910, ibid., pp. 268-269. Klee was interested in the work of the Cubists in general. In his review of D. Robbin's *Albert Gleizes* (op. cit.), M. Franciscono is convincing when he points to the relationship of Gleizes' *The City and the River*, 1913, a picture now lost but formerly in the Graf Collection in Stuttgart, to Klee's 1916 lithograph *Destruction and Hope* (*Art Journal*, XXIV, 1965, p. 312).

34. W. Haftmann, *The Mind and Work of Paul Klee*, New York, 1954, p. 58.

35. Cf. W. Grohmann, *Paul Klee*, New York [n.d.], p. 131.

36. Klee, diary entry no. 681, in *The Diaries of Paul Klee*, op. cit., p. 185.

37. A.H. Barr, Jr., *Matisse: His Art and His Public*, New York, 1951, p. 86.

38. K.E. Lindsay, unpublished manuscript.

39. W. Kandinsky, *Concerning the Spiritual in Art*, New York, 1947, p. 39.

40. Ibid., p. 73.

The Aesthetic Theories of Wassily Kandinsky

At a time when so much painting is in the non-objective vein, it seems relevant to investigate the aesthetic theories of the artist who was the first champion of non-objective art, or "concrete art,"[1] as he preferred to call it.

It is possible that non-objective paintings may have been painted prior to Kandinsky's first non-objective watercolor of 1910 [later dated 1912 or 1913] and his more ambitious *Impressions, Improvisations,* and *Compositions* of 1911. There are abstractions by Arthur Dove, for example, which are dated 1910. Picabia and Kupka began working in a non-objective idiom not much later,[2] and Delaunay painted his non-objective *Color Disks* in 1912.[3] In Germany Adolf Hoelzel ventured into non-objective painting as early as 1910, but whereas for Hoelzel it was merely experiment in additional possibilities, Kandinsky made non-objectivity the very foundation of his pictorial imagery.[4]

Kandinsky formulated his ideas of non-objective painting over an extended period of time. Notes for his essay "Concerning the Spiritual in Art"[5] date back to 1901, while the book was completed in 1910. His thoughts were continued in his essay "Uber die Formfrage" for the famous almanac *Der blaue Reiter.*[6] Both essays were first published in 1912.[7] These essays are to a considerable extent based on previous aesthetic theory and were very much in keeping with the avant-garde thinking of the prewar years. They also constitute almost a programmatic manifesto for the Expressionist generation.[8]

Kandinsky's particular didactic style makes his writings difficult to read and analyze. Kenneth Lindsay in his study of Kandinsky's theories described Kandinsky's peculiar literary style as follows: "Characteristic of Kandinsky's writing is the technique of breaking up the given topic into opposites or alternatives. These opposites or alternatives usually follow directly after the posing of the problem and are numbered. Often they suggest further sets of opposites and alternatives. The sequence of thought is flexible, sometimes abrupt and cross-tracking, and frequently associative. The dominating relativity of the thought process contrasts strongly with the conclusions, which are often positively stated."[9]

The Rejection of Material Reality

Kandinsky was always strongly predisposed toward sense impressions. In his autobiography he indicates that he experienced objects, events, even music primarily in terms of color, and he did not conceive of color in its physical and material aspects but rather in its emotional effect. During his scientific studies he lost faith in the rational scientific method and felt that reality could be fully comprehended only by means of creative intuition.

Kandinsky was not alone in his rejection of positivism and pragmatism at the turn of the century. Generally it might be said that "the twentieth century has in its first third taken up a position of reaction against classic rationalism and intellectualism."[10]

Even in the pure sciences the value of the intuitive as against the purely experimental was stressed during the early part of the twentieth century, so that by 1925 Werner Heisenberg was able to formulate the "Principle of Uncertainty," stating that there is a limit to the precision with which we can observe nature scientifically. This did not mean a return to metaphysics, but it indicated the inherent limitations of quantitative observation.

Kandinsky's doubt of the ultimate possibilities of quantitative analysis was shared by many philosophers also. His philosophy finds perhaps its closest parallel in the thinking of Henri Bergson, who taught that true reality can be grasped only through artistic intuition, which he contrasted to intellectual conception. The intellect, according to Bergson, is man's tool for rational action, but "art, whether it be painting or sculpture, poetry or music, has no other object than to brush aside the utilitarian symbols, the conventional and socially accepted generalities, in short, everything that veils reality from us, in order to bring us face to face with reality itself."[11]

Similarly Kandinsky turns away from the representation of visible objects in his attempt to penetrate beneath the epidermis of appearances to the ultimate or "inner" reality.[12] As early as his first encounter in Moscow with the paintings by Monet, Kandinsky felt that the material object was not a necessary element in his painting: "I had the impression that here painting itself comes into the foreground; I wondered if it would not be possible to go further in this direction. From then on I looked at the art of icons with different eyes; it meant that I had 'got eyes' for the abstract in art."[13] Later he wrote: "The impossibility and, in art, the purposelessness of copying an object, the desire to make the object express itself, are the beginnings of leading the artist away from 'literary' color to artistic, i.e., pictorial aims."[14]

Agreeing with earlier writers such as the symbolists, Van de Velde, and Endell, Kandinsky felt that art must express the spirit but that in order to accomplish this task it must be dematerialized. Of necessity, this meant creating a new art form.

It was not only for philosophic reasons that Kandinsky wished to forsake objective reality. Psychological reasons, it seems, also played their part. Speaking about his period of study at the Munich Art Academy, he wrote: "The naked body, its lines and movement, sometimes interested me, but often merely repelled me. Some poses in particular were repugnant to me, and I had to force myself to copy them. I could breathe freely only when I was out of the studio door and in the street once again."[15]

It is significant that the human body, which is found as an almost universal motif in the art forms of most cultures, is here eschewed as subject matter.[16] It is true that the art of the West emphasized the nonhuman aspects during the nineteenth century, when painters turned their attention to still life and landscape. The conscious rejection of the human form, however, is certainly psychologically significant. Indeed a psychological interpretation of the reasons for this response might give us a more profound understanding of the non-objective artist and his work.

From the point of view of the history of aesthetics it is also interesting that Kandinsky's rejection of the forms of nature occurred at approximately the same time as Worringer's publication, *Abstraction and Empathy*. Here Worringer submits the theory that the cause for abstraction is man's wish to withdraw from the world or his antagonism toward it. The lifeless form of a pyramid or the suppression of space in Byzantine mosaics clearly shows that what motivated the creation of these works of art was a need for refuge from the vast confusion of the object world—the desire for "a resting-place in the flight of phenomena."[17] Worringer's thesis of abstraction as one of the bases of artistic creation preceded Kandinsky's first non-objective painting by about two years, and it is important to keep in mind that the two men knew each other in Munich during this critical period.

Kandinsky himself maintained that the immediate cause of his first essay at non-objective painting was the shock of suddenly entering his studio to see one of his paintings lying on its side on the easel and being struck with its unusual beauty. This incident, he believed, made it clear to him that the representation of nature was superfluous in his art.[18] The emphasis on the element of distance in the aesthetic experience found a parallel in the theories of the contemporary English psychologist Edward Bullough: "The sudden view of things from their reverse, usually unnoticed, side, comes upon us as a revelation, and such revelations are precisely those of art."[19]

Kandinsky felt, however, that he could not immediately turn to "absolute painting." In a letter to Hilla Rebay,[20] he pointed out that at that time he was still alone in the realization that painting ultimately must discard the object. A long struggle for increasing abstraction from nature was still necessary. In 1910 he was still writing: "Purely abstract forms are in the reach of few artists at present; they are too indefinite for the artist. It seems to him that to limit himself to the

indefinite would be to lose possibilities, to exclude the human and therefore to weaken expression."[21]

But he was already pointing out at that time that the abstract idea was constantly gaining ground, that the choice of subjects must originate from the inner necessity of the artist; material, or objective, form may be more or less superfluous. He insists that the artist must be given complete freedom to express himself in any way that is necessary according to the "principle of inner necessity." He looked hopefully to the future where the eventual predominance of the abstract would be inevitable in the "epoch of great spirituality."[22]

In 1910 [later dated 1912 or 1913] Kandinsky painted his first abstract painting, a watercolor. The first large non-objective oil dates from 1911, and throughout 1912 he did both "objective" and "concrete" paintings. After 1912 there were very few "objective" works. His art had become completely free from nature and like music its meaning was now meant to be inherent in the work itself and independent of external objects.

Kandinsky distinguished what he called "objective" art from "concrete" art by distinguishing between the means chosen by the artist. In "objective" art both artistic and natural elements are used, resulting in "mixed art," while in "concrete" art exclusively artistic means are used, resulting in "pure art."[23] In a short article, published in 1935, he gave a lucid example of this distinction: "There is an essential difference between a line and a fish. And that is that the fish can swim, can eat and be eaten. It has the capacities of which the line is deprived. These capacities of the fish are necessary extras for the fish itself and for the kitchen, but not for the painting. And so, not being necessary they are superfluous. That is why I like the line better than the fish—at least in my painting."[24]

The element of representation is thus rejected by Kandinsky for his art. He insists that a picture's quality lies in what is usually called form: its lines, shapes, colors, planes, etc., without reference to anything outside of the canvas. But here occurs an apparent contradiction in Kandinsky's theory, because he—like Expressionists in general—did not believe that a picture must be evaluated from its formal aspects. Kandinsky and the Expressionists did not agree with "formalists" like Roger Fry, who believe that the aesthetic emotion is essentially an emotion about form. Seeing Kandinsky's first abstractions, Fry concerned himself only with their form: "...one finds that...the improvisations become more definite, more logical and more closely knit in structure, more surprisingly beautiful in their color oppositions, more exact in their equilibrium."[25]

Kandinsky himself takes strong issue with this theory. In his aesthetics the formal aspect of a work of art is as unimportant as its representational quality.

The Insignificance of Form

Form, to Kandinsky, is nothing but the outward expression of the artist's inner needs. Form is matter, and the artist is involved in a constant struggle against materialism. Kandinsky's words are reminiscent of medieval thought when he says: "It is the spirit that rules over matter, and not the other way around."[26]

The artist should not seek salvation in form, Kandinsky warns in his essay "Uber die Formfrage," because form is only an expression of content and is entirely dependent on the innermost spirit. It is this spirit which chooses form from the storehouse of matter, and it always chooses the form most expressive of itself. Content always creates its own appropriate form. And form may be chosen from anywhere between the two extreme poles: the great abstraction and the great realism. Kandinsky then proceeds to prove that these opposites, the abstract and the realistic, are actually identical, and that form is therefore an insignificant concern to the artist. This he does as follows:

In the "great realism" (as exemplified in the art of Henri Rousseau) the external-artificial element of painting is discarded, and the content, the inner feeling of the object, is brought forth primitively and "purely" through the representation of the simple, rough object. Artistic purpose is expressed directly since the painting is not burdened with formal problems. The content is now strongest because it is divested of external and academic concepts of beauty. Kandinsky preferred this "great realism," also found in children's drawings, to the use of distortion, which he felt always aroused literary associations.

Since the "great abstraction" excludes "real" objects, the content is embodied in non-objective form. Thus the "inner sound" of the picture is most clearly manifest. The scaffolding of the object has been removed, as in realism the scaffolding of beauty has been discarded. In both cases we arrive at the spiritual content itself. "The greatest external differentiation becomes the greatest internal identity:

$$Realism = Abstraction$$
$$Abstraction = Realism"[27]$$

The hypothesis that the minimum of abstraction can have the most abstract effect, and vice versa, is based by Kandinsky on the postulation that a quantitative decrease can be equal to a qualitative increase: 2 plus 1 can be less than 2 minus 1 in aesthetics. A dot of color, for example, may lose in its *effect* of intensity if its *actual* intensity is increased.[28] The pragmatic function of a form and its sentient meaning are dissimilar, yet abstraction and realism are identical.

Kandinsky cites several examples to prove this thesis. A hyphen, for

instance, is of practical value and significance in its context. If this hyphen is taken out of its practical-purposeful context and put on canvas, and if it is not used there to fulfill any practical purpose at all—such as the delineation of an object—it then becomes nothing but a line; it is completely liberated from signification and abstracted from all its meaning as a syntactical sign; it is the abstract line itself. At the same time, however, it has also become most real, because now it is no longer a sign but the real line, the object itself.

It may be argued that Kandinsky uses a very narrow definition of both the abstract and the realistic, and that the line may be a great deal more realistic and more meaningful as a sign, such as a hyphen, in its context, than it is as a line only. It is a valid objection to say that this identity of the abstract and the real holds true only in this verbal analogy, and that Kandinsky has not presented logical proof. Kandinsky, however, was not concerned with the correctness of intellectual thought, or with the proof of his spiritual values. He admits: "I have always turned to reason and intellect least of all."[29]

He concludes his analysis of form by saying: "In principle there is no problem of form."[30] The artist who expresses his "soul vibrations" can use any form he wants. Formal rules in aesthetics are not only impossible but a great stumbling block to the free expression of spiritual value. It is the duty of the artist to fight against them to clear the way for free expression. Often in the history of art, artists were bogged down by matter and could not see beyond the formal. The nineteenth century was such a period, in which men failed to see the spirit in art as they failed to see it in religion. But to seek art and yet be satisfied with form is equivalent to the contentment with the idol in the quest for God. Form is dead unless it is expressive of content. There cannot be a symbol without expressive value.

In his introduction to the second edition of *Der blaue Reiter* Kandinsky states the aim of the book as "to show by means of examples, practical arrangement and theoretical proof, that the problem of form is secondary in art, that art is above all a matter of content."[31]

Kandinsky understood his own time as being the beginning of a new spiritual age when the abstract spirit was taking possession of the human spirit.[32] Now artists would increasingly recognize the insignificance of form per se, and realize its relativity, its true meaning as nothing but "the outward expression of inner meaning."

Art the Affirmation of the Spirit

We have seen that in Kandinsky's aesthetics form as well as object, the formal and representational aspects of art, have no importance by themselves and are meaningful only insofar as they express the artist's innermost feelings. Only through the expression of the artist's inner emotion can he transmit

understanding of true spiritual reality itself. The only "infallible guide" which can carry the artist to "great heights" is the *principle of internal necessity* (italics his).[33] This concept of internal necessity is the core and the basis of Kandinsky's aesthetic theory and becomes a highly significant element in expressionist criticism in general.

The period of spiritual revolution which Kandinsky believed to be approaching, he called the "spiritual turning point." He perceived indications of this period of transition in many cultural manifestations. In the field of religion, for instance, theosophy was attempting to counteract the materialist evil. In the Theosophical Society, "one of the most important spiritual movements,"[34] man seeks to approach the problem of the spirit by the way of inner enlightenment. In the realm of literature he cites Maeterlinck as, "... perhaps one of the first prophets, one of the first reporters and clairvoyants of the *decadence....* Maeterlinck creates his atmosphere principally by artistic means. His material machinery ... really plays a symbolic role and helps to give the inner note.... The apt use of a word (in its poetical sense), its repetition, twice, three times, or even more frequently, according to the need of the poem, will not only tend to intensify the internal structure but also bring out unsuspected spiritual properties in the word itself."[35]

By using pure sound for the most immediate effect upon the reader or listener, the writer depends on prelanguage signs, i.e., sounds which—like music—do not depend on language for their meaning. This level of signification is also the basis of Kandinsky's non-objective painting. In music Kandinsky points to Schönberg's panchromatic scheme, which advocates the full renunciation of functional harmonious progression and traditional form and accepts only those means which lead the composer to the most uncompromising self-expression: "His music leads us to where musical experience is a matter not of the ear, but of the soul—and from this point begins the music of the future."[36] Kandinsky conceived of music as an emancipated art, which furthermore had the quality of time-extension and was most effective in inspiring spiritual emotion in the listener. Painting, while still largely dependent on natural form, was showing similar signs of emancipation. Picasso's breakdown of volumes and Matisse's free use of color for its own sake were manifestations of the turning point toward a spiritual art.[37]

How would the artist achieve full spiritual harmony in his composition? Kandinsky pointed out that the painter had two basic means at his disposal— form and color—and that there was always an unavoidable mutual relationship between them.

In his prewar writings he still did not come forth with a thorough analysis of forms as he did later with his systematic *Point and Line to Plane,* yet he was already stating: "Form alone, even though abstract and geometrical, has its internal resonance, a spiritual entity whose properties are identical with the

form. A triangle...is such an entity, with its particular spiritual perfume."[38]

But color is the most powerful medium in the hand of the painter. It has a psychic as well as a physical effect upon the observer. It can influence his tactile, olfactory, and especially aural senses, as well as his visual sense, and in chromotherapy it has been shown that "red light stimulates and excites the heart, while blue light can cause temporary paralysis."[39] Color is the means by which the artist can influence the human soul. Its meaning is expressed metaphorically by Kandinsky: "Color is the keyboard, the eyes are the hammers, the soul is the piano with many strings. The artist is the hand that plays, touching one key or another purposively, to cause vibrations of the soul."[40]

Kandinsky then proceeds to develop an elaborate explanation of the psychic effect of color. This contrasts to the more scientific color theories of Helmholtz, Rood, Chevreul, and Signac and closely approaches the psychological color theory of Goethe and metaphysics of color of Philipp Otto Runge. Like his romanticist predecessor, Kandinsky believed that color could directly influence the human soul.[41]

Blue in Kandinsky's system is the heavenly color; it retreats from the spectator, moving toward its own center. It beckons to the infinite, arousing a longing for purity and the supersensuous. Light blue is like the sound of the flute, while dark blue has the sound of the cello.

Yellow is the color of the earth. It has no profound meaning; it seems to spread out from its own center and advance to the spectator from the canvas. It has the shrill sound of a canary or of a brass horn, and is often associated with the sour taste of lemon.

Green is the mixture of blue and yellow. There the concentricity of blue nullifies the eccentricity of yellow. It is passive and static, and can be compared to the so-called "bourgeoisie," self-satisfied, fat and healthy. In music it is best represented by the placid, long-drawn middle tones of the violin.

White, which was not considered a color by the Impressionists, has the spiritual meaning of a color. It is the symbol of a world void of all material quality and substance. It is the color of beginning. It is the "sound" of the earth during the white period of the Ice Age.

Black is like eternal silence. It is without hope. It signifies termination and is therefore the color of mourning.

By the symbolic use of colors combined "according to their spiritual significance," the artist can finally achieve a great composition: "Color itself offers contrapuntal possibilities and, when combined with design, may lead to the great pictorial counterpoint, where also painting achieves composition, and where pure art is in the service of the divine."[42]

Kandinsky's color symbolism is in no way based upon physical laws of color or the psychology of color vision. He himself pointed out when writing about color that "all these statements are the results of empirical feeling, and are not

based on exact science."[43] This may even explain his own inconsistencies such as his statement in *Concerning the Spiritual in Art* that "red light stimulates and excites the heart,"[44] contradicted by his assertion that "red . . . has brought about a state of partial paralysis."[45]

It is also true that specific colors call forth different associations in people as well as cultures. Specific reactions to specific colors have never been proved experimentally. Max Raphael in his book, *Von Monet bis Picasso*, points out that colors have had altogether different meanings for those individuals most occupied with them. Yellow, for example, signified the earth for Leonardo, had gay, happy characteristics for Goethe, meant friendliness to Kant and heavenly splendor to Van Gogh, suggested the night to Gauguin and aggressiveness to Kandinsky.[46] We might add that it symbolizes jealousy in German usage, an emotion which is associated with green in English idiom.

Such examples could be increased *ad infinitum* and it is very doubtful that Kandinsky attempted to set down scientific rules for color associations. He was articulating his own personal associations; he stated: "It is clear that all I have said of these simple colors is very provisional and general, and so are the feelings (joy, grief, etc.) which have been quoted as parallels to the colors. For these feelings are only material expressions of the soul. Shades of color, like those of sound, are of a much finer texture and awaken in the soul emotions too fine to be expressed in prose."[47]

In his second significant book, *Point and Line to Plane*, subtitled "A Contribution to the Analysis of the Pictorial Elements," Kandinsky presented his grammar of line, forms, and space in a manner similar to his color theory in *Concerning the Spiritual in Art*.

It is the task of the painter, according to Kandinsky, to achieve the maximum effect by bringing his media, color and form, into orderly and expressive composition. Each art has its own language, and each artist, be he painter, sculptor, architect, writer or composer, must work in his specific medium and bring it to the expression of greatest inner significance. But once painting, for example, is divested of the scaffolding of natural form and becomes completely abstract, the pure law of pictorial construction can be discovered. And then it will be found that pure painting is *internally* closely related to pure music or pure poetry.

Synthesis of the Arts

Kandinsky points out that human beings, because of individual differences, differ in the type of art expression to which they are most receptive. For some it is musical form, for others painting or literature, which causes the greatest aesthetic enjoyment. He also realized that the artist could achieve aesthetic effects in sensory fields not limited to his own medium. He was much interested,

for instance, in Scriabin's experiments with sound-color combinations. The re-enforcement of one art form with another by means of synaesthesia will greatly increase the final aesthetic effect upon the receptor. The greatest effect can be obtained by the synthesis of all the arts in one "monumental art," which is the ultimate end of Kandinsky's aesthetics.

Kandinsky here continues the nineteenth-century tradition—from Herder to Wagner—with its desire for a union of all arts. Kandinsky believes that a synthesis of the arts is possible because in the final analysis all artistic means are identical in their inner meaning: ultimately the external differences will become insignificant and the internal identity of all artistic expression will be disclosed. Each art form causes a certain "complex of soul vibrations." The aim of the synthesis of art forms is the refinement of the soul through the sum-total of these complexes.

In his essay "Uber Bühnenkomposition"[48] and in his "Schematic Plan of Studies and Work of the Institute of Art Culture,"[49] Kandinsky outlines the possible steps to be taken for the achievement of "monumental art." Present-day drama, opera, ballet are criticized as much as the plastic arts. By discarding external factors in "stage composition,"[50] particularly the factors of plot, external relationship, and external unity, a greater internal unity can be achieved. Kandinsky then experiments with such a composition, "Der gelbe Klang."[51] There he attempts to combine music, the movement of dancers and of objects, the sound of the human voice (without being tied down to word or language meanings), and the effect of color-tone, as experimented with by Scriabin.

Kandinsky admits that his "stage composition" is weak but believes the principle to be valid. It is necessary to remember, he maintains, that we are still at the very beginning of the great abstract period in art. Materialism still has its grasp on modern activity and is not as yet completely vanquished. But the new, "the spiritual in art," already manifests itself in most fields of creativity.

Kandinsky made his first attempt at the realization of a synthesis of the arts when he proposed and founded the Institute of Art Culture in Moscow in 1920, a comprehensive institute for the study and development of the arts and sciences. Kandinsky was active in this organization as vice-president for about a year; then political pressure forced his resignation and he found a similar field of activity in the Bauhaus in Weimar, which he joined in 1922.

Conclusion

Expressionism, which began by shifting emphasis from the object to be painted to the artist's own subjective interpretation, reached in Kandinsky the total negation of the object. In this respect he was of great inspiration to succeeding artists. The final phase of Expressionism also became the beginning of an altogether new artistic concept, non-objective painting, and Kandinsky was

heralded as its innovator by the following generation, even by painters such as Diego Rivera working in an altogether different style: "I know of nothing more real than the painting of Kandinsky—nor anything more true and nothing more beautiful. A painting by Kandinsky gives no image of earthly life—it is life itself. If one painter deserves the name 'creator,' it is he. He organizes matter as matter was organized, otherwise the Universe would not exist. He opened a window to look inside the All. Someday Kandinsky will be the best known and best loved by men."[52]

In his rejection of the representational aspect of art, Kandinsky cleared the way for new values in art. By experimenting with the possibility of an expressive—rather than a formalistic—art in the non-objective idiom, he threw out a challenge which performed a most valuable function in the history of modern art. Through his activity as an aesthetician as well as a painter he was able to write a series of books which full articulate his ideas and have become as influential in the history of modern painting as his paintings themselves.

Kandinsky's aesthetic theory continues, among other things, the precept that the elements of painting—lines and colors and their combinations—evoke emotional associations in the observer. This precept is basic to Expressionism, although not original with the Expressionist movement. Much of it is implied in romanticist aesthetics and clearly stated in the theory of empathy. It is set forth differently in Paul Signac's theory of Neo-Impressionism and occurs again in Bergson's *Essai sur les données immédiates de la conscience.*[53] It is significant for an understanding of symbolism and its corollary *Jugendstil,* and was reiterated by such men as Gauguin, Denis, Sérusier, Walter Crane, and August Endell.

Kandinsky's essays, however, are exceedingly important because they were written by the man who himself was the innovator of non-objective painting. Now in the total absence of representational objects the plastic elements were to become sole carriers of the artist's message. This probably is why he felt called upon to express verbally what he had done in his painting through the intuition of "inner necessity."

In the analysis of his color theory it was pointed out that no direct parallels can be established between the artist's statement and the observer's response. Both projections rest on highly personal and subjective factors. This, however, does not greatly differ from music. It has, for example, been shown that the major and minor modes are by no means endowed with characteristics which would call forth identical reactions in different listeners.[54] A great deal depends on previous experience and training.

As Kandinsky himself has indicated, prose cannot express the shades of emotion awakened by sound and color. Each person may verbalize differently about the experience of a work of art and his verbalization may be at great variance with that of the artist. Yet direct communication can take place on a primary visual (preverbal) level, before either spectator or artist articulates. It is

toward this level of communication that the art of Kandinsky and other Expressionists was directed.

Notes

This article is based on a chapter of the author's book, *German Expressionist Painting,* University of California Press. It was originally a part of a doctoral dissertation, "German Expressionist Painting from Its Inception to the First World War," University of Chicago, 1954. The author wishes to acknowledge his debt particularly to Drs. Ulrich Middeldorf and Joshua Taylor, under whose supervision this dissertation was prepared. The translations are by the author unless otherwise indicated in the footnotes.

1. Wassily Kandinsky, "Abstrakt oder Konkret," *Tentoonstelling abstrakte Kunst* (Amsterdam: Stedelijk Museum, 1938).

2. Kupka's *Red and Blue Disks* in the Museum of Modern Art, New York, is dated 1911–1912, but it is just possible that this date was added later.

3. Germain Bazin in his biographical notes to René Huyge's *Les Contemporains* (Paris: Editions Pierre Tisné, 1949), cites 1914 as the year in which Delaunay did the first non-objective painting in France. This author is able to predate this by two years, since he has seen Delaunay's *Color Disks* (Delaunay Studio, Paris), a completely non-objective painting, dated 1912. It remains possible, however, that Picabia did non-objective paintings in Paris before then. Recently it has been maintained that the self-taught Lithuanian artist M.K. Ciurlionis painted non-objective pictures between 1905 and 1910 (Aleksis Rannit, "M.K. Ciurlionis," *Das Kunstwerk,* I, 1946–47, pp. 46–48, and idem, "Un pittore astratto prima di Kandinsky," *La Biennale,* VIII, 1952, no. 8). Ciurlionis' work is now in the Ciurlionis Gallery in Kaunas. The reproductions included in Mr. Rannit's articles on Ciurlionis, however, are highly symbolic abstractions, verging on the fantastic art of Kubin, Redon, or some Surrealists.

4. Hans Hildebrandt, *Adolph Hoelzel* (Stuttgart: W. Kohlhammer, 1952), p. 14.

5. Kandinsky, *Concerning the Spiritual in Art* (New York, Wittenborn, Schultz, 1947). This book was first published by Piper in Munich as *Uber das Geistige in der Kunst* in 1912. The first English translation was undertaken by Michael Sadleir under the title *The Art of Spiritual Harmony* (London, 1914). The first American edition, called *On the Spiritual in Art,* appeared in 1946 (New York, Solomon R. Guggenheim Foundation). The 1947 edition, authorized by Mme. Kandinsky and translated by Francis Golffing, Michael Harrison and Ferdinand Ostertag, will be used here because it is much closer to the original text.

6. Kandinsky and Franz Marc (eds.), *Der blaue Reiter* (Munich: R. Piper and Co., 1912).

7. In 1926 Kandinsky published his most systematic treatise, *Punkt und Linie zur Fläche* (Bauhaus Book, IX, Munich, Albert Langen Verlag, 1926). This book, translated as *Point and Line to Plane* by Howard Dearstyne and Hilla Rebay (New York, Solomon R. Guggenheim Foundation, 1947), was written at the Bauhaus and elucidates most clearly Kandinsky's thinking during this later period. It falls, however, beyond the realm of discussion in this study.

8. "If *Der blaue Reiter,* published by R. Piper, is taken together with Kandinsky's *Das Geistige in der Kunst,* as a unity, then this double volume is just as much *the* book of the prewar years as

Hildebrandt's *Problem der Form* was the book of the turn of the century. The separation of the two generations is already made clear in the title, which emphasizes form in the one and spirit in the other." Hans Hildebrandt, *Die Kunst des 19. und 20. Jahrhunderts* (Handbuch der Kunstwissenschaft) (Potsdam-Wildpark, 1924), p. 382.

9. Kenneth Lindsay, "An Examination of the Fundamental Theories of Wassily Kandinsky," unpublished doctoral dissertation, University of Wisconsin, 1951. Dr. Lindsay establishes incisive relationships between Kandinsky's theories and his paintings. While doing research in Kandinsky's studio in Neuilly-sur-Seine during the spring of 1950, I had adequate opportunity to compare my interpretations with those of Lindsay, which has led to a fruitful exchange of ideas. In a good many instances our interpretations differ, especially as to the placing of emphasis.

 I am also indebted to Dr. Klaus Brisch for many provocative ideas on Kandinsky. I unfortunately have not been able to see Brisch's doctoral dissertation, "Wassily Kandinsky: Untersuchung zur Entstehung der gegenstandslosen Malerei," University of Bonn, 1955.

10. Thomas Mann, *The Living Thoughts of Schopenhauer* (New York: Longmans Green and Co., 1929), p. 29.

11. Henri Bergson, *Laughter* (New York: Macmillan, 1911), p. 157.

12. Very much the same idea is expressed by Franz Marc: "I am beginning more and more to see behind or, to put it better, through things, to see behind them something which they conceal, for the most part cunningly, with their outward appearance by hoodwinking man with a façade which is quite different from what it actually covers. Of course, from the point of view of physics this is an old story. ... The scientific interpretation has powerfully transformed the human mind; it has caused the greatest type-change we have so far lived to see. Art is indisputably pursuing the same course, in its own way, certainly; and the problem, our problem, is to discover the way." (Franz Marc, diary entry, Christmas 1914, in Peter Thoene [pseud.], *Modern German Art,* Harmondsworth, Pelican Books, 1938.)

13. Kandinsky, "Notebooks," quoted in Nina Kandinsky, "Some Notes on the Development of Kandinsky's Painting," in Kandinsky, *Concerning the Spiritual in Art,* p. 10.

14. Kandinsky, *Concerning the Spiritual in Art,* p. 48.

15. Kandinsky, "Text Artista," *Wassily Kandinsky Memorial* (New York: Solomon R. Guggenheim Foundation, 1945), p. 65 (hereafter cited as "Text Artista"). This is Kandinsky's autobiography, written in 1913 and first published under the title *Rückblicke* by Der Sturm in Berlin in the same year.

16. Franz Marc, turning toward non-objective painting shortly before his death, gave a very similar reason: "Very early in life I found man ugly; the animal seemed to me more beautiful and cleaner, but even in it I discovered so much that was repelling and ugly that my art instinctively and by inner force became more schematic and abstract." (Marc, letter, April 12, 1915, in *Briefe, Aufzeichnungen und Aphorismen,* Berlin, 1920, II, p. 50.)

 In this respect Kandinsky and Marc differed decidedly from their associate in the Blaue Reiter, Paul Klee, who was always concerned with creating symbols to interpret man and the forces of nature: "The naked body is an altogether suitable object. In art classes I have gradually learned something of it from every angle. But now I will no longer project some plan of it, but will proceed so that all its essentials, even those hidden by optical perspective, will appear upon the paper. And thus a little uncontested personal property has already been discovered, a style has been created." (Paul Klee, June, 1902, "Extracts from the Journal of the Artist," in Margaret Miller [ed.], *Paul Klee* [New York: Museum of Modern Art, 1945], pp. 8–9.)

17. Wilhelm Worringer, *Abstraktion und Einfühlung* (Munich: R. Piper and Co., 1948), p. 29. First published Munich, 1908. English edition: *Abstraction and Empathy* (London: Routledge and Kegan Paul, 1953).

18. Kandinsky, "Text Artista," p. 61.

19. Edward Bullough, "Psychical Distance as a Factor in Art and an Aesthetic Principle," *British Journal of Psychology*, v. 1912, pp. 87–118.

20. Kandinsky, letter to Hilla Rebay, January 1937, *Wassily Kandinsky Memorial*, p. 98.

21. Kandinsky, *Concerning the Spiritual in Art*, p. 48.

22. Ibid., p. 77.

23. Kandinsky, "Abstrakte Kunst," *Cicerone*, XVII, 1925, pp. 639–647.

24. Kandinsky, "Line and Fish," *Axis*, II, 1935, p. 6.

25. Roger Fry in *The Nation*, August 2, 1913, quoted in Arthur J. Eddy, *Cubists and Post-Impressionism* (Chicago: A.C. McClurg and Co., 1914), p. 117.

26. Kandinsky, "Text Artista," p. 64.

27. Kandinsky, "Uber die Formfrage," *Der blaue Reiter*, p. 85.

28. Ibid., p. 84.

29. Kandinsky, "Text Artista," p. 71.

30. Kandinsky, "Uber die Formfrage," in Kandinsky and Marc, op. cit., p. 88.

31. *Der blaue Reiter* (2d ed.) (Munich, 1914), p. v.

32. This idea is very similar to Herder's theory of Inspiration: J.G. Herder, *Ideen zur Philosophie der Geschichte der Menschheit* (Leipzig, 1821).

33. Kandinsky, *Concerning the Spiritual in Art*, pp. 51–52.

34. Ibid., p. 32. Kandinsky himself—as Lindsay has pointed out ("An Examination of the Fundamental Theories of Wassily Kandinsky," pp. 208–213)—was not a member of the Theosophical Society. He admired, however, the cosmology of Mme. Blavatsky, which attempted to create a significant synthesis of Indian wisdom and Western civilization. The antimaterialistic concepts of the theosophical movement attracted a good many artists and writers yearning for a new religious spirit during the early part of the century. Besides Kandinsky: Piet Mondrian, Hans Arp, Hugo Ball, William Butler Yeats.

35. Kandinsky, *Concerning the Spiritual in Art*, pp. 33–34.

36. Ibid., p. 36.

37. Ibid., p. 39.

38. Ibid, p. 47.

39. Ibid., p. 45.

40. Ibid.

41. The following remarks about color are taken from "The Language of Form and Color," *Concerning the Spiritual in Art*, Chap. VI, pp. 45-67.

42. Ibid., pp. 51–52.

43. Ibid., p. 57n.

44. Ibid., p. 45.

45. Kandinsky, "Text Artista," p. 75.

46. Max Raphael, *Von Monet bis Picasso* (Munich, 1919), p. 102.

47. Kandinsky, *Concerning the Spiritual in Art*, p. 63.

48. In Kandinsky and Marc, *Der blaue Reiter*, pp. 103–113.

49. Kandinsky, "Text Artista," pp. 75–87.

50. By "stage composition"—*Bühnenkomposition*—Kandinsky is referring to the totality of movement on the stage.

51. Kandinsky, "Der gelbe Klang," in Kandinsky and Marc, *Der blaue Reiter*, pp. 119–131. The possibilities of such a synthesis in the film were not yet explored in 1912.

52. Diego Rivera, quoted in "Notes on the Life, Development and Last Years of Kandinsky," in *Wassily Kandinsky Memorial*, p. 100.

53. Bergson, *Essai sur les données immédiates de la conscience* (Paris, 1904).

54. Christian P. Heinlein, "The Affective Characteristics of the Major and Minor Modes in Music," dissertation, Johns Hopkins University, Baltimore, 1928; quoted in Lindsay, "An Examination of the Fundamental Theories of Wassily Kandinsky," p. 104.

Emil Nolde

The Lonely Years of Preparation

As one drives along the German-Danish border westward from Flensburg the country becomes increasingly flat. The sparse forests of the Baltic coast thin out into a few isolated clumps of trees, the nearly bald plain is relieved only by an occasional windmill or red brick church steeple and the low mounds raised centuries ago by the Dutch as foundations for farms and houses. Dikes protect the low green marshland from the North Sea, and sturdy cattle and horses roam somberly over wind-swept pastures. The immense vault of the sky is rarely clear but billows with heavy clouds. At evening the sky is richly colored by the sun as it breaks through for a little while. Then at sunset the most unexpected hues and formations appear in the skies: storms build the clouds into towering thunderheads; when the light changes and wind sweeps across them, new configurations emerge, totally altering the mood of the land. At certain times of the year fogs blanket the plain, sometimes briefly summoning weird forms which appear and disappear in the mist, and dulling the whole countryside for long months, letting in only an occasional burst of sunlight.

The house of Seebüll in North Schleswig, where Nolde lived and worked during the last thirty years of his life, is close to the little town of Nolde where—christened as Emil Hansen—he was born in 1867. During his entire life he always returned to the marshes on the edge of the sea—indeed no modern painter was so intimately rooted to the earth and his homeland.

Taciturn and morose by nature, and highly introverted, Nolde felt most at home among the peasants of his native soil. He shared a great many of their fears, superstitions and prejudices, but with his unique artistic gifts he was able to lend these notions a mystical and often demonic aspect. He visualized himself as a missionary whose privileged duty it was to create a vital, intense art of the North. Standing somewhat apart from the main stream of the art of his time, he remained essentially a regionalist, but a regionalist of genius.

In his several autobiographical volumes and in his published and

unpublished letters, Nolde appears as a misanthrope: one who suffered greatly from perpetual loneliness, who was constantly aware of his inability to take part in the normal human community, yet who longed desperately for signs of friendship or at least of acceptance. From early adolescence he shunned other people; he seems frequently to have experienced deep religious feelings and mystic identifications with Christ's Passion. His attitude of melancholy mysticism remained with him throughout his long lifetime.

Nolde's copious writings are clumsy in syntax and phrased in a naïve vocabulary, which is only partly due to his own strange language, characteristic of the European border peasantry that is never fully at home in the culture of any language. His persistent anti-intellectualism of course merely contributed to this awkwardness of expression. Here was an artist who tells us that during his entire life he managed to read only a single book all the way through: the rather simple *Ekkehard* by Victor von Scheffel. While he waited for many years to "become an artist," he remained almost entirely self-taught. He could no more submit to a teacher than he could assimilate from the arts of past or present. After looking forward with greatest anticipation to studying in Paris and Italy, he returned, writing: "Paris has given me very little, and I had expected so much."[1] And later: "Artistically the country [Italy] gave me nothing. In no previous years had I accomplished so little and such poor work."[2]

His admiration for the primitive and the primeval was to lead him as far as the South Seas, but it was the same attitude that made him return to his native soil. A suspicion of the "isms" of the twentieth century as well as his morose personality made him rely deeply on animistic fantasy and his intense experience of nature in the forms of the sea, clouds, marshes and flowers. But in the true fashion of the romantic and the expressionist, he imposed his special artist's personality on the world, distorting its image to express his own unresolved conflicts.

It was at the age of thirty that Nolde, whose name was still Hansen, painted his first canvas, *The Mountain Giants*. Although he was surrounded solely by peasants in his childhood, his propensity for art had manifested itself early. While still a small child he modeled a series of clay figures which were almost at once demolished by his comrades. Soon he began coloring the pictures in his Bible, drew avidly, loved his drawing classes in school and then made attempts at painting, using the juice of elderberries and red beets. He read with admiration about Dürer and, coming across the obituary of Hans Makart, noted that an artist could still enjoy glory in his own time. While he worked on the family farm, he stole time to draw and paint, leaving the cattle hungry.

At seventeen he left the farm, took the still unusual step to the city and became an apprentice wood carver in a furniture factory in Flensburg. There he drew and carved ornaments for twelve hours a day, six days a week. Sundays he studied drawing with a professional painter. In his spare time he sketched

landscapes and portraits. His determination and constancy of purpose were certainly those of a young man convinced of a mission.

After four years of apprenticeship, Nolde began his period as a journeyman cabinet maker, working briefly in a furniture factory in Munich and then in Karlsruhe, where he was able to quit his job for a short time to attend all-day classes at the School for Arts and Crafts. By 1890 his solitary wanderings took him to Berlin, but it was so difficult for him to find employment there that the further burden of bitter poverty was added to his loneliness. He sketched, did odd jobs and finally found a decent position with a large furniture manufacturer. Soon thereafter, however, he learned of a vacancy at the Museum of Industrial Arts in St. Gall and was accepted as a teacher of drawing. He was to remain there from 1892 till 1898, leading for the first time a more regulated existence. In Switzerland he sought close physical contact with nature, even daring some very perilous ascents on the Jungfrau, Monte Rosa, and the Matterhorn. It was during his stay in Switzerland that he learned for the first time something about contemporary thought, from friends who talked to him of the philosophy of Nietzsche, the poetry of Verlaine and Rimbaud, the music of Wagner, the plays of Ibsen and Strindberg, the novels of Hamsun and Gorky. He went to Milan where in Santa Maria delle Grazie he saw Leonardo's *Last Supper*, which made a lasting impression on him. But in the art museum in Vienna he was still not ready to pause in front of the paintings, fearing that their attraction would precipitate him too rapidly into the career of an artist. Among contemporaries he admired Böcklin and was partial to Hodler, and one day he even met a famous artist when Lovis Corinth visited St. Gall.

During this period Nolde sketched the Swiss towns and mountains, but he was especially fascinated by the peasant types and made caricatures of their faces. He did a series of grotesque and demonic masks and endowed the mountains with troll-like features in accordance with the concepts of popular fantasy and nomenclature. He made small postcards of these personified mountains and, encouraged by their reproduction in the famous magazine *Jugend,* printed an edition of 100,000 cards. Their crude and simple anti-art quality, which made no demands on intellect or esthetic sensibility, so captured popular taste that the edition was exhausted in ten days, earning Nolde 25,000 Swiss francs. As soon as he could, he gave up his teaching job and left for Munich to become a full-time student of painting. He was now thirty-one years old.

At once he applied to the famous Franz von Stuck for admission to his classes at the Academy, only to be rejected. He commented later: "How beautiful it might have been to meet there Kandinsky, Klee, and perhaps also Marc, who were all students of Stuck's at that time"[3]—indeed a fascinating speculation. Instead, he studied privately with Friedrich Fehr in Munich and Adolf Hölzel in Dachau. Hölzel, who later became a pioneer of abstract painting, at that time still practiced the dark, moody naturalism which was as characteristic of the regional

nature painters in both Worpswede and Dachau as it had been of the earlier Barbizon painters. Nolde at last had time to study the work of other artists; he began making structural sketches of paintings by artists who then enjoyed popularity—Böcklin, Constable, Goya, Liebermann, Menzel, Millet, Stuck, Watts, Whistler, Zorn—reducing their compositions to two-dimensional planes and paying particularly attention to the contrast and balance of tonal values. The two painters whom he considered the "most significant of our time" were G. B. Watts and Arnold Böcklin, with Millet and Whistler following as close seconds.[4] He was already convinced, at least in theory if not necessarily in his choice of artists, that a great work of art had to be a fusion of "ability, fantasy, and poetic power."[5]

In the autumn of 1899 Nolde went to Paris, where his great expectations were to be so disappointed. He enrolled briefly at the Académie Julian under Lefebvre and Fleuri, but found his time more profitably spent in the museums, where he made a faithful copy of Titian's *Allegory of Alfonso d'Avalos* and admired Rembrandt's *Supper at Emmaus.* He was greatly interested in Daumier's paintings and in Rodin's sculpture which he saw at the World's Fair of 1900; he familiarized himself with impressionism, loving Manet's "light beauty" and disdaining the "sweetness of the paintings by Renoir, Monet, Pissarro, which did not appeal to my harsher Northern senses."[6] A year later, the restless Nolde moved to Copenhagen where he went through an anguished crisis in both his solitary life and his still incipient art. His loneliness at least was ended by his marriage in 1902 to a Danish girl, Ada Vilstrup. The young couple moved back and forth between Berlin, Flensburg, and a little fisherman's shack on the island of Alsen, and as nobody would buy Nolde's paintings they lived in abject poverty for a good many years. Ada, who had had some theatrical training, made an unsuccessful attempt as a music-hall entertainer in Berlin, which was followed by complete physical exhaustion and a recuperative trip to Sicily during the winter of 1904-05.

At the time of his marriage the painter had changed his name from Emil Hansen to Emil Nolde—after his native village—not only because of the great number of Hansens in that part of the world, but also in order to mark the separation between his life of preparation for art and his life as an artist. During the first years of the century his work was still quite eclectic. One of his first canvases, *Before Sunrise,* borrows from Böcklin's fantasy, with two birdlike dragons on high mountain cliffs over a Leonardesque landscape. *Moonlit Night* of 1903 is painted in veiled grey tonal values related to Hölzel's paintings of Dachau moors in Bavaria, although the more Northern painter emphasizes in a quite personal way the vastness of the flat marshland lying in the mysterious moonlight, and the solitariness of the single habitation. A year later the lovely *Spring Indoors* clearly indicates his familiarity with impressionism. The composition of related warm colors, the room penetrated by light, and the quiet

intimacy of the interior scene with Ada reading at a table are all very similar to the work of Bonnard. Yet, although Bonnard was Nolde's exact contemporary, the two painters never knew each other and probably never saw one another's work. Both great colorists, their paintings, except for this single example, are completely different.

Nolde was soon to go in a very different direction. He had studied the work of the impressionists and greatly respected the paintings of Van Gogh, Gauguin, and Munch. However, his opinion of the German impressionists, who were the leading figures at home, was never very high. He felt they were weak imitators at a time when it was necessary to forge ahead. He wrote about the magic power pure brilliant color had for him, and in the summer of 1904 he excitedly applied the brightest pigments with a broad and vehement brushstroke to his canvas *Harvest Day*. In this canvas, the rhythms of the brushstroke and the personal feeling for the free expression of color, no longer tied directly to the object, establish him as an artist with a different approach. In a letter to his close friend Hans Fehr he relates: "I was as if intoxicated when I painted this picture. I surprised myself and was astonished by its effect, its movement and brightness."[7] Almost at once Nolde had both mastered impressionism and transformed it into a more passionate and energetic statement of great intensity.

Harvest Day was painted before he left on his Italian trip of 1904-05. Upon his return he found that it had been accepted for the important annual exhibition of the Berlin Secession. He met Carl Ernst Osthaus, one of the first patrons of advanced art in Germany, studied Osthaus' superb collection, which later became the Folkwang Museum,[8] and even sold his *Spring Indoors* to the collector. Soon he met the print connoisseur Gustav Schiefler, who was to purchase a number of his etchings. While most of the criticism of his work was hostile and negative, at least he was now recognized. And encounters with two older painters whom he esteemed highly, Christian Rohlfs and Edvard Munch, for the first time gave him much-needed moral support for his way of painting.

Bridge to Himself

Having supposed himself to be completely alone in his search for new artistic expression, Nolde was overjoyed when in February of 1906 he received a letter from Karl Schmidt-Rottluff, inviting him to become a member of the recently formed Dresden artists' group *Die Brücke* (The Bridge), which had as one of its aspirations: "to draw to itself all revolutionary and fermenting elements."[9] The young *Brücke* artists, seeing a few paintings Nolde had exhibited at the Galerie Ernst Arnold in Dresden, admired his "tempests of color" and expressed their esteem in this invitation. Nolde speaks of his amazement and joy at recognition by his peers: "I was not alone! There were other young painters imbued with the future, with aims similar to my own."[10] Schmidt-Rottluff accepted Nolde's

invitation to visit him in Alsen during the early fall, at which time views and opinions were freely exchanged. In 1907 the Noldes went to Dresden, where the always sickly Ada underwent special medical treatments while Nolde enjoyed the stimulating company of the young Kirchner, Heckel, and Pechstein. He was grateful to belong to a group of avant-garde artists, not only to share their ideas but also, quite practically, to join the fight for the acceptance of a new, still unnamed kind of painting, and to get his work exhibited and perhaps bought. He gladly participated in the group shows of *Die Brücke* not only in Dresden, but also in Hamburg, Flensburg, and Magdeburg.

Nolde had needed their understanding and fellowship. Beginning with 1906 the sheer quantity of his production increased considerably. Breaking through Nolde's isolation, the young painters helped him to find his own style as nothing else could have done at that time. Nevertheless he soon retreated to his apartness, rejecting this or any community of artists. He felt that these younger men were still groping, that their group was too closely knit and their paintings all resembled one another; at the time of the 1907 exhibition at the Kunstsalon Richter in Dresden, he remarked that they should "not call themselves Brücke but van Goghiana."[11] He realized that to retain his identity as an artist, he must solve his own problems by himself.

After a series of successful garden pictures, done in dazzlingly brilliant colors, he portrayed himself as *The Free Spirit*, a large, introverted, proud individual, dressed in a Roman toga, unaffected by the smaller praising, doubting and mocking figures to his left and right. This canvas of 1907 foreshadows his religious paintings in its symbolic content, and its clarity of composition also presages his later work. The four figures—bright red, orange, green, and blue— are painted in large flat planes and are firmly constructed. After completing this canvas, however, Nolde turned it to the wall and showed it to no one, possibly realizing that it was not completely successful, for the four figures have a comical aspect not in keeping with the seriousness of his intention.

Nolde now returned for a number of years to painting nature, relying on his spontaneous reaction to pure color rather than on narrative fantasy. He painted garden pieces, cows at pasture, trees or forests, indicating in all of them his love for sensuous color. He wanted almost passively to follow the beckoning of color. Nolde, very prudish in his attitude to life, became a hedonist when writing about color, and he wished to transmit this joy to the viewer.

In his *Wildly Dancing Children* of 1909, the pigment is applied with extraordinary freedom. "The quicker a painting is done, the better it is,"[12] he wrote, and forecasting, like Kandinsky, the art of fifty years later: "In art I fight for unconscious creation. Labor destroys painting."[13] The loaded brush went wildly over the canvas as if making its own wriggles and swirls. Colors are extremely bright, with light purples and juicy green predominating. The gay colors, the whirling brush, the exaggerated impressionist dissolution of depth

and form create a sweeping joyous movement. For a brief time, Nolde's work seems happy, and unencumbered.

The Religious Pictures

The loose and sparkling paintings after nature did not, however, suffice for Nolde's aspirations. In his etchings, woodcuts and lithographs he had first made some fantastic figure compositions of considerable dramatic force. During his entire life he felt a deep personal, almost visionary concern with religion, regarding himself as almost a mystic evangelist. In the summer of 1909, while he was living alone in Ruttebüll in northwestern Schleswig close to his birthplace, he fell severely ill. During this time he experienced a sudden, urgent need for religious self-expression through paintings. "I followed an irresistible desire to represent profound spirituality, religion and tenderness, without much intention, knowledge or deliberation,"[14] he recalls in his autobiography.

Although when painting *The Last Supper* Nolde undoubtedly remembered Leonardo's fresco and perhaps even more vividly Rembrandt's *Supper at Emmaus*, this canvas bears little relationship to traditional iconography. Instead he expressed the fervent religious beliefs of the myth-inspired Northern peasantry as well as his own childhood fantasies.

Color and light are used evocatively, reaching the greatest climax in the figure of Christ with His glowing yellow face, red robe and hair, and white shirt. His personage dominates the scene in light, color, and value. The space is crowded and confined. The Apostles with their crude, masklike faces modeled from Frisian fishermen press toward the center, implying a great symbolic embrace. Christ's gesture, too, is in keeping with the general spiritual and mystic content of Nolde's painting. Instead of the dramatic situation represented in Leonardo's mural, when Christ exclaims, "One of ye shall betray me," Nolde shows Christ offering the eucharistic wine, conveying the impression of unity and self-sacrifice.

The Last Supper was followed by the great *Pentecost*, similar in composition and intense emotion. *The Last Supper* and *Pentecost* mark the turning point from external and optical charm to deeply felt inner experience.[15] The following year, still living in the little house in his native marshland and still imbued with Old and New Testament images, Nolde completed no less than ten religious canvases. Among them is the bold *Dance Around the Golden Calf*, brilliantly colored in strident yellows and blues, and wildly turbulent in its jerky rhythm. Here the story of the Jews' unrestrained worship of the forbidden idol serves as a pretext for painting a sensual and frenzied scene, expressed through movement and color. Nolde's biblical paintings frequently combine a pronounced sensual excitement with his unquestionably sincere religious passions: religion seems, after all, to have been for him a matter of primitive

passion, and often he frankly expressed inhibited sexual drives. On the other hand, a rather simple personal color symbolism is the key to the tender *Christ Among the Children*, formerly in Hamburg's Kunsthalle. Here the tender figure of the Saviour, draped in a blue mantle, looms up protectively as an overpowering diagonal form, separating the bright children—all aglow in red and yellow—from the dark purple disciples, rebuking those who brought the children, dubious and astonished at Christ's concern for them.

Nolde now turned to his most ambitious work, a large nine-part cycle of *The Life of Christ*,[16] related in form and spirit to the late medieval German altarpieces in the church of St. Mary in Flensburg which he had copied with loving emotion and helped restore during his years of apprenticeship. He began this great cycle in Berlin during the winter of 1911-12. It included the rather blurred and pulsating *Christ and Judas*, and the striking panel of *Holy Night* in which Mary, seen in profile much like a figure in an Egyptian wall painting, holds a pink fetal Christ Child in her proudly outstretched arms. There is a large central panel of the *Crucifixion*, with its jagged angular forms and glowing color, and the austere and powerful composition of the *Doubting Thomas*. As the cycle progressed, the forms became simplified, and the vestiges of impressionist technique in the broken color patches were abandoned for firm construction in large areas of separate, symbolic colors, arranged two-dimensionally in broad planes.

In 1912, he also completed the powerful triptych of *Mary of Egypt*, inspired by the legend of the Alexandrian prostitute who, after seventeen years in her profession, was converted to a chaste life by an image of the Virgin in Jerusalem and became a hermit in the desert across the River Jordan, where she finally died in solitude and was buried by St. Zosimus with the help of a lion. The artist's violent feelings are expressed in this triptych through vibrant gestures and rhythms and, above all, through the blazing reds and yellows. Color pulls the viewer into a picture which is lacking in traditional spatial illusion. But color and gesture are overtly sensuous in the left-hand panel, where the harlot is seen at the height of her powers, flaming like a torch of sensuality among the lustful and vulgar men. Nolde's notions of sensual behavior and attitudes can be primitive almost to the point of caricature. In the central panel Mary, in a vermilion gown with her hair falling in a black cascade, cries out with savage pain in her revelation before the naïvely painted statue of the Virgin. At the right her body has become emaciated, her face peacefully transfigured as she lies dying in the company of the old praying saint and a lion who looks as if he had been borrowed from a children's book.

"In intervals of a few years my pictures with biblical religious content came into existence. The concepts of the small boy, who during the long winter months used to spend all his evenings earnestly reading the Bible, were reawakened. There were pictures of the richest Oriental fantasy. They kept rising

in my imagination until the adult man and artist could paint them in dreamlike inspiration."[17]

After a journey to the South Seas, Nolde resumed his biblical subjects in 1915. It was then that he accomplished what is probably his finest painting, the monumental *Entombment*. Here ecstatic excitement has been subdued to deal with the tragedy of death. The two large shapes of Mary and St. Joseph of Arimathea seem to hold Christ's body like a coffin, containing or trying to contain Him. Mary seems to want to take Him back into her womb, but He is much too large for her or for the space that holds Him in the picture. This Christ is not resigned to death but is still struggling: broken-up areas of yellow against the large blue forms create a tension which symbolizes the ultimate tragedy of death. Nolde's great concern with masks at this time may account for St. John's mask of agony, the amazement of Joseph of Arimathea and the tragic suffering of the Christ.

Nolde returned intermittently to biblical subjects in paintings and prints until almost the end of his life. An outstanding later example is *Christ and the Adulteress* of 1926 with its golden-yellow glow and stable composition. Its Christ is loving, its mood one of contentment. In *"Be ye as little children,"* the child is still a romping youngster much like those in the earlier *Christ and the Children*, but the Apostles seem to wear Oceanic masks, while the Christ of the parable is treated as though He were a benevolent and blessing demon.

When Nolde sent his *Pentecost* to the annual exhibition of the Berlin Secession in 1910 it was arrogantly refused, causing a heated public argument. Four years later Max Sauerlandt, the young director of the Halle Museum, bought *The Last Supper*, provoking a pointed censure from Germany's art czar, Wilhelm von Bode. Nolde, who with Rouault and Chagall painted the most significant twentieth-century pictures of explicitly religious subjects, never found acceptance for his work among ecclesiastical authorities. Osthaus, enthusiastic about the large nine-panel *Life of Christ*, exhibited it at an international exposition in Brussels in 1912, only to have it rejected by the Catholic clergy. Nolde then discovered that the Protestant church had little more appreciation for his biblical paintings, mostly because it objected to his use of pronounced Jewish types for Christ and the Apostles. Yet, when a number of his religious paintings, including both the large altarpiece and the triptych of *Mary of Egypt*, were exhibited at St. Catharine's Church in Lübeck in the winter of 1921-22, a reviewer remarked that only when seen in the environment of the big medieval church, with the brilliant colors muted by the diffused light, did they achieve their full, vibrantly glowing effect.[18]

But none of Nolde's religious paintings was ever commissioned, or even permanently installed in a church. With rare exceptions, such as the Dominican church at Assy, the Church of St. Matthew at Northampton in England and the synagogue of the Hebrew University Medical Center near Jerusalem, religious

authorities in our time have tended to prefer sweet, or at least "non-controversial," devotional images to powerful and authentic statements about life and its ultimate values, and this was doubtless why no use was found for Nolde's myth-making representation of violence and tragedy.

Life in the Metropolis

In 1910, when Nolde was already exhibiting all over Germany, he was outraged at having his *Pentecost* rejected by the jury of the Berlin Secession. The entries of the *Brücke* painters were all turned down that same year, and it became quite evident that the powerful Secession, originally founded in the spirit of artistic freedom and once advocating progressive tendencies in painting, was now determined to protect its own vested interest against a new generation.[19] Faced with this situation, Nolde attacked the leadership, appointing himself spokesman for the new generation of German artists.

The Secession was under the direction of Germany's most prominent dealer in contemporary art, Paul Cassirer, and the country's most renowed painter, Max Liebermann. Both men were oriented toward French impressionism and they were both Jewish. Nolde seemed to blame the Jews for his lack of general acceptance during these first ten years of his activities as a painter; his autobiography and letters are filled with the narrow-minded anti-Semitism, nationalism, and racism prevalent among the isolated German peasantry and later exploited so successfully by the Nazis. And although his own painting had evolved from impressionism, he now vehemently rejected it in order to affirm his forceful, often brutal kind of art. Admitting that during the nineteenth century Paris had made the greatest contributions to art, he proclaimed that the time had finally arrived for German art to wrest leadership from the French.[20]

No sooner had the leading Berlin art journal *Kunst und Künstler* published an attack upon the young painters, than Nolde took the offensive with an open letter to the Secession's president, Max Liebermann, in which he accused him of dictatorial methods, of personal publicity-seeking, and of bad painting. Naturally this precipitated a public controversy in the Berlin art world. Artists, critics, and dealers took sides, and the Secession expelled Nolde. A group calling itself the New Secession under the leadership of Max Pechstein and including all the *Brücke* artists was formed, but most of its members shared neither Nolde's uncompromising attitude nor his provincial chauvinism, and that organization was soon disbanded.

Meanwhile an important exhibition at the Galerie Commeter in Hamburg, directed by the noted archaeologist Botho Graef, proved so successful that some of Nolde's financial worries were solved. In addition he seems actually to have enjoyed the public controversies and now began happy and productive years, in which the summers were spent on Alsen and the winters in Berlin, where he

became the rallying point for the new generation of German artists. He participated with them in the great Sonderbund exhibition in Cologne in 1912, which was the first show to manifest the international character of a new type of art. He was visited by a great many artists, including Barlach, Lehmbruck, Beckmann, and Marc. In 1912, when the futurists held their show at Walden's Sturm gallery, Boccioni and Marinetti called on him. Soon thereafter Otto Freundlich returned from Paris and told him about the new cubist movement. Nolde was sincerely excited by all the new developments in painting and observed how they exerted their influence on most of the German painters of his generation. He was fascinated by the cubist analysis of form, but finally reached the conclusion that "instead of disintegration I sought after cohesion, instead of the breakup of forms I wanted concentration, and in place of taste and technique I searched for deepened expression, broad planes and healthy, strong colors."[21]

During these years Nolde spent only a small part of his time and energy on Berlin art politics, for he became as absorbed in the night life of the metropolis as he had been in the harbor life of Hamburg in 1910. He had always loved the dance; he was fascinated by Loïe Fuller and grew to be a close friend of Mary Wigman, the famous exponent of modern dance, whose portrait he painted in watercolor. He was also greatly attracted to the stage and for a while could be seen almost nightly in Max Reinhardt's famous theater, sketching the most celebrated personalities of the Berlin stage in plays by Shakespeare, Molière, Goethe, and Hebbel. He went to the circus, cafés, cabarets, and dance halls, sketching singers, dancers, night club impresarios, as well as spectators. These drawings, often catching a quick movement, gesture, or glance with a single expressive line, have the vitality of immediate impressions. Their exquisite lightness and sophistication stand in great contrast to most of Nolde's painting and show unexpected versatility.

After setting down these quick impressions, Nolde painted some of the night-life subjects. *A Glass of Wine* of 1911 retains much of the sketchy quality of the drawings and has an astonishing similarity to Kirchner's paintings of the same time—this was the year in which Kirchner moved to Berlin from Dresden. *Slovenes*, also of 1911, is a more carefully executed character study of a rather depraved couple at a café table: a brutish-looking man with a dark face and a grim, despondent lady with a large and most expressive walleye are seated behind a significant still life of bottle and glass. The facial expressions of these individuals, although related in style to the Berlin sketches, seem hardened into masks.

Nolde's use of masks as a theme in his paintings indeed began at about this time. His interest in primitive objects went back to the time he was introduced to them by the *Brücke* artists. But now, early in 1911, he had visited James Ensor in Ostend. Ensor had been using masks as a device for portraying human cruelty and suffering ever since the eighties; unlike his masks, however, Nolde's are never

social comments, nor are they satirical. He had neither much interest in society nor much sense of humor. His masks are less literary than Ensor's, and more awesome in their grotesque shapes, symbolic color, and savage fantasy.

Nolde's love for the dance, like his interest in the mask, stems from a concern with primitive life and ritual. His paintings of the dance, such as *Wildly Dancing Children, Dance Around the Golden Calf,* and *Candle Dancers,* gave him the chance to make the paint move in the exciting, sinuous patterns he wanted to trace on the canvas. In *Candle Dancers* the entire painting dances: the tall, flickering candles repeat in staccato rhythm the writhing movements of the dancing women. Even the paint dances: the white of the canvas shimmers at intervals among the vibrating reds and yellows of the background and the twisting green and bluish stripes of the women's skirts. The rich pinks of the half-nude bodies leap out startlingly against the shrill Chinese reds and sulphur yellows behind them, and the women's great nipples leap on their breasts like flames. With the vibrant, emotional colors Nolde expresses his own sensuous reactions to this spectacle.

Search for the Primitive

Over the years Nolde's interest in primitive art had constantly grown more intense. He even hoped to publish a book on the art of indigenous peoples, based on his studies in the ethnological museums. He saw in this art, with its abstract and rhythmic sense of ornament and color and its mystic power, an affirmation of his own anti-classical art. He was one of the first artists to protest against the relegation of primitive art objects to anthropological museums, where they were still exhibited as scientific specimens. His own "blood and soil" mystique made him an early proponent of the indigenous art of all peoples.

He was delighted, therefore, to be asked by the German Colonial Ministry to participate as pictorial reporter in an expedition to investigate standards of health in German New Guinea in 1913. The Külz-Leber Expedition, consisting of two physicians, a trained nurse, Nolde, and Ada, left Berlin in the early autumn. After traveling by rail across European Russia and Siberia to Manchuria, they sailed to Korea and Japan, where they stayed for three weeks, then across the China Sea back to the Asian continent and Peking, Hankow, Nanking, Shanghai, and Hongkong. From there they went to Manila and the Palau Islands and on to northeastern New Guinea and New Ireland (at that time the German colonies of Kaiser-Wilhelm-Land and Neu-Mecklenburg) and to the Admiralty Islands.

Nolde made sketches at each stage of the journey. There are drawings of patient Russians waiting for days in Siberian railroad stations, of junks sailing the China Sea, of native dancers of New Guinea, as well as idealized and heroic portrait studies of natives. He completed relatively few paintings but made innumerable sketches in pencil and watercolor. He was enthralled with the

cohesion of art and life among the aborigines. His long letters, as well as the diary notes for the book *Welt und Heimat*,[22] are full of admiration for the islanders and are highly critical of the European administration's colonial officials, and the missionaries, all of whom he felt exploited the natives: "A magnificent people insofar as they have not already been spoiled by their contact with the white man...who is trying to bring the inhabitants of the whole world into servitude."[23]

While Picasso and some of the *Brücke* painters actually changed their styles under the impact of primitive art, thus giving rise to cubism and the mature *Brücke* style, Nolde never made use of the formal aspects of tribal art. Even his masks, though infused with vital intensity, are painted in a completely Western style. He hoped, however, that by absorbing some of the culture of the islanders, he would be able to approach the mystic sources of art and recapture what Jung would call a "racial memory."

During the winter of 1913-14 the Noldes spent six months in Melanesia, where he was sick with tropical diseases for part of the time. They then returned by way of Indonesia, where Nolde loved the rich ornamentation of the Javanese temples, and Burma, where he made sketches of the dances. Finally they sailed from Singapore to Port Saïd only to be caught by the declaration of war. Their belongings were seized by the British, but the Noldes themselves managed to return to Germany and the isolated island of Alsen. The canvases Nolde had completed in Melanesia were among the confiscated baggage, and it was not until 1921 that he was able to recover them, in almost miraculous good condition, from the loft of an importer in Plymouth.

Nusa lik, which he painted in New Ireland, was among this group. One of the least representational landscapes Nolde ever painted, it is conceived in large and decorative rhythms of blues and greens. The whole vast lonely scene with its little boats in the small bay and the sea under a bank of clouds is seen from a great height, which accounts for its abstract contours, unusual in Nolde's work.

The impressions of his extensive travels remained with him after his return to Germany, and much of his work was based on the material he had brought back in his sketchbooks. A painting like *Evening Glow*, with the beautiful lyric colors of clouds, water, and setting sun, is derived from the studies he made in the China Sea, as well as from actual observation of the sea in the Baltic.

Nolde's new love for Oriental splendor is combined with the intensely personal quality of his religious pictures in *The Ruler*. The ruler, garbed in his bright yellow robe and striped turban, is seated on his throne, glancing sideways at the viewer with a sly smile. In the background on the left are three soldiers behind bars, while on his right and separated by a definite black vertical line—the painting has the appearance of a diptych—we see two sensuously naked girls from his harem. The space in this painting remains undefined: the girls seem to be in some sort of limbo, yet they continue the colors and lines of the chief, while

the soldiers are quite out of focus. Everyone's position—in space and therefore in life—seems to depend on the temper of the ruler, who alone is endowed with real presence.

The character sketches Nolde had made of Russians during his Trans-Siberian journey led to a series of paintings in 1914-15. Perhaps the finest of this group is the *Three Russians*; their half-length figures are heavily painted, with masklike faces crammed into the frame in regular, rhythmic arrangement like a continuous frieze of heads. Yet there is a sharp distinction of types: the emaciated, ascetic face on the right is in sharp contrast to the other two dark, square, heavier ones—symbols of brutishness and primitive strength.

The Sea, the Marsh, and the Garden

After his return from the South Pacific Nolde relied increasingly on emotional expressions intensified by his feeling for color. Although he hated all categories and wrote: "Intellectuals and literati call me an expressionist. I do not like this narrow classification. A German artist, that I am."[24] He was indeed recognized as a founder and leader of the expressionist movement. He may be so regarded if expressionism can be defined as a probing search for a deep emotional reality behind appearances—a reality that the artist finds by observing his own subjective reactions, and for which he then fashions an adequate and equivalent formal means to evoke a similar response in the viewer.

Nolde set out to paint a scene as it must feel from inside it. His response to the ocean was particularly acute. He was born on the edge of the sea and all his life he chose to live close to it. His brief stay in Hamburg in 1910 brought about not only a group of superb drawings, woodcuts, and etchings, but generated also a series of splendid oils of tugboats and steamships in which the color itself communicates the life of the harbor, its feel and smell, and its atmosphere of water, clouds, and diffused light. He tells of a violent crossing of the Kattegat which took place at about this time. The small boat was tossed angrily with each wave. "This day," he says, "has remained so fixed in my memory, that for years afterwards all my paintings of the sea consisted of wildly heaving green waves and only a little edge of yellow sky on the upper fringe."[25]

The experience gave rise to a long series of pictures in which the ocean is no longer seen from a distance as in traditional seascapes, including Nolde's own early *Moonlit Night*. These paintings, with their surging bottle-green waves and sparkling, heaving whitecaps, the dark valleys between the crests, the low horizons and sometimes strange sweeping cloud formations are more than depictions of the sea. They are visual equivalents of a physical experience. It is as if the painter were saying: "This is what it feels like to be tossed about in the sea." Usually the pictures of autumnal seas are close-up views, limited to waves and sky. Occasionally boats appear, as in the recollections of the China Sea of 1915 or

in a painting such as *Fishing Boat* of one year later. But no safe shore line is ever indicated. The sea was for Nolde the embodiment of a regenerative primordial force, always changing and never tame—an element of ominous power. He continued painting the ocean until the very end of his long life, but over the years his seascapes became less tempestuous, more quiet, and a soft light becomes an increasingly important element in them. In *Luminous Sea*, one of his last paintings, a diffuse light dematerializes the seascape in a manner reminiscent of the late work of Turner, its still mood and fusion of sea and sky suggesting infinity.

During the twenties and thirties Nolde continued to spend his winters in Berlin and to take an active part in the artistic and intellectual life of the metropolis. He exhibited widely, by this time being recognized as a major force in modern art. His paintings were entering the chief museums. In 1921 Max Sauerlandt published an important monograph on his work, and in 1927, on the occasion of his sixtieth birthday, a large retrospective exhibition of over two hundred paintings was arranged by Rudolf Probst in Dresden and later shown in Hamburg, Kiel, Essen, and Wiesbaden. In 1931 he was finally elected to membership in the Prussian Academy of Fine Arts and the same year he published the first part of his memoirs, to be followed by a second volume three years later. There is no doubt that Nolde enjoyed his status as a public figure and that he needed and loved the excitement of the capital and the various stimuli it offered. But late in the spring he always returned to the north country, and it was there that all his significant later canvases were executed.

He had left his little fisherman's shack on the island of Alsen in 1916 for small quarters in the village of Utenwarf close to his birthplace. When after World War I this area joined Denmark, Nolde became a Danish citizen, remaining a Dane until his death. In 1926, however, he acquired land on the German side of the border, where he began building his own house and studio, calling it Seebüll. He and Ada found the particular spot after extensive searching, largely on foot, along the whole coast of Schleswig-Holstein. Here the artist designed a strange, six-cornered brick building of no particular style, too heavy for the landscape which it dominates like a castle, but whose unconventional plan was precisely what he needed and wanted. There he spent his long summers until 1941, and the entire year throughout the remainder of his life.

In Utenwarf and Seebüll, in this rather desolate and lonely northern countryside, he executed some of the most powerful landscapes of the twentieth century, landscapes that speak of the vast spaces and the great quiet of the moors, where the ever-changing light and restless clouds give drama and life to nature. Long stretches of marshland with low horizons appear in *The Evening*, in which a jagged, grey cloudscape dominates the lonely green marsh, and the viewer is pulled along the winding path toward a distant center where a sulphur-yellow sky and a distant blue mountain range beckon. He painted clouds which sweep

across the sky like the threatening finger of a mighty hand, intimidating young horses. In *Sultry Evening* he superimposes a huge bunch of flowers on a fantastic landscape. The flowers do not relieve the frightening aspect of the scene, with its orange cloud looming out of the green sky and surmounting the low-lying black cloud that enshrouds the farmhouse; its blazing color threatens the spectator like an eerie manor in Gothic tales, but with far more effective simplicity of statement. He made pictures of the mills which dot the countryside, but communicate a feeling of mystery, as in *Nordermühle*, where no wind animates the arms of the mill, and no human being enters the portentous scene. A burning orange and yellow cloud is reflected in the silent pool, and the still water seems to be smoldering with a sulphurous flame. He loved the mysterious mood: in *Frisian Farm on a Canal*, mostly composed of the saturated green of the moorland and the rich ultramarine blue of the sky, two small light clouds and the glowing yellow haystack only underline the mood of heavy solemnity.

This painting was made in 1935, when Nolde had been gravely ill for some time with cancer of the stomach. He now underwent surgery, and the mood of his work became less forbidding after the successful operation.

In addition to the northern ocean and marshland, Nolde always loved flowers. Poor as he was, he planted a luxurious flower garden next to his little hut in Alsen. When he moved his summer quarters to Utenwarf, he grew another garden (they were unknown to the farmers in the coastal regions until that time). Finally, when he had erected Seebüll, he planted a lush flower garden in that bleak countryside and filled it with sunflowers, amaryllis, roses, poppies, even camellias. The flower beds themselves were arranged to form the initials "A" and "E" for Ada and Emil (Nolde's taste was a peculiar combination of middle-class banality and unique individuality); this garden served as his model for a great many oils and watercolors during the last thirty years of his life.

The garden pictures of 1906 were the first really successful group of paintings. He recalls: "It was in midsummer. The colors of the flowers attracted me irresistibly and at once I was painting. My first flower pictures came into being."[26] In them he began to approach color for its own sake, and it was these paintings which appealed to the *Brücke* painters as "tempests of color," causing them to invite him to membership. The dramatic quality of these pictures, still impressionist, was soon enhanced. He became less interested in the effect of light, working in the shade in order to see color most clearly without the diffusion of sunlight, and by about 1913 color has overcome other elements in the garden pictures. They resemble tapestries in which massed flat areas of color are placed in a rhythmic arrangement. At times he strove for a great brilliance of color; at others a dark, subdued, almost ominous mood prevails. Here, even more than in his other oils, color is the basis for his form and does in fact create an order following its own needs. He was also fond of including flowers in his still lifes, combining a bouquet with Melanesian masks, Burmese carvings, Chinese idols,

or other items from his variegated collection of exotic objects. This mélange of oddities often lends a strange, almost surreal flavor to the familiar flowers themselves.

But his finest flower pictures are removed from all environmental relationships. Like the waves seen without coastlines, they are painted without soil or vase. Nolde presents us only with petals, stamens, pistils and perhaps a few leaves. These he humanizes with his own emotion: "The blossoming colors of the flowers and the purity of those colors—I love them. I loved the flowers and their fate: shooting up, blooming, radiating, glowing, gladdening, bending, wilting, thrown away and dying."[27]

It took considerable boldness for a painter who admired van Gogh[28] as much as Nolde did to paint sunflowers, yet he often returned to them and added a new and rich interpretation to the motif. *Ripe Sunflowers* of 1937 is an impassioned painting of the flowers in full bloom. These blossoms are large, engulfing, womb-like creations, but they are also already marked with the sign of death as the heavy flowers bend with their own weight, soon to lose their seeds, which they will no longer be able to hold.

In a much happier mood is *Great Poppies—Red, Red, Red* of 1942, one of the few pictures he dared paint during the Nazi persecution. The Whistlerian subtitle suggests that Nolde was concerned primarily with the pure play of color: vermilion, pink, and purple. These flowers, beautifully composed within the picture frame, stand up against the elements with a fresh, windswept vitality.

At times Nolde would also set personages in his gardens. *In the Lemon Grove* is a modern allegory on the theme of love, expressed of course by means of color. *The Great Gardener* of 1940 resembles a quiet poem about the mystery of creation: the naïvely conceived God—the German *Lieber Gott*, bearded, kind, benevolent—tends His garden, fructifying a miraculously tall orange flower which grows toward Him like a burning chalice.

The Prints

Nolde, who came to occupy the top rank among twentieth-century printmakers, had begun etching in 1898. His first important group of etchings—a series of grotesques and fairy-tale fantasies—was made in 1904, about four years before his work in oil shows a similar richness of imagination. At times certain compositions appear years earlier in Nolde's prints than in his paintings, but in a good many instances the painted version precedes the graphic one. Yet in every instance, the peculiar characteristics of the medium had a determining effect on the final products. "I want my work to grow from the material, just as in nature the soil from which it grows determines the character of the plant," Nolde wrote in 1906.[29]

His early etchings were still soft and rather diffuse, showing an influence

from impressionism much like that in his early painting style. In other prints, especially of nudes, the decorative, sinuous line indicates a derivation from art nouveau. Soon, however, he developed a unique and personal technique which, though achieved by pure etching, gives his prints an effect similar to aquatint. In these his interest in tonal values rather than in line determined the results. As early as 1906 Gustav Schiefler, the collector and connoisseur of prints, while working on the definitive catalog of Edvard Munch's graphic work, was attracted by Nolde's etchings and became their first important collector. Soon thereafter Schiefler wrote the first comprehensive essay on Nolde and as early as 1911 published a definitive catalog of his prints to date, following it with a second volume in 1927.

When in 1906 Nolde joined the *Brücke*, he was already an accomplished etcher, and while he was teaching his friends about etching, they in turn introduced him to the woodcut.[30] He was fascinated with this printing technique, mastering it quickly because of his early training in wood carving, and he completed his first series of about thirty woodcuts that same year. These woodcuts show the influence of Munch as much as that of the *Brücke* painters. A comparison of Nolde's early woodcuts with those of Kirchner reveals the contrast between the two rather than their similarities. As a colorist, Nolde is concerned with light and dark values and their planar relationships, whereas Kirchner surrenders himself to the free arabesque of linear movement. In his woodcuts Nolde gave free rein to his imagination. In *The Large Bird*, an awkward little girl stolidly confronts a monstrous gloomy bird flapping his big wings; the enormous bird—itself a rather threatening image—seems frightened by the girl. It suggests some strange legend of a bird, pursued by a child much smaller than itself, neither aware of its own power and strength. Six years after having made this woodcut, which perhaps was known to Munch when he did his lithograph *Omega and the Bear* in the *Omega* Series of 1908–09, Nolde did a highly effective painting of the same fantasy, now in the Royal Museum of Fine Arts, Copenhagen.

In 1910 Nolde went to Hamburg where, enthralled by the harbor, he made a group of superb India-ink drawings with a dry brush, as well as woodcuts and etchings. These prints are not as subjective in content as the earlier (or later) series; he was thoroughly excited by the visual stimulus of the industrial landscape, the port with its barges, tenders, tugs, and docks, and its waves and smoke. During the day he sketched and drew in a small boat, and at night in his sailor's hostel he etched his plates with furious speed, placed them in the acid, lay down to sleep for a few hours, and awoke in time to remove them from the bath. Sometimes he seems to have used double biting for the deepest lines. These etchings of Hamburg harbor with their network of brittle lines capture the vital atmosphere of the port as it was experienced in the artist's highly stimulated imagination. They also show his enjoyment of the medium and the rich

inventiveness of his technique. The woodcuts of identical subjects are simpler and harder, as one would expect. Like the ink drawings, to which they are related, they are also reminiscent of Far Eastern art in their large and emblematic calligraphic forms.

The prints of Hamburg were followed in 1911 by a series of religious etchings, such as *Solomon and His Wives*, *Saul and David*, and *Scribes*, revealing the same fantastic and mystic vision that gives such force to his religious paintings. "My etchings," he wrote, "do not belong to some kind of art that can be enjoyed from a comfortable easy chair ... they demand that the viewer leap drunkenly with them."[31]

He sought a similar effect in the series of powerful woodcuts of 1912. *The Prophet* from this group is startling at first glance because of the large areas of black, but the white sections are actually those that receive chief emphasis. Broken by black lines an inch or half an inch in thickness, these white areas are largely concentrated in the center of the picture. The gaunt cheekbones, the retina of the left eye, the stubborn lower lip, the high, sloping bony forehead— these areas, besides being effective because of their central position, are also easily read as symbols: they are traditionally associated with the prophet. Like a legendary mask, this disembodied head floats into the picture and gives the print some of the dramatic intensity and the heavy monumentality of an icon. Although as a graphic medium the more painterly lithography was to occupy his chief interest and attention after 1911, Nolde continued to work in both etching and woodcut. In 1917, in fact, he completed another fine set of woodcuts, including the rather savage print, *The Family*. These are freer in form than the earlier prints, and the artist's inclination toward the broadly conceived plane finds the woodcut technique particularly congenial.

The last series of etchings, done in 1918 and 1922—grotesques and fantasies as well as landscapes—shows an increasing graphic sensibility, a new delicacy of technique and a mastery of the material which results in infinite variations of greys and beautifully textured surfaces of organic richness.

As early as his Munich period in the nineties, Nolde made an attentive study of Daumier's lithographs, fascinated by their tension and large planes of light and shade. Perhaps he had seen and admired Daumier's prints even earlier; his caricatures of Swiss types would certainly suggest such a possibility.

It was also while in Munich that Nolde first became familiar with the technical process of lithography. In 1907 he made his first series of thirty-one lithographs, drawing the faces and figures of music-hall dancers with India ink on tracing paper and simply using the stone for multiplication of the design—a procedure that was customary at the time. But it was not until 1913 that he really learned about the medium, when in a lithography workshop in Flensburg he was given complete freedom among the stones and presses. Like Picasso at Mourlot's in 1947, Nolde was enthralled with the medium, realizing that "the painter can

experience the fascination of the technique and its far-reaching possibilities only when he himself works creatively on the stone."[32]

He loved the possibilities of stones for various colors and at times used as many as five, indeed expanding the limits of color lithography by making huge prints which combine a powerful color symbolism with the flatness peculiar to the graphic medium. He constantly experimented with different states and variations: *Young Couple* exists in seventy-two printings.[33] This print, *The Three Kings*, *Discussion*, *Mother and Child*, and the magnificent *Dancer*, while lacking the often brutal roughness of the oils, have an emotional appeal equal to that of his work in any medium. His feelings about human encounters as sacred, spiritual, or magical events are evoked by color and plane as well as by expressive gesture. As a unit, Nolde's thirteen color lithographs of 1913 constitute the climax of German expressionist graphic art.

Nolde returned once more to color lithography in 1926, now eliminating the black stone entirely. In keeping with the general development of his work in the twenties, these large prints, while lacking the dramatic agitation of the earlier lithographs, are handled more broadly. They have an effect of great peace, and, at times, as in *The Sea*, done in the late twenties, achieve monumentality.

Owing partly to a weakening of his eyesight, Nolde gave up his work as a printmaker in his sixties; this coincided with his greatest concentration upon the fluid medium of watercolor.

The Fluid Image

Expressionism may be described as the utterance of the artist's subjective emotion; expressionists generally are not particularly concerned with problems of structure or composition. Kandinsky, Nolde's most important contemporary, and pioneer among the abstract expressionists in Germany, insisted that form must be nothing but the outgrowth of the artist's "inner necessity." The best expressionist paintings are those in which this direct and instinctive approach strikes home without the intervention of rational thought. Nolde was quite aware of the need for spontaneity, although he placed more emphasis on the act of seeing and never turned to pure abstraction: "I have found it difficult, after having reached the creative climax in my work—something that happened rather early in the process—to sustain the tension until it was completed. When the pure sensual force of seeing weakens, rational coldness can take over, leading to a slackening and even destruction."[34]

Because of the great importance of immediacy in Nolde's creative process, he found watercolor an ideal medium. Here no change was possible, and there was no need for a prolonged translation from imagination to formal structure. In his analytical remarks about his work he continues: "I could imagine my work down to the smallest detail, and my concept was usually much more beautiful

than the finished work. I became the copyist of my own conception. It is for that reason that I try to avoid all thinking. A vague concept of color and luminosity suffices, and the picture evolves during the act of painting."[35]

His first fully realized work was a minute watercolor (3½ x 4 inches) of a mountain sunrise of 1894 while he was still in Switzerland. He was quite aware that "it indicated a direction, because it made me so happy. But I was unable to turn out another picture of this kind. Did I already suspect that the long road from joy in nature, externally perceived and described—as in all my preceding landscapes in watercolor—would ultimately lead me to artistically free concepts that came wholly from within?"[36]

It took him over a decade to continue along the direction anticipated in this small watercolor. It was not until his brief stay near Jena in 1908 that he was able to achieve a similarly strong and evocative feeling in a group of glowing watercolors. Again he was working under trying conditions. He had failed with a group of oils; it was extremely cold, yet he felt he must work outdoors, and he turned to watercolor, sometimes sitting in the snow and using pieces of ice to paint with. "At times I also painted in the freezing evening hours and was glad to see the frozen colors turn into crystal stars and rays on the paper. I loved this collaboration with nature, yes, the whole natural alliance of painter, reality and picture."[37] Thus as early as 1908 he was letting the material speak for itself and welcoming the element of chance: the traces of ice crystals formed by the frozen watercolor are still visible in the lower margin of *Sunset*.

The following years, in a state of great excitement, he began working again with watercolor, or rather wash and pencil on paper, in studies for heads of the Apostles for *The Last Supper*. In 1910 he did his telling interpretations of Hamburg harbor with a dry brush and India ink, and in 1911 he turned to watercolor and a thin brush for his quick, delightful renditions of Berlin night life.

He found watercolor most useful for rapid sketches on his trip to the South Seas in 1913. He executed a group of extraordinary watercolors of Chinese junks which, although using Western illusionistic space, are nevertheless strongly reminiscent of Oriental art, not merely in their subject matter but in the astonishing certainty of the dashing line, in their economy of means, and in the definite emblematic appearance of the black shapes and their disposition on the page.

In New Guinea he made a number of portraits of aborigines, lending them the nobility of native deities. Nolde quite clearly continued to be imbued with romantic faith in the Noble Savage.

A number of watercolors of the Northern landscape, many of which were executed in Utenwarf, were done on non-absorbent paper whose whiteness served as the white of the picture. After applying the color, Nolde would add strong and decorative black outlines which animate the composition.

But after this trip to the Orient, and possibly slightly earlier, he also used a different technique which he pushed to a highly advanced point. Employing an absorbent Japan paper, he moistened it and then applied the watercolor, permitting the pigments to flow into each other, controlling their movement with a tuft of cotton. There is no white, only color. This new use of watercolor was his innovation, necessary to permit him the free improvisations he desired. Often—almost as in a Rorschach ink blot—the configuration on the wet page would suggest a cloud, a mountain, the sea or a flower, from which the artist would capture and articulate the vision.

These watercolors are impossible to date. Chronological classification seemed pedantic and unnecessary to Nolde, for he once told Fehr: "To the annoyance of art historians I shall destroy all lists that give information about the dates of my pictures."[38] In view of this attitude, it is amusing as well as helpful that a precise catalog of his oils was kept by Ada Nolde and, after her death, by Joachim von Lepel, as director of the Nolde Foundation. Unfortunately, however, this list did not include the thousands of watercolors, and as there is little stylistic or thematic change after about 1920, it is impossible to assign specific dates to most of them. The only alteration which seems apparent is that in the late sheets he used an even easier and softer transition between color areas and a spotty technique within individual areas, giving them an organic appearance of fungi or lichens that he had earlier achieved only in the etchings.

The themes of the watercolors vary little from the oils. He was fascinated by the skies, the drama of light and dark performed by the clouds. There are many close-ups of flowers, some beautifully decorative, some with heavily symbolic sexual overtones; his figure pieces, increasing in number over the years, are also preoccupied with the male-female relationship.

The watercolors range from the lightest transparency to deep and full opacity, from the firm structure of the usually earlier ones with their heavy outlines to the more fluid later pictures. They have become the most accessible and therefore the most popular of his works, but perhaps they are also the most fully resolved. Nolde elevated watercolor far above the level of a specialized technique and achieved works of a breathtaking and ephemeral beauty which stand unique in the history of twentieth-century art. They remain unencumbered by the occasional awkward handling of pastose paint but rather convey by a light directness the spontaneity with which they were done. In this wet-on-wet technique Nolde welcomes the accident, he controls it, and anticipates a later generation of "informal" painters, some of whom surely felt the impact of his work.

The "Unpainted Pictures"

"Blood and Soil," "Art and Race," and similar cultural propaganda slogans trumpeted by the Nazis could not fail to appeal to Emil Nolde, whose own

position was consistently that of a pan-German chauvinist. National identity has always been a highly sensitive matter among the Germans. But a feeling of national insecurity is apt to run especially high among the border populations, like those of South Tyrol, the Sudetenland, and the Baltic, as well as North Schleswig. In addition, Nolde felt that all great art had to be "indigenous to the race," which accounts to a considerable extent for his admiration of primitive art. His own position as a German artist, as we have seen, had been consistently anti-French and anti-Jewish. He was, however, thoroughly inexperienced politically, and when Hitler and his supporters proclaimed the German National Revolution of 1933 Nolde naïvely expected to become a part, and indeed the artistic spearhead, of "The Movement."

He was soon to be deeply disillusioned. The petty-bourgeois taste of Hitler himself prevailed against all aspects of modernism, and Nolde in particular was singled out for attack as a "degenerate artist" and "cultural bolshevik." His friends among the German museum directors, including his champion Max Sauerlandt, were dismissed from their positions as soon as the Nazis took power, and Nolde's own work began to disappear from the walls of museums. An exhibition of his work was closed by the Gestapo. In the Degenerate Art exhibition in Munich in 1937 the Nazi art officials mockingly displayed twenty-seven of his works together with those of most other important modern artists. Soon all his paintings not in his own or other private hands were seized, and some were sold at auction in Switzerland. Unlike most of his contemporaries at work in Germany—artists such as Albers, Beckmann, Feininger, Grosz, Kandinsky, Klee, Kokoschka—Nolde did not emigrate. As a Danish subject he could not have been prevented from leaving the country, but he could not conceive of giving up his beloved Seebüll, and in any case he still had faith in the eventual acceptance of his German art by the National Socialist government. He continued to petition the authorities and even took new hope when his local chapter of an organization of German nationalists in North Schleswig was absorbed into the Nazi party in 1940. Yet in the summer of 1941 he was ruthlessly informed that: "In view of the Führer's decree concerning the elimination of degenerate art from the museums, 1052 of your works have been confiscated.... For your lack of reliability you are expelled from the Board of National Culture and are as of this instant forbidden from exercising any professional or avocational activity in the fine arts."[39]

When Nolde wrote to his friend Hans Fehr about this annihilating decree, he nevertheless still expressed his hope and faith in Germany's victory in the war. Still he did not wholly obey the interdiction, but secretly painted many very small watercolors, the "Unpainted Pictures." As late as 1942 he made a final attempt to appeal to Nazi officialdom, traveling to Vienna to see Austria's *Gauleiter,* Baldur von Schirach, only to be rejected once more. To add to his misfortune, his Berlin studio was totally burned in an Allied air raid in 1943, and all his etching plates, woodblocks, and lithography stones as well as about three

thousand prints and drawings were destroyed. At the same time he was anxiously concerned over the whereabouts and condition of all his confiscated paintings—the creative endeavor of a lifetime.

Nevertheless, sitting in a small room in Seebüll during the years of Nazi persecution and using very small pieces of paper, he painted hundreds of watercolors. These he called "Ideas for Paintings" or "Unpainted Pictures." As in the earlier watercolors he allowed wet paint to flow over the wet paper, and again the old artist's trained eye and matured imagination spontaneously caught the images suggested by the fluid color. But unlike larger watercolors, the Unpainted Pictures are denser in their composition. Their much smaller size—usually only about eight by six inches—and the fact that they were intended as studies for oil paintings necessitated this change toward a more definite condensation.

These multitudes of small papers are only now beginning to be known. There are still occasional landscapes, but almost all of them deal with the human figure. Many look almost like specific illustrations to unwritten stories. But the only fable that is illustrated by these untitled watercolors is Nolde's own fantasy, the imagination of a storyteller whose images emerge from ancient myth and personal fantasy.

Many years before Nolde turned to these strange little pictures, on the occasion of his sixtieth birthday, his close friend Paul Klee had written: "...In their divorce or flight from earth, abstractionists sometimes forget Nolde's existence. Not so I, even on my remotest flights from which I always return in order to rest with a newly discovered weight. Nolde is more than only bound to the earth. He is also a demon of the lower earthly regions. Yet, even from another sphere, one senses in him a cousin of the depths, but a cousin by election....His hand is a creative human hand, not without heaviness, which writes in a script not without flaws, the mysterious full-blooded hand of the lower regions....The heart of creation beats for all and nourishes all spheres."[40]

But now at last the hand of the old painter works "without heaviness." By this time Nolde had learned much about human relationships, and in this great cycle he gave a passionate visual form to his wisdom. There are figures that appeal, reject, wail, smile, and contemplate. There are lonely people, jealous people, alienated individuals who wish to form contacts but are unable to do so. This world is peopled with beautiful and desirable young women, blindly groping old men, grimacing gnomes, and compassionate demons. Again we see combinations of man and flower as well as disputations between the most unlikely antagonists. The imagination here often recalls the *dramatis personae* of *The Tempest, Peer Gynt*, or Munch's anxious fantasies, although it is much less perturbed than that of Munch. Indeed, Nolde's private world has been transfigured into a serene realm of human actors whose chief function is their subservience to the color which gave them birth.

The colors are still "tempestuous" but no longer aggressive. Instead they

now have the full resonance that occurs at times in the work of masters in their old age. The colors and the figures to whom they have given form pursue Nolde's interest in the dualities of human relationship. He asks here the same time-worn questions so often asked by creative artists: How do the sexes face each other? What is the relationship between old age and youth, tragedy and joy, good and evil? How does man confront society? Which is reality and which the mask? But all these questions have become visual questions and are expressed with "ability, fantasy, and visual power," the three virtues Nolde postulated for great art during his student days in Munich.

After the bitter and frustrating years of Nazism and war, Nolde emerged as the grand old man of German art. But in 1946 his wife Ada, long an invalid, died of a heart attack. To combat his loneliness the aged painter became engaged to the twenty-six-year-old Jolanthe Erdmann, daughter of his friend, the pianist Eduard Erdmann, and was married to her in 1948. He continued painting, translating some of his Unpainted Pictures into oils. His colors were more subdued now and he shunned the contrast of complementaries which he had liked so much in his earlier, more vigorous days. His final paintings have a softened quality; their mood is serene and contemplative. A diffuse, liquid light was added to his vocabulary and became, indeed, an essential element.

In 1952 a great celebration honoring his eighty-fifth birthday took place in Seebüll, where distinguished friends from all over Germany, Denmark, and Switzerland mingled with his peasant relatives. He was now decorated and bemedaled, given an honorary professorship, awarded important national and international prizes and large retrospective exhibitions. He could finally look back on the rich accomplishments of a fertile life.

His last oils are dated in his eighty-fifth year, and he continued painting watercolors almost until his death on April 13th, 1956, at the age of eighty-eight.

Always reluctant to part with his paintings, which he and Ada considered their children, Nolde had retained a very large number of his oils, watercolors, and prints, including many of the most important works. These he left in permanent trust to the Nolde Foundation, administered after his death under the capable and loving direction of his devoted friend, the late Joachim von Lepel. The studio-house of Seebüll has now become the Nolde Museum and is a fitting memorial to a great painter. There in Nolde's own countryside, which was so essential to his art, the visitor can concentrate in quiet contemplation upon the unique pictorial language Nolde created: a language which endowed the mystical spirit of the North and a turbulent personal fantasy with a command of color, unprecedented in its power.

Notes

1. Nolde, *Das eigene Leben*, Berlin, Rembrandt Verlag, 1931, p. 152.

2. Nolde, *Jahre der Kämpfe*, Berlin, Rembrandt Verlag, 1934, p. 62.

3. Nolde, *Das eigene Leben*, p. 127.

4. Nolde, letter to Hans Fehr, Dachau, May 7, 1889, in Hans Fehr, *Nolde*, Cologne, DuMont Schauberg, 1957, p. 23.

5. Ibid.

6. Nolde, *Das eigene Leben*, p. 144.

7. Nolde, letter to Hans Fehr, Friedenau, March 5, 1909, in Paul Westheim, ed., *Künstlerbekenntnisse*, Berlin, Propyläen Verlag (n.d.), p. 237.

8. Karl Ernst Osthaus founded the Folkwang Museum in his native Hagen in 1902 to house principally his own collection of impressionist and post-impressionist painting. This early museum of modern art was designed by his friend, Henry van de Velde. In 1922, after his death, the Folkwang Museum was transferred to the city of Essen, and a handsome new building was built after World War II. The city of Hagen now has its own museum, which is called Karl-Ernst-Osthaus-Museum in memory of the great collector.

9. Karl Schmidt-Rottluff in Nolde, *Jahre der Kämpfe*, pp. 90-91.

10. Nolde, *Jahre der Kämpfe*, p. 91.

11. Nolde in Fehr, op. cit., p. 53.

12. Nolde, *Jahre der Kämpfe*, p. 95.

13. Nolde in Fehr, op. cit., p. 63.

14. Nolde, *Jahre der Kämpfe*, p. 104.

15. Ibid., p. 107.

16. Nolde never wanted to part with this nine-part work and retained it in his own collection. It is now permanently installed in the Nolde Museum in Seebüll.

17. Nolde, *Jahre der Kämpfe*, p. 189.

18. (Karl) With, "Künstlerbrief Lübeck," *Feuer*, vol. III, no. 2-3 (Nov.-Dec. 1921), pp. 15-18.

19. For a more detailed history of the *Berlinger Sezession* and the *Neue Sezession* see Selz, *German Expressionist Painting*, Berkeley and Los Angeles, University of California Press, 1957, pp. 36-38, 113-114.

20. The German expressionists were not alone in their conviction that they had assumed the succession of the School of Paris. The futurists in Italy announced the same thing at the same time. More than a generation later a similar belief prevailed among members of the New York School.

21. Nolde, *Jahre der Kämpfe*, p. 196.

22. Nolde, *Welt und Heimat*, Cologne, DuMount Schauberg Verlag, 1965. This, the third volume of Nolde's autobiography, deals with his trip to the South Seas and his activities in Germany during World War I.

23. Nolde, letter to Hans Fehr, May 24, 1914, in Fehr, op. cit., pp. 86-88.

24. Nolde, *Jahre der Kämpfe*, p. 182.

25. Ibid., p. 96.

26. Ibid., p. 93.

27. Ibid.

28. Nolde was interested in van Gogh as early as 1898 when he saw van Gogh's *Self Portrait* on exhibition in Munich.

29. Nolde, introduction to the catalog of his exhibition at the Kunstverein, Cologne, 1950, p. 4.

30. E. L. Kirchner, *Chronik der Brücke*, translated in Selz, op. cit., Appendix A, p. 320.

31. Nolde, letter to Hans Fehr, Hilchenbach, October 23, 1905, in Westheim, op. cit., p. 234.

32. Nolde, *Jahre der Kämpfe*, p. 228.

33. William S. Lieberman in Andrew C. Ritchie, ed., *German Art of the Twentieth Century*, New York, Museum of Modern Art, 1957, p. 200.

34. Nolde, *Jahre der Kämpfe*, pp. 181-182.

35. Ibid., p. 183.

36. Nolde, *Das eigene Leben*, second enlarged edition, Christian Wolff Verlag, Flensburg, 1949, pp. 141-142.

37. Nolde, *Jahre der Kämpfe*, pp. 88-89.

38. Nolde in Fehr, op. cit., p. 65.

39. Verfügung des Präsidenten der Reichskammer der bildenden Kunst, August 23, 1941, quoted in Fehr, op. cit., p. 154.

40. Paul Klee, in *Festschrift für Emil Nolde*, Dresden, Neue Kunst Fides, 1927, p. 25.

Lyonel Feininger: The Precision of Fantasy

Born in New York City in 1871, Lyonel Feininger spent most of his creative career—50 years—in Germany, but always longed to come back to the place of his childhood. Both his parents were esteemed concert performers, and he himself excelled as a violinist and eventually was to compose a series of fugues for the organ. Originally, he wanted to study music, but upon arriving in Germany in 1887, he decided to enter art school and within a few years Leo—as he called himself at the time—was a highly successful cartoonist and caricaturist. For almost fifteen years he worked for Berlin and Paris newspapers and humor magazines, and he sent one of his early American comic strips to the *Chicago Sunday Tribune*. The grotesque satires in these drawings, in which distorted figures occupy distorted spaces, combine a German and an American usage with a highly personal wit and fantasy.

As a young cartoonist, Feininger diagnosed the social and political milieu of his time. Later he was to develop some of the most advanced artistic concepts of his time. He was close to the artists of the Brücke in Germany—especially Karl Schmidt-Rottluff, to whom he wrote his last letter from New York in 1956—and exhibited with his friends in the Blaue Reiter. But, like Max Beckmann, he remained essentially aloof from the Expressionist groups. Their introverted projections must have seemed excessive and self-indulgent to the Yankee painter in Berlin, just as he could never limit himself to the strictures of Analytical Cubism.

Feininger, whose work comprised the very essence of the modern sensibility, was one of the first artists to be invited by Walter Gropius to join the Bauhaus in 1919 and he remained affiliated with it until the end in 1933. His woodcut, significantly entitled "Cathedral of Socialism," was chosen for the cover of the *First Bauhaus Manifesto*. The Romantic concept of creating a meaningful and relevant future on certain premises of the medieval past was central to the thought of those who shaped this focal point of the modern movement. It finds its enduring and prophetic symbol in many of Feininger's great canvases of

churches and towns, such as the Whitney Museum's superb "Gelmeroda VIII" of 1921, where the Gothic church is treated with the same purity of structure and transparency of form which was to appear a few years later in Gropius' Bauhaus building in Dessau.

Even before joining the Bauhaus, Feininger had discarded the anecdotal element which was so endearing in his early work. The encounter with Cubism was all-important in this regard. He exhibited six canvases in the Salon des Indépendants of 1911, the exhibition in which the Cubists made their first great impact on the art public in Paris. After 1912—and for the rest of his life—the Cubist dissection of form and space, the Orphist simultaneity of color and definition of light as a force, the Futurist rendering of physical movement by jagged, angular lines became part of Feininger's visual vocabulary, but he would use these elements in a manner uniquely his own. The visual laws of the Cubists, Delaunay's great interest in aesthetic theory, and the social ramifications of Futurist doctrine held no interest for Feininger. He continued to explore the visual world and the realm of his personal fantasy, searching for a synthesis of reality and imagination in his work.

Throughout his long and productive career Feininger fused diverse threads into a new—his own—unity. Steeped in the Romantic tradition and longing for a distant life of the past, he, nevertheless, was enthralled by the mechanical and technological inventions of his time and chose all kinds of engines for his themes: locomotives, bicycles, and, in 1902, an imaginary vehicle for interplanetary travel. Ultimately he was to paint both the skyscrapers of Manhattan and the narrow, forgotten streets of the Thuringian villages. They, too, had stately towers. He employed his nostalgia for the past and rendered it with a uniquely modern sensibility. And, when he did his sublime views of the medieval town—Gelmeroda, Halle, Gothen, Zirkow, Neppermin, Erfurt, Lüneburg, Gross-Kronsdorf, and Nieder-Grunstedt—the Gothic structures were painted with a transparency which was only possible after his encounter with Cubism.

The experience with Cubism, particularly the meeting with Robert Delaunay, however, was of great consequence in the unfolding of Feininger's own art toward compositions close to the condition of music. Conscious of this development, he wrote to his close friend, the painter Alfred Vance Churchill, in 1913: "Music is as much my life as air and creating in paint. My pictures are ever nearing closer to the *Synthesis of the fugue*.... Cubism is a synthesis, but may easily be degraded into mechanism.... My 'cubism'...is visionary, not physical."[1]

His first major exhibition was held at Herwarth Walden's avant-garde Sturm gallery in Berlin in 1917, but Feininger's particular kind of image can be seen as early as 1913 and 1914 in his seminal pictures of churches, bridges, steamers, and high houses. For a time, man all but disappeared from his painting,

probably because he could not justify morally the break-up of the human figure which his new constructions of luminous, transparent planes of light and color would have necessitated. Later when man re-enters his work, it is a transfigured human being which becomes part of this crystalline world. The seascapes of the twenties, in which man finds his place among enormous skies and vast, empty spaces, recall the great Romantic paintings of Caspar David Friedrich, whose work Feininger did not as yet know, and James Mallory Turner, whose work he admired very early. But, unlike those of his great Romantic precursors, Feininger's human figures are not submerged in the overwhelming forces of nature, but are part of an Einsteinian world of light and energy.

His visions of vast spaces combine mystery with a scientific comprehension of the universe. Clouds and grand skies have the structure and transparency of modern architecture. Perhaps the essential element of Lyonel Feininger's art was his ability to deal with fantasy with the precision of the scientist: here was a scientific, mathematical mind capable of embracing the poetic aspiration for the universal.

In this respect Feininger clearly assumes the heritage of Cézanne, and like Cézanne, he is constantly troubled, unsure, painting to find his anchor in reality. Picasso was so right when he said, "Cézanne's anxiety, that is what interests us." Early on, Feininger wrote to his wife Julia that "my paintings are the battlefields on which I try to find clarification for myself." This statement, so typical of the modern artist, helps us to understand Feininger's dilemma: how to give pictorial monumentality to the transparency he discerned in nature. At times, when he moved into the realm of the metaphysical as in "Broken Glass" of 1927 or at the end of his life in "The Cutting" of 1949 or "Lunar Web" of 1951, he succeeded magnificently.

During his early years in Germany, Feininger felt himself an exile from America, where he had grown up. "I am very homesick after America and like Germany less and less. In fact I consider it as a prison and would give anything to get back to America,"[2] he wrote to his childhood friend H. Francis Kortheuer in 1890. Thirty-five years later, when Galka Scheyer tried without success to establish a reputation for modern German art in the United States by traveling exhibitions of the Blue Four (Jawlensky, Kandinsky, Klee, and Feininger), he became sadly disappointed about returning "home." "My art would be impossible here...I am here as an 'alien' and have great hesitations about my home country—I cherish no illusions."[3] In 1929 Alfred H. Barr, who had visited the artist in Dessau two years earlier, included him in one of the first exhibitions of the newly founded Museum of Modern Art, New York, entitled "Paintings by 19 Living Americans." Having received little acclaim in his native country, Feininger was very pleased to be re-established as an American.

To celebrate his 60th birthday, in 1931, a great retrospective of his most

significant works took place at the National Gallery in Berlin, the most prestigious exhibition place in Germany for a living artist. But only six years later some of his finest paintings were shown by the Nazis in the "Degenerate Art" show, while over 300 of his works were confiscated from German public collections.

In 1936 Feininger returned to America for the first time since he had sailed from New York to Hamburg in 1887. Like many European artists, including Beckmann, Léger, and Moholy-Nagy, he was invited by Alfred Neumeyer to teach at Mills College in Oakland, California. After a summer in Oakland and San Francisco and a short stay in New York and Connecticut, Feininger went back to Berlin to find life in Germany unbearable, and in 1937 he returned to America— first to Oakland again and then to settle in New York, the native returning as a refugee. He found New York a strange, but fascinating and confusing place, where old memories were embroiled in a new reality. Many of his European friends were there and the Feiningers became part of the intellectually active life of European refugees in New York during the war.

For two years, while adjusting himself to a new and very difficult life, he was unable to paint and when he did begin working again, his oils and watercolors showed a nostalgia for the past and an astonishment with the present. Many of his new paintings were spiritual reflections on his earlier German themes, but he also painted fantastic visions of the canyons of Manhattan, in which his immaculate graphic lines took on a new-found freedom which led ever closer to abstraction. When his retrospective exhibition was held at the Museum of Modern Art (significantly with Marsden Hartley, that other modern American painter who had done such important work in Germany), over twenty of the works exhibited were from his American period, and Alfred Barr referred to him as "Lyonel Feininger, the American artist."

The paintings from the last ten years of his life reflect the assurance of an artist who no longer struggles with problems of form, but is able to yield to his creative intuition and the dictates of his systematic mind. Like Cézanne, he experiments in watercolors and then translates his discoveries about the transparencies of light and color into the oil medium.

In the late visionary paintings, Feininger makes use of a severely linear geometry of the plane to express his reveries and to give precise, tangible form to his mysterious fantasies.

I recall visiting Lyonel Feininger in Cambridge, Massachusetts, in the summer of 1952 to discuss his art with him while working on a book on German Expressionist painting. Clearly, Feininger was not an Expressionist and neither did he consider himself a German painter. He told me how in his early years in Berlin he was looked on as the American and how, on returning to New York, he was considered a German painter. Certainly, Feininger came out of both the

German and American tradition, but his work has a universal identity: here was an artist who gave pictorial form to the rhythms of the city and the sea.

Notes

1. Lyonel Feininger, letter to Alfred V. Churchill, quoted in *Lyonel Feininger—Caricature and Fantasy*, by Ernst Scheyer, Wayne University Press, Detroit, 1964, p. 133.

2. *Ibid.*, p. 35, Lyonel Feininger, letter to H. Francis Kortheuer.

3. Lyonel Feininger, letter to Ştefan Pauson, quoted in *Lyonel Feininger*, by Hans Hess, Harry N. Abrams, New York, 1961, p. 106.

Max Beckmann: The Years in America

For J. B. Neumann

When I. B. Neumann first came to New York in 1923 one of his chief aims was to promote the art of Max Beckmann. Neumann, a connoisseur who savored the best of all periods and cultures, a wise and loveable man, a dealer passionately devoted to the work of his artists, had known Beckmann since 1912. He had published some of his graphics, had been his dealer, champion and friend, and in 1926 he mounted a Beckmann exhibition in his New Art Circle in New York, but there was little response. Additional shows, some with special issues of *Artlover* dedicated to Beckmann, were to follow.[1] Three years later Beckmann, who in Germany had now achieved a second period of national fame, received his first recognition in the United States when *The Loge* was given honorable mention at the Carnegie International in Pittsburgh. From Pittsburgh the show went to Baltimore and St. Louis and prompted America's most prestigious art critic of the time, Henry McBride, to write of the "dynamics of his brushes that even Picasso might envy . . . a personage to be reckoned with."[2]

In 1932 the recently established Museum of Modern Art organized the exhibition "German Painting and Sculpture." With six paintings and two gouaches, Beckmann had the largest single representation. Alfred H. Barr, who had organized this first exhibition of modern German art in America, reported the critical response in *Museum der Gegenwart*, quoting many of the leading critics. Whereas a conservative reviewer like Royal Cortissoz found, not unexpectedly, the work "raw, gross and uninteresting,"[3] more positive attitudes were manifested by other writers. McBride felt that Beckmann dominated the show. In an article in *The Arts*, Lloyd Goodrich found Beckmann's vitality "as brutal as any of the other expressionists, if not more so. He has a strength that they lack."[4] The young James Johnson Sweeney, writing for the *Chicago Evening Post*, compares Beckmann's *Family Portrait* to works by Grünewald, Bosch, and Brueghel and speaks of his "obsession for line, contour and volume," counting Beckmann "without question in the first rank of contemporary painters."[5]

In 1938 Curt Valentin, an erstwhile assistant to Alfred Flechtheim in Berlin, organized the first of ten Beckmann exhibitions at his New York Gallery (originally called Buchholz Gallery). This show, accompanied by a modest brochure with quotations from Alfred Barr and Waldemar George, was sent on to Los Angeles, San Francisco, Portland, and Seattle. The triptych *Departure*— its centerpiece—was also shown at the Museum of Modern Art's Tenth Anniversary Exhibition, "Art in Our Time," in 1939. The museum acquired the painting three years later. In 1930 Beckmann also received a $1,000 prize for his second triptych, *Temptation*, at the Golden Gate International Exposition in San Francisco. Although prices for his work remained rather low for quite a long time, Beckmann's work began to sell in the United States.

In the spring of 1946 Curt Valentin exhibited fifteen paintings and as many drawings which Beckmann had done in Amsterdam between 1939 and 1945. It was an important occasion. Georg Swarzenski, the former director of the Städelsche Kunstinstitut in Frankfurt and a man thoroughly familiar with the master's work, wrote a brief introduction to the catalogue from Boston, saying "Perhaps never before has his imagination and his style of materialization gained such brightness and engaging persuasiveness."[6] And Beckmann's admirer, friend, and collector, Frederick Zimmermann, recalled later: "Here...we were seeing Max Beckmann in the fullness of his career, Beckmann in full control of the techniques and materials with which he was able to realize the rich moments of his powerful and penetrating vision."[7] *Time* magazine commented that "his fiery heavens, icy hells and bestial men showed why he is called Germany's greatest living artist. He has splashed on colors with the lavish hand of a man who wakes up to find a rainbow in his pocket."[8]

Invitation from St. Louis

It was at that time that he once more received calls from America. Henry Hope offered him a teaching position at Indiana University and Perry Rathbone, then the director of the City Art Museum of St. Louis, suggested an appointment at the art school of Washington University, which Beckmann accepted.

Like many artists of this century, Beckmann, however, was filled with heavy anxieties. As these offers for positions in America materialized Beckmann noted apprehensively in his diary:

> It is altogether quite hopeless—although it will probably work out. I still cannot find my way in this world. My heart is filled with the same dissatisfaction that it was forty years ago, only all the sensations diminish with age as the trivial end—death—approaches slowly. I wish I could be more prosaic and satisfied like the Philistines around me....Everything is falling apart. Hopeless...Oh, no, bad is life, is art—but what is better? The distant land—Oh save me you Great Unknown.[9]

The "Great Unknown" was not the distant land to which he was about to embark. It was death itself—both feared and welcomed. In the final years of his life he more frequently mentioned death as well as the severe depressions he experienced. He often referred to his heart ailment, and the word *Weh* (pain) appears in the diaries in numerous places. Later on, in the remarks he made when receiving his honorary doctorate at Washington University, he said:

> Indulge in your subconscious, or intoxicate yourself with wine, for all I care, love the dance, love joy and melancholy, and even death! Yes, also death—as the final transition to the Great Unknown. . . . [10]

These were hardly words normally associated with a formal acceptance speech at an official academic function. But we are dealing with a person who fought conventions all his life, as well as with a man who was now preoccupied with death. Yet together with all this anxiety there was a great affirmation of life. In the very next sentence of the acceptance speech he states: "But above all you should love, love, love! Do not forget that every man, every tree and every flower is an individual worth thorough study and portrayal!"[11]

These remarks were made in the spring of 1950 when Beckmann was actually at the height of his renown in America. Three years earlier, before sailing to America, he wrote about the impending departure from Europe as "the last sensation—except death—which life can offer me."[12] His wife Quappi and he sailed on the S. S. Westerdam on August 29, 1947, and found Thomas Mann as one of their co-passengers. But little interchange of ideas seems to have resulted from this fortuitous meeting of Germany's foremost painter and its leading writer.

After a brief stay in New York, the Beckmanns went to St. Louis, where his reputation had preceded him.[13] The artist enjoyed the gentle atmosphere of the old American Mississippi city. Provincial yet cosmopolitan, it reminded him of his old residence in Frankfurt. A man enormously attached to the physical aspects of life, Beckmann appreciated an atmosphere so much freer and opulent than his restricted life in Amsterdam had been. He liked meeting people, going to parties, dressing up for masquerades, visiting cabarets, drinking champagne. He often mentioned the food served at dinner parties as well as the people who attended. Perhaps he saw the physical aspects of life as a step to the metaphysical, perhaps he enjoyed them on their own account. After all, as he mentioned very early in his career, quality in art "is the feeling for the peach-colored glimmer of the skin, for the gleam of a nail, for the artistic-sensuous . . . for the appeal of the material."[14] While the style and meaning of his art had changed considerably since his early controversy with Franz Marc, the importance of the physicality of his work remained paramount. This certainly is one of the reasons why his paintings, with their chromatic splendor and dense interlace of warp and weft,

have an immediate sensuous appeal which precedes any investigations of iconography.

Friends and Students

In St. Louis he enjoyed the company of H. W. Janson, who was the curator of Washington University's museum at the time. Above all, he became a close friend of Perry Rathbone, who organized a major retrospective and published a catalogue in which he wrote an important interpretation of Beckmann's work. This exhibition, which traveled to Los Angeles, Detroit, Baltimore, and Minneapolis, helped cement the artist's reputation in America.

Assisted by Quappi, who acted as an interpreter, Beckmann began to teach again after an interruption that began when the Nazis dismissed him from his teaching job in Frankfurt in 1933. "Art cannot be taught, but the way of art can be taught," he asserted in an interview.[15] His teaching position at Washington University was actually a temporary one, vacated by Philip Guston, who had received a Guggenheim Fellowship succeeded by a Prix de Rome. Guston himself had admired Beckmann's work when he first saw it at Curt Valentin's 1938 exhibition and at that time he bought a monograph on the older artist.[16] He was always fascinated by what he referred to as Beckmann's "compressed" and "loaded" pictures.[17] And there is no doubt that the experience of Beckmann's work—not only his upturned figures with legs sticking in the air or ladders pointing into infinity—had a significant impact on the American painter. In Guston's later work, as in Beckmann's, there is also a particular combination of everyday reality which makes palpable an assumed strangeness and fantasy. There is furthermore a deep sense of the tragic in the work of both artists and a close affinity in their ultimate attitude toward art and its purpose. Beckmann might have stated what Guston stressed in 1965:

> Frustration is one of the great things in art; satisfaction is nothing ... I do not think of modern art as Modern Art. The problem started long ago, and the question is: Can there be any art at all? Maybe this is the content of modern art.[18]

Stephen Greene, a former student of Guston's who joined him as instructor at Washington University a year before Beckmann's arrival, also admired the German painter for his "crowded, firmly molded compositions," as H. W. Janson observed in 1948.[19] And Greene affirms that "I still deeply admire the man. [His work] has a psychological power, a strong formal manner, it stays as the signpost of what I most admire in twentieth century painting."[20]

Both Guston and Greene had left by the time Beckmann arrived in St. Louis, but his impact continued to be felt by other artists who were his students, such as Nathan Oliveira, who studied with him at Mills College in the summer of 1950

and who recalled that "most of all he was concerned with his own vision and dream and this was critical to me."[21]

Beckmann had painted many portraits of his wife and intimate companion over the years. *Quappi in Gray*, completed in 1948, was one of the last of these likenesses that covered a great range of moods and attitudes. In this portrait she appears with poised assurance, seated with arms crossed in a self-protective manner, holding the world at a distance. This is quite a different portrayal from the more open, pliant, and freer depictions of Quappi in earlier pictures. Much of the mood of this painting is established by the muted colors of related browns, greens, and grays as well as by the narrow, vertical format and the device of framing the sitter rather tightly between a curtain on the right and what appears to be a ladder—a frequent emblem of Beckmann's personal iconography—on the left.

The students at Washington University held regular masquerade parties which Beckmann greatly enjoyed. The mask, the world of make-believe, the mardi gras were very much part of his life and work. Over the years he portrayed himself in his paintings, prints, and drawings as clown, sailor, musician, sculptor, prisoner, man of the world, ringmaster, and frequently as actor. But he was also the observer, the *flâneur*, who looked at the world as a ship of fools. As with some of the scenes of the 1920s with similar themes, *Masquerade* of 1948 is not a frolicking affair, but a vision of death. The strong man with his absurd satanic mask, tiny top hat, and large club confronts the stout cat lady who bears a large human skull in her right hand.

Images in the New Country

Beckmann generally accepted invitations to speak in different cities. In February 1948 he gave a lecture at Stephens College in Columbia, Missouri. This lecture, in the form of "Letters to a Woman Painter," encapsulates many of his thoughts about art, philosophy, religion, and life. One wonders what the young ladies of the college might have thought when Quappi read to them a passage such as:

> Have you not sometimes been with me in the deep hollow of the champagne glass where red lobsters crawl around and black waiters serve red rhumbas which make blood course through your veins as if to a wild dance?![22]

But this query does furnish deeper understanding of the artist's own visual fantasy and provides greater insight into the meaning of a painting like *Cabins*, which was done in the summer of 1948.

The Beckmanns returned to Holland in the summer of 1948 to take care of their American visas as well as to see friends and make arrangements for a permanent move from Europe to America. *Cabins*, painted in Amsterdam

directly after their arrival, was Beckmann's immediate response to the trans-Atlantic passage. It is a difficult, hermetic picture. Life on the ship is seen from its vortex. The narration does not follow linear order or time; different space cells do not mesh. A large fish with an enormous eye in the center of the painting forms a powerful diagonal thrust across the darkly painted surface. But the fish is white, like Moby Dick. A sailor, probably Beckmann himself, is trying to take hold of the monster which is tied to a board. Behind, below, above, and on the sides are episodes of the shifting facets of human life in its passage. Directly above the sailor a violent drama is being staged in this mystery play, while a mourning scene can be observed behind the window on the upper left. Below there is a voluptuous girl lying seductively on a couch. In the upper right a young blonde is combing her long hair. Below a young woman is seen drawing the picture of a ship while large white flowers bloom behind her. A ship sailing at sea inside a life raft on its side is seen on the right edge and the elevation of a blue house on the extreme left. A party seems to be taking place behind the porthole in the lower center. The two blue and orange columns cross the picture diagonally at right angles to the fish: there is no stability. In fact the make-believe world is in a state of collapse, and the sailor will never gain possession of the fish.

While working on this picture in his old Amsterdam studio, the artist began working on *Fisherwomen*, which he completed after his return to St. Louis. The fish in this picture appear to stand for phalli. Beckmann actually explained the meaning of the fish in his work to his old friend, W. R. Valentiner, who visited him in Amsterdam in July 1948 while he was working on this painting. In a "half serious, half satirical" manner he told Valentiner "that man originated in the sea and that we all derive from the fishes, that every male still has something of a particular fish about him, some are like carps, others like sharks, others like eels, which clearly reveal themselves in their love of life."[23] In this painting the phallic-looking fish are held by sensuous young women in seductive gestures. "These women," Beckmann told Quappi, "are fishing for husbands, not lovers."[24] The three nubile young girls make use of all their female allurements: the black and green stockings and garters, negligees and tight corsets, uncovered breasts and thighs. The exposed buttocks of one of the creatures is seen through the neck of a suggestively placed vase. The provocative sexuality of the three young women is contrasted to the withered old hag, holding a thin green fish in the background, a juxtaposition which the artist also used in the slightly earlier Amsterdam painting, *Girls' Room (Siesta)*, where the interlocking bodies of young girls in suggestive poses are contrasted to an old crone who seems to be reading to them. The figures and objects in *Fisherwomen*, outlined by bold and heavy black lines, not only fill the available space, but they crowd it to the point of overload. After all, "It is not subject which matters, but the translation of the subject into the abstraction of the surface by means of painting."[25]

Beckmann always worked on several canvases simultaneously and all during

this time he was involved in the completion of his triptych, *Beginning*, which he had started in Amsterdam in 1946. It was the most autobiographical of his triptychs and called forth many early memories. Not long after its completion in the spring of 1949 he set out to Colorado, where he taught at the University during the summer. He liked the Rocky Mountains, managed to do a good deal of climbing despite the high altitude, and made fine drawings such as *Park in Boulder*. He then went on to New York, where he had accepted a permanent teaching position at the Brooklyn Museum School, a job in which he took great interest. His arrival in New York coincided with the greatest moment for Abstract Expressionism, but Beckmann remained isolated from it, just as he had always stayed aloof from all the art movements of his time.[26] Indeed, pure abstraction held little interest for an artist who had stated in his London lecture: "I hardly need to abstract things, for each object is unreal enough already, so unreal that I can only make it real by painting it."[27]

Life in New York

Except for his own circle of friends, collectors, admirers, and students Beckmann remained relatively isolated in New York but certainly enjoyed being a celebrated European artist. In October he received First Prize at the Carnegie International for his *Fisherwomen*. Göpel lists no less than 23 exhibitions in 1950, 15 of which were held in the United States.[28] Living in New York, first in the Gramercy Park section and later on the Upper West Side, he delighted in going to the elegant bars at the St. Regis and Plaza hotels, not only to look at the passing scene but also to be seen. He explored Chinatown and the Bowery as well as the seedy dance halls of Times Square. In the winter he went for walks and fed the squirrels in the snow in Prospect Park.

The still-life, like the landscape, was always an important subject in Beckmann's oeuvre. His love for the material aspect of the world found its expression in these "feasts for the eyes." Often the colors create an ensemble of great richness, as in his *Large Still-Life with Black Sculpture*. Again the space is completely filled and the work seems almost noisy with clutter and agitation. There is clearly a *horror vacui* in many works of Beckmann, who would speak of his fear of being crushed by the "dark holes of space" and of painting "to protect myself from the infinity of space."[29] It is this impinging of objects on each other which negates any sense of stillness in most of Beckmann's still-lifes. In this canvas the flame of the candle gently outlines the classical sculpture. There is a bowl filled with fish, another candle, a nautilus shell, a group of pears, an epiphyllum plant which bends its blossom toward the sculpture. The lower part of the ornate mirror reflects additional objects which are not on the right table. "Many mirrors are necessary to see behind the mirror,"[30] the artist wrote in his diary just before embarking on this painting. The sickle of the new moon is seen

outside the window and on the left is once more the grid of a ladder, set at a diagonal and occupying a frontal plane. Tucked away near the plant is a copy of *Time* magazine. This piece of current reality prevents any illusion of the still-life from gaining sway and, once discovered, has an alienating effect similar to Brecht's contemporaneous theatre. The painting is certainly indebted to similar and earlier compositions by Matisse and Picasso. Beckmann's painting, however, has greater density; it is filled with ambiguities and enigmas. The Parisian painters would never have introduced a rising moon with all its romantic implications in a still-life painting or held it in place with a segment of a ladder.

Goethe once wrote that "everything is a symbol," meaning that everything stands for another thing, transcends itself, be it the ladder or the gigantic figure with outstretched legs in *Falling Man*. Beckmann said that it represents man falling through the sky on his way to earth.[31] But, undoubtedly filled with premonitions of dying, the picture stands for death and quite possibly Beckmann's belief in some sort of reincarnation into "another state of being."[32] The man travels past the burning dwellings of mankind toward magnificent burgeoning plants while supernatural beings—magical birds or angels—float in ethereal boats. The semicircular object on the left has been interpreted as the railing of a balcony and as the wheel of time. Much of the painting is taken up by the intense azure sky. Never before had Beckmann opened up a picture in this manner in order to make room for space, which, although confined between the buildings, is infinite and without horizon. Ten years after expressing his fear of space in his London lecture, he stated: "For in the beginning there was space, that frightening invention of the Force of the Universe. Time is the invention of mankind, space or volume, the place of the gods."[33]

Soon after completing this transcendent picture, the artist painted a hellish vision, *The Town*. It is closely related to his earlier masterpiece, *The Night*, done more than thirty years earlier. Again the viewer witnesses a horrible act of torture. But now the grayish tints are replaced with rich and heavy colors, the brush stroke is looser, the forms less angular. The visual flow is smoother, but the space is again a claustrophobic room. Instead of the emaciated man being gagged to death on a wooden bench, the central figure has become the voluptuous body of a bound woman on a bier with phallic bedposts. This dominant figure is again surrounded by tormentors, but here they are more symbolic and sardonic than the more literal—but also cryptic—torturers in the earlier picture. In fact no mutilation takes place in *The Town*. The figures in the back, standing in a row, are all different in scale, creating a spatial discontinuum and dissonance, "so that some of the bewildering qualities of a large metropolis are conveyed directly by this means."[34] According to Beckmann's wife, the figures from left to right represent a prostitute, a disillusioned man, a guardsman, a cynic, and a street musician. There is a bar or bordello on the right. Below the bar lies a bottle of champagne, marked "REIMS." The monkey with the mirror might represent

vanity, and the naked figure picking up coins in the center suggests avarice. The sphinx with the postman's cap holds a letter addressed to MB. Is he perhaps the messenger of death in medieval symbolism? The skyscrapers with human heads in the background "signify nothing in particular."[35] On the left bottom there is the familiar ladder stopping in midair.

The central figure of the nude in splayed pose, taken quite directly from the *Reclining Nude* of 1929, is derived ultimately from the classical sleeping Venus or odalisque, but she is no longer an idealized nude. Instead she represents Lulu, the Earth Spirit, who is about to be sacrificed in some sort of Black Mass by the demonic and disillusioned denizens of an infernal city at night. In the painting, as in other late works, events from daily life are intermingled with dream, fantasy, and myth into an allegory which conveys the ambiguities of existence. Beckmann, like Kafka who was born just a year before him, presents the absurdity of the human condition by the use of tangible but enigmatic objects and personae.

While working on *The Town* Beckmann painted a major picture to which he first referred in his diary as "Pierette," then as "Yellow Stockings" and also as "Mardis Gras Nude." Curt Valentin called the painting "Mlle D." and it is now usually known as *Columbine* or *Carnival Mask, Green, Violet and Pink*. Like Picasso, Beckmann often painted circus performers, mountebanks, clowns, saltimbanques, harlequins, and pierrots—people who like artists exist on the fringes of society. Columbine wears a black face mask and carries a pink pierrot's hat in her left hand. Her right hand, holding a cigarette, is raised to her long grayish-blonde hair. Her red lips are sealed. The woman is placed against a purple wall, interrupted by a green curtain, and is seated either on a chair with round seat or a blue drum. Its surface is covered with playing cards, "marked with rough crosses, suggesting death,"[36] that seem to be thrown out carelessly in front of her lap.

As Friedhelm Fischer has pointed out in his analysis of this painting, both the discordant color and the woman's body are foreboding. It is a threatening painting with this dark Columbine as a monster, an archetypal image of woman, both seductively inviting and ominously menacing. Beckmann was greatly interested in gnosticism as well as theosophy, and owned a copy of Helena Blavatsky's *The Secret Doctrine*. He had read Carl G. Jung's essay on "The Relation between the Ego and Unconscious"[37] and was probably intrigued by Jung's theory of archetypal unities between the personal and the collective unconscious, the tragic and the timeless, as revealed in this, one of his most powerful and memorable paintings.

The picture was painted in 1950, a year in which two artists of the next generation, Jean Dubuffet and Willem de Kooning, were also occupied with the female image. Beckmann's woman is very flattened out. Except for the volume indicated around her shoulders, she is almost two-dimensional, a feature which is

carried much further still in Dubuffet's grotesque *Corps de Dames*, where the female body is totally lateral to the picture plane, indeed becoming a pictorial flatbed. The body of Beckmann's Columbine looks as though it had been wrenched apart and reassembled in an inhuman, hieroglyphic form.[38] Again de Kooning, using a more Expressionist brush stroke, goes one step further in his series of *Women*, called *Black Goddesses* at one time. The parts of the body—arms and legs, buttocks and breasts—are almost interchangeable in his wildly distorted paintings. Both Dubuffet's and de Kooning's women, however, are endowed with cruel grins while this figure confronts us with a fearful, cold stare.

Ever since his early youth—he painted his first portrait at 15 and it is the earliest painting which the artist preserved—"Beckmann held the mirror to his face, studied his personality.... Nobody since Rembrandt has examined his own physiognomy with such penetration as Max Beckmann."[39] He completed his last *Self-Portrait* between January and May 1950 during a time of extraordinary activity when he was painting, teaching, travelling, reading, exploring, even moving to a new apartment in New York. In this final self-portrait Beckmann looks drawn, tired, exhausted—but still defiant and perhaps more elusive than ever before. He draws on his cigarette as though for nourishment and leans against the arm of a high chair. The large flashing eyes of Beckmann, always the observer, are watching. Behind him looms yet another new canvas. The most startling thing about this picture, however, is the brilliant color: the unrelieved cobalt blue of the jacket, the bright orange shirt, the green chair—all against the dark maroon back wall. The very brightness of the colors contributes to the two-dimensional appearance of the painting; their disparate, almost cruel quality gives an insolent air to this wistful figure.[40]

Travels in California

Soon after the *Self-Portrait* was completed, he left New York for another stint of teaching summer school, this time at Mills College in Oakland, California. On the way he stopped in St. Louis to accept his Honorary Doctorate degree at Washington University, travelled to Los Angeles to renew his old acquaintanceship with W.R. Valentiner, and then he stayed in Carmel for a month's vacation. He was greatly impressed by the Pacific coast. He wrote about the sea lions he saw at Pebble Beach and indeed painted a picture of them, piled up on a rock, after his return to New York. He was fascinated by the big eucalyptus trees and especially by the giant birds,[41] but he also expressed great concern about the outbreak of a new war in Korea. At Mills College he was received by Fred Neumeyer, who previously had invited Lyonel Feininger, László Moholy-Nagy and Fernand Léger to teach at the Mills summer session. Neumeyer remembered Beckmann looking like a bulldog wearing a white tuxedo; he commented on discussions with the artist about Hölderlin and

Schopenhauer, Greek, Indian mythology, and the Cabbala.[42] While at Mills, Beckmann could see the whole range of his later work in an exhibition of paintings from the collection of his great patron, Stephan Lackner.

West Park and *Mill in Eucalyptus Forest* were painted in New York immediately after his return and represent his impression of the Mills College campus. *San Francisco*, based on a cursory drawing in his diary, is one of Beckmann's rare cityscapes. Like Kokoschka's portraits of the cities of Europe, it is a panoramic view seen from a high vantage point. *San Francisco* is a brightly colored, very dynamic painting with the curved arrow of Doyle Drive rushing past the Palace of Fine Arts towards the heart of the city which itself appears to be vibrating. A crescent moon and a sunset appear in the eastern sky in Beckmann's painting, which combines several aspects of the city seen from different viewpoints. In the immediate foreground he has placed three black crosses apparently stuck into the black earth of the curving ground. On the right above his signature is the fragment of a ladder.

Religious subjects occur frequently in Beckmann's early oeuvre, both in the more traditional paintings such as *The Flood*, *The Crucifixion*, or the huge Rubensian *Resurrection* canvas during his early romantic period, and also in more Gothic and expressive scenes such as the *Deposition* of 1917. In his late work, however, he veiled his message in more cryptic imagery, adopting instead the sacramental form of late German medieval altarpieces. In 1932, at the age of 48, he began a series of triptychs, completing nine and leaving one unfinished at the time of his death. Without doubt the paintings which took the greatest concentration and show the deepest profundity are those in which he was able to synthesize reality and fantasy, the known and the unknown, most completely. In his diaries he refers to them as "Triptiks" (sic), which is the German word for the papers a motorist needs in order to cross the borders. Indeed, Beckmann used these major works to charter his trip through life. These paintings are often hermetic and esoteric, and in his London lecture he cites the Cabbala, saying:

> What I want to show in my work is the idea which hides itself behind so-called reality. I am seeking for the bridge which leads from the visible to the invisible, like the famous cabbalist who once said: "If you wish to get hold of the invisible, you must penetrate as deeply as possible into the visible."[43]

Their message, ambiguous and often concealed, is best comprehended by initiated individuals who have the proper set of mind and feeling. In a letter of 1938 in regard to *Departure* he wrote to Curt Valentin:

> ... If people cannot understand it of their own accord, of their own inner "creative empathy," there is no sense in showing it. ... I can only speak to people who consciously or unconsciously, already carry within them a similar metaphysical code.[44]

·

As we know, Beckmann always worked on several paintings at the same time. Before completing the *Argonauts* he had started *Ballet Rehearsal*, telling his wife that "this triptych would not give him much trouble and it would be completed in a much shorter time than all the others. This one would become a humorous and gay triptych."[45]

Left unfinished, this work permits us to observe how the artist committed his first ideas to a canvas which might, in fact, have taken a long time to finish. It reveals his methods in painting, showing all the steps from the original charcoal black outlines to the introduction of oil paint. In his first diary entry on December 3, 1950, referring to this triptych, Beckmann calls it "Artistinnen" (circus performers), and indeed the women on the left wing are ballet dancers who gave the triptych its later name. But on December 5, when, presumably, he was working on the center panel, he referred to it as "Amazons," which recalls his early *Battle of the Amazons*, in which life is asserted with a Nietzschean vitalism and "Will to Power," and where the women are slaughtered in a violent battle with men. Now in this last painting, the only indication of a male is the face (perhaps Beckmann's) which seems to peer through the porthole in the right wing. Except for the lone voyeur, this is a world in which only women are in attendance.[46]

The Last Triptych

Beckmann's last completed triptych, *Argonauts*, can be seen as his testament. The left panel, originally called "The Artist and His Model," shows the painter practically attacking his canvas. The man resembles van Gogh in Gauguin's portrait of his painter friend at work; during the time in which Beckmann worked on the triptych—March 1949-December 1950—his diaries contain a number of very sympathetic references to "Vincent." In April 1949, for instance, Beckmann noted that he was rereading van Gogh's letters and in November he went to see the van Gogh exhibition at the Metropolitan Museum. Beckmann must have identified with the energetic painter, yet it is the mask on which the woman is seated which has the greatest resemblance to his features. The woman, representing Medea[47] in the Argonaut saga, brandishes a sword which also looks like a symbol of virility. She can be seen as threatening, but she is probably meant to be a protectress or an inspiring muse.

The right panel depicts the chorus of Greek tragedy—the intermediary between the action on the stage and the audience. Its purpose is to provide psychological distance and dramatic structure by means of measured comment. Beckmann's chorus is a chamber orchestra of beautiful, calm women playing and singing. While it is for the man to create and to engage in the adventure of life, it is the woman holding a sword who guards or inspires his genius, or the woman with guitar singing of his exploits. The right wing with the women rising in tiers,

the stringed instruments on their necks reversed to fit into the oblong composition, and the deeply reverberating colors which resemble stained glass combine in one of the most beautifully resolved paintings in Beckmann's oeuvre.

The painter's canvas in the left wing forms an acute triangle with the ladder in the central panel. The two are related. In fact in south German dialect the word *Staffelei* signifies both an artist's easel as well as a ladder. The ladder had often served Beckmann as a symbol of anguish, longing, and fulfillment in the same manner as the canvas is the artist's proving ground. Here the ladder no longer stands empty. The wise old man emerging from the sea has withstood all his trials and has completed the long journey. He now beckons with a prophetic gesture to the two young Argonauts setting out on their heroic adventure. On the right is Jason, a beautiful youth—the final state of an ideal figure which occupied Beckmann for a lifetime and made its first appearance in *Young Men by the Sea* in 1905; we see the same basic composition again in 1943. Both these paintings were important landmarks in his career. The composition is also related to paintings by Hans von Marées, a painter whom Beckmann always held in high esteem. The elbow of Jason rests on red rocks, their color inspired by the Garden of the Gods in the Rocky Mountains near Boulder. On his wrist is a fabulous bird, whose blue head and brown and green feathers may refer to the magical wryneck which Aphrodite gave Jason to help Argonauts pass through the Clashing Rocks of Symplegades. The gentle youth in the high center, adorned with a wreath of flowers in his hair and golden bracelets on his arm, must be Orpheus, whose orange lyre lies on the yellow beach beside him. According to Apollonius of Rhodes, Orpheus was the first of the large crew of Greek heroes enrolled by Jason to sail the Argo. The old man may be Phineus, the king who had advised the Argonauts to send a dove out from their boat to explore the way, and who had been blinded by the gods for prophesying the future. But he may also be Glaucus, builder of the Argo, who later became a sea god endowed with the gift of prophesy.

The painting may at least in part be indebted to the interpretation of the Argonaut myth by the Swiss cultural historian J.J. Bachofen, which was known to Beckmann.[48] Bachofen saw the myth, which describes the first encounter of the Greeks with the barbarians, as referring to the revolutionary change from a more ancient culture in which the "female principle" and greater harmony with nature prevailed over a culture of male dominance and Promethean striving.[49]

In the pink sky above the heroes Beckmann painted a purple eclipse of the sun, outlined by a fiery orange ring. On September 5, 1949, he expressed his astonishment when reading about sun spots in Humboldt and wrote: "I never knew that the sun is dark—very shaken."[50] Two orange new planets were included at this historic moment and they orbit between the sun and the crescent of the waxing moon.

The space in *Argonauts*, when compared with the earlier triptychs and

other compositions, is less jammed. The painting is not as violent or disparate, but is imbued with calm serenity and measure. The struggle between good and evil, the old dichotomy of black and white, no longer fully engaged the mature painter. He is now concerned with that spark of human activity which beckons to the great adventure, the quest for the Golden Fleece, and beyond that, to the achievement of peace and transfiguration. The old man-god points, as Beckmann might have said, to a plane of different consciousness.

On December 17, 1950, Beckmann sent his last letter to his son. He wrote: "I am just painting a triptych, *Argonauts*, and in 'Dodona' we shall see each other again."[51] This was ten days before he died. Dodona was the sanctuary of Zeus where an ancient sacred oak communicated the will of the god by the rustle of its leaves to those mortals who could understand the sound.

Notes

1. I. B. Neumann, "Sorrow and Champagne," in *Confessions of an Art Dealer*, p. 43 (typescript of unpublished manuscript in possession of Dr. Peter Neumann, Palo Alto, California, who graciously permitted me use of the manuscript).

2. Henry McBride in *Creative Art*, V (1929), p. 15.

3. Quoted in Alfred H. Barr, "Die Wirkung der deutschen Ausstellung in New York," *Museum der Gegenwart*, II (1931-32), pp. 58-75.

4. Lloyd Goodrich, "Exhibitions: German Painting in the Museum of Modern Art in New York," *The Arts*, XVII (April 1931), April 31, p. 504.

5. James Johnson Sweeney, quoted in Alfred H. Barr, "Die Wirkung der deutschen Ausstellung," p. 71.

6. Georg Swarzenski, Introduction to *Beckmann* (New York: Buchholz Gallery Curt Valentin, 1946).

7. Frederick Zimmermann, *Beckmann in America* (address delivered before the Max Beckmann Gesellschaft in Murnau, July 1962), New York, 1967, p. 6.

8. "German Seeker," *Time*, XLVII, May 6, 1946, p. 64.

9. Beckmann, entry of September 17, 1946, in *Tagebücher*, p. 177.

10. Beckmann, "Ansprache für die Freunde und die philosophische Fakultät der Washington University, 1950," trans. Jane Sabersky, in *Max Beckmann* (New York: Curt Valentin Gallery, 1954).

11. Ibid.

12. Beckmann, entry for August 23, 1947 in *Tagebücher*, p. 214.

13. In 1946 the St. Louis City Art Museum had purchased his *Young Men by the Sea* from Curt Valentin's 1946 exhibition. The Washington University Gallery of Art acquired *Les Artistes with Vegetables* from the same show.

14. Beckmann, "Gedanken über zeitgemässe und unzeitgemässe Kunst," in *Pan* (1912), pp. 499-502. Translated in Peter Selz, *German Expressionist Painting* (Berkeley and Los Angeles, 1947), p. 240.

15. Dorothy Seckler, "Can Painting be Taught?" *Art News*, L:I (1951), p. 30.

16. Dore Ashton, *Yes, but* (New York, 1976), p. 64.

17. Ibid., p. 73.

18. Philip Guston, "Faith, Hope and Impossibility" (lecture given at the New York Studio School, New York, May 1965), in *Art News Annual*, 1966, pp. 101-3, 152-53. It is interesting that among the leading American painters it was only Philip Guston who, going beyond abstraction, formulated paintings which are great visual allegories of the anxiety of modern life by turning into his own inner self toward the end of his life. Like Beckmann before him, Guston said in 1978: "The visible world, I think, is abstract enough. I don't think one needs to depart from it in order to make art." (Guston, Lecture given at the University of Minnesota in 1978, printed in *Philip Guston* [London: Whitechapel Gallery, 1982].)

19. H. W. Janson, "Stephen Greene," *Magazine of Art*, XLI (April 1948), p. 131.

20. Stephen Greene, letter to the author, November 14, 1982.

21. Nathan Oliveira, letter to the author, November 2, 1982.

22. Beckmann, "Letters to a Woman Painter," translated by Mathilde Q. Beckmann and Perry T. Rathbone, quoted in Peter Selz, *Max Beckmann* (New York: Museum of Modern Art, 1964), p. 133.

23. W. R. Valentiner, "Max Beckmann," in *Blick auf Beckmann: Dokumente und Vorträge*, edited by Hans Martin von Erffa and Erhard Göpel, Munich, 1962), p. 85.

24. Mrs. Mathilde Q. Beckmann in an interview with the author, New York, April 1964.

25. Beckmann, "On My Painting" (lecture originally delivered as "Meine Theorie in der Malerei"), given at the New Burlington Gallery, London, July 21, 1938. English translation in Herschel B. Chipp, Peter Selz, and Joshua C. Taylor, *Theories of Modern Art* (Berkeley and Los Angeles: University of California Press, 1968), p. 188.

26. Beckmann, for example, always resented being called an Expressionist. In his Washington University lecture he said, "I personally think it is high time to end all isms."

27. Beckmann, "On My Painting," in Chipp et al., *Theories of Modern Art*, p. 188.

28. Erhard and Barbara Göpel, *Max Beckmann, Katalog der Gemälde* (Bern, 1976), vol. II, pp. 107-8.

29. Beckmann, "On My Painting," in Chipp et al., *Theories of Modern Art*, p. 188.

30. Beckmann, entry for July 7, 1949, in *Tagebücher*, p. 339.

31. Beckmann's own interpretation as transmitted by his wife to the author.

32. Beckmann, entry for October 28, 1945, in *Tagebücher*, p. 140.

33. Beckmann, "Letters to a Woman Painter," in Selz, *Max Beckmann*, p. 132.

34. Margot Orthwein Clark, *Max Beckmann: Sources of Imagery in the Hermetic Tradition*, unpublished Ph.D. dissertation, Washington University, St. Louis, 1975, p. 333.

35. Göpel and Göpel, *Beckmann, Katalog*, vol. II, p. 497.

36. Friedhelm W. Fischer, *Max Beckmann* (London, 1972), p. 86.

37. Peter Beckmann (ed.), *Max Beckmann Sichtbares und Unsichtbares* (Stuttgart, 1965), p. 110.

38. Fischer, *Max Beckmann*, p. 85.

39. Selz, "Einführung," in Peter Beckmann, *Beckmann Sichtbares und Unsichtbares*, p. 5.

40. Selz, *Max Beckmann*, p. 97.

41. On June 19, 1950, writing in Carmel, he says that he finally learned the name of these exotic birds: "Corcorane." He was probably referring to the Cormorant, a large black aquatic bird found on the Pacific coast.

42. Fred Neumeyer, "Erinnerungen an Max Beckmann," *Der Monat*, IV (1952), pp. 70-71 and "Prometheus im weissen Smoking," *Der Monat*, VII (1955), pp. 71-73.

43. Beckmann, "On My Painting," in Chipp et al., *Theories of Modern Art*, p. 187.

44. Beckmann, unpublished letter to Curt Valentin, February 11, 1958, cited in Selz, *Max Beckmann*, p. 61.

45. Mathilde Q. Beckmann, in *Beckmann* (New York: Catherine Viviano Gallery, 1964).

46. This was pointed out to me by Robert Rifkind, who has both Beckmann's *Battle of the Amazons* and *Ballet Rehearsal* in his collection.

47. Göpel and Göpel, *Beckmann, Katalog*, p. 508.

48. Ibid.

49. Charles S. Kessler, *Max Beckmann's Triptychs* (Cambridge, Massachusetts, 1979), pp. 94-95.

50. Beckmann, entry for September 5, 1949, in *Tagebücher*, p. 348.

51. Beckmann, letter to Peter Beckmann, December 17, 1950. Published in *In Memoriam Max Beckmann* (Frankfurt am Main, 1953).

III

Art and Politics

The American Presidency in Political Cartoons: 1776-1976

The Changing Presidency

In 1945, at the end of World War II, Pablo Picasso wrote in *Les Lettres Françaises:* "... painting is not done to decorate apartments. It is an instrument of war for attack and defense against the enemy." This famous statement, made only a generation ago by the century's greatest artist, has all the more relevance at a time when so-called "color-field" painters under the guise of "modernism" decorate board rooms and the white, glazed expanses of banks with brightly painted acrylic stripes. Although most artists from Egyptian sculptors to today's "modernists" have been an arm of the Establishment, cartoonists and caricaturists have generally agreed with Picasso's pronouncement and have certainly been at their best when at their most critical. Caricature is an expressive, exaggerated, at times violent art. It cannot be analyzed in the formalistic language of such critics as Clive Bell, Roger Fry, or their present-day followers. "Significant Form" is rarely of concern to the man out to ridicule or destroy his political enemy; yet political art can achieve the intensities and heights of greatness to be found in the work of Hogarth, Goya, Daumier, George Grosz, John Heartfield, and Picasso.

There really is no such thing as abstract caricature, nor—to state the obvious—are the pictorial subjects of landscape or still life suitable for caricaturization, although of course, *paintings* of such subjects can be satirized, which, in a way, is what Roy Lichtenstein has been doing with remarkable success, and perhaps this is what Edouard Manet did back in 1863 in his *Déjeuner sur l'herbe*. Caricature by its nature is descriptive and has its source in western art at the time of the Reformation and the Peasant Wars, when it was used as a very powerful weapon to deal with the hypocrisy of the Papacy, with suppression of the populace by feudal landlords, or when it attacked the then sacrilegious teachings of Luther and other reformers. From its very beginnings caricature is a literary and anecdotal art form. Whereas high art was brought to fruition under

the patronage of church or princes, the flowering of caricature has its origins in popular art. We can learn a great deal more about the life of the people, their customs, their way of living, dress, and habits, from Holbein's woodcuts rather than from his paintings. But Holbein's woodcuts or Breughel's paintings and engravings are not caricature in the sense of *caricare*, i.e., to exaggerate. Even Leonardo's grotesque heads, which he called "physiognomic studies," were explorations of the frontiers of human form without the aspect of satire or comic purpose essential for the art form with which we are concerned here.

Caricature probably had its beginnings in the late 16th century in Bologna with the work of the Carracci who, precisely because they were engaged in idealizing the human form in the Grand Manner, rather than with attempting to copy nature, could also find enjoyment in exaggerating human features. It would seem that as long as artists were chiefly concerned with gaining a visual grasp on reality, the distortion of it was not yet possible. Caricature deals with truth—at least truth as seen by the caricaturist—which is different from beauty (*pace* Keats) as it is from reality. It often deals with ugliness and appears, therefore, precisely at the time when a norm of beauty is clearly established. Caricature is a form of wit or satire and as such usually has a moral purpose. It is not detached from life, and is more utilitarian than "pure art." Caricature is also bound by the time and place in which it was made and may, therefore, need more explication than pure painting or sculpture. While it can give us much information about the time, life, and thought of its origin, like other popular arts, it can date rather quickly. Yet, at its best, the political cartoon is able to retain amazing freshness and elicit an immediate response.

In their excellent essay on *Caricature*, the art historian E. H. Gombrich and the psychologist Ernst Kris suggest that the hidden and unconscious aim of fun, or wit, including caricature, is concerned with magic—that to copy a person, to mimic his behavior, is to annihilate his individuality. This is a shamanistic truth. The Navajos were aware of such dangers when they consistently prohibited artists or photographers from making visual records of their ceremonies, or any image of themselves. Perhaps because of this proscription they were able to maintain their culture when other Indian tribes had lost their identity. Today, when largely due to the abundance of media information and the semi-sophistication of the public, caricature—like most other forms of expression—has lost some of its direct power, it may be difficult to understand the seriousness with which this art form was approached in earlier times. Until the 17th century, artists were permitted to draw only the common people in a satirical fashion; only the humble could be seen as dogs or wolves or swine, whereas the exalted were not to be defaced.

Political caricature, or cartoon, as it began to be known in the 19th century, was feasible only after certain preconditions were established, primarily the general acceptance of a norm of beauty and the mental freedom to be able to

separate the symbol (i.e., the drawing) from the reality of the person to be satirized, ridiculed or castigated. In addition to these conditions, there also had to exist a climate of political freedom engendered by political stability, which permitted artists or writers to engage in satire. Such freedom first appeared in Europe in England under the Hanoverians at the end of the 17th century, and enabled writers like Daniel Defoe and Jonathan Swift to write their magnificent parables, and William Hogarth to eternalize the people—the rich and the wretched—of the time with moral passion and extraordinary artistic talent. He fused a classical sense of form with the popular tradition of Northern Europe, envisioning the world as a stage on which the human comedy is enacted.

Caricature is a graphic medium and for that reason required further preconditions to its development: the invention of mass printing methods and the availability of a support, i.e., paper, on which the image could be imprinted. In order for caricature to be effective, furthermore, a system for its distribution had to exist; over the centuries this system changed from broadsheets to humor magazines, and finally to newspapers.

The vocabulary of printmaking reflects a clear comprehension of the artist's attitude, which, especially in printed caricature, is one of attack. The printmaker working in a wooden block would *cut* into it, while the etcher uses a *needle* as well as *acid* to create the desired *bite*. Rare indeed is a good political cartoon in which the artist tries to show his subject in a favorable light.

Although a few early American cartoons were woodcuts, and there are occasional etchings, the majority were engravings issued as broadsheets. Engraving had been the medium of Hogarth, and of his important successors Thomas Rowlandson, George Cruikshank, and James Gillray. Gillray was actually the first artist to specialize in political cartoons, whether commentaries on the social scene in England, biting attacks on the French Revolution, or an occasional charge against these new United States. The earliest American prints come, interestingly enough, from the hands of illustrious political leaders, such as Benjamin Franklin's "Join or Die" of 1754, which appeared in many newspapers from Philadelphia to Boston, or Paul Revere's color engraving, "The Boston Massacre" of 1770, anti-British propaganda under the guise of a realistic rendering of the event. Franklin was a printer by trade and Revere not only a silversmith but an engraver.

Since the printmaker is intimately involved with the tools and techniques at his command, the medium has always had an important effect on his work. In engraving, the artist works slowly with a cutting tool, the burin. The engraved plate is inked and thereafter wiped clean until the ink remains only in the engraved lines. The prepared plate, overlaid with a sheet of dampened paper, is passed through a press, the pressure of which forces the paper fibers into contact with the ink-filled recessed lines of the plate. Fine details can be successfully reproduced by this technique. Most political cartoons of the early years of the

United States were printed in this manner, but actually, since newsprint for broadsheets or even for newspaper was very scarce, few political cartoons exist, especially in the period before Andrew Jackson was elected President in 1828. Stylistically the early cartoons follow British examples to a considerable extent, as in the work of William Charles, himself a Scot. Originality was not an issue of great importance at the time. As a matter of fact, it can be observed in general that the political cartoonist is not so much concerned with originality of form or content as is the painter or sculptor, much as a similar observation can be made about journalism when compared to poetry or prose. In contrast to English models, American cartoons, often cluttered with people with speech balloons issuing from their mouths, were simpler and more primitive in style. There was no Royal Academy propagating the Grand Manner in the United States. In early American cartoons, there is more humor in the verbal messages than in the caricaturists' distortions or the quality of their drawing.

In 1796, Alois Senefelder of Bavaria discovered a new technique which subsequently transformed printmaking. Lithography is a swift and inexpensive printing method based on the principle that oil and water do not mix. The artist draws his image with wax crayon on a smoothly dressed granite stone. The image is fixed chemically in the stone and the stone itself is moistened with water, then inked. The crayon image repels water but attracts and holds ink whereas the crayoned wet areas of stone repel the ink. Stone and overlaid paper are passed through the litho press to obtain a mirror-reversed image, as in all printing. Great subtlety of shading can be achieved in lithography, and the production of colored lithographs is easily accomplished by using a series of stones, one stone for each color to be added to the finished image.

Lithography made printmaking easy and, most important, rapid. The technique of drawing directly on stone encouraged a loose style appropriate to art for popular media. The artist could make his drawing, then leave the rest of the labor to the printer. The lithographer's stone surface, unlike the engraved plate, does not break down after repeated use. Lithograph images may be pulled indefinitely, in almost unlimited numbers. The ease of preparing a stone and of drawing on it—unlike the laborious, time-consuming preparation of an engraving plate—made lithography an ideal technique to distribute popular art forms, to edit political material whose timeliness might be crucial to the effectiveness of its message, and to serve the demands of an ever-widening public.

Lithography became popular almost at once. It reached its zenith in France in the work of Honoré Daumier, who made some 4,000 lithographs for the humor magazines *Caricature* and *Le Charivari*, both initiated in Paris in the 1830s. Here Daumier made caricature into a monumental statement. His observations of man, his artistic invention and brilliant draftsmanship, his deep sense of human dignity and outrage at repression, have never been equalled.

While the profound humanism and political acuity of Daumier were not attained by artists in the United states, American caricaturists began to flourish in the Jacksonian era. Andrew Jackson himself, the first American "log cabin" President, broke with the Federalist tradition whereby only members of the intellectual and social elite were elected to the highest office. Jackson was a man of colorful personality who provoked the kind of controversy necessary to produce good cartoon images. Lithography, introduced just before his election, enabled the art of cartooning to spread, especially after large printing houses such as Currier and Ives began to produce vast quantities of prints. Most cartoons of the pre-Civil War period, however, were rather hackneyed—predictable and naive both in drawing and political awareness. No powerful social satirist, no individual of personal vision comparable to Hogarth or Daumier, emerged on these shores. It must futhermore be kept in mind that Andrew Jackson's personal magnetism notwithstanding, Congress, rather than the President, was of prime interest to the public. Jackson's successors, moreover, were men of no particularly strong individuality or power. In fact this country was served by a series of mediocre Presidents, uninteresting individuals who did not call forth the kind of energy necessary to inspire work of very high quality by cartoonists.

Even when Abraham Lincoln, a President whose personality was in every way fascinating, came to the White House in 1861, he was generally accorded pejorative treatment by cartoonists. Particularly during his first term, he was often portrayed by them as foolish and incompetent, an image encouraged by Lincoln's gawky, countryman appearance, his high-pitched nasal Illinois twang, and his lewd barnyard humor. But as Lincoln gained extraordinary powers during the Civil War and extended the reach of his office to unprecedented levels of authority, cartoonists such as Frank Bellew began to realize that here was a President whose historical significance was evident, and whose intellectual stature, despite his mannerisms, was unique. Lincoln's bony frame, his craggy face, and inimitable bearing came to dominate cartoon images of him.

In England, where political opinion favored the Confederacy, Lincoln was sharply attacked by Sir John Tenniel, famous for his illustrations of Lewis Carroll's *Alice in Wonderland*. Matt Morgan, who later came to the United States, also made Lincoln his target. No American cartoonist had the skill or bite of Tenniel or Morgan. In fact, most of the important American cartoonists throughout the 19th century were foreign-born and largely foreign-trained. William Charles had come from Scotland. Bellew, the most original cartoonist at mid-century, was born in India of British parents. Frank Leslie, who was to publish the first successful humor magazine in America, was also born in England, as were William Newman and Matt Morgan, who did fine cartoons for Leslie's *Weekly*. Dr. Adalbert Volck, a practicing dentist in Baltimore, who did fine anti-Union cartoons in secret, came from Germany, as did America's greatest cartoonist, Thomas Nast. In the next generation, the leading men in the

field were also foreign born: Joseph Keppler came from Austria and Bernard Gillam from England. Perhaps a chief reason explaining the lack of an important native American cartoonist during the 19th century was the fact that no formal standards of visual beauty had been established here, and therefore there were no clear norms to distort. Fidelity to nature was by-and-large the aim of serious art in America.

At mid-century, humor magazines flourished not only in Paris, but also in London, where, in 1841, *Punch* was first published. Germany had its *Fliegende Blätter*, and *Kladeradatsch*, Austria its *Kikeriki*. Similar attempts in the United States met at first only with the briefest success, largely because they lacked a true sense of satire and humor, as one observer of the time remarked: "Many funerals are conducted in a manner far better calculated to minister to the sense of the ridiculous."[1] It was only when Frank Leslie established his *Illustrated Weekly* in 1855, to be followed by *Harper's Weekly* two years later, that humor magazines became successful in this country, a success owed largely to the extraordinary talent of one artist, Thomas Nast.

Nast, who began working for *Leslie's Illustrated Newspapers* (its original name) in 1855 at the age of fifteen, became America's first major political cartoonist. The German-born Nast had come to New York at the age of six. In 1860 he sailed for England and soon thereafter he joined Garibaldi's revolutionary forces in Italy as a correspondent. It seems quite likely that this experience also helped shape his own strong political stance. In 1862, again in America, he was hired by *Harper's Weekly* to send back sketches from the battlefields of the Civil War. These sketches were as significant in the history of American political cartoons as were Matthew Brady's photographs for the history of photography.

Having no major American standards, Nast chose English cartoonists, men like James Gillray, John Leech, and especially Sir John Tenniel, as his models. During his stay in Europe he also managed to study in the museums of Italy, France, Germany, and England, and somehow learned enough history and literature to fill his work with allusions to classical literature, Shakespeare, Cervantes, and the *Arabian Nights*.

Interestingly enough, Thomas Nast preferred the laborious process of wood engraving to the ease of lithography. Wood engraving creates a relief; the artist, working on an end-grain block, cuts away with knife or gouge all areas of the surface not intended to print. Wood engraving was developed to a high state of competence by Thomas Bewick in London in the late 18th century, and is a technique by means of which a great variety of shades and precise fine lines can be achieved, qualities unique to this process.

Thomas Nast's reputation as a great cartoonist is based solidly on his 1871 drawings attacking Boss Tweed and the Tammany Ring, prompting Tweed's famous demand to "stop them damn pictures." But Nast persisted in his

campaign with biting eloquence until this particular crook, who had corrupted the entire city government of New York, was ousted from office. Boss Tweed escaped to Spain, was recognized there from one of Nast's cartoons published in *Harper's Weekly*, extradited to the United States and ended his days in a New York jail. A clear example of the effect of art on politics!

Nast was active and highly effective in every Presidential campaign for over two decades, supporting Republicans until the nomination of Grover Cleveland in 1884. Ulysses S. Grant stated that Nast's pencil helped him win his office. In his editorial cartoons Nast formalized the basic iconography of the American political cartoon with such symbols as the Democratic Donkey and—his own inventions—the Republican Elephant and the Tammany Tiger and stamped these symbols on the American mind. When he left *Harper's Weekly* in 1887, his departure was partly responsible for the decline of that journal. He, in turn, lost his chief stage and political power. There was also the question of technological obsolescence: as photomechanical processes of reproduction were increasingly used in magazines and newspapers toward the end of the century, Nast's wood-engraving style went out of fashion and artists skilled in the new technique became popular.

"The great events in the nineteenth century history of prints were the discoveries of photography and the attendant photo-mechanical processes."[2] William Ivins goes on to assert that "in the whole history of human communication it is doubtful if any more extraordinary step had ever been taken than this."[3] The invention of photography, of course, pre-empted many of the informational and reportorial purposes of the older print techniques. But the use of photochemical processes for half-tone reproductions of both black and white and color prints made a new and cheaper way of visual communication practical.

By these means it became cheaper to produce cartoons, and during the last quarter of the 19th century, as America expanded economically and grew more prosperous, people could begin to relax, enjoy life, and laugh at themselves. Large new humor magazines were founded, such as Joseph Keppler's *Puck*. Keppler, a Viennese actor and artist, had come to St. Louis in 1867 and established *Die Vehme* and then *Puck*—both in German. He then went to New York and by 1877 he brought out an English edition of *Puck* which became highly successful because of his elaborate colored cartoons of trenchant satire and light-hearted wit, which appeared on the front and back covers as well as the centerfold of the weekly. Like Nast, Keppler did not resort to speech balloons and banderoles; he also used many Shakespearean and other literary references in his captions. His important competitor was the English-born cartoonist Bernard Gillam, whose sparkling work graced the pages of *Judge*, founded in 1881. (Another humor magazine, *Life*, appeared at this time; it was, however, more interested in social satire than in political commentary.) *Puck* and *Judge* exerted enormous political influence at the end of the century, primarily because of their

large editorial political cartoons. Although they continued to exist until World War I, it was the daily newspaper that began to provide the chief platform for cartoonists at the turn of the century.

The newspaper cartoons which began to proliferate during the early years of the 20th century are simpler in style and freer in execution. When daily deadlines had to be met, there simply was not the time for the careful elaboration of the color lithographs of the humor magazines. Cartoonists now worked largely in pen and ink and their drawings were reproduced photomechanically by the daily presses. Newspapers all over the country from New York to San Francisco eventually employed their own home cartoonists.

William Randolph Hearst managed to attract two particularly able individuals to his *New York Journal*. One of them, Frederick Burr Opper, had worked for *Puck* for some eighteen years and had developed a style of whimsical and droll drawings, filled with funny Lilliputian creatures. His work was similar to the drawings Lyonel Feininger was doing in Berlin for German humor magazines, as well as for the *Chicago Tribune*. Opper's mischievous comic strip wit was in contrast to the work of Homer Davenport, whom Hearst brought from New York for the *San Francisco Examiner*. Davenport had a visual imagination and power which had not been seen since the days of Thomas Nast. One of his memorable works, a cartoon done in 1900 for the front page of the *Journal*, depicts the figure of the Cleveland capitalist Mark Hanna—gross, fat, his suit covered with dollar signs and labor's skeleton beneath his feet—standing on the pedestal from which he has usurped George Washington, whose statue in front of the U. S. Treasury Building on Wall Street is being carted away to make room for Hanna, the true political power in his day. Other cartoonists who began to make important contributions to the political life of the early part of the century were men such as T. McCutcheon, who had started with the *New York Evening Post* and then worked for the *Chicago Daily Tribune* for 43 years; Clifford K. Berryman of the *Washington Star* and Jay N. Darling ("Ding"), who drew about 17,000 rather intricate cartoons with a conservative message for the *Des Moines Register* and the *New York Tribune*.

Newspaper cartoonists, as well as the men who continued working for the humor magazines, were lucky in having a fabulous subject in the White House for two terms. Theodore Roosevelt was a controversial, ruthless man of great energy and physical prowess. His appearance, with his toothy, broad grin, his thick glasses and his walrus mustache, was perfect grist for the cartoonist's mill. Even better, of course, were the behavior and the verbal expressions of the carrier of the Big Stick, the self-styled Trust-Buster, the Rough Rider, the Gunboat Diplomat, the Muckraker, the Bull Moose, the Big Game Hunter, Teddy.

The style of political cartooning changed little during the next decades. Cartoonists amused themselves with the enormous bulk of William Howard Taft

or ridiculed the scholarly personality, the progressive stance and reforming zeal of Woodrow Wilson, who by cartoonists like Iowa's "Ding" and others was frequently shown as a woman—which was bad enough—but worst of all as a schoolmarm. Nothing, really, could have been more degrading for an American President. Who in these United States would want a scholar or a teacher for the highest office in the land? The anti-intellectualism which had its beginnings in American political life with Andrew Jackson had become all-pervasive and was reflected in the work of the cartoonists who were, after all, in the employ of the newspapers. During World War I most cartoonists actively engaged in patriotic propaganda for recruiting or selling Liberty Bonds, as did the many artists who produced the flood of war posters of the time.

A very different kind of cartooning was to be seen in the Socialist magazine *The Masses*, founded by Max Eastman in 1911. With John Sloan as art editor many of America's leading painters and draftsmen, among them George Bellows, Robert Minor, Boardman Robinson, Stuart Davis, and Art Young, contributed to this left-wing journal. However, most of these artists were not really cartoonists and were willing to work as illustrators for the sake of their political beliefs. Rarely indeed did *The Masses* or its successors, *The Liberator*, *The Worker's Monthly*, and *The New Masses*, publish cartoons against a President, because as Marxists journals, they were more concerned with fighting the system than with taking issue with any individual. Art Young, Sloan's successor as art editor of *The Masses* and a man able to combine a great sense of satire with a powerfully drawn line, produced a series of superb cartoons, explaining that "practically all of them are generalizations on the one important issue of this era the world over: Plutocracy versus the principles of Socialism...."[4] While these men may not have created prints of the political and artistic incisiveness and perspicacity of a George Grosz or an Otto Dix, they certainly developed a socially conscious art, which recorded the miserable condition of the American working class, in opposition to the newspaper establishment, which ignored it.

Their serious satire was only rarely picked up by the world of official cartooning, although an excellent artist like Daniel R. Fitzpatrick of the *St. Louis Post-Dispatch* was clearly influenced by his more radical colleagues. During the post-war period, cartooning became an increasingly accepted field of journalism and the Pulitzer Prize Committee established a special award category for cartooning, the award to be determined, interestingly enough, by a jury of journalists rather than artists or art critics. Rollin Kirby, a good draftsman distinguished by his free and sketchy line who was working for the *New York World*, received the Pulitzer Prize for a political cartoon in 1922 and was honored by two additional Pulitzer Prizes in the years to follow. It was Kirby who invented the humorous figure of Mr. Dry, a ragged bum with umbrella and silk hat who showed a slight resemblance to Daumier's Ratapoil. After Prohibition (a highly popular topic for the cartoonist) became a dead issue, there were the

more serious matters of the Depression, Fascism, and World War II to deal with, as well as that most colorful personality, Franklin Delano Roosevelt.

The second Roosevelt had a splendid, large-jowled face, a long cigarette holder, a broad grin, a mysterious smile. His strong stands on a variety of economic and political issues—generally very controversial ones—made this four-term President and world leader a great subject for satire of all kinds on the part of American and foreign cartoonists, noteworthy among which were the clever and delightful Art Deco drawings of Mexico's Miguel Covarrubias for *Vanity Fair* and the caricatures of England's David Low, whose brilliant wit, broad and forceful line, and political insight made him the finest caricaturist of his time. *The New Yorker*, founded in 1925, became the leading organ for cartoons in America after the older humor magazines folded. It established its own sophisticated style of drawing, particularly appealing to both the intellectual and the social elite. It managed to attract such outstanding talent as Peter Arno, James Thurber, and the inimitable Saul Steinberg—men, however, whose wit in general was not directed toward the President.

During the post-war years editorial newspaper cartoons—like other forms of journalism—increasingly became syndicated, so that the same cartoon, be it Harry Truman's frozen smile, Eisenhower playing golf with his office staff, or John F. Kennedy as the charismatic Knight of Camelot, could be chuckled over the breakfast table from Boston to Los Angeles. New cartoonists reached great popularity in the post-war years, men such as Bill Mauldin, who had first come to national attention with his satirical drawings for *Stars and Stripes*, in which he showed the true foxhole experiences of "Willie and Joe." In the *St. Louis Post-Dispatch* and later the *Chicago Sun-Times*, Mauldin continued his ironic attacks on the establishment, being a particularly strong advocate of civil rights. Herbert L. Block (Herblock), working for the *Washington Post*, established his own influential style—partially indebted to the American comic strip—a style which relies as much on the salty wit of his verbal as on his visual message. He became the most admired political cartoonist of a generation, especially after he carried out a powerful campaign against Joe McCarthy's witchhunts and associated hysterical anti-Communist activities of the 1950s. Although he did not measure up to Thomas Nast as an artist, Herblock once more became a political force so that Richard M. Nixon, who has always been a favorite subject of liberal cartoonists, said in 1960, upon receiving the Republican nomination for the Presidency: "I have to erase the Herblock image."[5]

Cartoonists had a field day with Lyndon Baines Johnson, with his big Stetson hat and his friendly Texan drawl about the "Great Society," and his long justification of a debilitating war in Southeast Asia that many still consider to have been illegal. Indeed, Johnson's schizophrenic politics and Nixon's unmitigated lust for absolute power, by means of which criminals were able to masquerade as apostles of "law and order," created an Orwellian situation which renewed the force of political cartooning. It was, in fact, the resulting

disillusionment with politics on the part of the young that brought new life to the American political cartoon, originating largely in the underground press, the political poster, and other manifestations of counter-culture. The more orthodox political cartoonists, Herblock and Maudlin, Pat Oliphant, Paul Conrad, Hugh Haynie, and Lou Grant were followed by a new crop of draftsmen, men such as Robert Grossman, David Levine, Ranan Lurie, Robert Pryor, Edward Sorel, and Paul Szep. These cartoonists, unlike their predecessors, went to art schools such as the Ontario College of Art, the Art School of Cooper Union, or Pratt Institute. Levine even went to Hans Hofmann's art school in New York, although little of the abstractionist's push-pull theory of painting is evident in the art of the young draftsman.

Today, as in the 19th century, many of the younger American cartoonists are foreign born and trained. Pat Oliphant, syndicated from the *Los Angeles Times*, is Australian, and his intricate, droll, and often involuted style is indebted to England's famous social cartoonist, Ronald Searle. Canadian-born Paul Szep, called the "Boston Strangler" on account of his virulent attacks on corruption and hypocrisy, developed a highly individualistic drawing style. Ranan Lurie, who was born in Israel and studied there, as well as in Paris, is a professional painter as well as a cartoonist; his work appears in New York, London, Paris, and Israel. All of these men, as well as Edward Sorel (whose book, *Making the World Safe for Hypocrisy*, is a superb example of the new art of satire) and Harold M. Talburt, have brought new vitality to the political cartoon in America.

Another source for the new art of political satire is the renewed popularity and sophistication of the comic strip. Jules Feiffer, a playwright and filmmaker as well as cartoonist who draws a strip cartoon for the *Village Voice* and *Playboy*, was largely responsible for bringing politics back into the world of the comic strip. His example has recently been followed by Garry Trudeau's highly popular "Doonesbury."

The renaissance of the political cartoon in America was certainly unpredictable. It seemed, for a time, that the purpose and function of the political cartoon were a matter of the past. For one thing, a valid form of beauty from which the cartoonist could diverge no longer exists in the visual arts. Once distortion became completely accepted as art, whether the personal emotional impulse of the Expressionists, the surgical breakdown of the human form into geometric planes by the Cubists, or the transformation of the human figure into fantastic dream images by the Surrealists, it became very difficult for the cartoonist to find his own form of distortion. Cartoonists, therefore, went on, doing their editorial jobs at a remove from the developments in high art. Things became even more difficult, however, when an artist like Roy Lichtenstein became extolled by critics, art galleries, and museums for his painted lampoons of cartoons and comic strips. What, now, remained for the professional cartoonist himself to do?

Another problem facing the cartoonist during these last twenty years has

been the competition of the visual media. How may he possibly rival the reality of seeing the actual horror of Mai Lai on the evening news, or with witnessing the faces of our political leaders during the Congressional hearing by the McCarthy or the Ervin Committees?

But art and the history of art remain unpredictable. Political art, which, in America, had become pretty much extinct after the late 1930s and the disillusionment of radical artists with the Hitler-Stalin pact, became a new reality in the 1960s. Cartoonists again engaged themselves in the battle against war and corruption. They grew a great deal more aggressive when America was engaged in aggression in Viet Nam, and even more so when the administration attempted all kinds of tricks—old and new—to stifle the free press. Suddenly—and this is a very recent development—art galleries which heretofore had used their space only for high art, began showing drawings by political cartoonists. The very concept of art began to expand. During the last decade, art has increasingly become a part of life rather than the special concern of artists and cognoscenti. In the last ten years, artists have created earthworks in the desert, curtains across canyons, protest murals in the ghettos. Happenings, environments, street art, body art, process art, conceptual art, all have expanded the range of art far beyond what had been known or accepted before. With Viet Nam and Watergate, political protest art has once again found a wide following in America, a source of strength for the battle against the Establishment. The brilliant caricaturist David Levine, working in the *New York Review of Books*, renewed the art of the political caricature with his whimsical, old-fashioned style of shaded drawing, resulting in works of trenchant, devastating, sardonic wit. Levine's politicians generally carry their own attributes, be they Churchill's cigars, LBJ's stomach scar in the shape of the map of Viet Nam, Nixon eating grapes while embracing a swine. A great caricaturist, Levine expresses his passionate protest by means of poignant satire with a result that affects the attitudes of the viewer. Even President Ford, gazing forlornly at a gallery of U. S. political cartoons, recently conceded, "The pen is mightier than the politician."[6]

Notes

1. Richard Grant White, "Caricature and Caricaturists," *Harper's New Monthly Magazine*, April 1862, p. 606.

2. William M. Ivins, Jr., *Prints and Visual Communication*, Cambridge, Mass., 1953, p. 115.

3. Ibid., p. 177.

4. Stephen Hess and Milton Kaplan, *The Ungentlemanly Art*, New York, 1966, p. 143.

5. John D. Weaver, "Drawing Blood," *Holiday*, August 1965, p. 72.

6. Stanley Kanfer, "Editorial Cartoons: Capturing the Essence," *Time*, February 3, 1975, p. 63.

The Artist as Social Critic

Expressionism, the vanguard art movement of pre-World War I Germany, was primarily concerned with creating works of spiritual vitality, emotional content, and passionate authenticity. Problems of form were of secondary importance to the expressionists. They strongly believed that an artistic revolution could help bring about a radical social and political change by purifying and transforming the individual. Abstraction, coming from "inner necessity," could, they hoped, create a new consciousness by affecting the viewer directly on a subliminal and primary level with its universal message of creativity.

In 1912 the German art historian and critic Wilhelm Hausenstein, a strong advocate of expressionism at the time, concurred with the move toward abstraction, declaring that "art which is tied to the object is a primitive form of art."[1] But eight years later, after the end of the war, Hausenstein reversed his position and welcomed the "salvation of the individual in the object." He now recalled the "limitless intensity of expressionism," its "chiliastic madness and greatness," but also noted that this kind of cosmic painting had degenerated into mannerisms, that it did not explain the catastrophic postwar situation. "Der Expressionismus ist tot."[2]

Similarly Wilhelm Worringer, whose influential treatise of 1908, *Abstraction and Empathy*, was related to expressionism in its attitude and style, noted in 1920 that in expressionism "men in hopeless solitude wished to find a community.... Agitated revelations, visionary flashes of light have been handsomely framed, declared permanent and degraded to peaceful wall decorations."[3]

The expressionists had rejected realism, that is, an art relying on the visible world, in favor of a subjective search for inner reality. They longed to communicate these deeper values to an undefined "people" and share with them their turbulent and often prophetic visions. But by 1920 Armageddon had occurred: four years of trench warfare, followed by misery, starvation, riots, murders, assassinations. Apocalyptic events occurred daily. The holocaust had been predicted by expressionist poets (von Hoddis, Benn, Heym, Trakl) and

painters (Kandinsky, Marc, Meidner, Kokoschka), but now in the daily postwar chaos, there was no longer the need for visions. The war had not turned out to be the great cleansing experience which the painter Franz Marc, among others, had foreseen as a "moral breakthrough to a higher experience."[4] Instead the war had killed ten million people—including Marc, who fell in action in Verdun in 1916—and wounded another twenty million. When it was all over, when armistice was finally declared, the nature of political power had not changed significantly throughout most of Europe, but most of the values of European civilization had been shattered. In 1918 Oswald Spengler published a book in which he thunderously announced *The Decline of the West.*

The armistice of November 1918 was preceded by nausea of war and followed by turmoil. In Germany the Revolution of the Left was quickly aborted by the assumption of power by the moderate wing of the bourgeois Social Democratic Party, which was soon embroiled in bloody battles with the left-wing Spartacist group. There was much bloodshed in Berlin, Hamburg, and Munich, and throughout Saxony. The German bourgeoisie was not ready to accept a revolutionary government of the left, and the Social Democratic Party became the organ of law and order, suppressing revolutionary elements. The threat from the left was answered by the murder of its leaders, Rosa Luxemburg and Karl Liebknecht, in Berlin, and little was done to stop the militant right from assassinating the leaders of the short-lived Soviet Republic of Bavaria. The old order was restored. The Imperial German military, although decimated by four years of war, was reconstituted under its old chauvinistic officers' corps. The unreconstructed judicial system condemned men of the left to death sentences or long imprisonment while rightists were hardly troubled at all. Even Hitler was to serve less than a year in light imprisonment after his *Putsch* of 1923. The ruinous inflation that devastated the economy of Germany (in November 1923 one U.S. dollar was worth 42 trillion marks) hit the average citizen even harder than the war itself; it was finally resolved by an adjustment of Germany's obligations to pay reparations to the Allies. The United States established the Dawes Plan to help rescue a fellow-capitalist country, and the German currency was stabilized. For a brief time during the 1920s businesses and industry recovered; nevertheless the number of unemployed workers rose rapidly from some three hundred fifty thousand in 1921 to over four million ten years later. The old establishment was consolidated, however, when the long-retired general and war hero Paul von Hindenburg was elected president of the German Reich in 1925 and Germany was accepted in the League of Nations the following year.

Soon after the abdication of the Kaiser (November 9, 1918) and the armistice (November 11), artists, architects, writers, and musicians established the Novembergruppe in Berlin, calling on "Expressionists, Cubists, Futurists" to produce a new art for a new time. In 1919 the Workers' Council for Art was founded and published its *Call to All Artists* for a socialist art and architecture, its

fervent message still communicated in an idealistic, utopian, expressionist style. Although these groups intended to attack all bourgeois values, the educated middle class accepted their art while ignoring their political message. The Novembergruppe continued to exist throughout the period of the Weimar Republic. But in place of its earlier program to establish a new relationship between the artist and society, it became little more than an organ for exhibitions.

Even before the end of the war Dadaism came to Berlin. The Berlin Dadas had no use for either the style or the politics of their liberal colleagues, disdaining above all their continuing faith in spiritual renewal. In Zurich, where Dada had its origin, pacifist exiles attacked all cultural values—including art; in New York, Dada was essentially a remote aesthetic manifestation in spite of its anti-art stance. In Berlin, however, Dada was a provocative political event. When Richard Huelsenbeck returned to the German capital in 1917, the possibility of a revolution was very real. He joined the Herzfelde brothers and the poet Franz Jung and the painters George Grosz, Raoul Hausmann, and Johannes Baader, the "Oberdada," all partisans of that revolution. They had nothing but scorn for the expressionists, who "on pretext of carrying on propaganda of the soul . . . have in their struggle with naturalism found their way back to the abstract emotional gesture which presupposes a comfortable life free from content or strife."[5]

Although expressionism could no longer survive the reality of daily life in postwar Germany, certain aspects of the movement remained: its innovative form and the conviction that a work of art by a committed artist could reform life through new personal awareness and that it could raise the moral level of society. This belief underlay the powerful political statements of brilliant radical artists like George Grosz and John Heartfield, who were largely responsible for the strongly communist direction taken by Berlin Dada in the early 1920s. It is also echoed in the basically utopian theories of the architect Walter Gropius, who in forming the Bauhaus hoped to reinstitute the cooperation among architects, sculptors, and painters that existed under the medieval guild system.

At the Bauhaus significant painters like Kandinsky, Klee, Schlemmer, and Feininger continued their formal experimentation, but most of the art in Germany during the postwar period focused on the external world, dealing with the grim reality at hand. The trend toward realism was by no means unique to the art of Germany during this time. This tendency toward an art of the real is traceable to Picasso's Ingresque *Portrait of Ambroise Vollard* (1916), a pencil drawing which can be said to have inaugurated his "classical" period. At about the same time André Derain's accommodation of the art of the past became paradigmatic for many artists, including the erstwhile futurist Gino Severini. Georges Braque renounced cubism, and even Robert Delaunay painted representational pictures. Jean Cocteau published his influential *Rappel à l'Ordre* in 1926. In Italy the painters of the Scuola Metafisica, although disrupting

logic, gave a new and often mysterious meaning to the object. After the war a group of important Italian painters formed the Novecento group and published the Roman journal *Valori Plastici*, advocating a return to ordered and rational painting in the Italian Renaissance tradition. They were not without sympathy for Mussolini's glorification of the Italian past. English vorticism had come to an early death with the end of World War I, and reactionary government policies brought about the demise of constructivism in the Soviet Union. In the United States also the early experimentation in pictorial abstraction by members of the Stieglitz circle, John Marin, Marsden Hartley, Arthur G. Dove, and Georgia O'Keeffe, came to an end. Each of these artists now developed a personal visual vocabulary to describe the forms and forces they saw in the real, visual world around them.

Just as Berlin Dada was more strongly politicized than its counterparts in Zurich, New York, and Paris, so also was new realist painting more political in Weimar Germany than elsewhere. Even there, however, not all of these new realists were politically engaged artists. When Gustav Hartlaub, director of the Kunsthalle in Mannheim, organized the landmark exhibition in 1925 which he called "Neue Sachlichkeit," he was very much aware that there was a conservative or "classicist" wing as well as the politically committed left wing. Picasso, with his neoclassical paintings of nudes, belongs in the former category, as do most of the Italianate Munich "Magic Realists" of the 1920s. The more radical artists, whom Hartlaub called "Verists," included George Grosz, Otto Dix, and Georg Scholz, as well as Max Beckmann. Hartlaub sent out a circular in 1923 which first announced an exhibition in which he meant to assemble paintings by artists who rejected both "impressionistically vague and expressionistically abstract" art and whose work was "neither sensuously external nor constructively internal." He appealed to artists "who have remained true or have returned to a positive, palpable reality" which would enable them to reveal the true face of our time.[6]

Hartlaub's term "sachlich" was first used some twenty years earlier by Hermann Muthesius, the head of the German Werkbund, to convey his opposition both to the lavish decoration of architectural historicism and to the nonfunctional linear decoration of Jugendstil. "Sachlich" was applied to trends in architecture and design which began to take form in the early years of the century and which were characterized by functional simplicity. It was a similar factual and honest objectivity or sobriety that Hartlaub recognized in the painting of "tangible reality," taking shape all over Germany in the early 1920s, the period of stabilization and further industrialization of the German economy.

By the mid-1920s, in fact, "sachlich" was used to characterize not only new architectural and artistic styles, but also the style of factual journalistic reporting, a new kind of popular fiction, and the new *Realpolitik* of men like Gustav Stresemann. Hartlaub's categories within Neue Sachlichkeit of Right or Classicist and Left or Verist wings have largely been accepted by recent Western

scholars on Weimar art. Marxist scholars, on the other hand, use the term "Neue Sachlichkeit" for the "rational," industrialized, and dehumanized art of the middle class during the stabilization period of the Weimar Republic, an art whose pictorial motifs are isolated and not cognizant of the social and political context. They accept the use of the term "Verism" for the left-wing group that developed largely out of Berlin Dada, and which was an art involved in the class struggle. Other subdivisions such as a breakdown by the most important centers—Berlin, Munich, Karlsruhe, Dresden, Breslau, Hanover, Cologne, and Düsseldorf—have also been suggested.

There were indeed many differing aspects to the new realism in Germany. Perhaps the most useful and most precise subdivision, however, is one based on political ideologies which was suggested by Roland März for the large exhibition *Realismus und Sachlichkeit*[7] held in East Berlin's National Gallery in 1974. März discerns the following five groupings:

1. Berlin Dada (Hausmann, Schwitters)
2. Verism (Grosz, Dix, Beckmann, Hubbuch, Scholz, Schlichter, Schad)
3. Neue Sachlichkeit (Grossberg, Radziwill, Räderscheidt, Kanoldt, Schrimpf, Mense)
4. Proletarian-Revolutionary (Griebel, Nagel, Grundig, Völker, Querner)
5. Political Constructivism (Hoerle, Seiwert, Nerlinger)

The present exhibition deals primarily with März's Verist, Neue Sachlichkeit, and Political Constructivist groupings. Almost all the paintings by the "Proletarian-Revolutionary" artists are in East German collections and could, unfortunately, not be borrowed for this exhibition.

Many of these painters adopted a realistic attitude in their endeavor to picture without sentimentality a highly charged place and time. Many of them, although politically committed, painted pictures whose formal qualities appear detached. It is, of course, never possible for a painting to be an accurate mirror of reality. To begin with, the two-dimensional surface differs markedly from the three-dimensional world. Furthermore, many of these new realists were engaged individuals who tried to penetrate to a deeper understanding of reality and its meaning. They would certainly have agreed with Bertold Brecht's observation that "A photograph of the Krupp factory tells us next to nothing about the place."[8]

Individuality was no longer held as a sacrosanct value by many artists in the postwar period who thought of themselves as social beings. At the same time that the Bauhaus set up a program to integrate the artist into a technological society, the Verists and other radical left-wing artists sought to become an integral part of the social structure. They knew like Daumier a hundred years earlier that "il faut être de son temps." They found a new and tough post-expressionist form to give form to their polemics. They painted commonplace

themes, mostly of urban life. They observed the cabarets, the dance halls, and the night life. Their paintings reflect a world which we know from Brecht's plays and von Sternberg's films. With whores crowding the streets of German cities during the depressed years of the Republic, they expressed their disgust with or protest against a system which prostituted many of its women and degraded its men. Some of them glorified the peasant and worker, while others revealed the misery of their existence. Industry and technology became a significant subject. Factories were at times analyzed with cool detachment or even with a sense of promise. The subject painted most frequently by the German realists, however, was the portrait—including the self-portrait—probably because it was there that the cool and sober, static and analytical approach of these artists could find its theme. The clinical analysis of the self or others was a way of investigating the nature of the human race.

George Grosz formed the link between Dada and the later, less frenetic Verist movement. In 1918 when the surviving veterans returned from the trenches, he, called "Propagandada," walked the Kurfürstendamm in Berlin, dressed as Death. To the idealist message of the expressionists, *"der Mensch ist gut,"* he countered *"der Mensch ist ein Vieh."* But, above all, Grosz felt that his art had to be in the service of a political and social revolution. "My art was to be my arm, and my sword," he recalled, "pens that drew without a purpose were like empty straws."[9] With a total commitment to the masses, Grosz developed a knife-hard and incisive drawing technique. The individual and his destiny were no longer of prime importance in his analysis of the human figure. People in his polemical paintings, drawings, and prints, although realistic enough, are transformed into signs and ciphers. His work indicates a belief that a person's social position and political stance shape his psychological responses and even his physiognomy. In other words, he developed a truly materialistic, or, if such exists, a Marxist style in his art. People stand for the class to which they belong. They are cogs in the wheel of the socio-political super-machine.

Grosz remained active as a communist artist until the mid-1920s, publishing portfolios of prints and drawings for political journals, and painting powerful oils. In all of these he attacked the ruling class, the military, the capitalists, and the clergy, and revealed the ruthless exploitation of the working class. He also ridiculed the upstanding German *Bürger*, the "pillar of society," and exposed the sexual depravities that prevailed in postwar Berlin. Three times the artist was arrested and tried by the authorities for slander, blasphemy, and defaming public morality.

His scepticism and pessimism reasserted themselves in the mid-1920s. The revolution in Germany had not materialized and the artist, although remaining loyal to the communist cause for some time, was disappointed by a visit to the Soviet Union. When he gained recognition and began to be shown at Flechtheim, Berlin's most influential gallery of modern art, he shifted his thrust from

political to a less controversial social criticism and slowly his style grew softer years before he left for the United States to become a romantically conservative artist and teacher at the Art Students' League.

Otto Dix was looked on by many artists as the leading figure of the Verist movement. Like Grosz, Dix came from a working class family. He was always enamored of the German Renaissance and romantic masters and under their influence he developed a precise realism. He painted incisive portraits in a pointed and often cruelly realist style. Having served in the trenches, Dix painted and etched the most horror-evoking depictions of the war since Goya. His *War* series was the shocking pictorial equivalent of Erich Maria Remarque's novel *All Quiet on the Western Front*. Dix also painted the crippled veterans, the prostitutes, the beggars—the various victims of war whose appearance was so common in the German cities of the 1920s. His style, far from being soberly detached, is often intensely passionate but always controlled. His figures often strike the viewer as being grotesque, but he worked in and criticized a world that was incongruous indeed. Although most painters of the Neue Sachlichkeit worked in one of Germany's art centers, Otto Dix moved from Dresden to Düsseldorf and on to Berlin, finally returning to Dresden to a professorship at the academy in 1927, and was in contact with Verist groups in all these cities.

Rudolph Schlichter and Georg Scholz were important members of the Verist group. Both had studied in Karlsruhe with the popular sentimental painter Hans Thoma and the impressionist landscapist Wilhelm Trübner. After their return from the war, they were close to the Dada group in Berlin (Schlichter was actually a member) and thereafter they were active in Berlin radical circles. In 1924 they were founding members of the Rote Gruppe, a communist artists' association dedicated to art in the service of the class struggle. Schlichter was an almost clinical observer of the Berlin scene, of its sexual obsessions and fetishisms, and of its people: he created incisive portraits of Berlin intellectuals such as Bertold Brecht and the radical journalist Egon Erwin Kisch. Scholz brought his talent to bear on paintings of workers and peasants in which he depicted the frightening effect of industry on the old and established order of life, but he also produced still lifes and sunny landscapes. Karl Hubbuch also came to Berlin from Karlsruhe and painted the city and its people, caustic, cynical, and precise. All three artists were partisans of the left who depicted their sober subjects with clear and severe realism, accusatory without resorting to sentimentality. Along with other painters of the Neue Sachlichkeit, they showed a preference for static and quiet form and for thin application of pigment that did not disclose personal brushwork.

The most meticulous, the most photographic paintings were those of Christian Schad. Schad, although not a politically engaged artist, is generally classed with the Verists in discussions of the Neue Sachlichkeit. Born in Bavaria, Schad became a member of the Dada group in Zurich and Geneva, where he

invented the photograph without camera, called "Schadograph" by Tristan Tzara. This was in 1918, several years before Moholy-Nagy originated the "photogram" and Man Ray the "rayograph." In the 1920s, first in Naples, then in Vienna and Berlin, Schad turned to portraiture, presenting himself and his friends with cold detachment. His portraits are painted with painful fastidiousness and seem almost like surgical performances. His figures are removed from their time and their place and seem totally self-centered, alienated from a world to which they do not belong, alone in their chilling solitude.

Max Beckmann, too, exhibited with the Verists. It is difficult, however, to place Beckmann, one of the towering geniuses of modern art, into any group or movement. Beckmann, who had painted colossal pictures of cataclysmic events in a romantic style before the war, underwent a radical change in style caused by the horrors of war. He felt the need to be engaged in the struggles that embroiled Germany, writing in 1920: "Just now, even more than before the war, I feel the need to be in the cities among my fellow men. This is where our place is. We must take part in the whole misery that is. We must surrender our heart and our nerves to the dreadful screams of pain of the poor disillusioned people.... Our superfluous, self-willed existence can now be motivated only by giving our fellow men a picture of their fate and this can be done only if we love them."[10]

After Beckmann was discharged from the medical corps of the German army in 1916, the works he produced were certainly related to the work of the Verists, and indeed anticipated much of the content and form of the group. He painted pictures of contemporary concern. He painted his observations with great clarity of detail and created pictures in which almost rigid figures exist in precise and angular compositions with a precise sense of order. He painted them in light colors with a thin application of the brush. All these aspects of Beckmann's art relate him to the Verists, but unlike them, Beckmann looked at the physical world as a means of finding his own entry to the metaphysical. His protest against the state of things was not primarily social or political but religious in nature. Even in his most realistic pictures, there is a sense of the mystery of existence. Later he articulated this when he wrote: "What I want to show in my work is the idea which hides itself behind so-called reality. I am seeking for the bridge which leads from the visible to the invisible, like the famous cabalist who once said: 'If you wish to get hold of the invisible you must penetrate as deeply as possible into the visible.' "[11] There was nothing mystical in the work of the so-called Proletarian Revolutionaries. The strongest representatives of this group were the painters Karl Völker, Hans Grundig, and Kurt Querner, who worked in the highly industrialized Saxony region. Völker, the oldest of this group, painted a cycle of murals for a Socialist meeting hall in his native Halle in the early 1920s in which he depicted the class struggle within a framework of Christian iconography. Völker became an active member of the Rote Gruppe, and altered his style in the mid-1920s, making it clear, rational, and

dynamic. His best-known paintings represent large groups of industrial workers on the move, and are carried out with pictorial economy. While the Verists pictured the misery of the working class, painters like Völker followed a different strategy. His paintings exhibit a mighty proletariat, united in class solidarity and confident in their power.

Grundig and Querner were very close to Otto Dix, who worked in Dresden after his discharge from the army in 1916 until 1922, returning there as a professor of the academy in 1927. Grundig, an active member of the Communist Party from 1926 on, concentrated on explicitly proletarian themes in strong propagandistic paintings. At the end of the decade he painted prophetic pictures of terrifying, ghostly cities with empty streets and threatening skies.

Querner, the artist closest to Dix, was also aware of the masters of the German Renaissance. In the 1920s he drew pictures of the disenfranchised, the unemployed, the hungry. He painted workers on hunger marches and the impoverished peasants working small parcels of poor soil. Querner, even more than his Dresden contemporaries, allowed himself to be influenced by Courbet's famous *Stonebreakers*, that great revolutionary painting of 1849 which occupied a place of honor in Dresden's Gemäldegalerie until it was destroyed by the firebombing of 1945.

The three Saxon artists were members of the "Association of Revolutionary Visual Artists of Germany" (ARBKD), a communist organization that absorbed the Rote Gruppe in 1928. The association's theoretical polemics, as articulated by Alfred Durus, were Marxist in the narrowest sense, defining art solely as a matter of class conflict. Members of the ARBKD were expected to produce agitprops, street decorations, political posters, propaganda sculpture. Much of this work was effective at a time when a communist revolution in Germany seemed possible and when Russia's prestige among German intellectuals and artists still stood high. After the crash of 1929, economic conditions worsened and both the extreme left and right became more militant. Although the ARBKD boasted of sixteen local groups and close to 800 members in 1933, it did not attract many of the better-known German artists.

When the Cologne group of Progressive Artists applied for membership in the ARBKD, they were refused because of their "anarchist tendencies."[12] In Cologne Heinrich Hoerle and Franz Wilhelm Seiwert, the "Political Constructivists," attempted to combine a radical artistic style with revolutionary politics as had seemed possible in Russia during the years just preceding and following the October Revolution. Like other artists in Germany in the 1920s they were influenced by the metaphysical painters of Italy, but they were also aware of cubism, purism, constructivism, and de Stijl, and were in touch with many of the artists of the European avant-garde. As radical and humanist Marxists, they objected to the authoritarian program of the Communist Party. In their painting, a faceless human image is part of a technological, mechanical

world. The human figure becomes a geometric form and a standardized, objectified, and universal sign.

The Cologne painter Anton Räderscheidt, although apolitical, was a friend of the Progressives. He, more than anyone else in Germany, reflects de Chirico's influence. His figures are lonely and isolated from each other and the world. As he "continued to explore the theme of alienation, so his art acquired a more personal character, transforming the wildness of the expressionist *angst* into a coolly detached yet brutal psychological study of himself."[13] Most of Räderscheidt's work was lost or destroyed during the time of Hitler, but judging from what has remained and from photographs, his paintings of men dressed in black suits and bowler hats, unrelated to the nude women in the empty space they share, look very much like stills from Antonioni's films.

Human beings are totally absent from Carl Grossberg's cold world of machines and industrial landscapes. Grossberg was fascinated by the new technological equipment, and his own work with its clear, sharp lines, its quick mechanical perspectives, its hard surfaces showing no imprint of the human hand, seems itself to be machine-made. In his technique of thin applications of brightly-colored paint he resembles Charles Sheeler; both artists, furthermore, accepted the technological world without criticism, and were sought out by industrial concerns who gave them commissions to make paintings of their factories, much as English aristocrats in the eighteenth century engaged artists to make paintings of their country houses. It was work like Grossberg's that prompted Brecht to write his poem "700 Intellectuals pray to an oil tank."

Although most of the left-wing artists of the Neue Sachlichkeit were denounced by the Nazis, prohibited from painting, and their work exhibited in monstrous "Degenerate Art" shows, a painter like Grossberg could be tolerated. Art sponsored by the Nazis, glorifying the land, the family, the hero, was generally more painterly, academic and sentimental, but their ideologues could find precedents both in the nebulous folk mythology of the expressionists and in the idealization of the industrial world, as well as in the clean, realistic style of Neue Sachlichkeit painters. On the other hand they totally condemned both the expressionists' subjective search for inner truth and the rational attitude and revolutionary political commitment of many Neue Sachlichkeit artists. But like the expressionists, who felt that their art could change human consciousness, and many of the Verists, who believed that their art could help in the revolutionary class struggle, the Nazis took art seriously. Paul Schulze-Naumburg, who was a leading race theorist of the Nazi movement, wrote in 1932, just prior to Hitler's assumption of power: "in German art rages a battle for life and death, no different from that in the field of politics. And next to the fight for power, this struggle must be pursued with the same seriousness and the same determination."[14] And certainly this was done.

That art and politics do indeed mix becomes clear from any study of Weimar

Germany. Rarely in modern times has art become more intimately interwoven with the socio-political framework than it was during these turbulent years. In fact, the acute social and political problems stimulated certain artists and helped produce a vital art of realist engagement with the political situation. The socio-political condition acted as a catalyst which energized many of the artists to produce outstanding work. The importance of this stressful stimulation cannot be overemphasized: when the political situation changed with the Nazi assumption of power and the strangulation of the arts, many of the artists went into exile and their work suffered enormously. The sense of direction and the core were gone.

Notes

1. Wilhelm Hausenstein, *Die Kunst in diesem Augenblick* (reissued by Prestel Verlag, Munich, 1960), p. 256.

2. Ibid., p. 265.

3. Wilhelm Worringer, lecture to the Deutsche Goethegesellschaft, Munich, November 1920; published in *Künstlerische Zeitfragen* (Munich, 1921), p. 18.

4. Franz Marc, "Die neue Malerei," *Pan* 2 (1912): 556.

5. Richard Huelsenbeck, "Dadaist Manifesto," in Hans Richter, *Dada, Art and Anti-Art* (New York, 1965), p. 104.

6. Gustav Hartlaub, "Werbendes Rundschreiben," 18 May 1923, in F. Schmalenbach, *Kunsthistorische Studien* (Basel, 1971), p. 21.

7. Roland März, Introduction to *Realismus und Sachlichkeit: Aspekte deutscher Kunst 1919-1933* (Staatliche Museen zu Berlin, 1974).

8. Bertold Brecht, *Gesammelte Werke* (Frankfurt a.M. 1967), Vol. 17, p. 161.

9. George Grosz, *A Little Yes and a Big No* (New York, 1946), p. 163.

10. Max Beckmann, "Schöpferische Konfession," Berlin, 1920, as translated and published in Peter Selz, *Max Beckmann* (New York, 1964), p. 32.

11. Peter Selz, *German Expressionist Painting* (Berkeley, 1957), p. 240.

12. Jürgen Kramer, "Die Assoziation Revolutionärer Bildener Künstler Deutschlands (ARKBD)" in *Wem gehört die Welt* (Berlin, 1977), p. 183.

13. Robert Jensen, "Political Constructivism: The Cologne Progressives" (unpublished masters' thesis, University of California, Berkeley, 1979), p. 50.

14. Paul Schultze-Namburg, "Kampf um die Kunst," *Nationalsozialistische Bibliothek*, Vol. 36 (March 1932), p. 5.

John Heartfield's Photomontages

In the early months of World War I, the Kaiser and his militarists succeeded in persuading patriotic Germans to greet each other on the street with "God Punish England." This particular kind of chauvinistic idiocy caused the young painter and graphic designer Helmut Herzfelde to change his name forthwith to John Heartfield. The Kaiser's officials naturally refused to legalize this "un-German" appeal for change of name, but "the name Heartfield proved to outlast the Kaiser's empire"—so writes Wieland Herzfelde, the artist's brother and life-long collaborator, in the first important monograph on John Heartfield, which has just been published in Dresden.[1]

Heartfield was born in Berlin in 1891, son of a socialist poet. Orphaned at the age of eight, the boy was brought up by various relatives and in sundry institutions. By 1910 he had found his way to becoming an art student in Munich, and he soon grew to know the radical thinkers and artists, before a wide gulf began to separate the artistic and political revolutions.

In the search for new forms to express a new conviction, Heartfield and his friends discovered photomontage. Originally, it seems that the soldiers on the Western Front, unable to get their reports of butchery past the censors, turned to pasting together photographs and cutouts from illustrated papers to tell their tale of horror to their families and friends back home. Using this ingenious technique, as well as the collage of the Cubists, Heartfield and his close friend, George Grosz, invented the new technique of photomontage. A dozen years later George Grosz recalled to Erwin Piscator: "When John Heartfield and I invented PHOTOMONTAGE in my South End studio at five o'clock on a May morning in 1916, neither of us had any inkling of its great possibilities, nor of the thorny yet successful road it was to take. As so often happens in life, we had stumbled across a vein of gold without knowing it."[2]

It is possible that Grosz took too much credit in this matter. Grosz, Raoul Hausmann, and Hannah Höch were experimenting with photomontage in Berlin and so was Rodchenko in Moscow. But the invention was probably Heartfield's and the technique remained central to his work. He, who had little

understanding of painting, pursued this new medium and developed it into a major art form.

Active in the revolutionary atmosphere of the German capital at the time of the disintegration of the German empire, the Berlin Dadas adopted an activist political position different from that of the original Zurich cohort or of the slightly later group in Paris. While the Dadaist Tristan Tzara continued to announce, "Dada ne signifie rien," Hausmann and Huelsenbeck were calling for "the international revolutionary union of all creative and intellectual men and women on the basis of radical Communism." The new art and the new political system were to go hand in hand, and "the simultaneist poem was to be introduced as a Communist state prayer."³ All the Dadaists, however, agreed on the need to attack and disrupt the staid morality and the cheap sentimentality of the bourgeoisie. They were anti-war and anti-establishment, and as art was clearly part of the corrupt bourgeois world, they were also anti-art. Yet no matter how nihilistic their activities may have appeared, their attitude was actually highly constructive and therefore moral.

The Berlin Dada group—Hausmann and Huelsenbeck, Heartfield and Herzfelde, Grosz and Höch, Mehring and Baader—became part of the general revolutionary struggle in post-war Germany. Many of them believed in the political as well as the esthetic revolution. But Dada itself remained "a matter of the spirit and as such could accept no master, neither the aristocrat nor the proletarian";⁴ therefore, "the more these people were thrown into the revolutionary movement of the proletariat, the more they lost their identity as dadaists."⁵

Heartfield himself, in association with his brother Herzfelde and with George Grosz, published the clandestine avant-garde periodical *Neue Jugend,* and used entirely new typographic ideas in which old engravings and various types were thrown together with a Joycean free-association—a technique which was later employed successfully at the Bauhaus and finally adopted widely by commercial artists, but which was brilliantly original in 1917.

During the twenties Heartfield did book jackets in both typography and photomontage for the Malik Verlag, a Berlin publishing house headed by his brother, which published the best of the world's left-wing literature from Upton Sinclair to Maxim Gorky and Ilya Ehrenburg, as well as portfolios of lithographs by George Grosz. Heartfield worked for various radical periodicals and contributed regularly to the Communist *Arbeiter-Illustrierte Zeitung.* He was also active in stage design, at first working for the famous Max Reinhardt and later for Erwin Piscator's more experimental proletarian-revolutionary theatre. He became a great friend and disciple of Bertolt Brecht's and accepted many of Brecht's tenets. As Germany suffered from inflation, depression and immediate threat of fascism, Heartfield's art increasingly showed an aggressively political nature and "he consciously placed photography in the service of political

agitation."[6] As the political situation in Weimar Germany grew more acute, Heartfield's art grew more acrid and simultaneously more mature. In 1929 he created his *Face of Fascism,* a montage which spread all over Europe with tremendous force. A skull-like face of Mussolini is eloquently surrounded by his corrupt backers and his dead victims.

The peculiar character of Heartfield's art is evident in a photomontage such as this and can be distinguished clearly from all other types of collage. The Cubists had revived the eighteenth-century technique of collage for reasons of formal structure and also in order to postulate questions about the nature of reality. Schwitters' Merz-collages salvaged the discards from the trashcan, commenting on the jetsam of civilization. They "established disparaged values," as Dubuffet might have said, and became important to later artists concerned with junk culture. Heartfield, in contrast, worked rationally and purposefully in his search for photographic cutouts which he assembled so as to evoke the most highly charged thematic associations in the spectator. In this respect his art is more clearly in line with Futurist collage than with the largely accidental work of some of his former Dada colleagues like Jean Arp and Max Ernst. Heartfield utilized photomontage for purposes of bitter social protest and political propaganda. As Daumier had done a century earlier with lithography, John Heartfield turned to the newest, the least traditionally encumbered medium to comment on his time with powerful anger and great artistic talent. "The intolerable aspect of events is the motor of his art," said the writer Oskar Maria Graf about his friend Heartfield, and, indeed, this was how he created, in 1932, the most memorable images of Hitler swallowing gold coins and cackling hollow sounds in *The Superman,* or raising his arm in the Nazi salute with "Millions" standing behind him. A little over a year after Hitler's assumption of power we see the Führer holding a Nazi version of the hammer and sickle as he speaks to German workers, while his propaganda chief Goebbels drapes the beard of Karl Marx around him; or again, in 1936, Hitler sharpens his knife to kill the Gallic Cock while he smirkingly poses as the innocent vegetarian. Like emblems of old, these photomontages merge in a powerful fusion of picture and motto and like emblems they became engrained in the mind and eye of a generation.

After the burning of the German Reichstag, a crime almost certainly engineered by Goering and Goebbels in order to incarcerate the Communists, John Heartfield made the brutally powerful montage of *Goering the Hangman,* the human bloodhound with his axe standing in front of the burning parliament. Soon thereafter Heartfield executed another masterpiece on the same theme, showing the mutilated and broken figure of Justice who, in place of blindfolded eyes, has a bandaged head in order to illustrate Goering's words from the trial of the Reichstag fire: "For me Justice is something bloody." *The Dagger of Honor: Blood and Honor* (1935) refers to another trial in which a brownshirt was acquitted by a German court of justice for stabbing a worker to death with the

SA's "Dagger of Honor" because the worker had dared insult his uniform. In *Blood and Iron* the swastika is formed by four blood-soaked axes. Like Eisenstein's films, Heartfield's photomontages use diametrically opposed images to provoke a conflict in the spectator which will give rise to a third synthetic image that is often stronger in its associations than the sum of its parts. To form another swastika he has a brutal looking Nazi screw additional pieces of wood to Thorwaldsen's Cross of Golgotha for the *Establishment of the State Church.* Heartfield's poignant caption reads: "The Cross was still not heavy enough."

One of his strongest works of warning is the photomontage of the skeleton hand with bomber planes issuing from its five fingers, raised hugely over the destroyed city with bodies of dead children in the foreground. This word was horribly prophetic when first published during the Spanish Civil War in 1936. Later on, during the Allied bombings of German cities Heartfield re-issued it under the heading of "The Benefit Accomplished by Air Raids from the Point of View of Racial Selection and Social Hygiene," with a cynical clipping from a current number of the *Berlin Journal for Biology and Race Research:* "The densely populated sections of cities suffer most acutely in air raids. Since these areas are inhabited for the most part by the ragged proletariat, society will thus be rid of these elements. One-ton bombs not only cause death but also very frequently produce madness. People with weak nerves cannot stand such shocks. That makes it possible for us to find out who the neurotics are. Then the only thing that remains is to sterilize such people. Thereby the purity of the race is guaranteed."

These photomontages are far removed from the early work of the Dada rebellion. They are images of piercing simplicity created from a deep conviction in order to be political weapons. They fulfill what Picasso once considered to be the purpose of painting: they are indeed "instruments of war for attack and defense against the enemy."[7] Recognizing the power of Heartfield's weapons, the Nazis early determined upon his arrest, but in the spring of 1933 he escaped to Prague, where he immediately carried on his work of accusation against the Nazi terror. In fact, a good many of his most powerful political posters were made during his years of exile there. An international incident was precipitated when the leading Czech artists' association exhibited his work in Prague in 1934, causing the Nazi government to demand the withdrawal of many of his political posters. Herzfelde's current monograph documents this case in fascinating detail. The Czech government maintained its principles of free expression as long as it could, but its final capitulation to Hitler's demands was certainly prophetic of later events. Heartfield's case, however, had become a matter of international morality, and Paul Signac as head of the *Indépendants* in Paris wrote to his friends in Prague in May 1934:

I join you in protesting against the unjust and stupid persecution to which my colleague John Heartfield has fallen victim. My whole life long I have been fighting for the freedom of art and therefore I do not need to stress the fact particularly that I am with you wholeheartedly.

I am prepared to contribute my share in organizing a French exhibition of our friend's works. I hope that many French artists will join you and help you. From all sides the tide of reaction is rising. The club is poised for battle against the freedom of the spirit. Let us unite to defend ourselves.[8]

The French exhibition was, in fact, organized in the spring of 1935; for it Louis Aragon wrote an extensive article on John Heartfield and the nature of his revolutionary achievements. This important essay by Aragon is reprinted in the new monograph and as it brilliantly summarizes the thinking by an outstanding Communist intellectual about a leading Communist artist, passages from it are quoted here:

John Heartfield is one of those who expressed the strongest doubts about painting, especially its technical aspects. He is one of those who recognized the historical evanescence of that kind of oil-painting which has only been in existence for a few centuries and seems to us to be painting per se, but which can abdicate at any time to a technique which is new and more in accord with contemporary life, with mankind today. As we know, Cubism was a reaction of painters to the invention of photography. The photograph and the cinema made it seem childish to them to strive for verisimilitude. By means of these new technical accomplishments they created a conception of art which led some to attack naturalism and others to a new definition of reality. With Léger it led to decorative art, with Mondrian to abstraction, with Picabia to the organization of mundane evening entertainment.

But towards the end of the war, several men in Germany (Grosz, Heartfield, Ernst) were led through the critique of painting to a spirit which was quite different from the Cubists, who pasted a piece of newspaper on a matchbox in the middle of the picture to give them a foothold in reality. For them the photograph stood as a challenge to painting and was released from its imitative function and used for their own poetic purpose....

John Heartfield *today knows how to salute beauty*. He knows how to create those images which are the very beauty of our age since they represent the cry of the people—the representation of the people's struggle against the brown hangman with his craw crammed with gold pieces. He knows how to create these realistic images of our life and struggle, arresting and gripping for millions of people who themselves are a part of that life and struggle. His art is art in Lenin's sense for it is a weapon in the revolutionary struggle of the proletariat.

John Heartfield *today knows how to salute beauty*. Because he speaks for the countless oppressed people throughout the world, and this without depreciating for a moment the magnificent tone of his voice, without debasing the majestic poetry of his tremendous imagination. *Without diminishing the quality of his work*. Master of a technique entirely of his own invention, a technique which uses for its palette the whole range of impressions from the world of actuality; never imposing a rein on his spirit, blending his figures at will, he knows no signpost other than dialectical materialism, none other than the reality of the historical process, which he, filled with the anger of battle, translates into black and white.[9]

After a trip to Paris to attend his exhibition, Heartfield returned to Prague where he executed some dramatic posters on the Fascist intervention in Spain.

When the Nazis invaded Czechoslovakia after the Munich agreement of 1938, Heartfield had a narrow escape to London where he was received with considerable warmth and admiration. Living in England during the war, he exhibited his work there and published photomontages in *Lilliput* and in *Picture Post*. He spoke at political rallies, organized anti-fascist groups, wrote articles on the relationship of art and politics, and took part in a successful political cabaret. He also designed jackets for Penguin Books. But during his twelve years in England he was not in good health and had no opportunity or no creative need to execute great political posters.

When he returned to East Germany in 1950, he was welcomed with a retrospective exhibition, but he has remained more an honored memento of the past than a man engaged in current struggles and problems. During the last twelve years [1950–1962] he has kept busy doing stage designs, posters, and book jackets. While he was and is celebrated as a cultural leader, his chief idiom, photomontage, was still suspect during the fifties among the more orthodox advocates of socialist realism, who criticized it as an avant-garde art form of the twenties. Exhibitions of his great and acid pre-war work, which had chronicled the bloody rise of fascism and had affected the thought and actions of hundreds of thousands of people, were held in Moscow and Peking, where they were widely acclaimed.

But the problems of working in the East German situation are not unlike those which had been faced by his friend Bertolt Brecht. Heartfield is an artist whose significant work was accusing, aggressive, and often violent; he was a master of a visual metaphor with which he effectively mocked the enemy. How is a man who was motivated by the struggle against brutality and injustice to function in the supposed euphoria of a socialist society?

Only on rare occasions, as in the great peace poster *Never Again!* of 1960, has he paralleled the power of his earlier work—a power which was achieved by means of the inventive use of subject matter and the absolute clarity of metaphor working together to engender a violent emotion in the audience.

Notes

1. Wieland Herzfelde, *John Heartfield* (Leipzig: VEB Verlag der Kunst, 1962).

2. George Grosz, "Randzeichnungen zum Thema," *Blätter der Piscatorbühne* (Berlin, 1928).

3. Richard Huelsenbeck, "En Avant Dada: A History of Dadaism [1920]," in Robert Motherwell, ed., *The Dada Painters and Poets* (New York, 1951), 41.

4. Richard Huelsenbeck, *Dada Manifesto 1949* (New York, 1951).

5. L. Moholy-Nagy, *Vision in Motion* (Chicago, 1947), 318.

6. Herzfelde, 24.

7. Picasso's written statement of March 24, 1945, quoted in Alfred H. Barr, Jr., *Picasso: Fifty Years of His Art* (New York, 1946), 248.

8. Paul Signac, quoted in Herzfelde, 59.

9. Louis Aragon, "John Heartfield und die revolutionäre Schönheit," published originally in *Commune* (Paris, May 1935) and translated into German in Herzfelde, 310–313.

A Contrast in Meanings: Neue Sachlichkeit vs. Photo-Realism

Kirchner, *The Street*, 1913

Ernst Kirchner's *Street* of 1913 is a city scene filled with anxieties.* The space is tight, crowded, almost like Italian Mannerist space. The front area is occupied almost entirely by three mannikin-like individuals. Behind them mill an indefinite number of people. The three protagonists are close together but there is no communication, no reciprocative relationship. Everything is pointed, sharp, almost hurtful. The uptilted perspective throws the persons in the picture right up against us, the viewers. The paint is applied in hatchmarks, a calligraphic device Kirchner developed first in his woodcuts and then transposed into painting during this period.

In his unpublished notes, written at the time, Kirchner describes how his individual solitude was increased by the pulsating and threatening life of the city of Berlin to where he had just moved from Dresden. He talks about undefined fears and his need to paint the rhythm of people walking through the city streets, people whose faces were strangely distorted by the electric lights. His antagonism to modern technology, materialism and urbanization is typical of the expressionist attitude. At the same time the sociologist Georg Simmel wrote about the alien forces in the city, oppressing and alienating the individual who is unable to assimilate them.

Stöcklin, *Rheingasse*, 1917

Only four years later, the German-Swiss artist Nicholas Stöcklin painted a very different scene of a city. This painting is often considered among the first works of the Neue Sachlichkeit. It was seeing paintings of this very different nature that

*This essay was delivered as a paper at the meeting of the College Art Association of America in Toronto in 1984.

prompted the art historian Franz Roh to write his book *Nach-Expressionismus,* Post-Expressionism, in which he made a chart pointing out that the ecstatic theme was replaced by the sober object, that things have become clarified, that composition is static rather than dynamic, quiet instead of loud and frenzied. Right angles parallel to the picture plane have taken the place of diagonal and acute angles. The pigment has become thinner and the execution more careful, less vehement. This attitude is cool rather than hot. In other words, objective reality takes over from subjective feeling and we are faced with a new realism which Gustav Hartlaub, director of the Mannheim museum, was to call Neue Sachlichkeit—New Objectivity—or New Sobriety (John Willett). It was seen as an unsentimental, detached sort of realism, which dealt with objective reality rather than expressionist ecstasy. In this paper I want to compare this new realism which developed in Germany in response to the situation of extreme economic and political crisis in post-World War I Germany to the photo-realist painting in the prosperous consumer-oriented America of the 1970s. Both movements discarded a prior, emotionally charged expressionist style for a more precise and cool rendition of reality. Both movements occurred in countries that had recently experienced military defeats. But, as we will see, the differences are more important and more telling than the similarities.

Estes, *Ansonia,* 1977

Let us compare Richard Estes' street scene of 1977 with the street scene of Stöcklin. They both deal with the urban environment, with everyday occurrences in the city, each artist looking at the city where he lived, Basel and New York respectively. But compared to the high-tech picture of Estes, Stöcklin's painting, which appeared so cool and naturalistic when contrasted to Kirchner's, begins to look very romantic in a nostalgic sort of way. It is a scene of an isolated street in Basel's Altstadt. The more we look at the painting the stranger and less objective it appears. The neat little pile of collars in the laundry on the left seems lost in the large store window. Above we see an old woman who together with her cat may be lying in wait for that poor pigeon on the ledge below. Somebody seems to have urinated recently in front of the arched entrance. Is this a sheep's head squeezed above the pilaster on the right or is it some sort of gargoyle? Next to it we see a butcher shop in uptilted perspective, which is advertising its liver and blood sausages while in the window directly above we see a coffin and a funeral wreath. A lonely red ball is in the gutter and a discarded letter in the lower left corner. The longer we look at the painting, the more ghost-like it appears.

In Estes' painting we also see a city street, empty of people. But, whereas in Stöcklin's picture the very presence of the creature behind the windows gave the work its peculiar gruesome character, the woman who appears on the left side of the Estes is barely visible and is really a "pedestrian" rather than a person. The

kind of emotional quality still present in Stöcklin is precisely what the photo-realist in search of detachments wants to avoid. For him the street is a *still* life, a *nature morte.* "When you add figures," Estes said, "people start relating to the figures and it's an emotional relationship. The painting becomes too literal, whereas without figures it's more purely a visual experience."

After Mr. Clement Greenberg assured us that what he called "Modernist painting" is a matter of a totally two-dimensional surface, a flatbed, and that old-fashioned illusory painting is dead, Estes and many other photo-realists dissolved the flat surface largely by the use of reflections. The use of reflecting surfaces or mirrors is, of course, a very old and time-honored tradition from van Eyck's *Arnolfini Wedding* to Velázquez's *Las Meninas.* Estes first takes photographs of streets, paying attention to the reflecting quality of windows. From literally thousands of photos he selects what he wants from the contact sheets and then translates the image from photograph to canvas. The paintings he ends up with are meticulous. *Ansonia* is super clean and super crisp. No indication of urban blight in this view of the Upper West Side. This, by itself, is rather disorienting. Like the mother who shows slides of the new baby—although the infant itself could be seen in its crib in the next room, Estes uses the photograph to intercede and thereby control emotional response.

<div align="center">

Grosz, from *Ecce Homo,* 1923
Pearlstein, *Reclining Nude on Green Couch,* 1971

</div>

Now let us look at the most traditional subject, the treatment of the female nude. Here I want to compare George Grosz, the central figure of the so-called Verist wing of the Neue Sachlichkeit, with the leading new-realist, Philip Pearlstein.

Grosz's drawing from *Ecce Homo,* dating from 1923, is a document of life in post-war Berlin as seen by an artist with the most incisive brush, the realist as satirist, certainly the artist as social critic and bitter accuser. It is not so much an accusation of moral turpitude, as it is a political attack on a system which dehumanizes man, especially woman. In an article published at this time, Grosz counters the expressionist slogan, *Der Mensch is gut,* with *Der Mensch ist ein Vieh.* Man is beast. Grosz lashed out against "Expressionist Anarchism," the bohemian ivory tower of the expressionist artist. He advocated an art which is understandable to all and admonished the artists of his time to take part in the revolutionary struggle. He urged them to "Come out of your houses, even if it is difficult for you, do away with individual isolation, let yourself be possessed by the idea of the working masses and help them in their struggle against a rotten society. Your brushes and pens must become weapons in the struggle—not empty straws."

It is only in this political context that a watercolor such as this can be properly understood. Surely, no such political advocacy can be seen in Pearlstein's

nudes. Pearlstein simply looks at the naked body as it is with no prejudice, bias, or message. He is not concerned with signification but with objecthood. Pearlstein protests when classified with the photo-realists, because he does not use the camera, saying that he can see much more with his eyes. In a significant way he has transformed himself into a camera, as Linda Nochlin has observed, and "assimilated many of the characteristics normally associated with photography, such as arbitrary cropping, the close-up, and radical disjunction of scale." Instead of unmasking the world—and human relationships—as they really are, Pearlstein paints the naked body as it looks. He does not idealize his nudes but paints his women (or men) as objects and does so with unflinching probity. His images are frozen and deadpan. The inanimate sofa is handled the same way as the woman. Nochlin, a strong advocate of the new realism, considers Pearlstein as the *chef d'école* of the new movement, writing that "like all major stylistic innovations, Pearlstein's canvases constitute a challenge to the status quo, force a transvaluation of values in the critical realm, a confrontation with the reigning ideology of reductionism, flatness and objecthood." But, it seems to me that he precisely reduced the human body to an object. His formal innovation is little more than a reintroduction of the third dimension. Refuting Greenbergian formalism, and writing that the "flatness of the picture plane is no more a truth than the flatness of the world before Columbus," he nevertheless ends up with his own formalism, basically returning to the academic study of the nude.

Grosz, *Far Away in the South*, 1919

In a rather similar and slightly earlier painting, Grosz places figures and episodes of different scales together in a narrative position, using futurist simultaneism as his tool. He has painted a kaleidoscope of abhorrent behavior and sexual desire. As in old *vanitas* images, we also see depictions of the figure of Death. The lettering which is an integral part of the watercolor says: "Far in the South—Beautiful Spain." In other words, one of the things suggested by the large pink nudes and all the questionable activities in this collage-like picture is the quality of life on the Spanish beaches, perhaps the Costa del Sol.

Morley, *Beach Scene*, 1969

When Malcolm Morley paints a beach scene, he tells us something very different. He worked from a kodachrome of a happy American family at play on Daytona Beach. In this nice picture everyone is smiling. They are good consumers and the happier for it. The picture might be advertising anything from a toothbrush to suntan lotion or airplane tickets. Back in 1931 Walter Benjamin discussed this kind of photography, which, he prophetically pointed out, "can endow any soupcan with cosmic significance but cannot grasp a single one of the human connections in which it exists."

Morley actually began painting in an abstract expressionist mode, but faced the dilemma of where to go once an absolute minimum was reached by Newman and Reinhardt. He explained: "I feel that Barney Newman emptied space and I'm filling it up again." So he turned to work from photographs and did so with great accuracy by dividing the photo into a precise grid, transferring the image square by square. What we are looking at here is a slide taken from a reproduction of a painting of a photograph. Of course we are used to seeing reality through photographs. In fact, photos seem more authentic than actual experience. Kim Levin, when first writing about Morley's work, said that he "chooses the simulated experience of reality, the counterfeit, and subverts it from within...his attitude is closer to the Dada than to the realist tradition. His double-edge illusionism relates to Dali's desire to make hand-painted photographs and to Duchamp's defaced *Mona Lisa.*" So we are back with Dada, which is where George Grosz comes in. But it is Dada with a difference. It is not the Dada of Grosz and the other Berliners who repudiated all aspects of European culture but more akin to New York Dada, which was involved more in a polemics in the aesthetic realm. Morley himself, as we know, soon found it necessary to inject personal, emotional content in his work and became an initiator of new expressionism as these earlier paintings were a source of photo-realism.

Schlichter, *Margot,* 1924

Rudolf Schlichter, like Grosz (or Otto Dix), took prostitution as a major subject. In cities like Berlin whores were seen at every street corner and when Schlichter painted his *Portrait of Margot,* he confronts us with a tough woman, standing on the street, one arm akimbo, the other holding a cigaret which is turned downward. Her facial expression is totally cynical. Schlichter like many of the Verist artists was a member of Communist artists' groups and he paints the prostitute clearly as a class-conscious proletarian woman. His painting is realistic very much in Courbet's popular sense, in showing the harsh realities of daily life. Clearly there is a polemical aspect in this picture, something that is quite absent in Besser's *Betty.*

Arne Besser, *Betty,* 1973

The New York photo-realist's woman is also a "tough number," but compared to Margot, who looks us straight in the eye and confronts us directly, Betty is just another prop. Margot's environment is a slum district and we see a poster advertising the circus and asking us *Quo Vadis?* Betty's background is the sleek, curtained window, the reflection of the equally sleek highrise and the sexually suggestive fire plug. Everything in the painting of the 1970s, the girl, the airplane model, the building, the stainless steel window frame, is a capitalist

consumer proposition. Whereas Besser's neutral attitude has no argument, Schlichter's painting is a critical accusation directed against the bourgeois spectator who is being looked at by Margot.

Karl Hubbuch, *Ironing Board,* 1923
Richard Joseph, *Drawing Table,* 1968

At first glance Karl Hubbuch's *Ironing Board* of 1923 and Richard Joseph's *Drawing Table* of 45 years later look remarkably similar and the resemblance of the motif does not need to be dwelt on. An important difference is that Hubbuch's picture, realistic as it appears, looks like a painting, whereas it is almost surprising to learn that Joseph's is oil on canvas. Important also is that Hubbuch's composition consists mostly of diagonals and is therefore more dynamic, whereas Joseph has chosen the static quality of a composition in which right angles predominate. More: the ironing board conveys drudgery, the drawing table a sense of refinement. The pink dress in Hubbuch's painting clearly belongs to a hefty, full-bosomed woman. We can almost still see her. We are not sure of the purpose of the cheesecloth on Joseph's drawing table; it may be to wipe and clean the camera next to it. Most important: the *Ironing Board* is a picture about life, the *Drawing Table* about art, about photography and its translation into painting, about the possibility of true objectivity, of painting without moralizing, censuring, or glorifying. Hubbuch's world as exemplified by this pink dress with its gaping tunnel-like opening is filled with mystery. Joseph's is just as it appears. The photo-realists would agree with Robbe-Grillet's meticulous and cool description of detail and anti-existential statement that the world is neither significant nor absurd.

Kurt Querner, *Farm Workers,* 1933

How do artists of the Neue Sachlichkeit and photo-realists look at rural life? Kurt Querner was younger than most of the German artists we've been discussing. His father was a shoe-maker and he himself was trained as a metal worker before he studied painting with Otto Dix at the Dresden Academy. Like Dix he was interested in painting pictures of political significance and like his teacher he also admired the style of German Renaissance painting and admired Courbet's masterpiece, the *Stone Breakers,* which hung at a place of honor in the Dresden Museum until it was destroyed in the War. His *Farm Workers,* like Courbet's, is an unvarnished image of rural labor, of hard times in the country. Painted in 1933, it was done at the depth of the agricultural crisis and the resultant misery on the land. We see the peasant, standing with clenched fists and an expression of restrained anger, his son at his side, and women doing hard farm labor in the background.

Richard McLean, *Miss Paulo's 45*, 1972

Querner's painting is an enormous contrast to the work of Richard McLean, an Oakland artist, born just 30 years later than Querner, but in very different circumstances. His well-groomed horses and people stand in a field, which is as neat as Querner's is stony. Instead of overworked cattle pulling a plow, here is a fine race horse and her colt standing at leisure as do the owners. Whereas Querner's color is dark like the earth, McLean's is in bright technicolor tints. Everything is nice and clean in this painting, which might very well be about law, order, and *property*. When speaking about the work of artists like McLean, his dealer Ivan Karp talks about his admiration for the technique, about the two months it takes McLean to complete one of his canvases, transposing the color photograph from a magazine into oil on canvas. The subject matter itself and its possible significance are not discussed. The artist himself told me that he is not concerned with matters of content. But does not the fact that McLean *chose* to paint prize horses and spend months doing so with much care, tell us something about his choices? Can this really be denied, simply because the artist is involved in meticulous treatment of the picture surface? When Jasper Johns made his flag paintings in the late '50s, we know that he was primarily concerned with the problem of the flat surface. But does this deny the fact that he was making large pictures of the Stars and Stripes at the time when America enjoyed its greatest imperial power? Roy Lichtenstein, to be sure, based his paintings on comic strip characters, but his paintings of bombardiers dropping their payload *did* occur during the early days of this country's involvement in Viet Nam. Perhaps there is a connection between the use of depersonalized photographs, comic strips or other referential signs by the painter and the removed action of the bombardier who is out of touch with his target when his instruments inform him to press the button.

Christian Schad, *Self-Portrait with Nude*, 1927

Schad belonged to the Swiss Dada group earlier on and was, incidentally, the inventor of the photogram—prior to those made by Man Ray and Moholy-Nagy. Cool as it is, this self-portrait is certainly charged with suppressed emotion. The painter is seated on the edge of the bed in a transparent shirt which fits him like membrane or skin. He is well groomed, every hair in place, and looks severely out of the painting. Behind him and unapproachable is a woman—probably his wife—propped up in the bed, not nude, but undressed: we still notice the upper edge of her stockings, a bow on her left wrist. Her hard-edged face is marked by a great scar, like the brand of possession men in Naples are said to burn on their women. (Behind the couple we notice an urban, industrial night scene with a train and smokestack.) It is a disturbing erotic painting—erotic despite its

stillness, its immobility—and nothing could be more obvious than the narcissus, which is equidistant between the two heads, but there is no communication here. In the alienation of his people, in his cool attitude, Schad is in many ways the most modern of the German painters of the time.

Chuck Close, *Self-Portrait*, 1968

In 1954 Alfred Barr stated that "portraiture, once a major brand of painting, has largely sunk into the hands of fashion specialists." This was quite true 25 years ago, long before painters, instead of considering photography as a great rival, would *use* photographs as the basis of their portraits.

In his *Self-Portrait* of 1968 Chuck Close began with a photograph, transferred the camera information onto the canvas by means of a carefully drawn grid, and then created a monumental frontal image. Close is again primarily concerned with the technical aspect, the syntax of painting. He worked on a painting like this for a whole year—sometimes there are as many as a million hand-painted dots in a portrait of this size: nine feet high. Close uses a great variety of processes, such as airbrush, drawing, fingerpainting, watercolors, pastel, acrylic, and more recently huge Polaroid photography. In other words, we are dealing primarily with the application of different *crafts*: the image hardly ever changes. The size is astounding and reminds one of late Roman marble heads. But instead of the introspective stare and the inward look of Constantinian heads, Close looks at the human face like a roadmap, transferring all its imperfections and blemishes from photo enlargement to large painting. Again he avoids any kind of emotional expression. His portraits are powerful images, largely due to their scale, which is indeed impressive.

Kurt Querner, *Self-Portrait with Nettle*, 1933
Alfred Leslie, *Alfred Leslie*, 1967

The contrast, finally, between Querner's *Self-Portrait with Nettle*, 1933, and Alfred Leslie's *Alfred Leslie* of 1967 is too obvious to be dwelt on for any length of time. Querner, the radical painter, whose oppressed *Farm Workers* we mentioned earlier, presents himself standing in a farmhouse with an angry, determined face, holding a nettle as his attribute. Painted in the style of the German Renaissance, it is nevertheless a highly militant self-portrait. Leslie, a painter who had made an earlier reputation as a second-generation abstract expressionist painter, turned to super-realist painting in the mid-60s. His purpose is about the opposite from Querner's. Whereas the German revolutionary artist wants to arouse the spectator's sympathy for his anger, Leslie wants to present us nothing but the external appearance of his self-image under strong light, focusing simultaneously on his head and his belly.

The German Verists of the Weimar Republic, expressing their social concerns, wanted to become an integral part of the social framework. The American realists, both pop and photo-realists, on the other hand, avoid social issues and stay aloof from political concerns. Their work, which purposely seeks the impersonality of the assembly line, seems a manifestation of total alienation. Yet their popularity, the high prices commanded by their art, and the resulting comfortable life of the artists actually *integrated* them into the prevailing capitalist system. Like many good citizens in our consumer society, they produced items demanded by the market. In many respects, therefore, they appeared to be a more constituent part of the socio-economic order than were painters of advocacy of the Weimar Republic.

In his 1940 essay *Art and Mass Culture,* Max Horkheimer, a Marxist critic of the Frankfurt School and almost a contemporary to the Neue Sachlichkeit artists, explained that while the artist of the earlier European avant-garde was still able to rely on his inner life and resist the values of the dominant economic and political order, these possibilities disappeared with the rise of a passive mass culture in the post-World War II period. The artist is no longer the guardian of nonconformity. Increasingly, art instead of an organ of criticism has become a saleable commodity. The dominant culture industry demands the absence of personal insight, antagonistic force of tragic meaning. Photo-realism, like pop painting, color field painting, and neo-expressionism with all its splash, reconciles the viewer to the status quo. In one of his last essays Theodor Adorno pointed out that the culture industry tolerates no deviation from the norm and replaces consciousness with conformity.

IV

New Images of Man

New Images of Man

Marsyas had no business playing the flute. Athena, who invented it, had tossed it aside because it distorted the features of the player. But when Marsyas, the satyr of Phrygia, found it, he discovered that he could play on it the most wondrous strains. He challenged beautiful Apollo, who then calmly played the strings of his lyre and won the contest. Apollo's victory was almost complete, and his divine proportions, conforming to the measures of mathematics, were exalted in fifth-century Athens and have set the standard for the tradition of Western art. But always there was the undercurrent of Marsyas' beauty struggling past the twisted grimaces of a satyr. These strains have their measure not in the rational world of geometry but in the depth of man's emotion. Instead of a canon of ideal proportions we are confronted by what Nietzsche called "the eternal wounds of existence." Among the artists who come to mind are the sculptors of the Age of Constantine, of Moissac and Souillac, the painters of the Book of Durrow, the Beatus Manuscripts, and the Campo Santo; Hieronymus Bosch, Grünewald, Goya, Picasso, and Beckmann.

Again in this generation a number of painters and sculptors, courageously aware of a time of dread, have found articulate expression for the "wounds of existence." This voice may "dance and yell like a madman" (Jean Dubuffet), like the drunken, flute-playing maenads of Phrygia.

The revelations and complexities of mid-twentieth-century life have called forth a profound feeling of solitude and anxiety. The imagery of man which has evolved from this reveals sometimes a new dignity, sometimes despair, but always the uniqueness of man as he confronts his fate. Like Kierkegaard, Heidegger, Camus, these artists are aware of anguish and dread, of life in which man—precarious and vulnerable—confronts the precipice, is aware of dying as well as living.

Their response is often deeply human without making use of recognizable human imagery. It is found, for instance, in Mark Rothko's expansive, ominous surfaces of silent contemplation, or in Jackson Pollock's wildly intensive act of vociferous affirmation with its total commitment by the artist. In the case of the

painters and sculptors discussed here, however, a new human imagery unique to our century has been evolved.

Like the more abstract artists of the period, these imagists take the human situation, indeed the human predicament, rather than formal structure as their starting point. Existence rather than essence is of the greatest concern to them. And if Apollo, from the pediment of Olympia to Brancusi's *Torso of a Young Man*, represents essence, the face of Marsyas has the dread of existence, the premonition of being flayed alive.

These images do not indicate the "return to the human figure" or the "new humanism" which the advocates of the academies have longed for, which indeed they and their social-realist counterparts have hopefully proclaimed with great frequency, ever since the rule of the academy was shattered. There is surely no sentimental revival and no cheap self-aggrandizement in these effigies of the disquiet man.

These images are often frightening in their anguish. They are created by artists who are no longer satisfied with "significant form" or even the boldest act of artistic expression. They are perhaps aware of the mechanized barbarism of a time which, notwithstanding Buchenwald and Hiroshima, is engaged in the preparation of even greater violence in which the globe is to be the target. Or perhaps they express their rebellion against a dehumanization in which man, it seems, is to be reduced to an object of experiment. Some of these artists have what Paul Tillich calls the "courage to be," to face the situation and to state the absurdity. "Only the cry of anguish can bring us to life."

But politics, philosophy, and morality do not in themselves account for their desire to formulate these images. The act of showing forth these effigies takes the place of politics and moral philosophy, and the showing forth must stand in its own right as artistic creation.

In many ways these artists are inheritors of the romantic tradition. The passion, the emotion, the break with both idealistic form and realistic matter, the trend towards the demoniac and cruel, the fantastic and imaginary—all belong to the romantic movement which, beginning in the eighteenth century, seems never to have stopped.

But the art historian can also relate these images to the twentieth-century tradition. Although most of the works show no apparent debt to cubism, they would be impossible without the cubist revolution in body image and in pictorial space. Apollinaire tells us in his allegorical language that one of Picasso's friends "brought him one day to the border of a mystical country whose inhabitants were at once so simple and so grotesque that one could easily remake them. And then after all, since anatomy, for instance, no longer existed in art, he had to reinvent it, and carry out his own assassination with the practised and methodical hand of a great surgeon." Picasso's reinvention of anatomy, which has been called cubism, was primarily concerned with exploring the *reality of form* and its

relation to space, whereas the imagists we are now dealing with often tend to use a similarly shallow space in which they explore the *reality of man*. In a like fashion the unrestricted use of materials by such artists as Dubuffet and Paolozzi would have been impossible without the early collages by Picasso and Braque, but again the cubists were playing with reality for largely formal reasons, whereas the contemporary artists may use pastes, cinder, burlap, or nails to reinforce their psychological presentation.

These men own a great debt to the emotionally urgent and subjectively penetrating painting of the expressionists from the early Kokoschka to the late Soutine. Like them they renounce *la belle peinture* and are "bored by the esthetic," as Dubuffet writes. Like most expressionists these artists convey an almost mystical faith in the power of the effigy, to the making of which they are driven by "inner necessity." Yet the difference lies in this special power of the effigy, which has become an icon, a poppet, a fetish. Kokoschka and Soutine still do likenesses, no matter how preoccupied with their own private agonies and visions; Dubuffet and de Kooning depart further from specificity, and present us with a more generalized concept of Man or Woman.

Much of this work would be inconceivable without Dada's audacious break with the sacrosanct "rules of art" in favor of free self-contradiction, but negativism, shock value, and polemic are no longer ends in themselves. The surrealists, too, used the devices of Dada—the rags, the pastes, the ready-mades, the found object—and transported the picture into the realm of the fantastic and supernatural. Here the canvas becomes a magic object. Non-rational subjects are treated spontaneously, semi-automatically, sometimes deliriously. Dream, hallucination, and confusion are used in a desire "to deepen the foundations of the real." Automatism was considered both a satisfying and powerful means of expression because it took the artist to the very depths of his being. The conscious was to be visibly linked to the unconscious and fused into a mysterious whole as in Giacometti's *The Palace of 4 A.M.*, where the reference of each object within the peculiarly shifting space—the space of the dream—is so ambiguous as never to furnish a precise answer to our question about it. But all too often surrealism "offered us only a subject when we needed an image." The surrealist artist wants us to inquire, to attempt to "read" the work, and to remain perplexed. In the *City Square*, which Giacometti did sixteen years later, we are no longer dealing with a surrealist object. The space still isolates the figures, but instead of an ambiguous dream image we have a more specific statement about man's lack of mutual relationship.

Finally the direct approach to the material itself on the part of contemporary painters and sculptors—the concern with color as pigment, the interest in the surface as a surface—belongs to these artists as much as it does to the non-figurative painters and sculptors of our time. The material—the heavy pigmentation in de Kooning's "Women," the corroded surfaces of Richier's

sculpture—helps indeed in conveying the meaning. Dubuffet was one of the first artists who granted almost complete autonomy to his material when he did his famous "pastes" of the early 1940s. Even Francis Bacon wrote: "Painting in this sense tends towards a complete interlocking of image and paint, so that the image is in the paint and vice versa . . . I think that painting today is pure intuition and luck and taking advantage of what happens when you splash the stuff down." But it is also important to remember that Dubuffet's or Bacon's forms never simply emerge from an undifferentiated id. These artists never abdicate their control of form.

The painters and sculptors discussed here have been open to a great many influences, have indeed sought to find affirmation in the art of the past. In addition to the art of this century—Picasso, Gonzales, Miró, Klee, Nolde, Soutine, etc.—they have learned to know primarily the arts of the non-Renaissance tradition: children's art, latrine art, and what Dubuffet calls *art brut*; the sculpture of the early Etruscans and the late Romans, the Aztecs, and Neolithic cultures. When these artists look to the past, it is the early and late civilizations which captivate them. And when they study an African carving, they are enraptured not so much by its plastic quality or its tactile values, but rather by its presence as a totemic image. They may appreciate the ancient tribal artist's formal sensibilities; they truly *envy* his shamanistic powers.

The artists represented here—painters and sculptors, European and American—have arrived at a highly interesting and perhaps significant imagery which is concomitant with their formal structures. This combination of contemporary form with a new kind of iconography developing into a "New Image" is the only element these artists hold in common. It cannot be emphasized too strongly that this is not a school, not a group, not a movement. In fact, few of these artists know each other and any similarities are the result of the time in which they live and see. They are individuals affirming their personal identity as artists in a time of stereotypes and standardizations which have affected not only life in general but also many of our contemporary art exhibitions. Because of the limitations of space, we could not include many artists whose work merits recognition. While it is hoped that the selection proves to be wise, it must also be said that it was the personal choice of the director of the exhibition.

Alberto Giacometti

"To render what the eye really sees is impossible," Giacometti repeated one evening while we were seated at dinner in the inn at Stampa. He explained that he could really not see me as I sat next to him—I was a conglomeration of vague and disconnected details—but that each member of the family sitting across the room was clearly visible, though diminutive, thin, surrounded by enormous slices of space. Everyone before him in the whole history of art, he continued, had always represented the figure as it is; his task now was to break down tradition and come to grips with the optical phenomenon of reality. What is the relationship of the figure to the enveloping space, of man to the void, even of being to nothingness?

The philosophical and emotional implications of the problem he poses do not overly concern him. The loneliness of his figures, that elusive quality upon which all his critics and admirers—it seems impossible to be one without being the other—have commented, is, insofar as he is concerned, the effect of *his* retinal vision. His friend Jean Genet, for example, has Giacometti's objects saying, "I am alone, I am transfixed in a necessity which you cannot disturb. As I am what I am, I am indestructible. Being what I am and without reservation, my solitude knows about your solitude." His figures may indeed evoke this feeling of loneliness and alienation, but this is by no means the artist's purpose. He strives to discover the visual appearance and to render it with precision—not the reflections of light which occupied the Impressionists, nor the distorted view of the camera which fails to register distance, but the object as it is contained in space, as seen by the human eye, the artist's eye.

The eye is man's miraculous instrument: it is both the mirror of self and its means of communication. Giacometti stares at people's eyes, hoping thus to understand them. He says that the blind seem to think with their eyes, and that the difference between a living person and a corpse is the gaze. In his painting and his sculpture he concentrates on the eye. "It should be enough to sculpt the eyes," he has said. In his painted portraits all the lines converge intensely on the eyes. If he could render a single eye correctly, he maintains, he would have the head, the figure, the world.

Jean-Paul Sartre has declared that "after three thousand years, the task of Giacometti and of contemporary sculptors is not to enrich the galleries with new work, but to prove that sculpture itself is still possible." Giacometti is aware of this predicament, and his attempts to resolve it have led him to the problem that absorbs him today—to render precisely what he sees at a given distance. This distance—which creates the space containing the object—has become absolute: it is about nine feet, the distance from which his glance, focusing on the model's eye, can organize the whole. The result is a pervasive presence. The figures—in his paintings, his drawings, his sculpture—become clearest when we focus on them least. A standing nude female figure or a head of Diego becomes increasingly vague as we approach it. At close range, the nose, chin, breasts do not reveal themselves: they disintegrate and we are left only with a vital surface of light flickering over the rough bronze—crater-like surfaces which remain witnesses of the artist's struggle. But the figures retain their integrity. They do not allow us to come into intimate contact with them. They remain unreachable and can only be seen at the distance from which they were modeled or painted. Within the space that contains them, they become real. To be in a room with a figure by Giacometti is not to enjoy an object but to experience a presence.

Giacometti is constantly at work. His hands never rest but move up and down modeling the clay on the armature, drawing figures and hands on paper napkins, envelopes, table tops. His work is continuous. He draws, builds, destroys, paints, models—one activity leading into the other without interruption. Nothing is ever finished. When painting, he builds up, paints over, makes changes, and finally stops, hoping to achieve the goal next time. He may turn his clay models over to his brother Diego for casting, but when he sees the plaster he is likely to hack away at it and when confronted with the bronze, to paint on it, in a constant process of growth, or rather, search, that will never end. Like other artists of his generation he is engaged more in the adventure than concerned with the result. Each work is a step for him, a study for new work, for the task of achieving the impossible: to render reality truly as it appears to the eye and yet to make a sculpture or a painting which, somehow, can find its place in the history of art.

All his life he has copied works of the past, hoping thereby to find a path in his search: Egyptian, Cycladic, and African sculpture, the Roman portraits of the Faiyum, and Byzantine mosaics; he has done copies of the work of Cimabue and Giotto, Conrad Witz and Albrecht Dürer, Tintoretto, Rubens and Callot, Corot and Cézanne, as well as of his contemporaries. But he believes, finally, that the task of art has always been insurmountable, that all the achievements of the past were only tentative efforts, and that only his own work can lead him toward a greater understanding of the nature of reality.

The subject, although repetitious, is not a matter of indifference. He depicts his brother and his wife and his intimate environment. The landscapes at Stampa

remain the same, as do the interiors and still lifes. The figures, the standing females, hands on hips, who seem to be offering themselves in their elusiveness, the male heads, or walking men, hardly ever vary. They do not have much individuality; nothing, in fact, would interest Giacometti less than a psychological interpretation of the individual. Indeed, the longer a person sits for him, the more unknown, almost terrifying, he becomes. It is the basic structure of the head, not the personality of the sitter, that concerns him, not man's individuality but, rather, his universality. In this respect he recalls his important Swiss predecessor, Ferdinand Hodler, whose "parallelism" was the stylized symbolic expression of human solidarity.

Giacometti is convinced that this expression of universality can be achieved only by means of the most painstaking study of nature. He first modeled a head from nature in 1914 when he was a young boy—a head, he points out, that was the same size as those of his current endeavors. He studied first with his father, the well-known Impressionist painter Giovanni Giacometti, then in Geneva, and finally with Bourdelle in Paris. As he explained in an autobiographical letter, he soon gave up his hope of being able to work from nature, so he abandoned the model and, about 1925, began working from memory and imagination. For ten years he engaged in a series of highly original experiments. Subject to various influences, primitive and archaic carving as well as then-current Cubist sculpture (the work of Laurens and Lipchitz was of considerable interest to him), he yet affirmed a personality entirely his own. This became apparent as early as 1926 when he exhibited his *Couple* at the Salon des Tuileries, at Bourdelle's invitation. These bizarre and amusing monoliths and the monumentally concave *Spoon Woman* combine a powerful plastic confrontation with symbolic erotic content. Of great importance was a series of heads with oval indentations which had become flat during the working process without the sculptor's intention. Soon he felt the need of opening his forms and made undulating or static grill-like forms, and then open cages where he was able to analyze the object from the inside. Caves and enclosures dominate his memories of childhood—no wonder then that sculpture for him was to become the hollowing out of space. The cages, to which he turned around 1930, reach their climax in the fantastic *Palace at 4 A.M.,* which was completely realized in his mind in all its absurd precision before it was made.

Constantly searching for new sculptural concepts, he was also interested in the possibilities of obtaining actual kinetic movement and constructed his *Suspended Ball* in which a cloven sphere, held by a thread, can be made to slide along a crescent-shaped object. His frank erotic symbolism, the near-abstraction of his work, his exploitation of the dream and reliance on the unconscious, brought him into close contact with the Surrealists, and for a brief time he took part in their exhibitions and wrote for their publications. But whereas they seemed satisfied once they had found a certain style and imagery, Giacometti

continued to experiment, discovering new forms and symbols, such as the frightening *Hand Caught by a Finger*, a fiendish system of gears which, if they did function, would grind the hand to bits. The violent and destructive aspects of his imagination and an obsession with sexual murder are revealed most clearly in the *Woman with Her Throat Cut*, a nightmarish image, part woman, part animal, part machine. In the *Invisible Object*, on the other hand, his frightened self and his perpetual fear of the void find a mysterious climax. Simultaneously with work of this Surrealist nature, Giacometti also explored the solidity of objects, making his remarkable *Cubist Head*, which once again shows his fascination with man's glance.

But all the time he was aware that the day was not far off when he would once more have to sit down before a model and come to grips with the visible world. This became clear to him while he and Diego were engaged in the design and manufacture of vases, lamps, chairs, and tables for a fashionable Paris decorator. He realized that he was working on vases the same way he worked on sculptures, and he decided that a clear distinction had to be made between the manufacture of a fine object and the mystery of sculpture.

He went back to working from life, expecting, as he recalled in his letter, to refresh his eyes for two weeks; instead he was to work all day for five years. There was a time when the human form became no bigger than a pin and, reduced almost beyond its ultimate minimum, was barely able to withstand the onslaught of the void. Then, slowly, after the war, new figures began to emerge, elongated effigies rooted to their bases with enormous feet, superbly arresting in their immobility.

The reduction that had taken place was not only in the almost ascetic thinness of the figure. The compelling *Hand* of 1947 is more powerful in its effect than the caught hand of fifteen years earlier, precisely because it has abandoned all paraphernalia and exists with a mysterious power and contained violence. In the late forties he created unforgettable group compositions, of men passing each other in anxious search of their loneliness, or standing straight and detached like trees in Alpine forests, or separated from the viewer by an insurmountable chasm of space.

In his paintings, which begin again after the war, the problem of distance is also dominant: the repeated framing device isolates the sitter into an environment that is remote and uncertain. These grisaille paintings with their restrained colors seem out of place in a time when our sensibilities are constantly blunted by the brilliance of fresh and garish color. But colors, Giacometti feels, adhere to surfaces, and his problem—the problem of the sculptor as painter—is to grasp the totality of the image in space. His linear painting, nervous mobile drawings, and sculptures of "petrified incompletion" testify to a great artist's struggle to find an equivalent for the human phenomenon.

A New Imagery in American Painting

Time magazine in a recent article (Feb. 20, 1956) launched a wholesale attack against the so-called Abstract Expressionist painters. This vilification seems to justify the quoted remark by Mark Rothko that it is a "risky act to send a painting into the world. How often it must be impaired by the eyes of the unfeeling and the cruelty of the impotent who would extend their affliction universally."

The cry for a new realism, which has been raised periodically since the very beginning of the abstract movement in art, is now being reiterated with renewed vigor. *Life* magazine (Feb. 6, 1956) expounds on the greatness of Reginald Marsh after summarily dismissing the contributions of the American avant garde since World War II. Mr. Selden Rodman in *The Eye of Man* (New York, Devin-Adair, 1955) makes his subjective and rather idiosyncratic prejudice against abstraction the only valid standard in judging "expressive content" in painting. In a vast national advertising campaign Huntington Hartford attempts to enforce his rear guard opinions on art, implying that nonconformity is disloyalty.

Many of our contemporary artists are in fact deeply involved with developing a new imagery and are in search of symbols which may come to grips with basic human problems in a world where apprehension has been deeply altered by Einstein, Freud, and two world wars. Old stereotypes as proposed by Hartford and the editors of *Life* can no longer lay claim to finding valid solutions.

Yet it must also be admitted that Abstract Expressionism, without question the leading movement in American painting since the war, has found itself in an unfortunate predicament during the last few years. It has converted a very large number of disciples who no longer carry the original force and vitality of men like Gorky and the earlier De Kooning but have become followers of a new "style." In both national and local exhibitions Abstract Expressionist art predominates, but the inherent mannerisms of the technique do not permit a unique determination of form. Thus, although Abstract Expressionism lays claim to revealing the innermost psychological conflicts of the individual artist, we find myriads of "psyche-records" indistinguishable from one another, a situation which is depressing in its uniformity. A most intricate relationship of shapes and colors

creates and activates a surface which some critics consider both an expression of man's most personal psychological conflicts and, simultaneously, a vision of the galaxies of the universe—I should say an immiscible mixture.

Critics, however, have been reluctant to question the validity of the movement, not only because they find great merit in a number of the artists, but also because they have not wished to fall into the old pitfall of disparaging new forms with old standards. In addition there have been few vital new directions as alternatives with which to gauge and compare Abstract Expressionism. There has also been the inaccurate and discouraging implication by some of its protagonists that anyone not raising the banner for Abstract Expressionism must be either reactionary or Marxist in orientation.

With the spread of Abstract Expressionism and its corollaries (Action Painting, Tachism, Tubism) here and abroad its aesthetic value becomes increasingly questionable. The true significance of a painting by Franz Kline, Georges Mathieu, Jackson Pollock, or Clyfford Still lies in the actual process of "making the picture." The finished work, however, will often remain below the level of interpretation and distillation, so that the artist leaves us with no memorable forms and experiences. The impact is immediate, and the immediate impact is what seems to matter. The artist here presents the experience undigested and leaves it up to the viewer to do the rest. His technique is similar to the free association process used in psychoanalysis, but rarely does he go beyond random exploration.

Even if the work was created in Dionysiac frenzy, it is often too undirected to furnish us with a powerful visual experience. As we cannot watch the ritualistic dance itself but only its record, we are left to contemplate a dead record of once agitated action.

Frequently completely ambiguous, lacking a referential framework of operation, the freedom of Abstract Expressionism or Action Painting is the freedom of escape rather than the true freedom of deliberate action. De Kooning himself has stated: "It is exactly in its uselessness that it is free."[1] Perhaps escape toward the supreme doodle is the most cogent answer for the artist in the present socio-political framework of conformity and witchhunt; yet other possibilities begin to appear.

De Kooning himself has found a significant answer. His writhing images of "Women" probably occurred to the artist during the working process itself and have become fairly specific in their reference. By his exposition of hate and brutality De Kooning has indeed infused his work with a deeply human content. Like Kafka he does not respond to the external world but hopes to communicate insights he himself has been able to attain. If the result is fragmentary, enigmatic and frenetic, it is because De Kooning's experience differs considerably from the "American Century" of *Time* and *Life*.

The search for an adequate expression which may come to grips with the

experiences of the post-World War II generation has brought forth a new imagery which like De Kooning's painting retains the agitated surface of the Abstract Expressionists and which has also evolved forms which lead the spectator toward more specific responses.

It is perhaps significant that these painters have generally appeared outside New York, which is still under the strong and vigorous influence of the Abstract Expressionists. Hyman Bloom works in Boston, Joseph Glasco in New Mexico, James McGarrell in Los Angeles, while Chicago has emerged with a group of painters and sculptors—Leon Golub, George Cohen, Fred Berger, Cosmo Campoli—who are important in this context.[2]

Leon Golub

Rather than to discuss the work of a number of artists who have been concerned with this new kind of imagery, it will better serve the purpose of this article to analyze the work of one artist whose painting exemplifies this trend to a considerable degree.

Leon Golub, born in Chicago in 1922 and now living there, came to most people's attention in 1954 when he exhibited among the Younger American Painters at the Guggenheim Museum and simultaneously held his first one-man show of paintings[3] in New York at the Artists Gallery. His work immediately aroused considerable interest among American and European critics, because he represented a considerable deviation from the characteristic American avant garde.

Since this time Golub has been awarded the Florsheim Prize at the Art Institute of Chicago's 61st American Show and has exhibited at the Whitney Museum Annual of 1955 and the Carnegie International of 1955, as well as in a series of one-man shows at the Feigl Gallery in New York, the Pomona College Gallery, the Pasadena Museum of Art and the Allan Frumkin Gallery in Chicago.[4]

The affirmative act of painting—clearly present in Golub's work—is no longer sufficient for itself. Although highly personal, his work uses a fairly precise system of communicative symbols. This is because he conceives of the contemporary world as being in a state of crisis, caused by a discontinuity of the traditional mechanism of art, the isolation of the artist, and the search for new symbols.

The reaction of the Abstract Expressionists to this crisis situation seems to be based on an incapacity or unwillingness to reach a point from which to view man and his place in the world. Golub, on the other hand, through an arduous introspective act has attempted to establish a personal myth based on man's measure and scale. Like all myths, Golub's work proclaims a significant but unverifiable truth. It is irrational in the manner of primitive art.

Primitive—and ancient—man, at the mercy of jungle and desert, invented

dragons, griffins, sphinxes, and chimeras—all types of incredible monsters—with considerable realism. Similarly, modern man, wandering in the jungle of aggressive and hostile relationships, the lonely desert of a noncohesive society, apprehends the monster as a symbol. Golub's plastic form belongs to the 20th century, but it is also related to his iconography, which is essentially that of primitive and ancient cultures. Drawing upon the forms of pre-Columbian and Assyrian ritual art, he tends to freeze his figures in hieratic attitudes. Malraux's "Imaginary Museum" is inescapable for the modern artist aware of his heritage. The reason for the affinity of modern art with ritualistic art form is, as Malraux has pointed out, modern man's awareness of the human condition.

In *Thwarted* the viewer is presented with a man of Herculean strength, but one who is, however, incapable of utilizing his power, for he lacks the very instruments by which man assumes control of his environment. He has no neck to turn his head and help him view the world. His arms are amputated up to the shoulders. This torso is impressive as an image of tragic frustration.

Yet there is clearly a relationship to the battered sculpture of antiquity; Golub himself suggests the influence of the "Belvedere Torso," the Pergamese sculpture to which Michelangelo referred as his "school." But although the proportion and structure of *Thwarted* are reminiscent of classic sculpture, Golub's essentially tragic view of man has transformed the beautifully articulated classic statue into an interpretation of human destruction.

The thighs have been shoved up to annihilate the long articulation of the torso, thus avoiding any semblance of elegance and grace. This is similar to what happens in the neckless transition from the enormous chest to the square-shaped head, and the gracelessness is intensified as the thighs are pushed out horizontally. The figure becomes stumped. The head itself, a direct outgrowth of the body, is a stump or a block in which the features have been incised in a sculptural manner.

This rigidly frontal figure fills the canvas completely and, in his brutal force, seems to be about to explode beyond the limits of the frame. But *Thwarted* is saved from being simply an inchoate King Kong by a consciousness of a tragic destiny which he is powerless to overcome.

At various times during his career as a painter, Golub has turned to sculpture of a very peculiar kind. *Clank-Head*, also of 1953, is composed of found objects. An old wooden box, rusty nails and chains and old pieces of rubber are put together—not in a haphazard Dadaist manner, but rather with the purpose of creating a mechanical fetish.

The wooden box, which reminds Golub of a coffin, is the body. Eyes, made of rubber rings fastened to a rubber tube, stare out with ferocious melancholy at the spectator. A clanking chain descends to a metal ball, which, like a creature in Hieronymus Bosch's hell, has a rod protruding from its center. The *Clank-Head* indeed looks like a ceremonial object, and Golub's hell, although it is not specified, might well be the machine age.

Much more immediate in its reference is *Birth*, a painting which, according to Golub, "is supposed to combine the terrible ecstasy of birth and the tired relaxation thereafter." It was painted soon after his first son was born. His wife had experienced natural childbirth, and the child was placed on the mother's abdomen when the father was admitted to the delivery room.

Golub felt a need to communicate this experience, but he also felt the need to transform it into a ritualized, non-specific form, because the generalized concept comes closer, he feels, to universal human experience.

The mother's face again has the ritual markings which we saw in *Thwarted*. In its utter simplification this head has the strength of pre-Columbian images and like them it has sacrificial implications. The mouth is a large gash cutting across the block-like head; the eyes seem to twist, the nostrils are distended. From the head the viewer's eye is led to the hollow, ovoid breasts and then to the squatting child. The foreshortened upper leg seems to turn in agony, while the lower leg has a stiff, carved appearance. Like an enormous shadow the huge dark brown hand touches the upper limits of the painting.

The pronounced right angles not only add to the tortured appearance of the woman's body, but also, by framing the central image, focus the attention on the womb and the child. The ovoid sweep from the head on the right to the center, reinforces this emphasis.

The viewer sees the subject from above and simultaneously from the side, aspects of both interweaving and contrasting with the formal simplicity of the painting.

Golub makes no preparatory sketches, but develops his paintings directly while working on the canvas or—more frequently—on the Masonite, which he prefers for its slick surface and "challenge" to the application of paint. His process is one of continuously overpainting and reworking the surface until what was once only vaguely sensed emerges in specific form. He also frequently returns to the same theme. His images of burnt men, sphinxes, births and deaths, kings and princelings develop in series.

Based on an earlier picture, *Prodigal Son II* was done in 1953–54. Like the earlier canvas, or like *Thwarted* and a good many others of his paintings, it is in grisaille. Generally—though by no means always—he prefers subdued colors of low value to express his somber themes.

The *Prodigal Son* is an interpretation of penitence and forgiveness. Like *Birth* it appears to be a highly subjective expression. Iconographically it is less related to the prodigal son theme than to that of Abraham and Isaac in mediaeval sculpture. Again, however, the 20th-century painter felt the need of Expressionist distortion of the body image.

The pity and compassion of the father are traits rarely seen in contemporary painting. He has a powerful face, with the full circles of nose and cheeks suggesting completion and benevolence. His hair recalls the corkscrews of Assyrian beards. The head is both Hebraic and Assyrian—signifying forbearance

and strength to Golub. From the rounded flow of the nose, the viewer's eyes descend more quickly down the hinged-on arms to the tenderly enclosing hand, which echoes the form of the beard.

The son is still unformed. He looks almost foetal, and the spine of his delicately curved back is still exposed. His face is quite amorphous and malleable, the features just beginning to coalesce.

We are presented here with a father embracing his child perhaps in anticipation of the future tragedy of the prodigal son. At the same time, the image evokes a feeling of homecoming and rest, of security in the father's bosom. On another level it may be interpreted as a symbol of mourning: a sorrowing father and his dead son.

In the *Damaged Man* of 1955 the integrity of the body has again been destroyed but here by what appears to be internal growth. The figure's earforms look like horns or earphones. The head is still self-contained but the body has been flattened out into a skin like the flayed hide of a Marsyas.

The surface of this *Damaged Man* is eroded or encrusted with eruptions. It is as if the life sap had suddenly come to the surface of this mutant, whose carcass is all that remains. This painting, much like others in this series (the earlier "Burnt Men" for instance), is a carcass in the tradition of Rembrandt or Soutine, but it is significant that it has been painted after Buchenwald and Hiroshima. Yet the *Damaged Man* retains the significance of individual destiny. His pathetic persistence in continuing even to exist in spite of his mutilation also symbolizes endurance and strength.

During the last few years the sphinx has been a recurrent theme in Golub's work. Fascinated by the enigmatic double image of man and animal, he wishes to fix "that terrible moment of insight when the animal gains 'consciousness,' of indeterminate and ill-fated destiny."

The *Siamese Sphinx* is painted in greys and dark browns against a background that is a startling cosmetic pink. It is a fantastic animal, carrying two human heads and evidently crippled by the burden. The front head faces us directly with an expression of anguished violence contrasting strangely to the rigidity of the plinth-like leg that seems to fix the head in place against its will. The ritual face markings, actually scratched into the surface with a knife, are similar to those in *Birth* and recall the effigies of tribal cultures from New Ireland to Mexico. This head is also somewhat more animal than the other, which has been humanized and individualized in its features as well as in its expression of sorrowful reluctance.

The back head is, to a degree, reminiscent of Scopaic heads, and Golub explains: "Modern man can only know the Dionysiac aspects of Greek art—in spite of all his willful desire for the archaic. He can only really understand the Scopaic, because that is what corresponds to modern destiny. The Scopaic head is also so important because it is a reminder of the great Classic ideal, now lost to us."

The destiny of the *Siamese Sphinx* appears to be ambivalent: the individual and tragic are tied to the implacable, resurgent animal resentment.

The sphinx is important to Golub because "it is an enigma, a metaphysical symbol at the crossroads of human destiny." Because early cultures created the sphinx to relate the known to the unknown and the unknowable, he feels that the situation of modern man, since it is similar, calls for a similar image. (In a lighter mood he is willing to discuss the *Siamese Sphinx* as an animation of a Georgian ball and claw foot table.)

Our culture lacks a collective myth, and no truly public symbolism is therefore granted to our artists. Instead of a collective myth, we are confronted with the mass standardization and stereotypes of television, movies, popular magazines and public opinion polls. This anonymity has become so pervasive that a great deal of contemporary painting has been affected by it and has become similarly uniform. It is only by means of a highly introspective act and full awareness of the contemporary situation that a personal art can be evolved.

The new direction toward a meaningful imagery, which begins to emerge in the work of Leon Golub, is by no means a unique occurrence. No such insulation would today be possible or desirable. Golub himself is influenced not only by ancient and tribal art, but also by such 20th-century artists as Nolde, Picasso, Orozco, and Giacometti, and is related to some of Siqueiros' work. Among younger men parallel trends can be seen in the work of such divergent and personal artists as Marini, Brauner, Dubuffet, and Bacon in Europe. Some of his American contemporaries have already been mentioned.

The fact that Willem de Kooning has been led by the turbulence in his work to similar intense, disturbing images of women, is a significant indication of a trend toward an art that is more specific in its referential contact. Golub's painting may be seen as a part of this direction, but it differs from De Kooning's in being less concerned with the painting process itself and in evolving a fuller set of metaphors. Nonetheless, the impetus behind the work of each of these artists seems to be a desire to communicate certain insights, certain kinds of knowledge which may be intuitive but which are phrased in an intelligible as well as in a fresh and unique idiom.

Notes

1. Willem de Kooning, "What Abstract Art Means to Me" (symposium), *Museum of Modern Art*, vol. XVIII, No. 3 (Spring 1951), p. 7.

2. Patrick T. Malone and Peter Selz, "Is There a New Chicago School?" *Art News*, vol. 54, No. 6 (October 1955), pp. 36–9, 58–9.

3. He previously showed prints at Wittenborn's in 1952.

4. Mr. Golub contributed the article "A Critique of Abstract Expressionism" to *CAJ*, XIV, 2, p. 142.—Ed.

Leonard Baskin:
The Continuance of Tradition

In a square, old-fashioned frame house on the bramble-tangled grounds of what was once an imposing estate lives Leonard Baskin with his wife and child.* It is true that the house has been provided for him by Smith College—one of the highest-ranking women's colleges in the United States—where Baskin teaches sculpture, drawing, and print-making. Partly by chance, partly by intention, everything in and around the spot where he lives suggests those two qualities outstanding in Baskin's own oeuvre: reliance upon traditional forms and, what might seem to be contradictory but is not, a richness of invention. The profuse, undisciplined vegetation; the classical though headless lady in her chiton—a piece of garden statuary he and his wife found rotting under a bush; the beautiful old furniture; the extraordinary library lining the walls and piled up in stacks four or five deep beside the bed; the collection of prints and drawings proliferating across the walls as though they were alive: these elements state the dichotomy between a kind of organic confusion and cultural hodge-podge on the one hand and an intensely disciplined, conservative tendency on the other which reaches a resolution in Baskin's art.

The novelist Henry James, himself such a strong supporter of tradition, sadly criticized American society for its lack of richness and depth and spoke of "life being all inclusion and confusion and art being all discrimination and selection."[1] Where a culture lacks sufficient "density," its art is in danger of being short-lived for lack of material to feed upon. In such a case, the important artistic process of selecting and discarding becomes painfully constricted unless the artist can, almost singlehanded, dredge up the layers of traditions, provide the variety of forms, ideas, manners, and events which his culture lacks. This is one reason lying behind Baskin's avid collecting of books and works of art—those specific objects of the past to which he relates himself. His book collection is devoted

*This introductory essay for an exhibition catalogue circulated by the Museum of Modern Art was written jointly by Thalia Selz and Peter Selz.

chiefly to the history of the illustrated book with emphasis on the sixteenth century and with particular concentration on emblem books and herbals. There are several incunabula and a special library of perhaps sixty volumes on or by William Blake. He owns a large number of books on printing and typography and examples of the publications of private presses, as well as an important library on the history of drawing. Furthermore, the library at Fort Hill—the name of the house Baskin inhabits—is a working library, as can be attested from the extensive use made of it by one of the writers while pursuing research on the sources of Art Nouveau graphics and typography.

The Baskins have a rich collection of drawings, especially from the sixteenth and seventeenth centuries and including fine examples of the School of Mantegna, and works by Beccafumi, Guercino, Elsheimer, Maes, Ostade, Reynolds, Watteau, Bresdin, Daumier, and Rodin. Among the drawings of contemporaries are excellent examples by Ben Shahn and Rico Lebrun. There is an enormous accumulation of prints comprising a history of the print from its beginnings to the present, with fine impressions of the work of Altdorfer, Rembrandt, Tiepolo, and Bresdin in addition to many little-known sixteenth-and seventeenth-century masters. There is a fascinating assembly of medals—"a typical artist's collection," Baskin says, and adds, "a seventeenth-century artist." Most of the sculpture at Fort Hill is Baskin's own work—except for some superb T'ang pieces and several fine Rodin casts. But aside from four excellent pictures by Thomas Eakins, there are few paintings in his house. Color has no particular relevance to his work, and he might have written about himself when he said about an artist to whom he feels very close: "Kollwitz did not paint. The blandishments of colors, the inevitable sensuousness of fat oil or sparkling water paints were alien to her needs. She dwelt in a world of black and white...."[2]

Baskin has dwelt in a world of black and white ever since his childhood. Son of an orthodox rabbi, Baskin was brought up with the greatest esteem for the written word. His early adolescence was devoted to the study and interpretation of the ancient Jewish texts. But then, before he was sixteen, he entered the studio of the sculptor Maurice Glickman, where, like a Renaissance apprentice, he assisted the older sculptor and watched him at work using a variety of techniques. There he made his first break with the provincial Jewish life of the yeshiva and established his first important contact with the world of art. Baskin speaks of two critical events in his formative years: this intimate master-pupil relationship with Glickman and his attendance at Yale University. The art program at Yale in the late thirties and early forties was conducted by a most academic group of "illustrious unknowns." In his drawing classes he worked with a sharp fine pencil, for his gods were Botticelli and Ingres, but his teachers, to whom he refers as "brutes with charcoal sticks," showed no understanding and he left the studio for the library. Baskin read constantly and on every subject, immersing himself

particularly in history and literature. Having a thorough grounding in Jewish tradition and having found access to the world of art, he now penetrated into broader areas of knowledge.

During all this time he made sculpture. An extremely precocious young man, he had completed monumental carvings in walnut and Georgia marble before he was sixteen. These were strongly influenced by African sculpture as seen through the eyes of Modigliani and the Cubists. But since Baskin had, in fact, completed a manuscript on the history of world sculpture at fifteen he was fairly familiar with a great variety of styles and he seems to have used them all. While this early work is sentimental, it is amazing for its richness of ideas—rather literary, to be sure—and its technical virtuosity. Like many older sculptors of the time he was greatly taken by the nature of the material, the grain of the wood or the stone in which he carved. At eighteen, on vacation in Maine, he completed an "African totem pole"—thirty feet high, no small feat for even an accomplished carver. Baskin's youthful talent was impressive and might have led him in a great many possible directions, including writing. During the war, while he was a member of the Naval Air Corps, Baskin wrote a novel, a great deal of poetry, and the story for a ballet on Buchenwald. It was his discovery of the woodcut which finally disciplined his flow of creative energy. Here was a medium which, although requiring consummate skill, was better suited to his literary ideas than sculpting. Futhermore, his prints, which he began to do around 1949, were sufficiently appreciated almost from the first to win him nationwide prizes. They established his reputation as an artist and satisfied his ego. "Now liberated from tendentious themes, I was able to deal with real sculptural values, like these . . . ," he says, pointing to a fine example of Colima sculpture and a superb early T'ang lady in his collection.

During a year in Europe in 1950-51 two experiences were most important for Baskin: a day in Colmar where he witnessed the Isenheim Altarpiece, and a trip to Pisa where he was struck by the dramatic power of Giovanni Pisano's pulpits and even more by the sculpture of his pupil, Tino di Camaino. Tino's statuary combines the emotional Gothic rhythm of his master with the older quiet classicism and sturdy weight probably derived from Nicolo Pisano. His tomb of Henry VII in the Campo Santo with its calm inner life, its simplicity and strength, indicated to Baskin the direction he wanted his own work to follow.

Reliance on tradition is one of the essential aspects of Baskin's work, setting him apart from the majority of modern sculptors and printmakers and their experimentation in new formal structures, new media, and new techniques. Baskin is a master of old techniques: his drawings are made with a fine pencil or with the brush; the now famous illustrated books of his private press—the Gehenna Press in Northampton, Massachusetts—beautifully printed on fine hand-made papers, are examples of conservative design. He makes woodcuts, wood engravings, and etchings; he models in plaster for his bas reliefs and

sculpture in the round; he carves in wood and stone. His sculpture is solid and even his bronzes relate to a block-like form. The open forms and space extensions of his contemporaries do not interest him. He considers abstract art in general to be a blind alley and criticizes it for dealing with an elementary and fragmentary image of the world. In fact, his disdain for abstract art is matched only by his contempt for academic painting and sculpture. In a world which has placed a premium on "novelty," "freshness," and "ingenuity," Baskin invents within the established conventions, postulating an art which partakes of the western tradition.

The tradition which Baskin honors begins with Egyptian sculpture and proceeds up to modern sculptors like Barlach and Manzù. The solid bulk of the Egyptian sculpture recurs in Baskin's standing and seated figures from the *Walking Man* of 1955 to the massive *Seated Woman* of 1961.

These figures have the broad frontality and the rigid, self-contained quality of Old Kingdom sculpture and a similar generalized appearance, even a portrait such as the *Thomas Eakins* of 1960. Here Baskin deals with a man whose painting he greatly admires for its incisive and unconventional realism. Baskin has endowed his Eakins with an almost super-human power apparent in the great, heavy-shouldered torso resting on comparatively small legs—a device, incidentally, which he frequently uses for his male figures. The face, however, departs from the Egyptian sculptural type in its romantic air of earnest nobility. The fact that the right hand is slightly flexed toward the viewer, in contrast to the solid stillness of the body, gives that gesture great significance. Looking at this "portrait" of Eakins, we can apprehend the meaning in the words of his friend Walt Whitman, when he said in 1888: "Eakins is not a painter, he is a force."[3]

The Warrior, carved in the same year, deals with force in a different manner. Even more rigid than the Eakins (the arms are short and stiff, the hands clumsy), this is a brutal image with stocky legs and barrel-shaped chest and belly. Instead of Eakin's eager and open face, *The Warrior's* entire head is concealed behind his helmet. Here we have the quintessence of the warrior as a type, a monolithic mass moving without reason, a robot irrationally following someone else's command.

Another upright figure, the *Laureate Standing*, expresses Baskin's macabre irony: here is the artist who has achieved society's acclaim—the Poet Laureate—crowned with the laurel wreath, fat-bellied, heavy-jowled, and stupid. Baskin was preoccupied with the image of the poet laureate for a number of years. The *Laureate Standing* of 1957 was the final version and also the most simplified one. The scathing, dramatic wood engraving in the form of a tondo called *The Death of the Laureate*, also of 1957, depicts the poet swollen with corruption, his fat jowls sunk back on his neck with death, his pointed nose and the tips of the leaves in his wreath turned up to heaven. He has breasts: sign of degeneration in the male. His body is a webbed clutter of nervous lines, like a shroud woven of black wrinkles: the circular areas of white and black are criss-crossed by the horizontals

and verticals of line, binding these areas together into a formal unit. One year earlier, Baskin had made the small bronze bust *Poet Laureate*, a little pig-eyed man whose tiny coronet of laurel mocks the face it surmounts—that of a ward politician. A similar feeling of decadence also crops up in the earlier woodcut, the *Poet Laureate* of 1954-55. The small black lines create a deep, ugly cavity at the mouth and an intricate spidery network around eyes and nose. These stand in great contrast to the generously large white areas. The horizontal lines cutting across the entire face and chest are a typical device used by Baskin for the articulation of his images.

A study of the development of this single theme from woodcut to standing carved figure shows a frequently repeated sequence in Baskin's work. He may begin with a drawing or a woodcut (often the print will follow the drawing), proceed to a bronze figure or relief, and finally complete the cycle with a large carving. During this process from the freer to the increasingly more commanding medium, his forms become more simplified and indeed more plastic. One might also compare the four versions to successive frames in a film on the subject of laureate-ism. If the laureate in the woodcut is ugly, we still sympathize with his suffering; if the little bronze poet is self-inflated, he is still amusing; the standing carved figure may be pompous, yet he has a kind of sturdy nobility; but the wood engraving, the *Death of the Laureate*, is the rendition of a total decline—the artist, old, fat, and successful, has been betrayed into the image of his betrayer.

Glutted Death, a low relief plaque done in 1959 after a similar drawing, relates closely to this concept of the decay inherent in death. Here, too, the figure is almost frontal. There is an almost humorously ferocious air: the extreme length of the legs compensates for the missing arms, and these legs are like a caricature of classical beauty. With its sinuous curves and grotesque forms—the bloated belly resting on long, skinny legs—the relief, however, especially recalls early Japanese woodcuts. The lack of neck and arms and the pig's face heighten its grotesquerie. The pelvis, like a calyx on these twisted stems of legs, holds the swollen blossom of the belly: a carnivorous flower.

We are again able to compare drawing and bas relief in the *Kite and Dog* of 1957, and the plaque, *Qui m'aime, aime mon chien*, of 1958. In the later work there has been an "improvement" in the simplifying of form: the tail is gone, the jowls, an ear, the nose—any detail which might possibly distract the spectator from contemplation of the plain horror of this huge tongue vomiting out of its maw. In simplifying, however, the artist has somewhat altered his concept. Once we had a fearsome, ugly brute, hideous but real; now we have an Ur-monster that resembles an ancient Chinese bronze pot, a mystic goblindog on four bronze legs, capable of entering one's nightmares and demanding propitiation like a demon. In other words, horror has been removed from the area of the particular to the general, becoming in the process more effectively threatening.

In contrast to these images of horror and to the generally massive

appearance of most of his sculpture, Baskin on occasion achieves extreme delicacy and grace in this medium, as he does with *Thistle*, a bronze relief of 1959. In both its attention to botanical detail and its stylized forms this elongated plant suggests the delicate relief scattered so thickly over capitals and choir stalls of Gothic cathedrals. A similar effect is obtained in the plaque called *In Memory of Lewis Black*. This highly poetic rendering of grasses shows an acute observation of nature on the part of an artist who is steeped in the tradition of which Dürer's watercolor in the Albertina, *The Great Piece of Turf*, is surely a part.

The importance of the draftman's line translated into sculpture is evident not only in his low reliefs; it also appears in his bronzes—the all-important incised eyes in the beautiful head of *Esther* (1956)—and in his wood carvings. In the *Head of Barlach* of 1959, the lines of the delicately gouged-out wrinkles streak the face like tears. The *Head of Barlach* also went through the type of evolutionary stages discussed earlier. In 1957 Baskin published through the Gehenna Press a letter by Barlach in the form of a "keepsake" which he illustrated with three wood-engravings of Barlach's head. Barlach is an artist to whom Baskin looks with unqualified admiration, and perhaps also the modern artist closest to his own work. "Barlach," he says, "was one of the great artists of our time because he was concerned with elemental and basic human states, with man's suffering and endurance, with myth, with the future. He was able to integrate such diverse influences as the Gothic and Egyptian. He was able to state great abstract concepts with specificity."

Baskin paid homage to Ernst Barlach with this great poplar bole sitting powerfully on its base and radiating a great visionary force. Baskin frequently makes portraits of the men he admires most. In addition to Eakins and Barlach, there is the fine head of *Rodolphe Bresdin*, whose drawings and lithographs hang on the walls of Baskin's house; there is his bronze *Head of William Blake*, modelled after the famous life mask; or again the bas relief *Homage to Gustav Mahler*, which recalls in its linear simplicity one of the Archaic grave steles in the Karamikos of Athens.

Line is essential even in a solid wood carving like the *Crow*, where the gouging out of the wood transmits a remarkable texture to the surface and, quite aside from the realistic suggestion of a feathered body, creates a network of flowing lines that relate part to part as the lines do in his graphics.

Although it is only four feet high, this is a monumental piece of sculpture, a sentinel crow as impassive and threatening as the figure of a waiting warrior or a tycoon in his dinner clothes. He may be waiting for carrion: Baskin notes that "crows devour animals killed on the highway." Birds appear with great frequency in Baskin's work, from the limp, feathered body in the hands of the tenderly conceived wood sculpture called *Man with a Dead Bird* of 1954, to the bronze *Owl* of 1960, with its points like Bresdin's beard, resembling the surface of certain Sung bronze vessels. Over and over again we have the owl resting in the hands or

hovering over the head of some suffering human being. It has the softness of a ghost in the drawing of a *Tormented Man* of 1956, the hardness of fate in the woodcut *Torment*, done two years later. Questioned as to the meaning, Baskin has protested that he cannot answer this, but he has remarked that besides its conventional use from ancient times as a symbol of wisdom, the owl reappears in the middle ages as a symbol of the Jew. He further explains: "It went this way; light equalled truth equalled Christ. Darkness, on the other hand, meant falsehood or the Jews. The owl was the bird of night, of darkness, therefore the symbol of the Jew. In the same way it was also symbolic of tyranny and black magic, of necromancy"

These haunted faces may express the anguish of the burden of wisdom: they may express equally the pain and relentlessness of being identified with the pariah—an identification which becomes complete in the large ink drawing *Beaked Man* of 1961, in which symbol and object merge in a man's distorted bird-face.

The birds which recur so often in Baskin's work frequently seem to allude to death, and indeed the subject of death is essential in his work. In the *Hanged Man,* a large early woodcut, the conception of death has not the passion and despair, or the terror, of some of the other figurations of death that Baskin has done, such as the late woodcut called *Angel of Death,* where horror is rendered so calmly that this body with the twining lianas of lines might almost be a tree struck by lightning, or a grotesque whom we admire but with whom we cannot truly identify.

In great contrast to the intricate network of this woodcut is the ink drawing *Carl Dreyer's Saint Joan* of 1959, in which extreme simplification of form is carried to an exquisite conclusion. Inspired by frames from the Danish director's *The Passion of Joan of Arc,* this white drawing echoes the stark white backgrounds of the film; its smoothly sweeping line evokes both the grace and purity of Mme. Falconetti's face and attitudes as well as the marvelous horizontal movement of the camera.

In spite of Baskin's opposition to the non-objective movement, a drawing such as *Carl Dreyer's Saint Joan* is quite abstract in its simplification. The recent *Bartleby in the Tombs* makes use of a free language of form which was Paul Klee's unique contribution to art. In its spare verticals and even sparer use of delicate horizontal line it achieves a great serenity; it is a profoundly contemplative work and a comparison with the earlier drawing *Bartleby, the Scrivener,* done in 1958, quickly reveals the significant change that has taken place since the conception of the haunted and ruined figure in the earlier work. It is as though we had suddenly moved in for a closeup of the ruin of death, only to come upon a scene of the great order produced by the process of decay itself. There is truly an inherent likeness between this drawing and the granite and bronze effigies of dead men, but the drawing is perhaps even more profound

because its complex suggestions have been resolved into more satisfying simplicity of form.

Baskin's most recent work in bronze, *Death* of 1961, represents a shifting from object to agent, from the passive receiver to the active producer. His death figures are always brutal, like the *Glutted Death* in the relief or the pen and ink *Head of Glutted Death* of 1958, which bears such a strong resemblance to this sculpture and, incidentally, to the work of George Grosz. But the new freestanding sculpture is a curiously impartial representation. The bestiality of the *Head* and the insidiously threatening quality produced by the graceful grotesquerie of the figure in the bronze plaque are both gone and in their place we have the strength of death, a force with which it is at least honorable to struggle. The compact form emerging from the rough bronze suggests Rodin's great *Balzac* and indeed this conception of death is essentially a romantic, because heroic, one. But this is a hero of our time and therefore an ambivalent one. The smooth, viciously ugly cranium suddenly contrasting to the richly textured torso suggests the thug within the trappings; the beauty and brutality of the condition are articulated by the very form.

This unity of form and content, then, is used by Baskin for the specific end of comment upon man, for in the final analysis he is concerned even more with human than with plastic values. When asked in 1959 about his artistic intention in relation to human imagery, Baskin replied:

> ...Our human frame, our gutted mansion, our enveloping sack of beef and ash is yet a glory. Glorious in defining our universal sodality and glorious in defining our utter uniqueness. The human figure is the image of all men and of one man. It contains all and it can express all. Man has always created the human figure in his own image, and in our time that image is despoiled and debauched. Between eye and eye stretches an interminable landscape. From pelvis to sternum lies the terror of great structures, and from arms to ankle to the center of the brain is a whirling axis. To discover these marvels, to search the maze of man's physicality, to wander the body's magnitudes is to search for the image of man. And in the act of discovery lies the act of communication. A common communal communication of necessity.
>
> The forging of works of art is one of man's remaining semblances to divinity. Man has always been incapable of love, wanting in charity and despairing of hope. He has not molded a life of abundance and peace, and he has charted the earth and befouled the heavens more wantonly than ever before. He has made of Arden a landscape of death. In this garden I dwell, and in limning the horror, the degradation and the filth, I hold the cracked mirror up to man. All previous art makes this course inevitable.[4]

Notes

1. James, Henry. *The Spoils of Poynton.* London, Macmillan, 1922, preface, p. VI.

2. *Four Drawings and an essay on Kollwitz.* Massachusetts Review, v. 1, no. 1, p. 7.

3.　Traubel, Horace. *With Walt Whitman in Camden.* New York, Mitchell Kennedy, 1915, v. 1, p. 284. Statement by Whitman.

4.　Selz, Peter. *New Images of Man*, The Museum of Modern Art, New York, 1959, p. 35.

Notes on *Genesis*: Rico Lebrun

Rico Lebrun has written of himself that he " ... took to the Baroque notion long before I saw it in the museums. ... Whenever I have abandoned the kinship with its essence, I have produced aesthetic exercises. Whenever I have tapped it at the core, I have felt real."[1] Lebrun's *Genesis* mural at Pomona College, notwithstanding the contemporaneity of its concept, belongs to the Baroque tradition. His drawings, growing increasingly architectural in form, his paintings, his large collages demanded the large surface of a wall. Lebrun had only once actually worked on a wall—when the Treasury Department commissioned him to do a fresco in the New York Post Office Annex (now destroyed). Twenty years later, in the autumn of 1956, during a modest one-man show of his work at the Pomona College Gallery, Lebrun visited Claremont. At Frary Hall he again admired the monumental fresco by Orozco, but at the same time he was very much impressed by the generously proportioned building itself and expressed a great desire to paint a mural in close proximity to Orozco's *Prometheus*. As chairman of the art department at Pomona, I decided to pursue this proposal: how unprecedented, but how splendid to have two great murals in a single building in America! From the beginning I was supported by James Grant and Fred Hammersley, the two painters on the College faculty, both of whom had once been Lebrun's students. Later in the fall I met Donald and Elizabeth Winston of Los Angeles who agreed with great generosity to sponsor the mural and donate it to Pomona College. There ensued an unusually fruitful collaboration between Lebrun, the Winstons, and myself.

The Board of Trustees of Pomona College expressed interest in the mural proposal but wanted to see sketches before giving final approval. Both Lebrun and myself, however, took it as a matter of artistic—and indeed academic— freedom, that an artist of established stature should not be asked to submit work to a lay committee for approval, but rather should be judged by the record of his previous acheivement. In this attitude we were fully supported by the Winstons, and after some debate the College administration agreed to permit Lebrun to proceed with no restrictions whatsoever.

During the spring of 1958 Rico made repeated visits to Frary Hall and planned to prepare sketches during the academic year 1958-59 when he was to teach at Yale University. But his exuberant spirit was thoroughly depressed in New Haven by the dogmatic, Germanic attitude which then prevailed at the Yale Art School. The following year, however, when he was Artist-in-Residence at the American Academy in Rome, he devoted most of his time to sketches and finally to preliminary cartoons. He occupied a large studio at the Academy and in addition to hundreds of preparatory drawings and detailed studies, he executed cartoons ten feet in height and proportioned to the scale of the Frary wall. The iconographic theme at this time still included texts from Revelations as well as Genesis, but the basic architectural problems were solved by April 1960, when he sent a progress report to Dr. E. Wilson Lyon, President of Pomona College.

While Lebrun was in Rome the Frary wall was prepared: workmen erected a "curtain" wall designed to prevent damage to the surface from moisture and earthquake; the curtain was built and fastened to the original concrete wall by metal channels, over which was mounted a screen of steel mesh. In the summer of 1960 the artist arrived at Pomona and was joined by two assistants, James Pinto and William Ptaszynski. Pinto had previously worked in Mexico on a number of murals and Ptaszynski was a student and close friend of Lebrun.

During the working process Lebrun made numerous revisions. "The traditional procedure of completing a design, then enlarging, tracing, and painting was not followed by Rico at Pomona."[2] Instead, he made constant alterations, assembling and disassembling cartoons and using the collage technique with which he had become familiar several years earlier while working in Mexico. It is interesting to recall that when I mentioned to him years earlier that I felt a lack of completion in his Mexican collages, Lebrun replied that he thought of them only as preliminary sketches for some future project. During the summer of 1960 "the collage was temporarily hung to the wall in sections with masking tape—and then was subjected to prolonged and extensive shifting, filling in, eliminations, enlargements or reductions of figure sizes, mock ups of toned papers, drawing and re-drawing in various media, and trial changes of figure identities...."[3] In other words, the working process itself suggested changes and, although the basic design of the wall had been predetermined, both forms and images were altered.[4] The passages from the Book of Revelations were eventually abandoned, the figures of Jeremiah and Job originally on the right side of the wall disappeared to make room for Cain and Abel, while Jeremiah vanished entirely and Job, transformed in shape and content, was moved into the upper right lunette. One might almost say that action painting was carried to the wall itself by Rico Lebrun at Pomona, but perhaps this is how Tintoretto, too, proceeded at San Rocco.

Lebrun's medium was vinyl acetate, produced by dissolving clear vinyl pellets in acetone diluted with anhydrous alcohol. Lebrun used this medium in a

highly diluted solution so that it had the consistency of an ink wash. Only black and brown pigments were used. The white of the mural is the white gesso of the curtain wall itself. The color was applied in layers of thin washes, resulting in a general transparent effect almost resembling watercolor. Light streams in directly through the arches below the mural and the sensation of color varies with the time of day: in the early morning it may have an icy, bluish cast, while at noon, with the red tile of the floor reflected on the wall, it may have a light rose tint. The only colors surrounding the mural are whitewashed walls and the gray travertine of columns and arches. The areas directly below the mural on either side are painted in solid black "in order to discourage the inevitable temptation of sgraffiti."[5]

In December 1960 Rico Lebrun signed the wall, having completed a feat which in sheer size compares with Michelangelo's fresco over the altar of the Sistine Chapel (*Genesis* is 29 feet high, the *Last Judgment* measures 33 feet in height). The Pomona mural was officially dedicated on February 26, 1961.

The *Genesis* mural is not visible from the exterior courtyard. It is on the interior wall of Frary Hall, and has been designed to be visible from three distinct viewpoints: directly below from the steps, from the loggia floor (this is the main vantage point), and from an elevated balcony facing the mural wall. "All the figures have this multi-viewpoint," Lebrun said. "A single viewpoint on any figure wouldn't go. The figures are deployed like opening a clam.... The figures all have a barrel-like shape to repeat the tremendous curved shape of the arches. If I didn't do this, they would look too small, like a pebble in a great box or like whistling a song instead of orchestrating it."[6]

The ribs of the loggia ceiling were repeated by Lebrun in the center of the mural as the ribs of Noah's Ark, and at only one point, in the lunette of Sodom and Gomorrah on the upper right, does he permit his figures to spill out of the severe architectural framework. Scale was, of course, of primary importance. While Lebrun did not wish his figures to "rattle like pebbles in a great box," he also did not wish to overwhelm or diminish the viewer.[7] His purpose was clearly to induce in the viewer the experience of increased stature. Moreover, the use of the nude human figure directly communicates a life-enhancing and invigorating sensation of vitality. This quality of the nude has been exploited since the sculpture of the Egyptians and Greeks and articulated by thinkers on art from Goethe to Berenson. A sense of tragedy prevails in the mural, as it does in so much of Lebrun's work, yet never assumes the character of despair: "The human image, even when disfigured by the executioner, is grand in meaning."[8]

Confronting the mural, the viewer identifies with the entwined figures of Adam and Eve who, turning their backs to the spectator, witness the drama unfolding on the wall. Instead of emerging from Adam's rib, Lebrun's Eve is intrinsically bound to Adam in a welding together of forms. But if Adam and Eve are still separate entities, Cain and Abel above them are molded into a single

figure, a large, heavy, powerful hulk. By merging them into one, Lebrun comments on their partnership in guilt and the identification of the killer with the killed. Cain has indeed become his brother's keeper.

The group of ravaged, pig-like people in the upper right refers to Sodom and Gomorrah, but these carcasses are not actually closely related to the story of Lot. They are derived, rather, from Lebrun's preoccupation with the funnel-like pits of Dachau and Buchenwald, and resemble his drawings and paintings of the death camps. Here, too, "pain has a geometry of its own"[9]—bodies are spread like the spokes of a wheel with the cluster of heads converging below the lunette. As he often did, Lebrun here, too, operates in the realm between abstraction and realism, between geometry and life. But, not wishing to be frozen by the symmetry of the wall, he permitted his figures to spill, breaking through the architectural demarcation of the lunette.

Contained in the opposite lunette is the anguished figure of Job, the only character in the mural whose origin is not in the Book of Genesis. Originally this lunette was occupied by the Apocalyptic Beast. When the artist decided on Job he was for some time under the spell of the resigned and smitten Job in William Blake's visionary engravings. Blake's Job then merged with Lebrun's memories of his own earlier drawings of Neapolitan beggars on crutches. And finally the image of the Hiroshima man emerged. This Job then is no longer the submissive man of sorrow, but a victim who protests his suffering, who calls out: "I cry out of wrong, but I am not heard: I cry aloud, but there is no judgment."[10]

While in Mexico Lebrun witnessed the devastation caused by a great flood of the Santa Ynez river. He was struck by the power of the river, the twisted trees, the scooped-out roots, and hooked oak trees—by nature's mass transformed through energy forces. And the whole left side of the mural below the lunette is given over to the victims of the Deluge. They, too, are in a state of metamorphosis and transformation. These interlocked figures seem to struggle and carry each other; they clamber over one another to reach the protection of the Ark, only to find that the Ark is practically destroyed and no safety exists.

Lebrun "referred to Noah as a tower, a rock under cascades of surf.... He also called Noah a fortress, a shelter, a protective paternal figure."[11] This magnificent form is clothed in a great shroud, a cloak which has become a fortress. He is the image of hope and human strength. His bowed head, derived from drawings of seaweed and yucca plants, is the central image on the wall. The timbers of the Ark surround and embrace this monumental figure and are repeated in the wrappings of the child. Having completed the mural, identifying perhaps with this memorable central image, the artist said: "... what I have to say, I say with Sartre, Kafka, Camus.... 'In the midst of disaster, act as if you could mend that disaster every day.'"[12]

In his essay on James Joyce's *Ulysses* T. S. Eliot wrote:

In using the myth, in manipulating a continuous parallel between contemporaneity and antiquity, Mr. Joyce is pursuing a method which others must pursue after him. They will not be imitators, any more than the scientist who uses the discoveries of Einstein in pursuing his own, independent, further investigations. It is simply a way of controlling, or ordering, of giving a shape and a significance to the immense panorama of futility and anarchy which is contemporary history....[13]

These words can apply as well to Lebrun's work. Like Joyce, Lebrun is part of the historical continuum which he altered by his visionary insights and formal power. Growing from a tradition of European painting from which he selected as his paradigms the painters of Pisa's Campo Santo, Uccello, Signorelli, Grünewald, Michelangelo, Caravaggio and the masters of the Italian Baroque, Goya, Blake, Picasso, and Orozco, Lebrun finally found a style completely his own at Pomona. He was able to give up his superb *bel canto* drawing and all mannerisms, saying that drawing "should be, above all, not a thing of art, but a tool for understanding."[14] He gave up color and immersed himself in a world of black and white, a world of darkness, which to him was not only the value of tragedy, but which clarified mass. Black and white also helped eliminate the frills and the unnecessary details, and brought him ever closer to the essence of tactile forms— forms which are, however, constantly metamorphosed and transfigured in accordance with life which is never static. From the *Genesis* mural Lebrun moved on to his cycles on Dante and Brecht and to his immutable and timeless sculptures, which are also related to the great mural, existing as they do in Lebrun's own world located between the actuality of life and the geometry of form.

Notes

1. Rico Lebrun, "About Myself," in *Rico Lebrun Drawings*, Berkeley and Los Angeles, University of California Press, 1961, p. 6.

2. William Ptaszynski, Letter to the author, July 26, 1967. I want to thank Professor Ptaszynski for the indispensable information he supplied about the technical progress on the mural as well as its iconographic meaning.

3. Ibid.

4. The progress of the mural on the wall is well documented in a series of photographs by Constance Lebrun and Richard Fish.

5. Martha Davidson, "Rico Lebrun's Mural at Pomona," *Art Journal*, Spring 1962 (XXI:3), p. 174.

6. Rico Lebrun, quoted in Elizabeth Poe, "*Genesis:* Lebrun," *San Diego and Point Magazine*, December 1961, p. 94.

7. Lebrun discusses this problem in a letter of October 12, 1960 to P. J. Kelleher. This letter is

printed in *Genesis by Rico Lebrun—Loan Exhibition of Preliminary Sketches for a Mural at Pomona College,* The Art Museum, Princeton University, 1961.

8. Rico Lebrun, in Peter Selz, *New Images of Man,* New York, Museum of Modern Art, 1961, p. 97.

9. Ibid., p. 99.

10. *The Book of Job,* Chapter 19, Verse 7.

11. William Ptaszynski, Letter to the author, July 27-28, 1967.

12. Lebrun, quoted in Poe, op. cit., p. 63.

13. T. S. Eliot, "Ulysses, Order and Myth," in Seon Givens, editor, *James Joyce: Two Decades of Criticism,* New York, 1948, p. 201.

14. Lebrun, "Notes on Drawing," in *Rico Lebrun Drawings,* op. cit., pp. 27-28.

Two American Painters

Mark Rothko

The intimate view of Vermeer and Vuillard is denied to current experience; it no longer fits into our scale of values. The sunlit, peacefully disciplined interior of Vermeer seems to offer the outsider a candid glimpse into a well-regulated life which, though he may not enter it, yet presents him with a vision of order to contemplate. But desirable as this quiet world appears, it is no longer accessible to the modern artist, who requires different visions. The painters of the New York School have set out to create their own environments. Intolerant of the chaotic mass culture in which they live, they have also become thoroughly disillusioned with the painting of social and political revolt. (How far away the thirties seem to be!) And yet they reject the expressionist attitude of personal antagonism vis-à-vis society. Even the American scene does not to any extent inspire their mural-sized paintings. The vast plateaus of the Northwest, the vaster bottom-lands of Texas constitute only a small part of the artistic experience of these painters, whose culture is based chiefly on European art. Their large paintings have been formed within the walls of dreary lofts and studios, in the very heart of a congested city.

In his New York studio Mark Rothko has built a new habitat of extraordinary emotional dimensions. His paintings can be likened to annunciations. Rothko returned from a trip to Italy with great admiration for Fra Angelico's frescoes in the monastery of Saint Mark's. But no angels and madonnas, no gods, no devils furnish a common property to be invoked in Rothko's paintings. There is no public myth to express the modern artist's message for him. The painting itself is the proclamation; it is an autonomous object and its very size announces its eminence.

That the sense of belonging is gone and cannot be recaptured under the circumstances in which we live, is a truism. The personal estrangement of the artist from the mass culture surrounding him had better be accepted. But Rothko indeed has welcomed this new-found freedom; he wrote in the mid-forties: "The unfriendliness of society to his activity is difficult for the artist to accept. Yet this very hostility can act as a lever for true liberation. Freed from a false sense of security and community, the artist can abandon his plastic bankbook, just as he

has abandoned other forms of security. Both the sense of community and of security depend on the familiar. Free of them, transcendental experiences become possible."[1]

Rothko paints large surfaces which prompt us to contemplate. The actuality of the painted surfaces makes even the symbolic configurations of his earlier work unnecessary. His rectangular configurations have been compared with the work of the followers of neo-plasticism, but unlike them, Rothko does not paint about optical phenomena or space and color relationships. His work has also at times been classed erroneously with action painting, yet he does not inform us about the violence and passion of his gesture.

Holding tenaciously to humanist values, he paints pictures which are in fact related to man's scale and his measure. But whereas in Renaissance painting man was the measure of space, in Rothko's painting space, i.e., the picture, is the measure of man.

This is perhaps the essential nature of the viewer's response to Rothko's work: he contemplates these large surfaces, but his vision is not obstructed by the *means* of painting; he does not get involved in the by-ways of an intriguing surface; these pictures do not remind us of peeling walls or torn canvases. The artist has abandoned the illusions of three-dimensional recession; there is not even the space between various overlaid brush-strokes. The surface texture is as neutral as possible. Seen close up and in a penumbra, as these paintings are meant to be seen, they absorb, they envelop the viewer. We no longer look *at* a painting as we did in the nineteenth century; we are meant to enter it, to sink into its atmosphere of mist and light or to draw it around us like a coat—or a skin.

But, to repeat, they also measure the spectator, gauge him. These silent paintings with their enormous, beautiful, opaque surfaces are mirrors, reflecting what the viewer brings with him. In this sense, they can even be said to deal directly with human emotions, desires, relationships, for they are mirrors of our fantasy and serve as echoes of our experience.

It is important for an understanding of the art of this painter, whose work seems to have little precedent in the history of painting, that the visual arts formed no part of his early background. He recounts that art simply did not exist around him in his youth, that he was not aware of museums or art galleries until he was in his twenties. Since childhood, however, he had been preoccupied with cultural and social values. When Rothko finally encountered the world of painting, his mind was fully formed—much as Kandinsky's had been at the time of his arrival in Munich some thirty years earlier, before he became the great pioneer of early twentieth-century painting.

Rothko's task now was to make of painting something as powerful and as poignant as poetry and music had seemed to him, to make his painting an instrument of similar force. Even today, he says, he is concerned with his art not esthetically, but as a humanist and a moralist.

Rothko is largely self-taught as a painter. In fact, his paintings show no

direct reflection of the painting of the past. His work has been highly individualistic from the beginning. His city scenes of the thirties are characterized by large flat shapes of subtle color, for the plane of the picture asserts itself early in his work. Immobile human figures, isolated and without contact with each other, were the subject matter. "But the solitary figure could not raise its limbs in a single gesture that might indicate its concern with the fact of mortality and an insatiable appetite for ubiquitous experience in face of this fact."[2]

Rothko has never abandoned his search for means of expressing human emotion, although he no longer employs the symbol of the figure to enact his drama. He has found his own more conclusive way of dealing with human qualities and concerns.

Toward the eventual achievement of this vision, the experience of surrealism proved a liberating instrument for Rothko as it did for so many other American artists of his generation. He has always admired Dali, de Chirico, Miró, and Max Ernst. The impact of surrealism led to an exploration of myth. But his archaic mythological beings of the early forties, his soothsayers and oracles, are generalized and not recognizable. They appear to inhabit an imaginary world below the sea, and the familiar identity of things is destroyed by these organic, biomorphic beings made up of elements partly human, animal, or vegetable. These symbolic abstractions are muted in color and always dominated by a swirling calligraphic line. He exhibited this biomorphic series in his first important one-man show, held at Peggy Guggenheim's Art of This Century in 1945.

Soon thereafter the flat plane reasserted itself, and by 1947 Rothko was using diffuse, rectangular color shapes, permitting them to float freely in his ambiguous space. It was difficult for an unprepared audience to comprehend this departure into a new, completely uncharted world. "Yet the remarkable thing about that period was that the artist was really not alone, that there always was a small audience which greeted each new manifestation as an answer to what had to be done."[3] Nevertheless, on the occasion of a decisive show, held at the Betty Parsons Gallery, M.B. wrote in the *Art Digest* of April 1949: "But the unfortunate aspect of the whole showing is that these paintings contain no suggestions of form or design. The famous 'pot of paint flung at the canvas' would apply here with a nicety."[4]

Despite a complete lack of understanding of Rothko's indifference to accepted principles of design—of achieving precision without resorting to formulae—the reviewer's reference to Ruskin's celebrated insult is actually valid. Thomas B. Hess in fact immediately recognized an orientalism similar to Whistler's.[5] The orientalism may be doubtful, but as in Whistler's "Nocturnes," the shapes in Rothko's paintings are enveloped in mist. Less static, however, these thinly painted, elusive rectangles move past each other without friction, slowly, in veiled silence.

In 1943, in a letter written jointly by Rothko and Gottlieb to the *New York Times*, the artist outlined some of their esthetic beliefs. One of them: "We favor the simple expression of the complex thought."[6] Rothko achieved a further simplification around 1950. Subject matter in the conventional sense had, as we know, been abandoned for some time. Now line and movement were also eliminated.

Although the thin application of paint always permits an awareness of the weave of the canvas, texture is not important. Conventional recession into depth, as well as weight and gravity, has been eliminated, yet we cannot even speak of flatness when confronted with the surfaces which actually breathe and expand. Light has become an attribute of color. Few of the elements which are a part of most paintings have remained. In fact, Rothko's constant stripping-down of his pictures to their barest essentials, to a simplicity beyond complexity, is intrinsic to their being. His paintings disturb and satisfy partly by the magnitude of their renunciation.

Color, although not a final aim in itself, is his primary carrier, serving as the vessel which holds the content. The color may be savage, at times burning intensely like sidereal landscapes, at others giving off an enduring after-glow. There are paintings whose reds are oppressive, evoking a mood of foreboding and death; there are reds suggesting light, flame, or blood. There are pictures with veil-like blues and whites, and blues suggesting empty chambers and endless halls. At times the color has been gayer, with greens and yellows reminiscent of spring in its buoyant, almost exultant delight. There is almost no limit to the range and breadth of feeling he permits his color to express.

If color sets the general tenor of the mood, the shape gives a more specific feature as well as a more concrete character. Similar as the shapes may appear, the rectangular color fields vary considerably from painting to painting. They are always presented in relentless frontality in the canvases of the fifties. These symmetric shapes are usually not sharply outlined; they are never frozen, and are able to shift along a lateral axis because of their blurred edging. Areas often seem to fade into each other, or they may be most emphatically separate; the relationships between Rothko's shapes in space, however, are never explicitly defined. They are only implied, whispered, or, one might say, revealed. Between the major fields there are often zones which simultaneously divide and unify. "It is at the divide between the rectangular expanses of color forms that suspense—that element which Rothko calls violence—invigorates almost imperceptibly the overall lyricism."[7]

Although recession into depth has been eliminated, Rothko's canvases are by no means flat, two-dimensional areas of color and pattern. To be sure, there is no depth illusion as in Renaissance painting, nor is there the constructed space of cubism or the planar quality of Mondrian. The "space" is not really *in* these pictures of Rothko's, but rather it inheres in the sensations of actual physical

imminence, of immediate impingement, which they evoke in the viewer. And since man can be cognizant of existence, can *feel*, that is to say, only in a continuum of space, the space sensations in these pictures actually occur outside of the picture plane, on some meeting ground between the picture and the viewer.

A great many of Rothko's paintings of the fifties make us feel as if a charge has been set up; we seem to be confronted with the world during the heavy hours preceding the storm, when the clouds are about to close in on each other. Yet whereas the color shapes are informed with some impending ominous transformation the canvases are, so to speak, suspended at the point of instability. The spectator contemplates an atmosphere of alarm in which the contact of electrically charged and dangerous elements is held in check by the tense areas between them. In some pictures the vibrating areas are pulled apart by the outside color frames.

In other paintings we feel that all movement has eased. These suggest the aftermath of once violent activity. Eventually as other images occur to the viewer the metaphor of the creation of some universe becomes paramount. And increasingly—in the mind of this writer—these "shivering bars of light" assume a function similar to that loaded area between God's and Adam's fingers on the Sistine ceiling. But Rothko's creation can no longer be depicted in terms of human allegory. His separated color areas also create a spark, but now it takes place in some sort of revolving atmospheric universe rather than between Michelangelo's man and his God. Rothko has given us the first, not the sixth, day of creation.

An Apollonian intensity becomes evident in Rothko's work once we go beyond the immediate sensual appeal of the beautiful color relationships. In her interpretations of Rothko's work, Dore Ashton has compared it with Greek drama, "to the fatalism, the stately cadence and the desperately controlled shrieks."[8] Indeed, his work does not so much resolve agitation as contain it, in the sense of holding it within bounds. These apparently quiet, contemplative surfaces are only masks for underlying turmoil and passion.

In recent years even the bright or blazing colors have been largely subdued to make way for painting of a somber ritualistic nature. "As I have grown older, Shakespeare has come closer to me than Aeschylus, who meant so much to me in my youth. Shakespeare's tragic concept embodies for me the full range of life from which the artist draws all his tragic materials, including irony; irony becomes a weapon against fate."[9]

In 1958, when he began to paint murals commissioned for a large private dining room, they turned out to be paintings which may be interpreted as celebrating the death of a civilization. In these vast canvases he abandoned solid color areas for rectangular frames of a single hue set in a field of solid color.

The open rectangles suggest the rims of flame in containing fires, or the

entrances to tombs, like the doors to the dwellings of the dead in Egyptian pyramids, behind which the sculptors kept the kings "alive" for eternity in the *ka*. But unlike the doors of the dead, which were meant to shut out the living from the place of absolute might, even of patrician death, these paintings—open sarcophagi—moodily dare, and thus invite the spectator to enter their orifices. Indeed, the whole series of these murals brings to mind an Orphic cycle; their subject might be death and resurrection in classical, not Christian, mythology: the artist descending to Hades to find the Eurydice of his vision. The door to the tomb opens for the artist in search of his muse.

For about eight months, Rothko was completely occupied in the execution of his mural commission. When it was finished, and the artist had actually created three different series, it was clear to him that these paintings and the setting did not suit each other. One may go so far as to say that this modern Dance of Death had developed into an ironic commentary on the elegant Park Avenue dining room for which it had originally been intended. Like much of Rothko's work, these murals really seem to ask for a special place apart, a kind of sanctuary, where they may perform what is essentially a sacramental function. This is not an absurd notion when one considers the profoundly religious quality of much apparently secular modern art—indeed, the work of art has for a small but significant number of people (including spectators as well as artists) taken on something of the ecstatic and redeeming characteristics of the religious experience. Perhaps, like medieval altarpieces, these murals can properly be seen only in an ambiance created in total keeping with their mood.

Rothko's most recent dark paintings, done after the "Orphic cycle," combine the palette of these murals with the figuration of the previous period. They have the glowing color of embers and are as relentless in their austerity. Nietzsche wrote in *The Birth of Tragedy* an essay Rothko had read with great admiration when he was a young man: "There is need for a whole world of torment in order for the individual to produce the redemptive vision and to sit quietly in his rocking rowboat in mid-sea, absorbed in contemplation."[10]

Notes

1. Mark Rothko, *Possibilities I*, Winter 1947/48, "The Romantics Were Prompted," p. 84.

2. Ibid.

3. Mark Rothko, interview with the author, autumn 1960.

4. M. B., *Art Digest*, April 15, 1949, Vol. 23, No. 14, Fifty-Seventh Street in Review, "Mark Rothko at Parsons," p. 27.

5. T. B. H., *Art News*, April 1949, Vol. XLVIII, No. 2, Reviews and Previews, "Mark Rothko (Parsons; to April 16)," p. 49.

6. Letter, *New York Times,* June 13, 1943, jointly with Adolph Gottlieb.

7. Georgine Oeri, *The Baltimore Museum of Art News*, Vol. XXIII, No. 2, Winter 1960, "Rothko's 'Oliver over Red,'" p. 8.

8. Dore Ashton, *Arts and Architecture*, August 1957, "Mark Rothko," p. 8.

9. Mark Rothko, interview with the author, autumn 1960.

10. Friedrich Nietzsche, *The Birth of Tragedy*, translation by Francis Golffing, New York, Doubleday & Company, 1956, pp. 33-34.

Sam Francis: The Recent Work

In Sam Francis' recent painting there is a quality of endless space and infinite volume. The experience of seeing his new work is analogous to looking up or down into space itself. His whites expand and they are illuminated by areas of bright diaphanous color which float in their white environment without anchor. There are no focal points in these paintings. A constant dialogue occurs between the color areas and the white field. At times, the white does not appear as a field, but is perceived as a veil floating on top of the color zones. These areas define and delineate the white space just as the white surface creates their outlines.

When I first saw Sam Francis' large *Upper Red* (1969) in his studio in Venice, California, I was reminded of the experience I had had at the famous rock garden in the Ryoanji Monastery in Kyoto. The astonishing quality of this "dry landscape" in Kyoto is its scale, alluding to infinity. As the visitor contemplates the ancient rocks, emerging from their desert of white sand carefully raked into a wave-like pattern, he might be looking at mountains or at continents. Size is immaterial in this abstract garden. Macrocosm and microcosm are bound in a scale which has its own autonomy. There is a similar sense of scale and autonomy in the paintings by Francis, in which color blotches emerge from their sea of whiteness.

The colors themselves have the beauty of sensuous energy. Heavy at times and fluid at others, paint is applied in glazes, washes and stains. Sam Francis mixes his own colors, using essential dyes which he combines with neutral acrylic and to which filler is generally added to give it body. At times the color will be used in its pure, saturated state, which accounts for the dark surfaces with an almost metallic luster in some of the color areas and which stands in great contrast to the diluted and lighter splashes of mixed color.

Upper Red itself, measuring 12 x 27 feet, is the maquette for the mural *Berlin Red*, a canvas extending over more than 26 x 40 feet, which has recently been permanently installed in the new National Gallery of Berlin. The pristine environment of Mies van der Rohe's final architectural statement has become the perfect antiphony to the joyous freedom of the Francis painting, both masterpieces sharing a sense of restraint.

The large vertical painting *Berkeley* was done at the same time. Here the colored shapes near the edges are permeated with the white (or tinted white) of the ground. They are organic, they flow. They have been allowed to bleed at the edges, which gives them the effect of blots of damp paint, not unlike what we expect to find in watercolors painted on wet paper. The colors are very intense, which adds to the sensation of moistness. The hues are carmine, crimson, and purple, with some deep blue and green and touches of dark yellow and light green. Due to the bleeding of the colors, they vary a great deal in value: the green for example at its most opaque approaches black, but at its edges it fades into a light, transparent shade. The organic shapes and their dissolving edges have a liquid quality. Like drops of ink crushed beneath a sheet of glass, they are ready to flow out of the picture, to spill over the corners. This sensation is enhanced by the large white area which seems to exercise a centrifugal force, trying to push the four shapes out of the picture. Thus, the white becomes a thrusting dynamic center. The whole painting seems to be a record of a transitory phenomenon, conveying a sense of flux and fluidity. Sam Francis told me one time that for him painting has always been a "process to go to something else." And perhaps this is why he, more than almost any other living painter I can think of, has been able to constantly renew himself: there is an analogy between what goes on visually in one of his canvases and what has been happening in the evolution of his work over a quarter century.

The series of recent "white ring paintings" in which only the edges are colorful has its original inception in some of the artist's early watercolors and his all-over white paintings of the early fifties. One of the first large canvases of this later group, however, is *Iris* of 1965, in which the framing areas still loom very large. Sam Francis, related to the Abstract Expressionist tradition, works by feeling and intuition. But, instead of relying on the calligraphy of gesture, he channels this intuitive approach with conscious deliberation.

In *Iris* he applied five or six layers of white onto the sized canvas with a small amount of color tinted in. Then he moved into the white area with two different shades of red. Next the orange strip on top of the canvas was added, which appears again, extremely narrow this time, on the left margin. Finally the dark colors were applied. There is a conflict set up in the right area between the black veil, which spreads and flows over the compelling active large red vertical form, each fighting for dominance. The white volume presses upon the other colors. In fact, the large white tilted plane exerts a powerful force, pushing simultaneously against the red column on the right and the thin margin of dark color on the left. The white is held in place by the darker colors, but it also activates their being, as they, in turn, make the white come to life. There is always this interdependence, this dialogue between opposites, which hold and transform each other. The subject matter of much of Sam Francis' work (and I know of no significant painting without subject matter) is this inter-action of

opposites, this tension of co-existence. This is as true in a tough painting like *Iris* as it is in more obviously sensuous and softer works, like *Berkeley*, or the very recent *Entrance*.

Sam Francis rarely gives titles to his paintings and then only with great reluctance and much deliberation. But, when discussing this painting of 1965, he said it was "like a shutter or an iris." When I suggested this as a title, he also liked the allusion to the flower, to the woman's name. But the anatomical meaning of the works is what matters: the painting deals with an aperture. In fact, most of Sam's recent works can be seen as openings, as entrances, but also as mirrors.

Painted a year after *Iris*, *Mako* (1966) has become very austere. Color is restricted to narrow strips at the left and right edge of this large vertical canvas. On the left a strong red-orange dominates, while the color shaft on the right is very dark. The large central space has been compared by Francis to a "great white sail," and indeed the surfaces in this painting and the ones to follow seem to warp and to bulge, to twist and bend. These "white ring" paintings are certainly the most formal work Sam Francis has ever done, but even where geometry—such as a large white rectangle—occurs, Sam counteracts the coldness of geometric order. His abstractions remain "naturalistic," as James Johnson Sweeney has observed. The large central white spaces have their own volume and often these subliminally tinted off-whites are not only allowed to project or recede, but channels in the color margin permit them to flow beyond the limits of the canvas. Although all the elements are planned, Francis does not work according to preconceived patterns. The event of chance is welcomed, but it is a matter of the artist finding himself and his presence rather than the accidental use of a particular color or shape.

These white spaces as in *White Ring* of 1967 exude a great energy which is analogous but opposite to the bright color of the frame. These two elements belong to each other like the holes with their shape-meaning in Henry Moore's sculpture or the significant silences in John Cage's musical compositions. In a recent essay on "Art as a Form of Reality," Herbert Marcuse points out that "the way in which the story is told; the structure and selectiveness of verse and prose; that which is *not* said, *not* represented; and yet is present...these are some aspects of the form which remove, dissociate, alienate the *oeuvre* from the given reality and make it enter its own reality."

The color frames in these paintings of the late sixties often have the toughness and optimism which characterize much of recent American painting, but the white area which is carved out by them has an almost mystical nature. From the very beginning, the quality of light has been a dominant element in Sam Francis' painting. The large white spaces in these paintings have a dynamic expansiveness which alludes to the continuum of space, while their luminosity and splendor deal with light. In *A Storm of White*, Robert Duncan evoked the mystery of whiteness:

> *neither*
> *sky nor earth, without horizon, it's*
> *a-*
> *nother tossing, continually in-*
> *breaking*
> *boundary of white*
> *foaming in gull-white weather*
> *luminous in dull white, and trees*
> *ghosts of blackness or verdure*
> *that here are*
> *dark whites in storm*
> *white, white white like*
> *a boundary in death advancing*
> *that is our life, that's love*
> *line upon line*
> *breaking in radiance, so soft- so dim-*
> *ly glaring, dominating*
> . . .

In *Entrance,* painted this year, the framing device has been placed inside the white field. The observer is led into this painting by a symbolic gateway which can be seen as two posts and a lintel. Space has become three-dimensional. Solid protuberances push and press into the white center. Some of the colors, especially delicate blues and greens, seem to blow and bleed inwards, while more definitely outlined shapes of orange, purple, and a red breast-like form on top push forcibly into the center. The colors and textures of *Entrance* and other new paintings by Francis are extremely varied, ranging from soft washes to crusty and flaky surfaces and to heavy metallic effects. The variety of pigmentation and brush work results in a never-ending fascination on the part of the spectator, who becomes involved in a continuous exploration of sumptuous colors of different weights, textures, and consistencies. This highly seductive sensation leads on to further experiences: the purple diagonal stripe on the lower right not only supports the pillar, but continues out of the canvas, extending the metaphor of the entrance into a larger system of orifices.

The white area contained in the center is definitely on a distant plane. It is no longer an empty void, but this atmospheric volume is energized by arching lines of color flecks which float freely like far-away constellations. Always preoccupied with space, Sam Francis has created an opening into the void and defined and occupied its presence.

The large retrospective currently [1972-73] in four American museums[1] gives new insight into the extensive range of Francis' work, the changes and periods which are discernible over a period of some twenty-five years. But his style is given unity by his exploration of space and light and graced by a joyous radiance of color.

Note

1. Albright-Knox Art Gallery, Buffalo; Corcoran Gallery of Art, Washington, D.C.; Whitney Museum of American Art, New York; Dallas Museum of Fine Art, Dallas, Texas.

VI

Kinetic Sculpture

Homage to New York

A Self-Constructing and Self-Destroying Work of Art
Conceived and Built by Jean Tinguely

We know that emotion cannot be petrified, that love cannot be bound, that life cannot be conserved and that time cannot be held. Jean Tinguely's experiments are works of art in which time, movement, and gesture are demonstrated—not merely evoked. Tinguely accepts the Heraclitan change inherent in life. His is a world in flux and constant self-transformation.

Being very much part of his time, Tinguely uses machines to show movement, but he is fully aware that machines are no more permanent than life itself. Their time runs out, they destroy themselves. This he demonstrates dramatically in *Homage to New York*. Here he brings the motor into an ironic situation which controverts its function. Rendered helpless, it no longer operates in its normal way. It destroys itself more quickly because it performs more intensely.

In New York Tinguely finds a maximum concentration of human life and energy, a virility which accelerates its own dissolution. He believes that the idea of a self-constructing and self-destroying mechanized sculpture would never have occurred to him in the ancient ambiance of the Mediterranean coast. Its dynamic energy as well as its final self-destruction—are they not artistic equivalents for our own culture?

He has conceived and built this sculpture and is eager to witness its loss so that we may witness its choreography.

Directions in Kinetic Sculpture

Lessing's definitive distinction between the plastic arts which exist in space and the temporal arts which develop in time could easily have been contradicted by all the ingenious moving objects which, in the course of centuries, probably have delighted the populace far more than the statue of the *Laocoön*. Courts and fairs in the eighteenth century were filled with complicated clocks, mechanical magicians, wizards, and conjurers, fantastic automata and artificial singing birds. The latter, indeed, go back to antiquity and—as we know from Andersen's fairy tale—were present in the Imperial Courts of China. Bishop Lindfrand, in the account of his voyage to Constantinople in 949 A.D., describes the Byzantine Emperor's gilded trees inhabited by chanting mechanical birds; he also tells of bronze lions guarding the great royal throne—lions which could swing their tails and were able, on appropriate occasions, to roar with open mouths and trembling tongues.

In the first century A.D., Heron of Alexandria devised machines to perform religious magic: as the worshipper entered the temple, large doors swung open by themselves, a fine rain of holy water showered down, and bronze birds opened their beaks to sing. Robot priests seemed to perform incredible miracles by placing their hands into the sacred flames to bless them, then completing the curious service by dripping water from their hands to extinguish the flames. Two thousand years later, in the garden of the Museum of Modern Art, Tinguely's self-destroying machine burst into flames of its own volition. The firemen who were called in to preserve the safety of spectators succeeded in quenching flames, machine, and twenty centuries of mystery and holy fear in an ironic, Keystone-cops *finale* that was perhaps not inappropriate to Tinguely's original intention.

Most of the automata of the past were made primarily for public or private entertainment. Perhaps the most intricate device was a great duck which Jacques de Vaucanson built in the eighteenth century. This duck had wings articulated by 400 moving parts. It could chatter, eat, digest, and was able to waddle, to the great astonishment of spectators who traveled to see it from all over Europe. Earlier, Leonardo da Vinci devised a lion for Francis I which would walk toward the king

and open its mouth to disclose a large bank of white lilies on a blue ground. Despite the eminence of its inventor, the lion was undoubtedly considered chiefly as a clever object for the distraction of the court. The time for a high art of motion had not yet come.

No matter how artfully constructed, the automata of the past could only repeat their actions. The complex clock displays on the towers of city halls, guild halls and churches, with their mechanical figures striking bells and performing dances, were always a great delight to gaping spectators. Some of these devices were poignant enough in their literary imagery, as when the figure of Death would appear and swing his scythe as the hour struck.

Tinguely's contemporary *méta-matics*, whose ballpoint pens, fixed in rapidly moving arms, make colored drawings to the accompaniment of great clamor and rattle, have their precedent in the *dessinateurs* of Pierre Jaquet-Droz. Jaquet-Droz, also a Swiss, constructed a mechanical doll in 1774—only eight years after Lessing's *Laocoön* was published—which could make a charming drawing of a cupid riding a chariot which was drawn by a butterfly. The important difference between Tinguely's machine and that of his Swiss predecessor, however, is not the gratuitous result as opposed to that earlier decorative vignette, nor the loudly nervous energy expended by the *méta-matic* compared to the deliberate and calm movement of the *dessinateur*, but the fact that the latter could only make four different drawings when properly adjusted, whereas the modern machine's output is infinitely varied and operates according to the laws of chance. Modern kinetic sculpture is fortuitous, not predetermined. Or rather, it is designed to work at random.

Modern kinetic works are distinguished from all the automata of the past and the computers of the present in that their action attempts to be indeterminate. Only the weather vanes and the great fountains, the magnificent water plays at the Villa d'Este and Versailles, depend not solely on vast, engineered constructions of dams and hydraulic pumps, but on the uncontrolled force of the wind as well; they give, therefore, a greater visual and temporal delight than the most complicated contrivances which operate only on repetitive mechanisms. Random motions caused by wind and falling water retain their fascination for contemporary artists. If the weather vanes of old have their modern counterparts in the ever-changing constellations of Calder and Rickey, the possibilities of water which currently occupy the talents of men like Hans Haacke, Heinz Mack, Norbert Kricke, or Henk Peeters, are truly inexhaustible. Richard Buckminster Fuller, cosmogonist, comprehensive designer, and mathematician, recently commented on the main assumptions of two seminal theories in physics. His observations reveal important aspects of the attitudes which underlie the development of kinetic art and the artists who contribute to it:

Einstein shattered the Newtonian cosmos ... in the famous first law of dynamics, Newton had said that a body persisted in a state of rest or constant motion except as it was affected by other bodies; he was assuming that the normal condition of all things was inertia. Einstein realized that all bodies were constantly being affected by other bodies, though, and this meant that their normal condition was not inertia at all but continuous motion and continuous change. The replacement of the Newtonian static norm by the Einsteinian dynamic norm really opened the way to modern science and technology, and it's still the biggest thing that is happening at this moment in history.[1]

The whole Cartesian universe, with its inherent schism between man's thought and the physical world, Lessing's neat distinctions between the arts of time and the arts of space, could no longer hold once Einstein's theory of the space-time continuum, in which time is a coordinate of space, had been accepted. Yet, even before the Theory of Relativity was announced, movement and the process of change had become a major concern among artists. When, in the early nineties, Claude Monet exhibited fifteen haystacks and then twenty views of the façade of Rouen Cathedral at Durand-Ruel in Paris, it became quite clear that the artist's subject matter was no longer the inert object, but rather, the process of change itself.

Although Rodin, in his statement about the significance of equilibrium and movement in sculpture, referred to the movement of light animating the surface textures and not to actual motion, it is important to realize that by making bronze surfaces subject to the play of light, Rodin, and even more, his contemporary Medardo Rosso, clearly revealed a new concern with the aspects of change. "Nothing is motionless," Rosso wrote, " ... every object participates in the swift and multiple improvisations of nature."[2]

The Futurists of the next generation admired Rosso and considered him their unique precursor. But in 1912 Umberto Boccioni in his *Technical Manifesto of Futurist Sculpture* could say:

> The revolution of Medardo Rosso, although of the greatest importance, starts off from an external pictorial concept ... it thus has the same strong points and defects as Impressionism in painting.... In sculpture as in painting one cannot renovate without searching for THE STYLE OF THE MOVEMENT ... by making systematic and definitive in a synthesis what Impressionism has give us as fragmentary, accidental, and thus analytical.... [3]

With a violent burst on the public consciousness, the Futurists demanded " ... that universal dynamism must be rendered in painting as a dynamic sensation."[4] As they were conscious of the fact that " ... all things move, all things run, all things are rapidly changing ... ,"[5] they searched with the fervor of disciples to a new religion for the key which would translate their sense of the dynamic into painting and sculpture. Boccioni's bronze walking man, called *Unique Forms of Continuity in Space,* of 1913 and Marcel Duchamp's related but

earlier *Nude Descending a Staircase* (1912) are indeed imbued with all the energy of swift movement, even if the energy is still potential rather than kinetic. When Marcel Duchamp mounted a bicycle wheel on his studio stool, however, not only was he carrying out a gesture of Dada insolence, but his little construction turned the way a bicycle wheel does turn, and was therefore a moving object chosen by an artist. By 1920, Duchamp was spinning his rotating discs, pictorial jokes which would generate the illusion of space. But he soon decided, as he told Richard Huelsenbeck, "...life was more interesting than aesthetics," and abdicated from the creation of anti-art as well as art.

Duchamp's friend Man Ray made the first "mobiles" by hanging paper spirals from the ceiling of his studio in Paris to enjoy their rotation. Man Ray also assembled coat hangers on springs in order to let them swing about freely, and in 1923 he put an eye into the wand of a metronome.

Motion and speed, the hallmarks of the new epoch, have long since been accepted as integers of urban life in the twentieth century—integers which have altered the realities of the human condition. The Constructivist Vladimir Tatlin, when commissioned to build an architectural monument for the new Communist state, designed a gigantic tower of steel and glass, with a cylinder rotating once a year, a cone once a month, and a cube once a day. At the top, 900 feet in the air, there was to be a restaurant, affording its patrons a continually changing view. It is interesting to note that this monument, which was to be a tribute to modern technology and the symbol of a new way of life, was designed to function as a time-measuring device: in effect, it was to be a calendar, and thereby a first cousin to the guild hall clock-towers which measured the hours and days with performances of their mechanical parades.

In the new Russia, which at that time had not yet decided to return to time-worn aesthetic ideas, Alexander Rodchenko exhibited mobiles of circular hoops constantly turning within a large sphere containing them. At the same time large abstract moving sculptures were designed for parade decorations and stage sets in Leningrad.

A comparison of Man Ray's early "mobiles" with those by Rodchenko shows the two branches of kinetic art which were beginning to be distinguishable: on the one hand there was the playful preoccupation with the absurdities of using ready-mades—such as coat hangers—to make preposterous "works of art"; on the other hand there were the carefully designed kinetic objects of the Constructivists. The latter's position was rational, optimistic, an almost scientific attitude of research. The Constructivists and their heirs hoped to project and communicate a new "vision in motion."

Naum Gabo forecast a great deal of later work, such as the powerful bounding steel sculptures by Len Lye, when in 1920 he constructed a virtual volume from a weighted vertical steel spring set vibrating by a motor. This illusory body was entitled *Kinetic Sculpture*. At the same time he and his brother

Antoine Pevsner issued their *Realist Manifesto* in Moscow in which they stated their belief that space and time are the two fundamental elements of art, that mass and volume are not the only means of sculptural expression, and they proclaimed their liberation "from the thousand-year-old error of art, originating in Egypt, that only static rhythms can be its elements. We proclaim that for present-day perception the most important elements of art are the kinetic rhythms...."[6]

The Constructivist point of view was carried further and propagated by László Moholy-Nagy, who, with Alfred Kemény, issued a manifesto in the influential Berlin publication, *Der Sturm*. Here Moholy clearly saw into the future and formulated a theory of kinetic art which would not materialize for more than a generation. He advocated the activation of space by means of a dynamic-constructive system of forces and hoped to substitute relationships of energies for the old relationships of form in art. He projected sculpture suspended freely in space, and was careful to point out that, for the time being, this work could only be experimental but that eventually the spectator, instead of being merely receptive in his observation, would be totally engaged as a participant in an event, experiencing "a heightening of his own faculties, and become himself an active partner with the forces unfolding themselves."[7]

This manifesto was published in 1922 just before Moholy joined the faculty of the Bauhaus. There he proceeded to construct his famous *Light Display Machine* (1922-1930), a motor-driven sculpture, connected to many colored light bulbs, which projected a constantly varied display of light and became the source of Moholy's film *Black, White and Gray*. Here solid mass is truly shattered by light and motion.

At the Bauhaus, Moholy's analytic mind and his concepts of free-moving sculpture encountered the work of Paul Klee for whom, too, nothing was static, to whom "...movement underlies the growth and decay of all things." Klee began his *Pedagogical Sketchbook*, written for instruction at the Bauhaus, in 1923, by speaking about "...an active line on a walk, moving freely, without goal...,"[8] and writes metaphorically in the last section about the arrow who is the child of thought. Klee knew that "...pictorial art springs from movement, is in itself interrupted motion and is conceived as motion."[9] Klee's pictures, literally, have to be read in time, a device that he used to evoke the sensation of metamorphosis.

Kinetic sculpture was widely discussed at the Bauhaus and at its offshoot, The Institute of Design in Chicago. There Moholy-Nagy published his influential book, entitled *Vision in Motion*,[10] in which he postulates that kinetic sculpture is the fifth and last of the successive stages in the development of plastic form.

In the period between the wars, artists continued to experiment with kinesis. During these fertile years of experimentation, Alberto Giacometti,

constantly searching for new sculptural concepts, "...was interested in the possibilities of obtaining actual kinetic movement and constructed his *Suspended Ball* in which a cloven sphere, held by a thread, can be made to slide along a crescent-shaped object."[11]

It was during that time that Alexander Calder's work reached its first stage of maturity. Calder had come to the attention of the Paris art world with the delightful miniature circus he produced during the late twenties. These articulated dolls and animals, made of wood, cork, yarn reels, and wire, certainly are related to the animated toys of the past, but they also had the style and individuality of a modern artist: they were drawings in space as well as mechanically dancing and swinging figures. Soon thereafter Calder entered the field of abstract art, the result of a visit to the studio of Piet Mondrian in Paris in 1930. He intended at first to make three-dimensional vibrating Mondrians, but soon was making little sculptures which had to be moved by hand cranks or electric motors, and which were called "mobiles" by Marcel Duchamp. By the mid-thirties, however, he substituted mobiles which were driven at random by the wind and the air rather than mechanically. Here Alexander Calder introduced infinite, fortuitous variations into art. At the same time, he managed to make marvelous playthings of machines and his "...kinetic sculptures stir lightly, like leaves in the wind. His mobiles virtually create the space through which they move, and his work has been so satisfying, aesthetically, that he dominated the field until after the Second World War."[12] While to everyone's delight he has continued to make mobiles, Calder's most important contributions in recent years have been his solid yet open "stabiles," large sheets of iron which carve into space.

The kinetic artists of the postwar period, however, did not pursue Calder's example. In his review of the large Calder retrospective held at the Tate Gallery in 1962, George Rickey, whose own work is also moved by air currents, explained that Calder was too easily imitated, and "...he has ignored the vast possibilities of the kinetic art he introduced himself and left their realization to others mostly outside America and most indebted to constructivism rather than to him."[13]

Yet, although a new generation has explored new possibilities in kinetic sculpture, Calder remains a source of continual delight and joy. His graceful, precise biomorphic mobiles share their quality of playfulness with much of the more recent kinetic work. When we look at Robert Breer's *Styrofoam Floats*, those ridiculous white shapes creeping along the ground, art becomes fun once more. Charles Mattox's little machines are objects of irony: when his *Blue Seven* finally encounters the black ball, it is repulsed by its nasty growl. A little more fortunate, perhaps, is the little feeler in the *Act of Love* which manages to succeed in fondling the object of its affection, although it, too, is unable to establish union. Mattox's games are endowed by the viewer with human characteristics, as are Tinguely's self-deprecating machines that so rarely perform as expected.

Harry Kramer's contraptions, the least abstract works in this exhibition, appear at first glance as though they might be knicknacks produced by some tinker or hobbyist. Not at all; they are bewitched actors in a fairy tale: here is the big foot which stands still but is all alive inside, here the chair with funny motors on its seat, there a stovepipe, which moves itself, inviting comparison with our sleekly enameled contrivances. Indeed, Harry Kramer, who has been active as a dancer, comedian, film maker, and inventor of fabulous mechanical marionettes, has remained a choreographer. The objects which populate his studio are so light and transparent that they hardly seem to be present at all, until their little motors bring them back into the physical world. Kramer discourses on the close relationship of his sculpture to show business as he walks along the unbelievable Pop streets of Las Vegas.

Unlike actual machines, these objects—and all the others in this exhibition—serve no other purpose but their own. The function of kinetic sculpture is an aesthetic one; kinetic sculpture must be seen and judged by the continually changing aesthetic criteria of form and content. Its purpose may be to present an enchanted performance, like Kramer's, or the performance may indeed be frightening and overwhelming in its miraculous power, as when Len Lye unleashes his great *Flip and Two Twisters, "Trilogy."* The function may also be an optical one, as in the constantly moving disks by von Graevenitz or in Fletcher Benton's disk in which six semicircles are programmed to transform themselves into the *Yin and Yang.*

Bruno Munari, next to Calder the most important precursor of present kinetic sculpture, departed from Futurism to build "useless machines" as early as 1934. An ingenious inventor, he adopted the Constructivist tradition to carry on early experiments with projected light. He also designs books, useful as well as useless objects, and makes kinetic sculpture. He feels that the artist has a clear and present social responsibility "... to help his fellow men to develop their understanding of the world in which we live."[14] Munari and his Italian friends and followers are involved in programmed art, a "... visual language which can naturally and intuitively communicate the dynamic factors determining our new knowledge of the world."[15] Although their work is abstract and follows Constructivist principles, certain associations drawn from the actual world with its social and psychological conditions are unavoidable and perhaps intended. "In Boriani's *Magnetic Surface*, particles of iron dust are transposed by mobile magnets into constantly ascending groups, only to disperse and disintegrate eventually as the filings descend to their original layer... it may be seen as an ontological comment on man's existence."[16] Similarly Pol Bury's sculptures may be seen as commentaries on mass societies, be they ant hills or cities. Yet these slowly moving pins, nails, and balls may also be considered as experiments concerning the threshold of perception of visible motion—the point at which we can hardly distinguish mobility from immobility. The multiplicity of meanings

and associations possible for kinetic sculpture distinguishes such moving objects sharply from actual machines whose behavior they imitate.

Jean Tinguely's anti-machines are similarly sardonic metaphors on the world of the assembly line and conveyor belts. Tinguely seems a worthy successor to Charlie Chaplin, who back in 1936 (*Modern Times*) characterized the factory as a madhouse. While our temper, our very existence, depends on machines, Tinguely questions them with a sense of humor and bestows on them a rattling human soul. Those who witnessed his splendid white structure, *Homage to New York*, break itself to bits on that cold slushy evening in March of 1961 emphasized this large travesty on modern society, yet were also angry at the firemen who doused the burning piano and axed the big *méta-matic*: in our civilized culture even a machine wasn't allowed to commit its own suicide. Surely Tinguely's machines, his art of accident and transformation, has implications of which he himself is articulately aware. He told Dorothy Gees Seckler: "People have always tried to fix things into permanence because of their fear of death, but in reality, the only stable thing is movement. Our only chance is to make things move from the beginning, to allow them to eternally transform themselves."[17] Len Lye, whose pure Constructivist work is at the extreme opposite of Tinguely's accumulations of junk, would agree with this statement—it is so basic to the philosophy of kinetic sculpture.

The kinetic sculptor, working with movement and energy, has a much more self-assertive and optimistic attitude than had the leading artists of a previous generation. This is no longer an art of introspection, as in Abstract Expressionism and the New Figuration. If artists as different from each other as Willem de Kooning and Francis Bacon express the despair and irrationality so prevalent in our time, we are here dealing with a new generation which seems perhaps more affected by man's ability to leave the earth and move into outer space than by his failures on this planet. Perhaps this new optimism is partly due to the realization that mankind—thus far at least—seems to have been able to continue with some degree of coherence, even without those absolute values whose loss was so painful to a previous generation.

Kinetic art is more objective, more detached; there is far less stress on the individual act in this art which—by virtue of its essence—motion—tends to be anonymous. Indeed, many of the artists are members of teams, such as *Zero* (Düsseldorf), *Gruppo T* (Milan), *Gruppo N* (Padua), *Groupe de la Recherche d' Art Visuel* (Paris), *Equipo 57* (Spain), and work more or less collectively. Their attitude, generally, is more rational and scientifically oriented to a point where Bruno Munari even recommends the use of computers for his programmed art. Nevertheless, it is still the highly individual and personal performance of kinetic sculptures by a Lye, a Rickey, a Takis, and a Tinguely, which remains paramount.

The Movement Movement, as Hans Richter has referred to it, does not allow for the self-exploring process which was so basic to Abstract Expressionism or Tachism. Yet Action Painting was defined by Harold

Rosenberg as an arena where the painter enacts his physical movement: " ... the action on the canvas became its own representation"[18] as the artist would explore his voyage into the unknown. This consciousness of action as the essence clearly relates Abstract Expressionism to Sartre, whose Existentialism emphasizes action as the only key to reality; it was Jean-Paul Sartre who wrote the introduction to Calder's exhibition in Paris in 1946, in which he expressed his admiration for the sculptor's " ... pure play of movement."[19] But in kinetic art, instead of retaining on canvas the imprint of expired action, the artist becomes the choreographer of his own work—he creates performances.

Recent developments in sculpture indicate that many sculptors are no longer interested in making pieces predestined for pedestals in living rooms or gardens. Since Kiesler's *Galaxies*, since the environmental sculptures of Ferber and Goeritz, sculpture has assumed a new relationship with the spectator, who finds himself surrounded by the sculpture he is allowed to enter. In kinetic sculpture the viewer becomes engaged as a participant; he experiences sculpture in time, be this a noisy neo-Dada performance staged by Tinguely, or the experience of quietly observing Rickey's silent blades of steel serenely measuring space in time. Hans Haacke makes the viewer an active participant. His surging *Waves* must be handled by the observer, who alone can bring them to life. Colombo hopes to engage the spectator into becoming a technician. Charles Mattox lets his *Oscillator Number 4* vibrate vigorously as we approach it; as we walk away, this apparently prescient device calms itself to silence again.

As the theatre has long since moved beyond the confines of the proscenium, so sculpture has moved from its pedestal. All the arts, it seems, are currently intent on the fuller engagement of the observer; in order to achieve this end, they tend toward some sort of Synaesthesia or *Gesamtkunstwerk*. Kinetic sculpture figures as an important element in this general development. Many of the sculptures make noises related to their form: Tinguely's machines rattle, Lye's bellow, and Bury's seem to chirp, while Takis' emit electronic sounds.

The creation of sculpture in motion has attracted artists who were previously engaged in other pursuits: Bury had been a poet, and Takis, too, wrote poetry while he was imprisoned as a member of the Greek Resistance during the war. Lye made abstract films which indeed anticipated his Tangible Motion sculptures. Breer is still primarily committed to the film. Rickey had been a historian and a painter, Munari is well known as an industrial designer and graphic artist, Kramer is a choreographer and dancer. Not only the areas of artistic endeavor, but indeed all fields of human imagination and thought seem to have a bearing on kinetic sculpture. If Kramer is more interested in show business, Takis is concerned with theories of physics and the scientific discoveries of outer space. Kinetic sculptors may be interested in Gestalt psychology, cybernetics, the Theory of Games and Information Theory. They must be consummate craftsmen as well as four-dimensional designers.

Making use of man's accomplishments in this multiplicity of fields, kinetic

sculptors like Rickey and Bury achieve parallels to the movements in nature. Others, such as Tinguely, may comment on human society or hope to improve it by the example of their work, which seems to be a goal among the Italians. Or they may define this new universe of the twentieth century, in which matter and energy are indeed transformable, as Len Lye does when he dematerializes his mighty steel masses into visible energy, or as Takis does when he permits the invisible energy of the magnet to enter into sculptural form. Takis uses a weightless force together with musical sound. He " ... unites in him the hidden aspirations of our age: the dream of modern man to liberate himself from the tyranny of matter."[20]

Notes

1. Richard Buckminster Fuller, quoted by Calvin Tomkins in "In the Outlaw Area [Profiles]," *The New Yorker*, Jan. 8, 1966, p. 36.

2. Medardo Rosso, quoted in Carola-Giedion Welcker, *Contemporary Sculpture*, New York, 1955, p. 14.

3. Umberto Boccioni, *Technical Manifesto of Futurist Sculpture*, April, 1912; quoted by Joshua C. Taylor, in *Futurism*, New York, 1961, pp. 130-31.

4. *Futurist Painting, Technical Manifesto*, April, 1910; quoted by Taylor, op. cit., p. 127.

5. Ibid., p. 125.

6. Naum Gabo and Antoine Pevsner, *Realist Manifesto*, Moscow, 1920.

7. László Moholy-Nagy and A. Kemény, "Dynamisch-konstruktives Kraftsystem," *Der Sturm,* No. 12, 1922, p. 186.

8. Paul Klee, quoted by Will Grohmann, in *Drawings of Paul Klee*, New York, Valentin, 1944.

9. Op. cit., p. 16.

10. L. Moholy-Nagy, *Vision in Motion*, Chicago, Paul Theobald, 1947.

11. Peter Selz, *Alberto Giacometti*, New York, The Museum of Modern Art, 1965, p. 10.

12. Selz, "Arte Programmata," *Arts Magazine*, 39:6 (March, 1965), p. 20.

13. George Rickey, "Calder in London," *Arts Magazine*, 36:10 (Sept. 1962), p. 27.

14. Bruno Munari, "Programmed Art," *The Times Literary Supplement*, Sept. 3, 1964.

15. Ibid.

16. Selz, "Arte Programmata," p. 21.

17. Jean Tinguely, quoted by Dorothy Gees Seckler, in "The Audience is His Medium," *Art in America*, 51:2 (April, 1963).

18. Harold Rosenberg, "Hans Hofmann: Nature in Action," *Art News*, 56:3 (May, 1957), pp. 34-36 and 55-56.

19. Jean-Paul Sartre, "Introduction" [to the show catalogue], Paris, Gal. Louis Carré, 1946.

20. Paul Keeler, "Colossus in Space," *Signals*, 1:3-4 (Oct.-Nov., 1964), p. 3.

The Berkeley Symposium
on Kinetic Sculpture

The Berkeley Symposium on Kinetic Sculpture was held on the campus of the University of California on March 18, 1966, to coincide with the opening of the exhibition "Directions in Kinetic Sculpture." The exhibition, the first comprehensive presentation of kinetic art in the United States, was by no means exhaustive. It dealt only with current work and did not include a historic section. The contributions of the early innovators and predecessors of the present generation—the work of Tatlin, Gabo, and Moholy-Nagy, of Duchamp, Man Ray, and Calder—were mentioned only in the catalogue and in its extensive chronology. Omitted from the exhibition, furthermore, was the whole rich development in the kinetic use of light from Thomas Wilfred to Nicolas Schöffer, and the current pursuits of artists like Vardanega, Soto, and the achievements of the Paris Groupe de la Recherche d'Art Visuel. The exhibition grew out of earlier discussions at The Museum of Modern Art in New York, where the current concern with movement in art could and should be divided into:

1. Paintings and two-dimensional objects in which optical phenomena—actual or apparent—produce an intense visual sensation in the viewer's eye: the exhibition "The Responsive Eye," organised by my former associate William C. Seitz, with its stress on works by Vasarely, Albers, Agam, Poons, and others, was held in the spring of 1965 at The Museum of Modern Art, New York.

2. Moving (or kinetic) sculpture—motivated by air current, electricity, magnetism, or any other source of energy: this aspect was the subject of the Berkeley exhibition a year later.

3. The play of light and its relationship to movement: exhibitions of this development are under way in several museums.

The current notion that all important artistic developments now originate in this country cannot be extended to any of the aspects of art in movement, which is largely a European tendency. "Directions in Kinetic Sculpture" included the work of fifteen artists, ten of whom are European; and, for a variety of

reasons, the work of other significant Europeans such as Agam, Julio Le Parc, Bruce Lacey, Walter Linck, Bruno Munari, and Nicolas Schöffer could not be included. The exhibition did, however, give a comprehensive view of the main tendencies and current concerns among kinetic sculptors. It presented works by Fletcher Benton, Davide Boriani, Robert Breer, Pol Bury, Gianni Colombo, Gerhard von Graevenitz, Hans Haacke, Harry Kramer, Len Lye, Heinz Mack, Charles Mattox, George Rickey, Takis, Jean Tinguely, and Yvaral.

The international critical reaction to the Berkeley exhibition was most gratifying and, partly as a result of the exhibition, the whole area of kinetic sculpture has come into American focus. The popular response, too, was incredible: over 80,000 visitors appeared in the small University Art Gallery to see and thoroughly enjoy the exhibition. On one level, people were delighted to find that modern art can be a lot of fun. On a very different level, the whole problem of four-dimensional art, of an art developing simultaneously in space and time, formed the basis of discussions toward a new aesthetic for our time.

The four artists asked to participate in the Symposium present both the unity and diversity of this distinct phenomenon in contemporary art. Kramer's chief interest is in sculpture as a theatrical spectacle; Rickey's sculpture defines the character of natural movement; Takis is concerned with capturing invisible energy itself; and Lye's clanging stainless steel vibrations take us into a future which only he can define.

The Symposium was an important exchange of ideas among these four men, most of whom met each other for the first time on that occasion.

Transcription of the Symposium

Moderator: Peter Selz, Director, University Art Museum
Participants: Harry Kramer, Len Lye, George Rickey, Takis.

Selz: I am happy to welcome you to the Symposium on Kinetic Sculpture taking place here on March 18 [1966] at the University of California, Berkeley, the day after the opening of the international show "Directions in Kinetic Sculpture."

Introducing the Panel: on my left is Mr. Takis. Mr. Takis, whose work you see in the center area of the gallery, is a sculptor, born in Athens, who has lived in Paris since 1954, and has just arrived from Paris for this "manifestation."

Immediately to my left is Harry Kramer. Mr. Kramer has been an actor, soldier, prisoner of war, butler, dancer, choreographer, and film maker, a German sculptor and artist who has also lived in Paris since 1956. He is presently staying in Las Vegas.

To my right, Mr. Len Lye. Mr. Lye is from New Zealand. He has lived in Samoa, Australia, and London for many years and, for the last twenty years, he has been in New York. He is well known not only for his sculpture but also for his early abstract films.

To my extreme right, George Rickey, born in the United States, but brought up in Scotland and educated at Oxford, a historian as well as painter in his earlier years, and since the late forties he has been an art historian and a kinetic sculptor.

As my first question, I would like to ask the panel an autobiographical question. How did you come to make kinetic sculpture, when did you start, and why? Would you begin, Mr. Rickey?

Rickey: I started in 1949. I think I had made a few attempts—vague, rather uncertain attempts before that—but I began in 1949 to work with movement as a serious and continuing occupation. Before that I had been a painter for about twenty years. I had felt more and more that painting did not occupy all my interests. I had come of a family of mechanics and engineers, and I had some aptitude in that direction myself, which was put to use by the army. As I grew older and observed what went on around me in art, I began to realise that it was possible to put some kind of mechanical aptitude, or mechanical interest, to work as an expressive instrument. So I began to make constructions, first in a very difficult and perverse way—I used glass. I was interested in sound. I had seen Japanese wind bells as a child and I remembered these. But I was cured rather quickly of the glass—one could lose a week's work very fast, you see, in a few seconds, and so I sought more durable materials. I was very soon concerned with trying to construct objects in which movement itself, rather than the shape of the appearance or the association of the object, was the prime concern. I've been in that ever since.

Lye: I kicked off as a kid, sweating it out on aesthetic theory. I used to go to the library and read Ruskin and even Sir Joshua Reynolds, and others, to see what they had to say, so I could get the hang of this stuff. I was checking with my teacher one day, apropos of what painting he would buy if there were two similar paintings by two different artists we knew, and he said, well, if they were similar, he wouldn't know. And I said, "Okay, if you had to buy one, which one?" So he said, "Well, I'd get the work of the artist who had his *own* theories about it. He's got his *own* thoughts about his art. That means he's been working at it a little longer, and maybe even now and again dreaming about it." This really triggered me because it got me going on the idea that I could drop all this "swatting-up theory" stuff and get a theory for myself. I'd remembered that Constable did a lot of oil sketches of clouds in motion, and I was watching the sun come up, and a lot of clouds skitting about, and I said to myself, "Well, now, that's fine, but why copy the motion of clouds? Why *pretend* motion, why simulate it? Why not make things *move*, if you're so interested in motion?" So that kicked me off, and that was about 1917. I messed around a lot with it, and decided that after I had done a lot of hand-cranking—you know, you take a phonograph, an old hand-wound phonograph, and pull the handle out and you set it up in plywood, you stick it through, and you've got little pulley wheels on one side with strings going up to another little wheel so that it, too, turns a shaft on which you put a shape—and

you have a mirror to see what you're doing because you're on the other side of the sheet of ply turning the handle. But I thought this was a little awkward, so I decided that film was the way to control motion. I did that—for something like thirty years—on and on. Anyway, it went like that until, finally, I came to realise that you could use motors instead of just a phonograph handle. And here I am today, thanks to money.

Kramer: First, I don't know how to explain, my English is too dense. In 1952 I didn't know what to do, and I made a stab at the theatre. And this was a sculptural puppet theatre. After that I began to show my puppets as sculpture, as it was good to be a sculptor.

Takis: Well, I don't know if it's very important how I started to make kinetic sculptures. But in Greece, you often see children take the roots of certain vegetables, cut them to resemble dolls, and hang them on a string, letting them float in the wind. That's one thing which fascinated me when I was a child. But once I missed the train coming from London to Paris. In Calais I was obliged to wait three or four hours for the next train to get into Paris and was fascinated by the "signalisation" of the railways. I drew some sketches, thinking how dramatic this signalisation was, and how necessary a part of our century this was. When I came back to Paris I started making a sort of imitation of those signals and, as I used thin steel wires as bodies to hold the signals, accidentally they started moving, and I thought it was very fascinating. Later on, travelling by aeroplane, I saw for the first time radar, moving as if directed by an invisible power. Then I tried to make things move from a distance. I remembered having seen, just after the war, a newsreel showing how the English had detected with radar the German aeroplanes before they arrived in England. Going deeper into the subject, I discovered that the radar functioned by magnets. Therefore, I used magnets to move an object. But again quite accidentally, I saw that when this magnet came close to the metallic object, the object itself lost its own weight. I felt this marvellous thing of defying gravity. That's it, I guess.

Selz: The purpose of the next question is to try to differentiate kinetic sculpture from things which we don't call kinetic sculpture. Various kinds of moving objects, such as the water fountains at Versailles and Tivoli, weather vanes, antique clocks, automatic games and figures, have existed through the ages. How does the current work, which we call "kinetic sculpture," differ from the moving objects of the past?

Lye: The differences are: fine art and folk art. You see, to me fine art bears the impress of some particular individual, his particular temperament. So the work of art, no matter what it is—a poem, a composition—bears this impress. This is the biz. And if you can get this essence, into your imagery—that's it. Thank you.

Rickey: I have the feeling that interest in kinetic art became possible in the twentieth century in a way that was not possible before, because of the development of a conscious, abstract, non-objective art which permitted the isolation of the concept of movement from the other ideas in a work. When, in the Renaissance, they had automata that moved, or cuckoo clocks, or any kind of effigy in which movement was involved, the emphasis was on the *subject matter* of the object that moved, rather than on the *movement*; the movement was perhaps an attempt to give the object somewhat more life, somewhat more verisimilitude, but not at all the concept of movement itself. But with the full development of an art in which there was no subject matter, in which association was not important, it became possible to contemplate movement as an isolated and transcendent element. Thus the importance of movement and its potential as an expressive means became apparent.

Takis: Historically I have nothing to add to what the others have said. The only thing I know is that today we feel the need to go through the piece of art and participate in its own life. I think there is a great need today for art itself to live, like human beings, like us, ourselves. So we can sit next to it and be like it, so the art is like another person. Also I believe the work of art has to become old and the new generation is going to create a new art to follow this older art. With their own lives they will create the art of their own times.

Selz: How is kinetic sculpture different, what is the relationship of kinetic sculpture to science? In the catalogue of the show, which includes statements by the artist, Kramer writes: "The hope of the Utopians to find here finally the art of space-time is absurd. Every slot machine is more complicated, technically, than all kinetic sculpture. Kinetic art is more closely related to show business than to physics." I would like to ask Takis whether he agrees with that.

Takis: I don't agree at all. If I have to offer a homage, I'll offer it to Thales of Miletus, also to Newton, to Maxwell, because those people discovered motors. Thales of Miletus first was occupied with electricity, with the electron, with the magnetic stone. And I think that since my friend Kramer uses motors he should give some thought to the fact that it takes more spirit to create a motor than to manufacture canvas and paint.

Selz: What we have here is Takis who in his statement, in his whole work, in his whole thinking, is very much involved with science. He talks about radar, he talks about the great importance of physics, both old and contemporary. The first thing he wanted to do when he came here was to see the nuclear reactor up on the hill. And, as I said, at Stanford they are showing the linear reactor in the art gallery. And then we have Kramer who thinks this is nonsense, that this art has nothing to do with physics and science whatsoever.

Kramer: I don't see why I should make things which are technically more complicated than an atomic reactor.

Takis: Exactly what I believe. On the contrary, you have to make things appear much simpler than they actually are. My intention is not to make something complicated; for me, just a piece of magnet and a nail floating there can make me meditate. So I don't need to make any atomic reactor. My attitude towards scientists is one of great respect, and I wish them to feel the same respect towards the artist today, and break this isolation, which has lasted for centuries. I wish there could be a much closer contact between artists and scientists—much, much greater contact. So my intention's not complicated at all. On the contrary, it's to find the most simple means possible. Of course, a nail next to a magnet doesn't say a lot, but to me it says already very, very much—floating, I mean.

Rickey: I think that science is made by scientists, and I think art is made by artists, and I think they are different. There is a tendency now to establish a much more intimate relationship between them than actually exists and to try to force analogies which are false. A scientist investigates. When he finds that he has established something, he moves on to the next investigation. This is not the process of the artist at all. Art is not made by investigation; it is not made by experiment; it is not made by proof. The artist simply makes; what he makes may or may not have some involvement with science. When the artist has an idea or makes something which he feels has, or begins to have, a validity and life of its own, he doesn't abandon it and go on to another. He begins to try and see how much larger a life he can give to that particular idea. This is a completely different sort of progression from that of the scientist, who is constantly abandoning the revelation once it has been revealed. The artist wants a continuing revelation.

Lye: I agree with everybody. But I'd like to put it into my own words, if I may. To me, art and science are in the end after the exact same thing, which is truth. The artist gets at it emotionally, and the scientist gets after it with a verifying method. See? But if he can't isolate this quality, it remains cold-blooded fact. We hope— although in some of our kinetic work we may look as if we were cutting cheese or beating eggs, or something—nevertheless, we hope the image issues forth from the sensory side of our nature, rather than from the intellectual.

Takis: In the *Symposium* of Plato, Plato got Socrates talking and giving a definition of art. And Socrates said that for him the person who discovers and who makes the thing which is invisible *visible,* is an artist, and I think this statement is the most accurate statement that has ever been made.

Selz: For centuries there has always been a clear distinction between the plastic arts and the temporal arts: the temporal arts being poetry, theatre, the dance, music—the arts which develop in time; the figurative or plastic arts being the

arts which are static—painting, sculpture, drawing—arts which you look at. Now in the whole history of kinetic art going back over the last forty or fifty years, we find the visual, plastic arts developing in time, like the performing arts—such as music and the dance. The artist becomes almost the choreographer of his own work, as it were. This whole idea of the merging of art forms is happening here and the things that you are doing develop in time, which is certainly a rather new thing. George, do you want to start on that?

Rickey: I'm not sure that I would go along with the merging of art forms. I don't see kinetic art as a hybrid, which is what you imply. The introduction of time as a component in art occurred long ago in the dance, and it occurs in music and in the performing arts. The possibility has always been available to the artist, and perhaps it was because of technical difficulties that it wasn't introduced earlier into the plastic arts or was introduced so awkwardly. As I said before, I think that as soon as one had an art of constructed forms without subject matter, and the forms which were thus constructed became acceptable, it was bound to occur that these forms could be put into movement and that time, which had always been available and waiting to be used, could enter into the construction. This was easy because the sense of time, the awareness of time is common to many animals, including the human, without training. It doesn't have to be taught. You don't have to go to art school in order to be aware of the validity of this component, to be able to measure it, and to be able to foresee the intervals of time and the relations of intervals. Once this idea appeared, it became possible to enrich art enormously. This does not make kinetic art a hybrid. It is an extension, simply, of three dimensions and a tremendous enrichment of the work previously possible in three dimensions. Such art is very accessible.

Selz: I didn't mean a hybrid at all, but in a way we're heading to this point now. It really goes back to the late nineteenth century, to people like Richard Wagner, who talked about the "Gesammtkunstwerk," where you are trying to create a totality of esthetic experiences, of the theatre, of the dance, the sound, what Scriabin and Kandinsky referred to when they talked about synesthesia—this multiplicity of experiences in different forms. And I think that this is what I'm getting at. The question is the relations, the diffusion—the way sculpture developed in time.

Lye: George, do you think of time when you're composing a figure of motion? Do you consider, well, now I've got a thing I want to be about a minute long?

Rickey: Well, I certainly consider the velocity, which is an expression of time.

Lye: Yeah, but not in terms of "tick-tick."

Rickey: A little slower than that. But I certainly think of it—I think of it all the time.

Lye: Well, I only know things from my own angle, and when I'm working, the main thing is to get something that looks kind of magical, that keeps fascinating me; if it doesn't, I drop it and wait for the next creative urge, but if something does, why I go at it, and what I think of more than the "time" element are the limits of the material and the motions I have available, and working within those limits, and if I still like the image that the motion is forming, then I try to create some interplay which seems to me to get the best figure of motion out of the type of movement I'm involved with. That's about all.

Takis: I think that our age is really extraordinary, an age that can offer us these materials. And we can express ourselves without limits, and I hope this will be so even more in the future.

Selz: Kramer (speaking in German) says that he's a man of the theatre, he's interested in the theatre. He makes an object, he's interested in the reaction of the public to this object, the way it would be in a performance.

Lye: There is another angle to this, though—the classical as distinct from the theatrical. Harry's approach is absolutely authentic in a literary way, and it is one way of getting to the final image, which is making the image have a unique and magical quality and what-not.

Rickey: I'm not interested in performance at all. My thinking is in a completely different direction. I think rather of time as being a material that can be ordered in an exactly equivalent way that space is a material that can be ordered. Formerly sculpture was made of stone, bronze, wood, and so on, but now we think of sculpture as something that can be made of a solid material but also of space, and one can order both and both are, in a way, equally valid. One can think of time as a material to be ordered in just as valid a way as these other two.

Selz: While we are talking about time, a question that has occurred to me as I was going through the exhibition—that is, really a question which came to me in the last day or so—is the speed we are talking about. How important is it to you how quickly things move?

Takis: I think that what you ask is very important, because for my part, just as we time our talk, I think sculptures, too, have their own timing. I think that it's extremely interesting to watch the movement of sculpture—it has to be like talking, or music. In fact many artists use music on their own. I find it absolutely necessary. Somebody who wants to be understood has to talk and have a certain rhythm in his own talk. And since the kinetic sculptures are more expressive by their own movements, their timing is extremely important.

Selz: How do you feel about the time, the speed, "die Geschwindigkeit der Objekte?"

Kramer: We are five, and everyone speaks from his own works. I like speed, and I have speed all round me. I make a drawing of one of my pieces, and then I find it's very good, and then I must make it. The work takes so much time that I go crazy, and then I go out with the car, you know. When I made this theatre, I mixed very slow speed with very high speed. And you can do if you have a beat behind it. But if you haven't a beat, you couldn't imagine the speed. But in an open sportscar, you always think you are quicker than the other ones at close quarters, but they are also quick. Then you hear the beat. In kinetic sculpture you must have a beat to make it visible. Sometimes I try to give the metronome sign so you can read the speed. But the most fascinating thing I have seen in speed and what's really speed are the gyroscopes—they make a sound and you hear the speed, it seems, even if you don't see it.

Selz: Your *Flip and Two Twisters* moves very quickly, Len.

Lye: Well, it's entirely depending on what means of control you have over what, when you're starting to work, and what you get started on, and if it happens to be something that you can manipulate fast, and it looks good fast, well you stay with it. But if it looks good in a nice lethargic, or euphoric kind of sway, slowly oscillating stuff, you do that. But I'm interested in the business of *energy* and getting a feeling of zizz in the thing, you know? And if it takes speed to do it, okay, and if it takes slow motion to do it—oscillate and sway, or whatever, or jig around—that's okay, too. I'm only interested in the sensory approach. I want to get involved in the magic of motion without knowing why. I don't start with any thoughts such as, well, now I'll do a fast job, or a slow job, or anything like that.

Rickey: I'm rather inclined to agree with Len in this. I wouldn't say that one way was better than another. Fast and slow are as different as red and blue. Maybe Tinguely's having a red period and I'm having a blue one. It seems to me that it makes much more sense to think of speeds, not just as fast or slow, but having, as Len says, a kind of appropriateness to a particular situation; you choose the speed that fits it, and there's a tremendous range available within human perception. We have a certain range of perception of movement, just as we have a range of perception of sound or of light, and we work within this range. At different parts of it there are different effects, different tones, so to speak. That's why we all come out with different speeds.

Selz: To give you an idea—we've talked about tones, Takis was talking about music—I'd like at this point to let you hear some of this music. This is his sculpture. Sounds like electronic music. The "sound of sculpture."

Takis: It's a cord with a needle, the length of a knitting-needle, which is attracted by an electromagnet behind the panel.

Lye: This is a thing I have in my studio in New York. And this whole steel sheet has a lot of other metal hanging off it.

Selz: Are these compositions to be seen primarily as sculptural compositions in the tradition of sculpture, let us say, from Michelangelo to Giacometti, or are they inventions of new devices, new types of objects, exploring new possibilities? In other words, are they primarily sculptural compositions, or are they inventions? Do you want to start on that, George?

Rickey: I would take the position that they are extensions of traditional sculpture and in no way dependent for their quality on being new. As I've said earlier, they have qualities or components in them that have not been used in sculpture before, although these components have been used in other arts, and they are still involved with ideas of order and a kind of measure and expressiveness which has been in the tradition of sculpture for hundreds—thousands, if you like—years. In this way they are just a normal, and in a way expectable, development that reflects, possibly, changes in the environment, but carry out in many ways a sort of constant between the artist and his environment. As change takes place, so the form of the expression does.

Selz: Would most of you agree that this is really traditional sculpture?

Lye: No! Now look. I think we're in a separate category of art here, and I'll try to make an analogy as to why I say that. You see, I think that where the similarity exists in the arts is simply—individuality; but the vitality of the arts is mushrooming as much as is that of the sciences; they're making all sorts of discoveries. Ours are about emotional aspects of being. Take a playwright like Beckett. He seems to say, "Well, there's something being overlooked around here, and that's our feeling of bodily being, the bodily sense of our physical, daily routines. We needn't have kings and queens, heroes, villains, to typify and symbolise the essence of our individuality; we can have the old lowly *body* do it for us." And so he is an example of an artist taking one of the many facets of our "bodyness" out of ourselves to examine it and respond to its reality in this strange, new way. But, after all, this is truth, this is us, and you leave a Beckett play wondering what on earth it's all about, but feeling vaguely that it has some deep truth going, you see? Well, anyhow, to me kinetic art is plucking this kind of kinetic, sensory twanging of experience which we take for granted in our bodily sense of presence. For instance, you're sitting around there, and you would not feel the actuality of your existence unless you felt, sitting there on your fanny, that you had all your bodily weight to anchor you to your reality. That's why we have the phrase, "I pinched myself to find out whether I was awake or dreaming," you know? Anyhow, I think kinetic sculpture is as distinct as painting is to sculpture, and so on, music to poetry and the rest. Finally, I ask, is the most kinetic medium of all time, the cinema, an extension of sculpture?

Takis: I absolutely agree with Len Lye when he says that the sculpture of today doesn't have anything to do with traditional sculpture. I hope that is so because

what we have to do with any tradition is very little. The way of life today is completely changed, totally changed. So I hope that we represent our time, which is today and the future.

Rickey: You know, there was a Chinese emperor who wanted history to begin with him.

Selz: The question that arises is: is this kinetic sculpture a new movement? Is it a specific movement, such as, let's say, movements which are perfectly clear in one's mind, like Cubism or Surrealism, which had their beginning, their climax, their decline? Is it a short-lived movement like Pop art, which was so popular a few years ago, or is it something else? Are we dealing here with a specific kind of a movement in art, or is it an art form which has nothing to do with a specific movement? Do you get my question?

Takis: Well, I think that you have a very strong point there, but still, I would say that it is not a new movement; it's a further development of what has already been. The past fifty years have been very uneasy years for our whole civilization, after the explosion of the atom and all the electronic developments. Anyway, I think that it's a development of expression. I can't say that it's a new movement that is going to die or live; it's got to find its own destiny. Now maybe its destiny is cruel, and after two years we won't hear about kinetics, but we have to take our chances and not fear what is going to happen after a few years. As far as we believe it, we have to sustain the consequence of our beliefs. So many times the directions of art have been changed, nothing is possible but our actual destiny.

Rickey: May I say something? One should distinguish between its durability as a movement—a movement in quotes, you see—and its durability as art. . . . These are two different things. Movements, especially now, come and go, but if the art has quality, it is viable, and will endure. I don't think that there is any art that ever made other art obsolete. If it could be made obsolete, it wasn't art.

Selz: I myself would like to add something to that. This is really not at all a movement in the sense that there is any stylistic similarity; that the only thing the fourteen artists in this show, for instance, have in common is that everything is sculpture that seems to be developing in time. But their history goes all the way from Dadaism to Constructivism, from interest in science to interest in the theatre, and there's really no formal similarity among these things. So in that sense, it's no movement at all, I would say, and Richter's "Movement Movement" is wrong. What you really have is a *type* of thing, like painting is a type of thing, rather than a stylistic similarity of objects.

Rickey: Well, possibly, the development from what you just said is that movement is a possible extension in almost any style. You can extend Dada by movement, you can extend abstract art by movement, and so on.

Selz: It's just a development of things that have already been there, and are now extended in time.

Takis: Yes. But talking about established tradition, the tradition of two, three thousand years of civilization. Now this is too early, ours is a very new thing, so we can't call it tradition.

Selz: I only have one more question I would like to ask the panel, after which time I will open it to the floor. The back of the catalogue has a chronology of kinetic art and kinetic sculpture. And as one looks through this, one finds that practically all the important manifestations until tonight, or last night, have taken place in Europe. Although five of the fifteen artists here are American, by and large kinetic sculpture is a European and not an American development, even more so than, let's say, optical art, which was certainly a European rather than an American development. I think this is even more true of kinetic sculpture. And I would like to ask the two Americans, or more or less Americans, and the two Europeans on the panel, first of all, if I am correct in this assumption that kinetic art is European rather than American, and, secondly, why this might be true. Why does it develop in Europe rather than, let's say, in New York?

Selz: Kramer says he doesn't know. He came over here, and he hopes to find something.

Rickey: I don't really care where it developed. This is actually a sort of historical-sociological question, rather than an artistic question. I don't think as a question it really has much to do with art. As Len says, it develops where it develops. He didn't say it quite that way, but I think that was the implication. Where people are interested, or become interested, in a certain direction, they follow it. Perhaps their friends follow it. In this country for about ten years, the emphasis was so much on Abstract Expressionism—Action Painting—and it became so official an art form that everything, every other kind of art was belittled, even boycotted. There wasn't much encouragement. Interest in this kind of expression was much less exaggerated in Europe. There was an equivalent—Tachism or *Art Informel*—but it never took so extreme a form, so there was much greater variety in the development in Europe after 1945 than in this country, where there was much too homogeneous an interest in art. Now, fortunately, there's more diversity.

Takis: I think so. The question, first of all, is very, very interesting, and I think also that Rickey is right when he says that in France, there was space for all the directions, fortunately. There, in the time of Tachism, there was also kinetic art and there was abstraction—there were all the movements—and Paris is a very peculiar city in that for a long time it has been very hospitable, for a long time artists have wanted to stay there, because they could feel free, no matter what

direction they took. And while I don't know America, of course, I sense that in America every time there is a movement there is a strong fanaticism, and there is no space for anything else, which I think is totally wrong. I think to have a real development in art we need space. We need space to express ourselves without getting involved in fanaticism, which is a very negative thing, and of course I agree with Rickey, with what he said better in English than I can say myself.

Selz: All right! You're going to leave it really up to the art historians to figure this out in the future. Now, at this point, I would like to have questions from the floor. Please direct your questions to one of the four members of the panel. The first question I have here is in writing, and I will start with that, and as it's not directed to anybody, I will just read it. "When will the scientists be called in so that the exhibits will not be out of order?"

Lye: Very good. The point is with my stuff, which is always breaking down, all you have to do is fix it.

Selz: Let me say that Mr. Tinguely, if he were here, would say, "It's supposed to go that way!" Next question.

Selz: The question is (are you referring to Mr. Takis' reference to Plato, to make the invisible visible?), doesn't this work relate as closely as anything we have yet to Einstein's time and space continuum?

Takis: I'm not very aware of Einstein's theory. But, what Plato had Socrates say is that for him an artist is one who makes the invisible evident—evident, not visible, that was my mistake in expressing myself—for him that person is an artist, a creator.

Selz: Would anybody else like to answer this? Would you say something about Einstein on that?

Lye: No, no. I wouldn't dream of it. What was that switch of terms?

Selz: To make the invisible *evident*.

Lye: Oh, yes. So. I think that the "invisible" originally referred to might mean this "essence" or spirit, of the guy doing the job. And this you get at in any work of art, in spite of whatever the subject matter is, or whatever either the motion or the static imagery is: I'm talking now on a kind of psychological level. The temperament of some artists inclines to holding their imagery static, freezing it forever, as a basic image of the *permanence* of individual expression, then it suits those of us who unconsciously like to identify with the continuum of permanence, who might unconsciously say, for example, that here, in this static work, is a symbol for this permanence. On the other hand, other creative temperaments incline to a sense of progression, one felt in their innermost

being—of blood flowing, heart beating, breathing, and so on. But, in both cases, the image bears the impress of unique temperament. This is the invisible which is evident in art.

Selz: Next question: Tinguely's statement that we always try to make things static because of our fear of death; the only stable thing is motion, our only hope is to make things that move.

Takis: Well, I don't know. I mean, there is the fanaticism again. It's an excitement. He's excited and he writes this.

Lye: I think some statements are bland. And, you know, I think you can get down to it by just plain logic, instead of leaving it up in the air like a caption heading. Try and make an observation that you can analyse, such as: With a static image, you've got something to identify your wish to remain durable. You'd like to go on forever, no doubt. And there, in that concrete art object, is something durable. It bears the impress of individuality and it's going to be around forever, apparently, while you, poor soul, will willy-nilly yourself into the grave. On the other hand, if you want to respond to something which gives you a shot of kinetic empathy— and I include everything that has got this kinetic quality, such as poetry and music and everything—I don't think there's any value distinction about the essence of individuality, whether it's in one or the other of either the static or the kinetic image.

Selz: Because Tinguely isn't here, let me tear into this statement. You know, he says we never like to see things move because of our fear of death, and you can say exactly the opposite, that we want to make things move because of our fear of death, and it will make exactly as much sense.

Rickey: Tinguely is a humorist, and it is tongue-in-cheek.

Selz: This is a very good question. The lady (Mrs. George Rickey) says that one of the great pleasures in sculpture has been the tactile sense, the ability to feel the sculpture. Do the kinetic sculptors feel that seeing the movement replaces this tactile enjoyment? Anybody? The tactile, the feeling, the sense of enjoyment of feeling. You can't touch these things the way you can touch, say, a Rodin or a Brancusi, if you want to touch. Now, is the sense of movement replacing the tactile enjoyment?

Takis: No, I don't think so. It depends on how you touch things. If you pull them down...it's different than touching them. I think you can easily touch this stuff and play with it. It depends on the way you do it.

Rickey: The tactile is only one of the senses. As a matter of fact, one of the troubles with traditional sculpture is that it has been imprisoned in the *idea* of tactility, and I think that idea has been broken. You see, there is no requirement that sculpture should be limited to that sense.

Selz: The tactile thing is there in another sense, as Mr. Paul Keeler has just said (from the floor). You do get involved. In the early signals of Takis, you got involved. The first thing you see in our exhibition is this *Wave* by Hans Haacke. It makes very little sense until you touch it and swing it. And then it begins to take on its life. There's Mattox, with the photoelectric cell. You have to approach it in order to make it come to life, in order to make it move. So, while it isn't all a matter of feeling, the tactile sense, the spectator involvement, the communication with it—I think it's there to an enormous extent.

Rickey: It would be a great mistake to confuse tactility with the participation of the spectator. You may have to touch in order to participate, but I think that these are two completely different things, and that the sense of touch that was referred to in the question is not at all the sense of touch involved in making Haacke's *Wave* move. You are touching plastic, not water.

Selz: It's a different kind of spectator involvement than tactility.

Rickey: I think they are both things. You don't have to make them one thing.

Selz: Is it movement alone, or does the sculpture have to be some shape and form in a visual quality?

Kramer: This depends on who makes the sculpture. Some must turn to get forms, and some already have forms, and you do something more. But I find the important thing in this exhibition is that you have so many different kinds of kinetic sculptures. Some you must start. Other ones go by themselves. And some if you touch they goes broken.

Takis: I think that what Kramer said is correct. There are no laws for the visual representation of a piece of art. I mean, we don't believe in any set of laws of how they must be visual.

Lye: I could give another sidelight on that particular question as it affects me in my own work when I am making a film, say, out tracking down the type of animation which I think is worth going on with until I really get it, and I know this is it. Nevertheless, I may look at what I've got jigging, and it may get pretty monotonous after about ten seconds, say, but yet I know it's okay. I may then search around for some sound to go with it. Now, my stuff on film has got a strong vibratory and accented quality, so I usually choose ethnic music because the African musician seems to be at home with very resonant sound, and he seems to get a rhythm that just fits in with the characteristic resonance of the drum. So, I use that resonant and rhythmic type music. I think I use it because my type of image relates to the same kinetic field as the one on which the African does his dance to music. Now, the thing is that without the dance the music may also get boring to me to listen to after about ten seconds, but, when I run the vibrating picture and sound together, then I can go on looking and listening. It

seems to me that my empathy with this stuff on the screen has taken the place of dancing to the sound, and if this has any relation to the question, I'll throw it into the hat.

Audience (Mr. Paul Keeler): What importance do the members of the panel attach to random movement in their work?

Takis: Enormous importance. I think random movement expresses the piece of work more completely. When the movement has a monotony it comes and breaks it. So I think it gives more liveliness to the object, to the piece of art.

Selz: Kramer says if you don't make random movement into your philosophy, it's very useful.

Rickey: I also find randomness enormously important. I think that randomness is a component of nature, a pervasive component of nature, and this is one way in which nature is introduced into art, not as something to imitate, but as a kind of component or partner, and it gives it a very special kind of life.

Selz: The question is, and I don't know how we can answer it, that the movement here is still system-bound, and that the experience of movement does not develop in a new way. What do you mean by system-bound?

Rickey: It's a pretty difficult question.

Lye: If I get it right, you're talking about the absolute spontaneous freedom in motion, say, when a cloud decides to go the other way, and what-not. Where a curling smoke does this and that in any old which-way, and, well, that's controlled by the state of the currents of air and what-not. There's a system involved there, absolutely cut and dried. Any scientist will sort that out for you. But, when it comes to controlling motion, you can't just fling something up in the air and throw it away and hope it's going to do something vaguely artistic or what-not. You grab hold of it and make it do what you want it to, and if it gets boring, you put some random elements in it until you think it's good.

George Rickey: Sixteen Years of Kinetic Sculpture

Nature, it seems, must always clash with Art,
And yet, before we know it, both are one;
I too have learned; their enmity is one,
Since each compels me, and in equal part.

Who seeks great gain leaves easy gain behind,
None proves a master but by limitation
And only law can give us liberty.

Goethe, *translated by Michael Hamburger*

In the Berkeley symposium on kinetic sculpture held in conjunction with the first comprehensive exhibition of the Movement Movement in this country, George Rickey clearly stood out as the artist most aware of his place in the continuous stream of art. His analytic and rational mind, and the controlled precision evident in his work, occupy a clearly definable place within the larger framework of twentieth-century sculpture. His vertical *Lines*, his *Rotors* and *Cubes*, and his *Stars* may have precedents among ingenious weather vanes perched elegantly upon roof tops, but Rickey's constructions do far more than point the direction of the wind: they make us joyously aware of the movement of time. Boccioni, Duchamp, Gabo, Moholy, and Calder each had his important share in introducing time into human experience as a visual element. George Rickey, over the last fifteen years, has moved from making intricate mechanical contrivances related to the Constructivist tradition to his recent sculptural statements of monumental simplicity. His moving vertical blades, or *Lines* as he prefers to call them, attain that " ... simplicity on the other side of complexity" which was the great achievement of Brancusi.

Unlike Brancusi, who began working as a carpenter when a boy and as a sculptor when a very young man, Rickey came to sculpture relatively late in life, after having tried his hand at many other pursuits. He was born in South Bend, Indiana, in 1907, and in 1913 was taken to Scotland where he lived until 1930.

Rickey's interest in machines, tools, mechanical devices seems to have been present from childhood: his father was a mechanical engineer and his grandfather had been a clockmaker. But when Rickey went up to Balliol College, Oxford, he read modern history. By 1928, however, he was enrolled at the Ruskin School of Drawing.

After leaving Oxford, Rickey embarked on his *Wanderjahre*. He did not seem ready to settle down to any particular place or profession. He moved about, pursuing different aims, testing different roles, searching for self-definition, having a good time. First he travelled in Germany, then he studied in Paris with the " ... articulate and witty master, André Lhote." He practiced Cubist painting and at the Académie Moderne was " ... baffled by Léger and charmed by Ozenfant." Then, from 1930 to 1933 he was back teaching at Groton, saving up enough money to return to Paris where he lived from 1933 to 1934. Soon after that he found himself on the editorial staff of *Newsweek* in New York, sampling a career which he was tempted to pursue seriously, had not his deeper conviction that he must become an artist prevailed.

In 1937, Rickey was the first artist to receive a Carnegie artist-in-residence grant, at Olivet College, where his opposite number in literature was Ford Madox Ford. Olivet was a center of intellectual life during Rickey's two-year tenure, and he tells of an impressive roster of visitors who came and spent time there: Sherwood Anderson, Carl Sandburg, Gertrude Stein, Klaus Mann, and the founder of General Semantics, Alfred Korzybski. Rickey drew portraits of several of them. While at Olivet, he also painted a large panoramic fresco of Michigan "a little in the Mexican style," which was certainly the idiom of the time. (One wonders if it's still there.) In 1939, Rickey took his first trip to Mexico to study fresco technique at its modern source and returned there many times over the years. For a year he directed the Kalamazoo Institute of Arts and taught at Kalamazoo College and then, receiving another Carnegie grant, was artist-in-residence at Knox College in Galesburg, Illinois, after which he started the art department at Muhlenberg College in Allentown, Pennsylvania. Always, and now as much as ever, George Rickey thinks of himself as a teacher.

During the war, when he served in the Air Force, he made his first mobile sculpture, but upon his discharge he went back to school: being both a historian and an artist, he decided " ... largely out of curiosity, to study art history in its purest *Kunstwissenschaft* form at the Institute of Fine Arts in New York." The pursuit of art history also tempted Rickey, and in a way he has followed it as a secondary occupation. His rational mind, his training, his interests, have enabled him to make important contributions to the history and criticism of modern art, particularly in his major fields of concern: Constructivism and kinetic sculpture. He is able to detach himself sufficiently from his personal interests as an artist to write objective criticism and, keeping up lively contact with colleagues even in remote places, has become the American chronicler of kinetic sculpture. One of

the few Americans whose broad background and current contacts free him from the chauvinistic attitudes so prevalent in current criticism, Rickey has by this time published at least six important articles dealing with the developing phenomena of kinetic sculpture and his definitive book on painting and sculpture in the Constructivist tradition, *Constructivism and its Legacy*, is being published soon after this, his first major retrospective exhibition.

In 1946, however, after a year of art-historical study, Rickey made his final decision to remain an artist. Almost forty, he felt the need for time to work and also for additional learning experiences. After a summer of studying etching with Mauricio Lasansky at the University of Iowa, he spent a year taking courses at Chicago's Institute of Design. When I first met Rickey there in 1949 I was struck by his clear precision and acuity of mind. I recall particularly his admiration for Buckminster Fuller, whose sense of rational structure had led to the formulation of a new cosmology in our time.

When I saw Rickey again in 1955 at his exhibition at the Kraushaar Gallery in New York, he had become a professor of design at Indiana University, but had also made tremendous strides in his art. I recall with pleasure a colorful array of precisely tooled moving objects, some of which resembled paintings by the artists whom he admired most—Mondrian, Klee, Lissitzky. Several of these machines had to be set in motion by the touch of the hand, while others would vibrate by the action of air currents. Objects titled *Little Machines of Unconceived Use* forecast a most recent development in sculpture: objects now referred to as "primary structures" in fact often resemble large geometric utensils of "unconceived use."

While the Kraushaar Gallery show of 1955 was Rickey's first one-man sculpture show in New York, he had begun making articulated structures of wires as early as 1949 and then began to use pieces of window glass which he cut in curving shapes and painted in bright colors before mounting. In 1950 these early glass mobiles were exhibited in Louisville and Chicago. To the Metropolitan Museum's *New Sculpture* show of 1951, Rickey sent his *Square and Catenary*, a hanging piece made of steel wire and plastic. With its clear definition of lines and the order of its random movement, this important piece shows Rickey's adherence to the Constructivist tradition and forecasts simultaneously his future work. It was one of the first important kinetic sculptures made by an American—or a European, for that matter—of the post-Calder generation.

Unlike Calder, however, Rickey was from the very beginning more concerned with the organization of movement itself than with the shapes of the moving parts, and his forms appear more technical than the well-known free-form kidney shapes favoured by Calder. While Calder's organic shapes suspended from wires approximate nature, Rickey set out to investigate the behavior of movement itself. As early as 1953, in the exhibition catalogue for his first one-man sculpture show, held at the John Herron Art Museum in Indianapolis, he wrote:

Man loves what lives and moves and renews its being, and loves to make such things if he can—whether with a green thumb or a pair of pliers. If one makes a moving thing, one is always surprised, no matter how preconceived the design, at the movement itself. It seems to have come from elsewhere—the planting or the pliers have only made the arrival possible.

In the fifties Rickey's work grew more complex as he investigated different principles of movement in addition to suspending and balancing objects on a chain. Of particular importance were—and are—his experiments based on the mechanical principles of the pivot and the pendulum. In his autobiographical essay, published in *Art and Artist* by the University of California Press in 1956, Rickey describes his *Flag Waving Machine* as " ... exploring the possibilities of a series of concentric pivoted rings in which the outer circle turns on a vertical axis and is slightly unbalanced....The motion which tilting initiates in the outer one is transmitted to the inner rings. They respond at random and often at higher speed than the outer ring." The *Flag Waving Machines* are less amusing as parodies than they are effective as explorations of complex relationships of movement. As such, these space churners have continued to occupy Rickey's interest and now, greatly enlarged, exert the concomitant difference in effect upon the viewer.

Scale, which is usually a matter of great importance in art, had additional ramifications in kinetic sculpture, because an increase in size alters the time-span: the speed of a pendulum is in reverse proportion to its length. Rickey, who is thoroughly familiar with the principles of mechanics, makes use of these technical means. The rational style of his machines is based on, but is by no means exhausted by, their mechanical possibilities and limitations.

By 1959, at the time of his second show at Kraushaar's, many of Rickey's pieces were still in polychrome, some were still moved by hand, and a critic justifiably admired their engineering, especially in one work in which "a number of different motions take place simultaneously...a series of parallel, centrally attached stainless steel shapes seesawing slowly back and forth, with no piece even at the same level as another...."

It was just about this time that Rickey made important changes in his life. He gave up his administrative duties as chairman of the art department at Newcomb College of Tulane University, and a few years later resigned his position there. He had bought an old farmhouse in East Chatham, New York, and converted the barn into a marvelous studio set at the foot of a wooded hill in the Berkshires. It was then that his work became severely simplified. His complex machines were pared down, color disappearing, as the former painter turned entirely to sculpture in motion.

For a few years after his move to the Berkshires some of his delicately balanced machines seemed to resemble flowers and plants, and he gave them names like *Tree, Vine, Long Stem, Bouquet,* or *Sedge.* But slowly these figurative resemblances were also eliminated, as he turned increasingly toward basic

geometric shapes—triangles, rectangles, squares, cubes, circles—which move gracefully in a simple pendulum motion. At times he also uses a multitude of elements—revolving squares or rotors too numerous to count—which form large undulating metal planes, planes that weave back and forth and whose particles reflect the sun as they oscillate in space and measure time.

Although Rickey used rigid lines—individually and in bunches—all through the fifties, it was in 1961 that he began exploring the movement of vertical oscillating intersecting blades. The first of these important constructions, the *Sedge*, now at Dartmouth College, is counterbalanced by a group of heavy planar elements. Soon he began to eliminate these planar elements by placing the necessary counterweights into a hollow spar inside the stainless steel line itself, thus achieving the most elegant long swinging blades, which cut across each other in random motion. These objects are constructed with extraordinary craftsmanship and care.

I recall one particular instance: supervising the installation of the American sculpture I had selected for the Battersea Park exhibition in London, I found that the workmen, disgusted with some of our entries in the junk sculpture category, were suddenly reconciled and then filled with admiration when they saw the superb engineering of Rickey's entry, *Summer III*. They enjoyed placing the lead counterweights into their spars below the bearing and were delighted when the perfect balance was achieved just as the artist had designed it. Once installed on its low rise in the park, it withstood the English winds, although at times it was whipped into violent motion.

Rickey has recently made a series of variations on the *Line* theme, exploiting some of its many possibilities. The hanging piece which was commissioned for the Kunsthalle in Hamburg consists of twenty-four contrapuntally swinging lines, both vertical and horizontal, the longest of which are six feet. But for the *Documenta III* exhibition in Kassel in 1964, he constructed a truly monumental work, *Two Lines*, which is 35 feet high.

Installed in the place of honor in front of the Orangerie, this bold and austere work commanded its expansive space there as it now imparts the magic of motion to the upper sculpture terrace of the Museum of Modern Art. His subsequent exhibition at the Staempfli Gallery, October 1964, showed the development of an extensive counterpoint with this austere "*line*" theme. Discussing his own work in *Arts Yearbook* of 1965, Rickey explains: "I have worked for several years with the simple movement of straight lines, as they cut each other, slice the intervening space, and divide time, responding to the gentlest air currents."

Indeed, Rickey's sculptures deal with the nature of duration. The traditional three-dimensional unity of reality is no longer our sole mode of comprehending the forces of nature; Paul Klee spoke of space as a temporal concept. Also from the very beginning of the century artists became highly conscious of the dynamic aspect of visual elements and as early as 1902 Henry van de Velde saw the line as

"a force which is active like all elemental forces." Ten years later, the Futurists introduced "lines of force" into their painting. In Rickey's sculpture, however, linear movement is no longer potential—it is kinetic, it is palpable movement realized in time, and time is as much an element for this artist as is space or shape.

Rickey's sculptures not only measure time but also evince light: their stainless steel surfaces are bright on a sunny day, dull when the light is somber. Moving randomly with currents of air, reflecting the light of the day, these pieces are analogies to nature's own living forms. Rickey wrote: "Though I do not imitate nature I am aware of resemblances. If my sculptures sometimes look like plants or clouds or waves of the sea, it is because they respond to the same laws of motion and follow the same mechanical principles."

The analogy of Rickey's sculptures to nature, however, is so striking precisely because of their contrast. While these vertical lines, or the horizontal "clouds" and "stars," resemble trees and the sky in their movement, they are hard, they are not organic, they are made of bright steel, they are precisely engineered, they are the result of analytical thought. Produced by the constructive thought and intuitive temperament of a unique artist, they are machines which emulate the spirit of nature, but express man's ability to define motion in space.

Interview with Pol Bury

Selz: I understand that you began as a painter and then turned to sculpture. At that point in your development, did you add movement to your sculpture or sculpture to your movement?

Bury: I started as a painter, and my first meeting with movement was to add movement to painting. This goes back to 1953. The various possibilities of pure painting had exhausted themselves for me. I realized that painting with traditional means was outmoded. A year earlier—it was in 1952—I saw for the first time an exhibition of Calder's work. I immediately felt that a great door was opening for me.[1] I proceeded to make a series of *Mobile Planes,* which were in fact a fusion of my earlier painting and the revelation that the Calder mobiles had given me. I began to actually cut thin pieces of compressed wood into geometric shapes and attached each to an axis. These *Mobile Planes* were to be rotated by the viewer, and thus movement in these pieces was dependent on the viewer's action. To me sculpture is just another means to movement.

Selz: I believe it was in 1955 that you exhibited some of these early moving objects in the now famous exhibition "Le Mouvement" at Denise René's in Paris, together with Calder, Agam, Soto, Tinguely, and Vasarely. Could you tell me a little about your relationship to these other kinetic artists?

Bury: I showed my first kinetic piece at the end of 1953 in Brussels at the Gallery Apollo. Vasarely and Denise René came to see my show there, and that's when I first met them. Then in 1955, when Denise René did that show, she asked me to participate and I met Soto, Tinguely, and Agam at the exhibition. But I never belonged to any group of kinetic artists. Just as earlier, though I did exhibit with some of the Cobra people, I never was part of their group either. I was really much more interested in their poetry and moral position than in their painting. Also, in Europe, and in France in particular, the word *kinetic* is used chiefly for optical art. After all, Vasarely never made any moving objects.

Selz: Yes, I have always made a clear distinction between optical art or art of

virtual movement, on the one hand, and kinetic art, i.e., the art of *actual* moving objects on the other. After all, the viewer's eyeball moves when looking at a painting by Tintoretto as well as when looking at a Vasarely. But going back to your own work: ever since those early rotating planes your sculpture has been powered by electric motors. What is your attitude toward the machine in particular, and modern technology in general?

Bury: I'm neither for nor against it. Like wood or metal, I consider the machine a medium. I know that some artists are fascinated by technology, but I think this is only because it is new. It is what you bring to a medium that counts. It's not because you have a computer that you become a genius. You have to bring something to it: yourself. Technology is not a goal. For instance, if I wanted a volume moving around this room, I could not do it with any existing traditional technological means. Maybe it would be possible with cybernetics.

Selz: Would you be interested in working with cybernetics?

Bury: Yes, if I could find a way of working with it.

Selz: But in your case you would have to slow down the computer! It seems to me that the most important aspect of your sculpture is its slowness of movement—often an almost imperceptible movement. As you wrote in your essay "Time Dilates": "Between the immobile and mobility, a certain quality of slowness reveals to us a field of 'actions' in which the eye is no longer able to trace an object's journey...."

Bury: Yes, most important to my art is movement, and the importance of the movement is its slowness.

Selz: Do you have any idea what the reasons may be for your obsession with the slowness of movement?

Bury: Once I thought it was because my father, who was a mechanic, was involved with race cars. Maybe it's a revolt against Father...if Sigmund Freud exists.

Selz: Or against the rushing pace in our time?

Bury: No. Things are not that simple.

Selz: I recall reading a statement by Jean François Revel, written back in 1964: "Bury, touched by genius, discovered a sculpture which moves so little at first sight you will rank it with those that do not move. This doesn't sound exciting, when you read about it, but to see it, it is terrifying as a tale by Edgar Allen Poe." It seems to me that it is the effect of the unexpected slow motion that is fascinating.

I have another feeling about your slow movement. It seems to me to parallel organic and biological rhythms. I think it can be experienced as some kind of analogy to plants and animals and human organisms. Do you think there's anything to that?

Bury: If many people see it that way, then it becomes true. I never intentionally make an analogy to nature. I may see such an analogy *after* I've made something.

Selz: Do you spend time looking at the sea or at animals or organic movement in general?

Bury: Yes, I like to go into the sea with a diving mask. But when I'm looking at those flowers and animals at the bottom, I don't think: "Aha, I will make a sculpture of them."

Selz: No, it would not be that direct, but don't you like to watch a sea anemone open and close?

Bury: Yes, but I saw those things long before I made a sculpture.

Selz: As you know, critics have made associations with the erotic in much of your sculpture. Do you think this is justified?

Bury: I believe that this must be due to the movements themselves, because in a state of immobility, sculpture does not reveal itself as erotic. Although I don't think of reproducing biological organisms, I am fascinated with the interaction of geometric elements. Between a sphere and a cube, for instance, the sphere will be more feminine in form than the cube. So perhaps I have an unconscious reason for choosing one or the other, but it is not predetermined, you see.

Selz: But those geometric forms, while they may suggest masculine or feminine qualities, do not seem to me to produce the same erotic titillation as your earlier Erectile Compositions, such as "Rods on Round Background."

Bury: I have always carefully avoided anthropomorphic references in all forms that I've used. As for the slowness, it relates to immobility, and I don't know if the slowness seems slower next to the immobility or if the immobility is emphasized by its conjunction with the slowness.

Selz: To pursue this idea of mobility and stability. Would you subscribe to the ancient Heraclitean concept that fixity does not exist, and that everything is in flux? Is that one of the philosophical reasons for your movement?

Bury: As far as I'm concerned, immobility does exist. It exists by contrast to movement as silences exist in music. It would be better then to speak of some immobilities. I am searching for the point which exists between the moving and the non-moving.

Selz: I see what you mean. It is that tenuous moment you described in your little essay "The Ball and the Hole": "Was Newton aware of the hesitation of the apple falling into the void? . . . yet there was between the point of the fall and the apple a moment in which both hesitated . . . that imperceptible, immobile moment. . . ."

Bury: Yes. You know, in some of my work the movement seems to fight against gravity. And gravity, in itself, is something ridiculous.

Selz: Why?

Bury: I don't know. Because things fall, always fall. I wrote once in a text that when God himself discovered gravity he felt completely ridiculous.

Selz: I recognize here some of the sense of the absurd which I have often detected in your sculpture. I now remember you once wrote that "... the weight of the earth doesn't prevent the birds from flying." I feel you are concerned simultaneously with flying and with falling.

Bury: You see that glass? If you have a glass like that there's always an unconscious feeling that it will fall.

Selz: Of course. And in some of your sculpture this becomes very unnerving. I remember when we had the kinetic show in Berkeley how the balls in your "Nine Balls on Five Planes" seemed to be on the verge of falling all the time, and people would actually reach out and try to catch them before they dropped. I see what you mean by the absurdity of gravity. The paradoxes that appear in your sculpture: levity vs. gravity, movement vs. stability—the juxtaposition of these opposites is what strikes terror in the spectator—the terror of the unexpected. Is it not these elements of surprise, yet, and wit, which attracted you so much to the Surrealist movement?

Bury: Yes, although my own work is formally distinct from Surrealism. As you know, I was impressed by Surrealist poetry when I was only sixteen, and met the poet Achille Chevée. Later I saw paintings by Tanguy and Magritte. It was the total stance of the Surrealist movement which fascinated me.

Selz: And like the Surrealist poets and like Magritte, it seems to me, you are not interested in analyzing or naming objects—not even in metaphors or associations—but rather in encouraging a more direct perception of the object, which reveals its meaning on a pre-verbal or even pre-memory level. And this is perhaps why the movement is so significant. I meant to ask you earlier: Do you feel that your sculptures function as sculpture when they are not moving?

Bury: When they are not moving, they are incomplete. They may be nice shapes, but for me they are not finished sculptures.

Selz: Now as they move, the matter of chance, of accident, or randomness seems very important. How do you engender random movement mechanically? How do you get your objects to move so that we never know what will happen next?

Bury: Well, it's very simple. When you use electric motors the big problem is to alter the regularity of the motor. For instance, in the recent sculptures with

magnets, all the moving elements are free on the platform and the magnets are turning very slowly under the platform. When two elements meet each other, for instance, they change their movement, because of the nature of the magnetic force.

Selz: Why is randomness so important to you?

Bury: Because it changes the regularity of the movement. Regularity is boring. You cannot look long at a regular movement unless you want to have your brain washed.

Selz: I see we are right back at another Surrealist concept: the boredom of regularity and the promise of mystery. Let me ask you also: is it to be able to evoke a sense of mystery that you hide your mechanisms?

Bury: There's no reason to show the mechanisms. And I think as a consequence, there is no reason to hide it. When a painter wants green on his canvas, he doesn't need to show that he first puts down blue and then yellow on top to create the green. Maybe there is a mystery about his green, but there's no need to explain how he did it.

Selz: I think there is more of a mystery in your slowly moving sculptures than in the perception of a secondary color on canvas.

Bury: I only meant it as a metaphor.

Selz: In your recent magnetic pieces the magnets themselves are again concealed...but what was your main reason for turning from motors to magnets?

Bury: It was another way to change movement. I have to find new ways to act on my forms. So the magnet was something that I put between the motor and the moving element.

Selz: So it was not really a philosophic concern with the nature of magnetic force and magnetic fields, but rather to use the magnet as another tool toward random movement?

Bury: Yes, it's a means. It is a wonderful means. It is fascinating. And I think that scientifically, magnets are still a mystery. Not everything is explicable.

Selz: If I could see and know the mechanical means by which your sculptures are propelled, would your sculpture have less value?

Bury: I don't know.

Selz: I remember in the kinetic show everyone always wanted to know how your pieces were made and how they worked. But concern with how it is made seems

to me a very simplistic attitude toward art. After all, there must be a reason why you conceal the sources of your movement.

Bury: Yes. The movement should remain anonymous.

Selz: To explain scientifically and mechanically how the pyramids were built is, after all, only of archeological, but not of aesthetic interest.

Bury: The disturbing effect of art does not arrive from the way it is made, but from what it reveals.

Selz: I have the feeling that many things are left unanswered in your work, that our curiosity is unabated. We also don't know where all those low little sounds come from.

Bury: These aren't sounds, they are noises...because I don't like music.

Selz: But noises are interferences. Is that what we are meant to hear?

Bury: The noise is a consequence of the movement. I do not try to find a nice noise, or a nice sound. It's there because it's there. And it adds to the movement.

Selz: I'm surprised that you don't like music. Your pieces move in time. In that respect they are more like music, which also expands in time, and less like a static piece of sculpture, which merely stands there.

Bury: I'm more interested in the movies, especially American movies, which have the best sense of time.

Selz: Your cinetizations—do they refer to the cinema?

Bury: No, it was chiefly by coincidence that I called them cinetizations. They refer to kinetics.

Selz: So what you are really looking for is to get movement within a two-dimensional surface?

Bury: Not precisely to get movement, or a feeling of movement, but to show that the movement came and it changed the image a little bit. My cinetisized skyscraper reveals the slow-motion work of gravity. Better than in horizontal architecture, the cinetisized version is in the process of restrained collapse.

Selz: Yes, certainly our assumptions of security and stability are toppled along with the reeling skyscraper.

Bury: The intervention in the image might seem to be a menacing desire to destroy, but we must see in it the wish to give an air of liberty to that which thinks itself immutable. To illustrate the end of the world, the destruction of the world, is a morose delight which has its adepts, but it is in the final analysis only an anecdotal preoccupation.

Selz: Yes, I feel that you're not trying to issue apocalyptic messages, but are again concerned with what you called earlier the absurdity of gravity.

Bury: It can be satisfying to intervene in the respectable order of geometry, of decors, and of faces and to imagine thus that one can tickle gravity.

Selz: At the same time you defy the weight and authority of the Statue of Liberty, the Eiffel Tower, St. Peter's, and Mao Tse-tung. And in a way, you use irony to humanize the images of power. So you have continued to work in two dimensions, not only in your cinetizations, but also in the careful sketches for your sculptures, which remind me of old master drawings by the very skill of their execution, and recently you made a series of color etchings...

Bury: In these I deal with movement in a different way. Each one of them is unique: the forms and colors are slightly different, and it is only when you see a group of them that my sense of movement is conveyed.

Selz: These were done at the same time as your recent pieces in which magnetism is combined with a pure, reflecting surface. In these new sculptures, made of polished brass, copper and steel, you obtain numerous reflections in complicated mirror surfaces. When you have twelve balls on a reflecting surface they may look like an almost infinite number when you add movement.

Bury: I found a great advantage in these reflections. One is to multiply the elements. As you say, there could be twelve, twenty-four, forty-eight, or ninety-six. But it's also a way to show a multiplicity of movements. The reflected cube becomes different in size, and the mirror can also show the movement behind and between the elements. For instance, when there's a cylinder in front of a plain non-reflecting surface you see only the cylinder. But if it moves, with a mirror behind it, and mirrors on each side, you see a great many movements. And there's another thing that can be done with polished metal: if you curve it, you get distortions of the moving elements, and distortion of movement itself.

Selz: Would you like the viewer to experience one of these by itself, or do you agree with Jack Burnham[2] that the full impact of your work is achieved only when the viewer is surrounded by a room full of Burys? Then, almost by peripheral vision a multiplicity of visual sensations occurs which is reinforced by the little noises. Which do you prefer?

Bury: It's up to the viewer.

Selz: If you were to have five of your works installed in an exhibition, would you rather have them close together so that the viewer is surrounded by them, or would you prefer to have each in a separate space?

Bury: I think it's up to the viewer. Some people like to read five books at the same time, and some prefer to read just one.

Selz: Talking about that, do you work on several pieces at a time? Or do you finish one before you work on the next?

Bury: I prefer to begin a piece and finish it.

Selz: To go back to my previous question then, which deals with the way the viewer reacts to your work. Would you like him to be immersed in a roomful of your work, or should he contemplate one piece at a time? Does it make a difference?

Bury: Yes, it does. To get the exact feeling of the piece, I think they have to be isolated.

Selz: When you make a piece of sculpture, are you concerned with the impact it will have upon the viewer?

Bury: You know, the technical aspects are of uppermost importance when making a sculpture: cutting of the metal, sawing, putting together gets you fully involved. And often the result is very different from the intention.

Selz: Are you yourself surprised sometimes?

Bury: Sometimes, yes.

Selz: Getting back to the viewer involvement: would you like him to participate in some way in the movement of your work, or to put the question in another way, do you see your sculpture as resembling games?

Bury: No, I don't see them as games. When you participate in something, you become too much involved and become a player instead of a viewer. I know some artists who are very much in favor of audience participation, but I think that when you participate, you are no longer a viewer. The first kinetic object that I made was to be moved by the spectator, but I have gone beyond that. When the viewer participates, he acts like a player. But he is then no longer a viewer.

Selz: It is like some contemporary theatre which has gone off-stage. As soon as the audience participates in the action we deal with an entirely different kind of experience. And the same thing, it seems to me, can occur with kinetic sculpture. The viewer is trained neither in acting nor in making sculpture.

Bury: Yes, the viewer is the viewer. When I go to the movies I don't want to get involved with the people who make the movies. I want to sit in my chair and look and be moved or be bored.

Selz: Also, if the viewer were to look at your sculptures as a game of participation, would it not be the manipulation rather than the aesthetic experience that would engage him as he alters the work?

Bury: It's not what happens to the sculpture that is important, finally, but what happens to the viewer. Because the image can completely change the mind of the viewer.[3]

Notes

1. Just as Bury was stimulated in his work by seeing an exhibition of Alexander Calder, so Calder experienced a similar impact from an older artist at the time he visited Mondrian's studio in Paris in 1930, and decided to "put Mondrian into motion."

2. Jack Burnham, *Beyond Motion Sculpture* (New York: George Braziller), 1968, pp. 272–273.

3. This interview was taped in Paris, at Bury's home, in October of 1969.

VII

Pop and Funk

The Flaccid Art

Ten years ago painting in America was largely dominated by Abstract Expressionism. Today there is wider range of possibility in both style and subject matter. The older Abstract Expressionists are doing some of their finest work and Rothko has just completed a series of impressive murals for Harvard University. But, in addition, the Hard Edge painters are successfully synthesizing Mondrian and the New York School; a group of painters from Washington, Morris Louis and Kenneth Noland among them, have achieved new images by staining their canvases with simple shapes of decorative color; a rising generation of figure painters—Diebenkorn, Golub, and Oliveira—depicts the ruined and isolated human beings of a disaffected society. Also the detritus of our culture is being reassembled with often stunning and mordantly amusing results by the "junk artists." But the trend which has been most widely publicized and discussed during the past year is Pop Art.

Artists who make use of images and articles from popular culture—H. C. Westermann, Edward Kienholz, Marisol, Tinguely—are not necessarily practitioners of Pop Art. Westermann's metaphorical statements about the violent and ambiguous quality of contemporary life, Kienholz's incisively bitter social satire, or Marisol's sophisticated and humorous primitivism, the highly inventive constructions of Jean Tinguely, which have electrified and motorized our esthetic concepts, all differ significantly from Pop Art works. It is true that Pop Artists owe a great debt to Rauschenberg, but his Combine Paintings transform ordinary objects by fusing them provocatively with Abstract Expressionism.

The Pop Artists, some of whom came out of the advertising world, some out of the world of painting, stand apart as a group in that they not only take their subject matter from mass-production sources in our culture—magazines, billboards, comic strips, television—but they frequently employ commercial techniques as well: the airbrush, silkscreen reproductions, imitated benday screens. Sometimes, as in pictures by Dine and Wesselmann, actual objects are incorporated in the manner of collage. There is no theoretical reason why such

popular imagery, or even the use of commercial art processes, should not produce works of real interest and value. After fifty years of abstract art, nobody could propose an academic hierarchy of subject matter; after fifty years of brilliant invention in collage and assemblage, nobody would be justified in suggesting that any technique is taboo. The reason these works leave us thoroughly dissatisfied lies not in their means but in their end: most of them have nothing at all to say. Though they incorporate many forms and techniques of the New York School (there is a particular debt to de Kooning's women) and the Hard Edge painters, these forms have been emptied of their content and nothing has been added except superficial narrative interest. People who ought to know better have compared Pop Art to the work of Chardin, because it depicts actual objects among familiar surroundings: an eighteenth-century still life, a twentieth-century billboard—why not? Leo Steinberg in the Museum of Modern Art's symposium on Pop Art goes so far as to suggest parallels to the realism of Caravaggio and Courbet. But Chardin, Caravaggio and Courbet created worlds of their own in which the reality of the subject was transformed into an esthetic experience. The interpretation or transformation of reality achieved by the Pop Artist, insofar as it exists at all, is limp and unconvincing. It is this want of imagination, this passive acceptance of things as they are that make these pictures so unsatisfactory at second or third look. They are hardly worth the kind of contemplation a real work of art demands. If comparisons are in order, one might more appropriately be made to the sentimental realism of nineteenth-century painters like Meissonier, Decamps, or Rosa Bonheur—all exceedingly popular and high-priced in their day.

When I was a teacher in the 1950s, during and after the McCarthy period, the prevailing attitude among students was one of apathy and dull acceptance. We often wondered what sort of art would later be produced by these young men and women, who preferred saying, "Great, man!" to "Why?" or possibly even, "No!" Now that the generation of the fifties has come of age, it is not really surprising to see that some of its members have chosen to paint the world just as they are told to see it, on its own terms. Far from protesting the banal and chauvinistic manifestations of our popular culture, the Pop painters positively wallow in them. "Great, man!"

In the symposium on Pop Art at the Museum of Modern Art, Henry Geldzahler, an enthusiastic supporter of the trend, clarified both the attitudes of these artists and the reason for their prompt acceptance by the art world when he said, "The American artist has an audience, and there exists a machinery—dealers, critics, museums, collectors—to keep things moving.... Yet there persists a nostalgia for the good old days when the artist was alienated, misunderstood, unpatronized."

But I doubt that nostalgia is at issue here. What we have instead is a school of artists who propose to show us just how nice everything is after all. A critical

examination of ourselves and the world we inhabit is no longer hip: let us, rather, rejoice in the Great American Dream. The striking abundance of food offered us by this art is suggestive. Pies, ice cream sodas, coke, hamburgers, roast beef, canned soups—often triple life size—would seem to cater to infantile personalities capable only of ingesting, not of digesting nor of interpreting. Moreover, the blatant Americanism of the subject matter—packaged foods, flags, juke boxes, slot machines, Sunday comics, mammiferous nudes—may be seen as a willful regression to parochial sources just when American painting had at last entered the mainstream of world art.

Only in the Pop Artist's choice of subject matter is there an implicit taking of sides. Essentially he plays it cool. He makes no commitments; for a commitment in either love or anger might mean risking something. Aline Saarinen in the April issue of *Vogue* (such magazines are an important part of the machinery that creates art-fashion) aptly says of Warhol: "He seems to love everything and love it equally. . . . I suspect that he feels not love but complacency and that he sees not with pleasure or disgust but with acquiescence."

What is so objectionable about Pop Art is this extraordinary relaxation of effort, which implies further a profound cowardice. It is the limpness and fearfulness of people who cannot come to grips with the times they live in. The Abstract Expressionists dedicated their lives to art and made a point of doing so. And who could have been more committed than Caravaggio, Chardin, and Courbet? But the Pop painters, because of their lack of stance, their lack of involvement, are producing works that strike the uninfatuated viewer as slick, effete, and chic. They share with all academic art—including, by the way, Nazi and Soviet art—the refusal to question their complacent acquiescence to the values of the culture. And more ironic of all is the fact that this art of abject conformity, this extension of Madison Avenue, is presented as *avant garde.*

In his brief introduction to the catalog of the Recent Acquisitions for Brandeis University, Sam Hunter suggests that Pop Art uses many of the compositional devices of the "purer expressions of our times." Indeed it does. It uses them in the same manner that a Hollywood movie vulgarized and banalized the teachings of Freud, or, at best, as Truman Capote has popularized and sensationalized Faulkner. It is what Dwight Macdonald calls "Midcult," the exploitation of the discoveries of the *avant garde.* "It is a more dangerous opponent to High Culture than Academicism," he says, "because it incorporates so much of the *avant garde.*" This, I believe, exactly describes the relation of Pop Art to the tradition of modern art.

What we are dealing with then is an art that is easy to assimilate—much too easy; that requires neither sensibility nor intellectual effort on the part of either artist or audience; that has no more personal idiom than rock and roll music or the standard mystery story or soap opera. It is as easy to consume as it is to produce and, better yet, is easy to market, because it is loud, it is clean, and you can

be fashionable and at the same time know what you're looking at. Eager collectors, shrewd dealers, clever publicists, and jazzy museum curators, fearful of being left with the rear guard, have introduced the great American device of obsolescence into the art world. For one thing, many of these objects simply won't last physically, but—more important—they will soon be old-fashioned because "styling" has been substituted for style, and promotion has taken the place of conviction. Like all synthetic art, when its market collapses it will collapse for good.

For this is not a folk art, grown from below, but *Kitsch*, manufactured from above and given all the publicity Madison Avenue dealers have at their disposal. The creator of such objects is not permitted to mature as an artist, for he has allowed himself to be thrust into a role he previously rejected (though it paid well it was demeaning), i.e., that of the designer of tail fins for General Motors. Allan Kaprow, the author of environments and happenings, prophesies that art dealers may indeed turn into art directors, and he actually looks forward to this development with relish.

It has been suggested of Pop Art that "something good may come of it—just give it time." I am not a prophet, but as an historian I must point out that earlier movements of this century—Cubism, Constructivism, Dada, Surrealism, Abstract Expressionism—produced much of their best work at the outset. It is possible that artists of conviction and ability may use some of the imagery of Pop Art in genuine works of art. Some have already done so. But that is a different question.

28

Notes on Funk

funk (funk), v.i.; FUNKED (funkt); FUNK'ING. [Of uncertain origin; cf. *funk* to kick, also, in dial. use, to shy, kick up the heels, throw the rider (of a horse).] To be frightened and shrink back; to flinch; as to *funk* at the edge of a precipice; to *funk* in a fight. *Colloq. to funk out,* to back out in a cowardly fashion. *Colloq.*

funk, vt. *Colloq.* 1. To funk at; to flinch at; to shrink from (a thing or person); as, to *funk* a task. 2. To frighten; to cause to flinch.

funk, n. *Colloq.* 1. A shrinking back through fear; panic. 'The horrid panic, or *funk* (as the men of Eton call it).' *DeQuincey.* 'That Sahib's nigh mad with *funk.*' *Kipling.* 2. One who funks; a shirk; a coward.

Webster's New International (1909)

Mrs. Martin: *What is the moral?*

Fire Chief: *That's for you to find out.*

Ionesco, *The Bald Soprano*

The definitions in Webster's *Unabridged* are not very helpful in an attempt to find out what Funk[1] art is about. The quote from Ionesco at least gives us a clue to its anti-message content. When asked to define Funk, artists generally answer: "When you see it, you know it." They are probably quite right.

The term itself was borrowed from jazz: since the twenties Funk was jargon for the unsophisticated deep-down New Orleans blues played by the marching bands, the blues which give you that happy/sad feeling.

Funk art, so prevalent in the San Francisco Bay Area, is largely a matter of attitude. But many of the works also reveal certain similar characteristics of form—or anti-form. In the current spectrum of art, Funk is at the opposite extreme of such manifestations as New York "primary structures" or the "Fetish Finish" sculpture which prevails in Southern California. Funk art is hot rather than cool; it is committed rather than disengaged; it is bizarre rather than formal; it is sensuous; and frequently it is quite ugly and ungainly. Although

usually three-dimensional, it is non-sculptural in any traditional way, and irreverent in attitude. It is symbolic in content and evocative in feeling. Like many contemporary novels, films, and plays, Funk art looks at things which traditionally were not meant to be looked at. Although never precise or illustrative, its subliminal post-Freudian imagery often suggests erotic and scatological forms or relationships; but often when these images are examined more closely, they do not read in a traditional or recognizable manner and are open to a multiplicity of interpretations. Like the dialogue in a play by Ionesco or Beckett, the juxtaposition of unexpected things seems to make no apparent sense. Funk is visual double-talk, it makes fun of itself, although often (though by no means all the time) it is dead serious. Making allusions, the artist is able, once more, to deprecate himself with a true sense of the ironic.

Funk objects, which are loud, unashamed, and free, may be compared to Dada objects. Indeed Funk, like so many authentic developments in recent art, is surely indebted to the Dada tradition (how paradoxical that we can now speak of a Dada tradition!). Especially in works by artists like Bruce Conner do we find echoes of Kurt Schwitters' Merz collages and the Hanoverian's love for the trash which he rehabilitated. But Conner's fetishist death images, Wally Berman's inventive collages, or George Herms' mystic boxes are really only precursors of the present world of Funk, which is often just as non-formal and arbitrary, but much more flamboyant, humorous, and precise. Perhaps again it is Marcel Duchamp's stance that is of the greatest importance here, his total absence of taste (good or bad) in the selection of his ready-mades, his indifference to form and indifference even to certain objects he created, especially those he made some thirty years after he officially ceased making art. Duchamp's three small plasters of the early fifties, the *Female Fig Leaf*, apparently modeled from a female groin; the *Object-dart*, its phallic companion piece; and the *Wedge of Chastity*, with its touching inscription for his wife Teeny, are actually as Funk as can be. Jean Arp, one of the original leaders of Dada in Zürich, also comes to mind, particularly with his later biomorphic forms existing in the world between abstraction and figuration. But then, Arp's carefully modeled or carved sculptures have a pantheistic spirit which would be anathema to the irreverence of Funk. Closer, perhaps, are certain Surrealist objects, like Méret Oppenheim's fur-lined tea cup or Miró's *Objet Poétique*, a stuffed parrot perched on his wooden branch, surmounting a ball swinging freely on a string, adjacent to a dangling lady's leg, all supported by a man's dented hat. Objects like these are, I think, real prototypes for the current Funk, especially in the similar irreverence, satire, and free association. Like Dada and Surrealism, Funk has created a world where everything is possible but nothing is probable. There is also an important *difference* in attitude in the more recent approach. Dada set out to attack and combat the moral hypocrisy of the public; Surrealism in its prodigious publications and manifestos and programs hoped to establish a new and irrational order based on the revolutionary but contradictory doctrines of Marx

and Freud; but Funk does not care about public morality. Its concerns are of a highly personal nature: the Funk artists know too well that a fraudulent morality is a fact of their world, and they have no illusions that they can change it. If these artists express anything at all, it is senselessness, absurdity, and fun. They find delight in nonsense, they abandon all the straitjackets of rationality, and with an intuitive sense of humor they present their own elemental feelings and visceral processes. If there is any moral, "it's for you to find out."

Funk probably owes a considerable debt and momentum to the ingenious use of ordinary subject matter and common objects on the part of Robert Rauschenberg and Jasper Johns. Both Rauschenberg and Johns, like Schwitters before them, attempt to lead art back to life. While avoiding the tedious banality of many Pop artists, the Funk sculptors similarly share a general anti-cultural attitude and wholesale rejection of traditional aesthetics. They too enjoy and often exploit the vulgarity of the contemporary man-made environment and speak in a visual vernacular. Unlike Pop art, however, the Funk artist transforms his subject matter when and if he makes use of subjects at all. He is not satisfied with simply naming things and instead of a complete confusion of art and life, the Funk artist uses images metaphorically and his work expresses the sense of ambiguity which is the chief characteristic shared by all artistic expressions of our century. Moreover, in contrast to Pop art, which as a whole was passive, apathetic, and accepting, the Funk artist belongs to a new generation which is confident, potent, and often defiant.

Funk art has asserted itself strongly in Northern California. To be sure, the international art magazines are filled with idiosyncratic, sensuous, irrational, amoral, organic, visceral, and three-dimensional objects. They seem to turn up everywhere. Still, there is a heavy concentration of such objects in the San Francisco area. It is here that Funk sprouted and grew. In San Francisco Abstract Expressionism, originally under the leadership of Clyfford Still and Mark Rothko, soon took an eccentric direction—it was never really abstract for a long time. Its chief protagonists among the painters turned toward a new lyrical figuration (David Park, Richard Diebenkorn, Elmer Bischoff were the most prominent members of a whole new school of Bay Area Figurative painters), or, even when they remained superficially abstract, they did not exclude symbolic forms. Witty, zany, and unexpected breast forms and bulges can be discovered in Hassel Smith's canvases, and dramatic and disquietingly sensual, often phallic, configurations in Frank Lobdell's heavy impastos. Between 1957 and 1965, when Lobdell was on the faculty of the California School of Fine Arts (now the San Francisco Art Institute), Arlo Acton, Jerrold Ballaine, Joan Brown, William Geis, Robert Hudson, Jean Linder, and William Wiley were among his students. Many of the Funk artists began as painters, and much of Funk art, although three-dimensional, remains more closely related to recent traditions in painting than in sculpture.

Other aspects of the free-wheeling and often rebellious life among the

younger generation in California may have had an impact on the development of Funk. In the fifties the beat poets, with their vociferous disregard of social mores and taboos, were very much on the scene. These poets not only wrote poetry, but they also performed and entertained with it. Their first public readings, in fact, took place at the Six Gallery, successor to the aptly named King Ubu Gallery. With Kenneth Rexroth presiding as master of ceremonies, Michael McClure, Allen Ginsberg, Gary Snyder, and Philip Whalen read their poems, and Jack Kerouac, then on the Coast, was there and recorded them soon thereafter in *The Dharma Bums*. The beat poetry, read to the accompaniment of jazz, recalls in retrospect the simultaneous poetry and music recitations in Zürich's Cabaret Voltaire (Dada's birthplace)—but in San Francisco it was new and full of excitement, and helped bring about a kind of free environment in which Funk, itself a combination of sculpture and painting, could flourish. Already in the early fifties there were programmed events (similar to the later "happenings") in San Francisco, and as early as 1951 an exhibition under the title "Common Art Accumulations" was held. Bruce Conner and his friends in the Rat Bastard Protective Association put together ephemeral conglomerations, combining all kinds of uncombinable things, called them "Funk," and didn't care what happened to them.

The art scene in San Francisco with its peculiar general lack of support for the artist may have also sustained the growth of this highly personal art. Here the artist has not yet become a popular idol and, as in New York in the forties, there are only a handful of successful galleries, a paucity of collectors, and meager sales; art has not become a status symbol. Harold Paris, who has himself achieved considerable renown, recently explained this situation in his article on Funk by saying:

> In Los Angeles art is consumed voraciously—a bargain-table commodity. In San Francisco and the Bay Area artists live among a citizenry whose chief artistic concerns are opera and topless. The serious artists, galleries, and museums founder in this "Bay" of lethargy and social inertia. The artist here is aware that no one really sees his work, and no one really supports his work. So, in effect he says "Funk." But also he is free. There is less pressure to "make it." The casual, irreverent, insincere California atmosphere, with its absurd elements—weather, clothes, "skinny-dipping," hobby craft, sun-drenched mentality, Doggie Diner, perfumed toilet tissue, do-it-yourself—all this drives the artist's vision inward. This is the Land of Funk.[2]

Perhaps it is possible that Karl Shapiro was right when he said that San Francisco is "...the last refuge of the Bohemian remnant."

In 1959 Peter Voulkos came north from Southern California, where he had achieved an important reputation not only for the extraordinary quality of his ceramic sculpture but also for his highly funky endeavor to make useless pots. While Voulkos himself now works primarily in bronze, others have transformed pottery into pure Funk: James Melchert's ceramic pipes, socks, and globular,

bumpy, suggestive objects; Manuel Neri's funny, brightly glazed, child-like loops; Arneson's sexed-up telephones; or Gilhooly's zoo, fired in the kiln because, as he writes, "...animals just seem right when done in clay."

Kenneth Price, who worked with Voulkos in Los Angeles, has brought the useless pot into the realm of High Funk with his beautifully crafted egg forms from which germinal shapes extrude, shapes which evoke divergent but related associations in different spectators. Many of the Funk artists have recently turned toward a greater formality in their work. Even the idea of permanence has occurred to them. Although neatness or sloppiness is not the issue here, there is a general trend toward greater care in execution and more precision, partly due to a limited amount of recognition enjoyed by the artists, and partly facilitated by the use of new materials—all kinds of plastics, including fiberglass, vinyl, epoxy, and the polyester resins.

Jeremy Anderson now enamels his redwood sculptures; Arlo Acton uses shiny metal instead of old pieces of lumber; Robert Hudson's sculptures have consistently become more precise and clear-cut; and Jean Linder's sexual furniture looks increasingly antiseptic. Mowry Baden, whose sculpture previously had a rough and hairy finish, now produces a smooth fiberglass object like the *Fountain*; and Harold Paris, when not building his enigmatic, ritualistic rooms, makes little rubber organs placed in neat plexiglas boxes.

Jerrold Ballaine and Gary Molitor are using plastics, molded or cut and shaped by machine, which give their suggestive images a hard-edged, shiny, and ultra-clean appearance; Don Potts' constructions are most carefully carpentered; Mel Henderson has created an environment in which forms suggesting snakes, entrails, or pipelines present a highly polished appearance (and are all the more disconcerting for that reason), as does Sue Bitney's *Family Portrait* made of colorful fabric and brightly painted wood. Much of the work currently assumes this greater interest in a well-made finished product. But the imagery, the attitude, the feeling remain funky just the same: the same attitude of irony and wit, of delight in the visual pun, the same spirit of irreverence and absurdity prevail, even when dexterity and careful workmanship are more apparent in the finished sculpture. In fact, this precision of finish only enhances the ironic quality of the work.

Alfred Jarry knew precisely what he was doing when he had King Ubu enter the stage exclaiming "Merdre!" [*sic*].

And, although no one has ever deciphered the meaning, what could be more perfectly composed and more readily felt than:

> 'Twas brillig, and the slithy toves
> Did gyre and gimble in the wabe:
> All mimsy were the borogoves,
> And the mome raths outgrabe.

Notes

1. David Gilhooly prefers to spell it Funck, while William Wiley seems to alternate funk with Phunk.

2. Harold Paris, "Sweet Land of Funk," *Art in America,* March 1967.

Comments on Recent Artists

Harold Persico Paris:
The California Years

In 1953 Belle Krasne wrote an article entitled "Ten Artists on the Margin." It included Louise Bourgeois, Joseph Cornell, and Reuben Nakian, as well as Harold Paris. Paris has certainly remained on the margin. Although he lived in Europe for more than seven years and feels very much at home there, he is no more a part of European culture than he is of the American art scene. He never belonged to a group, movement, trend, or tendency. As a younger painter in New York in the early fifties, he could respect the Abstract Expressionists but could never work in their style. When his printmaker contemporaries at Stanley William Hayter's Atelier 17 investigated intaglio processes, Paris mastered the plate and sought after a personal—and anguished—image. When contemporary sculptors were engaged in welding, Paris renewed the age-old technique of lost-wax casting. When many of his colleagues in Northern California made "funky" things, he observed and appreciated their sensuously bizarre works but turned toward pristine environments. Now, as many artists use shiny plastic materials for their chaste objects, Paris transforms plastics into organic forms.

Like many of the artists of the past whom he admires, Harold Paris prefers to go it alone. In fact, I think he has chosen to live and remain in the Bay Area because there is so little of an art scene here.

Antonio Gaudí was also a solitary figure. His work probably made the single most important impression on Paris. He recalls a trip to Europe in 1954: "The thing that decided me to become a sculptor was Gaudí. When the boat stopped in Barcelona I saw the *Sagrada Familia*. I almost fell over. I stayed in Spain and stopped painting and turned to sculpture." It must have been the great Spaniard's biomorphic fantasy and incredible boldness which encouraged the young American to try his hand at sculpture. Years later Paris made enormous clay walls which recall to my mind the imaginative and extravagant altars of Churrigueresque churches in Mexico—an ultra-Baroque style which also had its echoes in Gaudí. Eventually, Paris's own environments were audacious spaces of a different kind.

The work of Harold Paris is characterized by polarities: black and white, death and life, rational and irrational. In his rooms he contrasts organic and biomorphic forms to geometric structures. Hot areas are juxtaposed to cold ones; there are damp surfaces adjacent to dry ones; there are smooth and rough shapes. There seems to be a dialectic scheme underlying his creations, like the dialogue of masculine-feminine, of phallic forms in womb-like enclosures. Appearance and reality are dichotomized. Paris creates the illusion of rigidity where pliancy prevails; hard plastic resembles soft skin. Art, no longer the reflection of reality, assumes the reality of reflection. This element of surprise, of displacement, of the interplay of opposites demands of the spectator a creative and emotional response, and evokes a need for a personal synthesis of conflicting symbolisms. The viewer takes his own risks in a world that shifts from turbulence to calm, that simultaneously accuses and defends humanity, that is both intimately private and dramatically public.

A world that is black and white ... Harold never really succeeded as a painter but he has made extraordinary prints and creates powerful pen and ink drawings. His microcosms suggest black worlds, vast architectural spaces. They seem designed as stage-sets for Giacometti's rigidly unassailable standing women and his striding men who rush into nowhere. The large environments are abstract rooms, altars of synthetic material, black chambers punctuated by white objects which yield no succor. They are lit mysteriously, if at all.

Harold Paris was still working on *Room I* in his El Cerrito studio when I first saw it. I felt that it was about life and death. Similarly, Dore Ashton thought it was about Vietnam. An awareness of death and of the horror of world events has influenced Harold since his earliest work. After the war, while on assignment with *Stars and Stripes*, he made a series of agonized prints of the Buchenwald theme. These were followed by his monumental *Hosannah* series—prints of a profound and compelling vision turned inward. Here again, tragedy and death are transfixed in visual poetry. The great bronzes of the early 1960s were also images of decay: human remains cling to his powerful chairs like corroded bodies that might remain after the holocaust. Paris's response to political tragedies is intense; moved by the brutal events which followed the closing of People's Park in Berkeley, he organized a funeral ceremony for James Rector and years later fashioned his poignant "Soul on Telegraph Avenue." And the concept of sealing off the large and splendid environment, the *Kodesh-Hakodashim*, is his accusation—responsible and hopeless—of man's irresponsible actions. He writes:

> Where does it come from—
> the wail of the sholar
> the 3000 years
> and a scream in Viet Nam.

Harold Persico Paris loves the theatre. He creates stages and he is on stage. He is the actor of his own productions, but so are we, the viewers. His father was an actor in the Yiddish Art Theatre in New York and Harold's work has always been infused with the intensity of performance and ritual. His *Souls* must be displayed dramatically so that the viewer may witness the mystic conversation amongst them. The great ceramic walls might well be backdrops of orgiastic rites. Writing about *Pantomina Illuma*, I commented in 1969 that "many a visitor felt somehow that he was enacting a dance of death in this reduction chamber of black and white—a reduction chamber, however, which makes us available for new experiences."

Often Harold Paris produces performances. In San Francisco he first buried a sculpture in a box, and in Milan he repeated this concept with great elaboration. He recalls that two women dressed in black were seen praying at the burning candles of his enclosed sculpture. At the time of his Brussels show in 1970 he presented a plastic coffin containing the *Soul of an Unborn Child killed in Viet Nam*. He proceeded to lead the guests at the vernissage to a hearse which was followed by a cortège of twenty cars, and drove through the streets to cast the coffin ceremoniously in the waters of a stream. In the same exhibition, entitled *Voices of Packaged Souls*, he commissioned electronic music for thirteen *Souls*, creating sounds of a flower falling, an old man loving, etc. Art as a multi-media experience, as a means of increased sensory awareness, art as total theatre is brilliantly manipulated by Paris to evoke heightened emotional responses and tactile participation from his audience.

The *Kodesh-Hakodashim* enacts its drama in complete exclusion. Here Paris combined "all the wonder I can evolve, all the love I can project," and felt the need to seal it all off. But if his major environment is hermetically closed, the *Souls* are all available. At one time Paris thought of simply giving them away to people who needed them. The *Souls*, senuous as they are, also deal with life and death. They are works of art, however, in which the former horror and anguish have been etherealized into luminous forms. We think of St. Thomas Aquinas: *Lux pulchrificat, quia sine luce omnia sunt turpia* (Light beautifies, because without light all things are ugly).

One must not overlook the most evident quality of his work: Harold Paris is a master technician. As a printmaker, he has worked extensively in etching, dry point, aquatint and plastic engraving, woodcut and lithography. In the early part of his career, he experimented with plastic plates for multicolor relief prints and later cast epoxy plates for low relief sculptured prints. In the *Hosannah* suite he combined etching techniques used in past centuries with his own new and unique experimentation. He learned about lost-wax casting in Germany, and helped establish the bronze foundry in Berkeley where he casts objects which nobody thought could be done in bronze. He has become a great expert in all plastic media, such as casting and laminating of epoxies, polyesters, urethanes, plexiglas

fabricating, vacuum forming, encapsulation systems for various rubber compounds, and adhesive technology for plastics. In his rooms, plastics are often combined with stainless steel, rubber and other substances. His recent *Soul* series utilizes cast clear silicon with inorganic phosphors. His students call him a walking encyclopedia.

He is a superb teacher of printmaking and all sculptural techniques, old and new. He experiments constantly with new media. And simultaneously he deplores the implications of the technology he has learned to master. His *Souls*, made of silicon gel and soft plastic, do not look like plastic objects. He is not interested in discussing their technical mastery. He prefers to tell about the children who come to his studio in the Oakland navy yard to look at his *Souls* and who keep coming back to see them.

Technology, politics, life, death, sex, poetry, drama, love, and art: all are converted by this artist into the enigmatic. There is always the hush of mystery, and often a sense of humor. Harold Paris likes to quote this dialogue from Sherlock Holmes:

> *Watson*: Is there any point to which you wish to draw my attention?
> *Holmes*: To the curious incident of the dog in the night-time.
> *Watson*: The dog did nothing in the night-time.
> *Holmes*: That was the curious incident.

The Artist as Dactylographer

"In the 1890s two Englishmen, Dr. Henry Foulds and Sir William Herschel, brought the use of fingerprints in the identification of criminals to the attention of Science....In the latter part of 1904 the United States Penitentiary at Leavenworth, Kansas, was granted authority to fingerprint prisoners there. Afterwards the use of dactylography for the identification of criminals rapidly increased."[1] In 1966 the chief counsel to the trustees of the California State Colleges advised that "there is no question but that fingerprints may lead to information relevant to an employee or prospective employee's *fitness for a position* [ital. mine] as may references, biographies and other information generally required."[2]

Jessica Mitford first brought this absurd and sinister policy to public attention in 1973, claiming that the taking of her fingerprints by the California State Colleges was an invasion of her civil rights. The case actually came to court, with the judge deciding that, since she was not notified of the fingerprint requirements at the time she signed a contract with the institution, an exception could be made on grounds of insufficient time. Her fingerprints, however, were actually held in escrow during her brief tenure as Distinguished Professor on the faculty of the California State University, San Jose, but no decision was forthcoming on the basic issue of civil rights.

The State University at San Jose also wanted Bruce Conner's fingerprints. But Conner, claiming that *his* fingerprints were an integral part of his persona and his qualifications as an artist, argued that the state has no right to take a citizen's property without due process, and he protested against the lack of respect by some impersonal state authority for his personal possession—his identity—his body.

Conner is serious about invasion of privacy. He saw how media attention destroyed the private life of the Beat Generation in San Francisco's North Beach in the '50s, and how a similar—and worse—loss of identity occurred in the '60s when the media, and then voyeurs of all kinds, invaded Haight-Ashbury. Conner admires the Hopis, who have never permitted photographs of their dances or

private ceremonies, fearing that their identity would be stolen, their spirit taken away.

Conner wrote Prof. Cathy Cohen, chairman of the art department at San Jose, in December 1973, requesting that his fingerprints be returned to him after their "use." He also stated: "My fingerprints have a value in themselves as works of Art. Unless they are sold or leased under agreement with me then they cannot be reproduced without my permission. Their value has to be secured against loss or damage. My own copyright for the fingerprints will be filed with the Library of Congress."[3]

Conner was informed by the dean of the faculty that his fingerprints could not be returned to him. He was also told by the department chairman that he could not enter his classroom unless the fingerprints had been procured. (He wondered whether the National Guard or federal marshals might be mobilized to prevent his students from being instructed by a nondactylographed teacher.) Finally on January 18, 1974, Conner and his dealer, Paula Kirkeby of the Smith-Andersen Gallery in Palo Alto, met with Dean Robert Sasseen to discuss the matter. (A full taped transcript of this meeting is among the documents in Conner's current [1974] exhibition at the Smith-Andersen Gallery.)

The dean seemed to be under the apprehension that it was all "a kind of joke"; Conner explained that his fingerprints were part of his identity as an artist and that he was hired, after all, for his artistic qualifications. After lengthy deliberation it was agreed that Conner would "produce" an "edition" of his fingerprints at the Palo Alto police station; it would be signed by the "printer" (the policeman who took the prints), and he would exhibit this suite of 20 actual copies of his fingerprints. The final copy (number 20/20) was supplied by the artist to university authorities; this doubtless enabled them to recognize his qualifications to teach beginning and advanced painting—which he did, for one semester which just ended.

The "hand of the artist" has always been synonymous with the essential stamp of the personal, the individual. We speak, for example, of a painting done by Rembrandt's own hand. Or we speak of being able to identify, in anonymous past work, "Hand A" and "Hand B." In 1947, Hans Hofmann imprinted his own paint-stained hand on canvas in *The Third Hand*; this artistic act recurred a few years later in Pollock's *One (Number 31, 1950)*. Jasper Johns' handprint appears in his drawings like *Studies for Skin*, lithographs like *Hatteras*, and paintings such as *Land's End* of the early '60s, and more recently, he has cast his hand in the round and attached it to works. Bruce Conner's fingerprints, "on the other hand," though far removed from the ceremonious Footprints of the Stars at Grauman's Chinese Theater, are somewhat more public in their ramifications.

Conner used a thumbprint in lieu of a signature when he made a suite of lithographs at Tamarind in 1965. While Conner has made disdainful reference to

the Tamarind philosophy of lithography as "the Stamp Collector's Philosophy of Art," citing emphasis on "classification, rarity, documentation and a full ritual of production as complicated as any exotic religion,"[4] he did produce a large lithograph consisting of his thumbprint and nothing else.

Conner's vivid and particular way of seeing the world was manifested in his extraordinary, doom-laden sculptures and assemblages of the late '50s and the '60s and in his pioneering collage films. He has always been concerned with poetic juxtapositions, with fragmentation and self-extension. A group of his recent felt-pen drawings, paintings, and lithographs are largely inspired by mandalas. This series, begun around 1966, is still in progress. Containing all-over webs of fine lines, drawn or painted with unbelievable patience, these works have an inward direction and sense of mystery (which is at variance with Conner's earlier accusatory sculptures). Involved with unceasing movement, they may remind us of whirlpools, rivulets, mazes, maps of the imagination or astral constellations; more important, their dense lines are closely related to the concentric or intricately parallel lines of the imprint of the human hand.

It is no surprise, then, that Conner considers his fingerprints works of art. He told Dean Sasseen: "Some of my work consists of very involved fine line detailed drawings ... somewhat like the lines of a fingerprint. I feel this project [the Palo Alto police-station prints] is an extension of the consciousness involved in those works. I don't feel that my fingerprints are that separate from the image coming out through my fingers when I draw. It's entirely part of my consciousness and the energies that exist within me."[5]

Notes

1. Britannica Junior Encyclopedia, Vol. 6, Chicago 1973, pp. 63-64.

2. Memorandum by Norman L. Epstein, Chief Counsel for the Trustees to the California State Colleges, Jan. 31, 1966, to the California State Colleges.

3. Bruce Conner, letter to Cathy Cohen, Dec. 10, 1973.

4. Bruce Conner, letter to the author, Mar. 27, 1974.

5. Bruce Conner, transcript of meeting with Robert Sasseen, Dean of Faculty, San Jose State University, Jan. 18, 1974.

Agnes Denes: The Visual Presentation of Meaning

Some 30 years ago, László Moholy-Nagy declared that "art is a community matter transcending the limitations of specialization. It is the most intimate language of the senses, indispensable for the individual in society. Its function is to be a seismograph for the relationships of the individual to the world's intuitive recreation of the balance between the emotional, intellectual, and social existences of the individual." In the intervening years all kinds of art movements have come and gone. Yet there have been few artists who have taken a truly universal and comprehensive view of the synergetic function of art that Moholy had in mind.

Although her work bears no likeness to Moholy-Nagy's, Agnes Denes shares his awareness that science and philosophy can be used in the service of art for the purpose of sensitizing the individual and society. Like the brilliant earlier modernist, Denes does not fit into any art movement or school. Although she has been described as a Conceptual artist by some critics, and although like certain Conceptualists she deals with a variety of intellectual problems, she gives palpable form and specific esthetic beauty resulting from the visual clarification of complexity to her scientific and/or philosophic probes. Her work brings new thoughts and insights into the art arena, stretching its boundaries toward a new breadth of thought and vision.

Increasingly, as many artists have rejected formalist esthetics, they have absorbed and appropriated materials from other disciplines for art (or non-art) purposes. But this is where we may easily misunderstand her. Denes is not interested in providing new scientific information. What she does rather is use the latest stages of scientific knowledge for the enrichment of artistic possibilities. She extends art, which traditionally had dealt with life and nature, into the realm of science; she is drawn to the enormous significance and creative energy in scientific thought. She also sees parallels between the structure of science and the structure of art.

At first encounter with Denes' work, one wonders about the relationship

between X-ray photographs and underlayers of famous paintings, diagrammatic studies of time and truth, the visualization of Pascal's triangle, concern with dust and bones, a visual presentation of human evolution, the exploration of organic cells through extreme magnification, a psychograph of artists' "profiles" based on questionnaires, various "abstract" studies of the meaning of language and communication, and many other such analytical works. Yet a certain unity of concept and form slowly emerges.

In her X-ray studies of paintings, 1970-72, for example, she cuts through to the "initial shock" of paint applied by Rembrandt, van Gogh, or Picasso. Instead of using methods of art history and art criticism, she turns to the physical object—the painting—and penetrates its layers to disclose working habits and painting techniques. Her aim is to reverse the process of paint application, as it were, in order to come face to face with the beginnings of the structure itself— and thereby the artist's mind.

In all her forays, Denes is attracted to the most basic of questions—the structure of matter and idea, the void, the meaning of life, the place of humanity in the world, the mysteries of human existence. It may be useful to point out that while her subject matter is essentially a unified one when viewed in terms of her broadest concerns, it is expressed in several different ways. Like much new and innovative art, some of it may be difficult to grasp. We are not accustomed to art which is presented in a philosophical/mathematical form. *Thought Complex*, 1972, for example, employs the methodology and figurations of crystallography to construct a diagrammatic and metaphorical homage to the human mind and thinking process. This drawing is a work of rhythmic measure, visual precision and order. And this is where we again may fail to realize the meaning of the work, as we tend to approach it from old standards and terminologies—for one does not need to be a mathematician or a philosopher to understand it. Her physical investigations (X-rays of paintings, magnifications of cell tissue, etc.), or those which use anthropological and psychological material, are, of course, more immediately accessible.

All her probes investigate man and his place in the world. A good example of this is *Evolution*, a gigantic, 17-foot-wide print, dealing with aspects of human evolution extending from the psychozoic age (the separation of man and ape) to the beginnings of knowledge, language, and art. This work required 2½ years to complete (1968-71); it contains material from the fields of comparative anatomy, physics, biology, cytology, genetics, and genealogy as well as time studies. The final result is a superb print done by a new direct-surface photographic printing technique of her invention; it includes drawings of extraordinary sensitivity and craftsmanship, interspersed with the scientific data; the result is a work as meaningful esthetically as it is informative philosophically.

Psychograph, 1971, a piece that is both anecdotal and humorous, takes on

the art world. In it, she surveyed the attitudes and reactions of 13 well-known contemporary artists by means of a sentence-completion-type questionnaire. The test results were then evaluated by two psychologists. What made the piece humorous was the fact that the questions were designed to be revealing, that the artists were well known, and that most of them were very cagey. Among them were Andre, Haacke, Huebler, Robert Morris, Larry Wiener (and Lucy Lippard and John Perreault were included in their capacities as writer-artists, not critics). The psychologists were also "unmasked" to a degree: what came across in their analysis of the test results was their powerful dislike of artists. Beyond this, *Psychograph* was important for its focus on the approximations and distortions of truth which take place when people attempt to communicate.

In 1965 Denes started to compile structures which investigate the meaning of words as symbols of communication, a line of activity which, like so much of her work, continues into the present. In 1968 she began a large and still ongoing series of works characterized by diverse elements which bear on a principal theme: she calls these "Dialectic Triangulation" (her own term). The first one was a 1968 piece in Sullivan County, N.Y.: Denes planted rice, to represent life/growth; she put heavy chains around trees to symbolize interference with life/growth and she buried her Haiku-like poetry, to represent "the abstract, the idea," and to "modify" the two actions. Denes writes, "Dialectic Triangulation is an art definition; it is a clarification of ideas and the reevaluation of accepted knowledge.... It probes to locate and expose the center of things, the true inner core of inherent but not yet understood or disclosed meaning. This type of art is analytical; it goes beyond illusionism and deals with realities."

A recent and complex series is *Studies of Dust*, which deals with the various physical dusts of creation, life, and destruction. The dust of creation includes "primordial soup"—i.e., the matter in the oceans which contained the origins of life; also present are intergalactic dust—meteoric and moon dust; plus heroin, LSD, gold particles, concentrated dirt from New York air, and particles from the H-bomb and the cobalt bomb. A sub-section of the larger piece, *Human Dust*, consists of numerous piles of human bone fragments, the residue left after cremation. It is a cogent comment on the vulnerability of existence. Questioning, reasoning, analyzing, dissecting, articulating, Denes has created here a poignant, almost mystic reading of humanity, encompassing our aspirations, hopes, egos, and the inevitable humiliation of becoming a mere statistic.

Denes brings new philosophic insight into the abundance of available information, dealing with man's "importance or insignificance in the universe." Her work is analytic in the Kantian sense. Her singular contribution is in the fact that her symbols remain visual, her attitude romantic, her approach intuitive. Denes' unique position in today's art is as the place where systematic and intuitive knowledge intersect.

Menashe Kadishman:
Planting Trees,
Making Sculpture

Menashe Kadishman's group of trees for the new campus designed by Philip Johnson for Muehlenberg College in Allentown, Pennsylvania is now reaching completion. The trees, which are being cut out of Cor-ten steel sheets, are negative forms: the shapes that are *not* physically there are the trees we see, the tree we can walk though. Kadishman belongs to a tradition which goes back at least as far as Synthetic Cubism in his questioning the nature of reality and illusion, but now the spectator becomes a participant in the actualized illusion. This small artificial forest is closely related in concept to the tree shapes Kadishman designed in 1974 to be placed in the ocean, in which the surf would splash though the open trees, adding a naturally induced kineticism to these technologically created static silhouettes. He has made two cut-out trees for two brothers, Victor and Jesse Shanok, and planted one on the Atlantic coast near Seaside, New York and the other on the shore of the Mediterranean in Caesarea, placing the cut-out solid section of one tree into the hollow part of the brother's and vice versa. The polarities of positive and negative space, of illusion and reality, of solid and fragile forms, of nature and technology, of man and his environment are basic to Kadishman's work, which otherwise is exceedingly diverse and versatile.

The large sculptures which created his reputation in four continents are daring and successful asymmetrical works within the general framework of Minimal sculpture, but they are more dynamic, dealing with problems of gravitation and equipoise. Among the most important of these are the 15-foot *Suspense* (1966), a brilliantly painted large yellow object in the Billy Rose Sculpture Garden of the Israel Museum, and *Elevation* (1971-74), three vast cantilevered disks of Cor-ten steel in front of the Habimah Theatre in Tel Aviv. The latter is based on a smaller work of 1966 installed in High Park, Toronto.

During the sixties Kadishman lived in London, first as a student at the St.

Martin's School of Art, then working with Reg Butler at the Slade and as a teacher at the Central School of Art. His early one-man shows at the Grosvenor Gallery in London (1965) and at the Harlow Arts Festival as well as exhibitions in Toronto and Edinburgh consisted of stone, metal, and glass sculptures. These pieces had the imprint of a sculptor who was concerned with problems of equilibrium and suspension, with monumental scale for unprecedented works of dramatic counterpoise. Like his colleagues in England and the United States, he suppressed the artist's "hand" and tended to work in large simplified shapes in works relating to a basically Constructivist tradition.

Compared to that of his confreres of the time, however, Kadishman's work is less geometric and feels less cold and detached due to the human, almost gestural quality of his work. His interest in perceptual ambiguities and his goal of defying the sense of mass in sculpture found expression early in large pieces combining steel and glass, a series which began in 1964 of extremely bold works of this nature. The following year he exhibited works of this kind in Documenta IV in Kassel and in 1969 he placed a similar sculpture in front of St. Paul's Cathedral for the City of London Festival. There, facing the ponderous Baroque facade, was Kadishman's *Up*, a slanting sheet of glass, inserted at an acute angle into its triangular steel base and appearing to carry a large steel drum. The viewer must have been absolutely baffled by this phantasmagoria. Similarly, in a work like *Floating* of 1968 (now in the Hirshorn Museum and Sculpture Garden), our perception of real form is totally confused by the sheet of plate glass which seems to hold up heavy metal blocks, giving the illusion of masses floating in space. This most precarious cantilever, combined with the simultaneous transparent and reflecting character of the glass, creates a multiplicity of illusions of weightlessness and suspended bulk.

The Museum of Modern Art's *Segments* of the same year carries the same contrast of solidity and transparency into a vast scale. An irregular arc, 15 feet across, is made of solid segments of white painted aluminum, interspersed by sheets of glass whose transparency interrupts the linearity of the piece, making it a part of the surrounding urban space which is partially visible. This piece recalls Duchamp's *The Large Glass*, which originally defied the convention of placing an opaque picture on an opaque wall. One of the most successful pieces of this series, the last one for many years, is *Aqueduct* (1970), installed in East Hampton, New York. Here the arcs of the stainless steel aqueducts are broken laterally and a large pane of glass, 21 feet long, separates the supports from the upper part of the arches. By the time these pieces had been completed, Kadishman had become a master of the contradictory, the inexplicable, and the impossible.

After his large show at the Jewish Museum in New York in 1970, an exhibition which consisted primarily of large, clean metal and glass pieces, Kadishman decided to use glass in its broken state. He loved its texture, its

multiple connotations, and he also noticed that it was very prevalent. In his next important show, "Concepts and their Realizations," at the Museum Haus in Krefeld in 1972, he blocked off a doorway and filled its wooden frame impenetrably with chunks of glass with all the connotations of a blocked entrance and the potential pain inflicted on anyone who dared to intrude. In *Doorway with Broken Glass* the pieces of blue-green glass piled up vertically, recalling geological striations and, even more, a waterfall spilling down. As Paul Wember pointed out in the exhibition's catalogue, "glass in a physical sense is not a solid, but a fluid material, a frozen liquid, if you like."

In the same exhibition Kadishman placed broken pieces of glass upon large photographic enlargements of the cracked desert floor, contrasting and relating a natural form with a man-made product which itself ultimately derives from the earth. One of the most notable works at Krefeld, entitled *In-Out*, consisted of a metal pipe placed through the plate glass window of the museum. The outside half corroded during the duration of the show, which was held in the middle of winter, and began to take on the color of the ground, while the interior part remained pristine, like the walls and floor of the enveloping space. The icy cold air from the outside circulated in the heated room. The relation of indoor to outdoor space and the effect of nature upon industrial products were emphasized in a straightforward, almost diagrammatic fashion.

The complex idea and its simple solution are very much part of Kadishman's recent concepts. For an exhibition entitled *Beyond Drawing* at the Israel Museum in 1974, he exhibited a glass thermometer filled with blue spirits of alcohol which, upon touch or with changing temperature, moved upward. Imaginatively expanding the traditional concept of drawing, he came up with a straight kinetic line. Multiple layers of broken shards of glass, standing pristinely against the walls, filled his exhibitions at the Julie M. Gallery in Tel Aviv in 1975 and the Rina Gallery in New York for the artist's one-man show in the winter of 1976. Kadishman's silkscreen print *Ring around the Moon* (1974) can be seen as a vast architectural project of this sort with a huge, smooth, open disk which does not revolve in outer space like Saturn's rings, but moves around the heavily textured mountain peak and again contrasts the human product to nature's form.

Kadishman, whose work has gained greater proximity to nature over the years, has made drawings which, without such intent on his part, can be seen to resemble the peaks and valleys of a mountain landscape in his innumerable creative doodles done on pages of telephone directories. He makes indentations and blocks out names, leaving some intact. The resulting pages may resemble mountainscapes or cityscapes, fever charts or cardiograms; they look like abstract drawings. Some resemble his compositions with broken glass, others are multicolored pastel drawings, and several pages have become dense, small monochrome paintings. They are restless "diaries of my travels" and rely on the only books to be found in hotel rooms in London or New York, in Krefeld,

Tokyo, or Amsterdam or some small town in Texas where the artist happened to be. Often the only things he leaves standing are the names of the city and the individual he knows. Everything else is crossed out; he has heightened our awareness of alienation by obliterating all remaining traces of individuality: people's names and their addresses. By a process of depersonalization he has transformed the pages of these thoroughly anonymous books into personal drawings. The artist also has put many of these pages together into new books, books in which the original information of the telephone directory has changed into a new kind of individual and subjective communication software between artist and perceiver.

But Kadishman always comes back to the tree. When he was a boy growing up in Israel, he, like all other children, planted trees throughout the barren countryside. Trees in Israel, great forests of them, are essentially man-made trees, and so are Kadishman's. He also recalls being up in Galilee and finding a boat that somehow had been placed in the hollow of a tree—"an act of love like placing pieces of paper between the rocks of the Wailing Wall." In 1969, when he was invited to participate in the Sculpture Symposium in Montevideo, he came with Europe's idea of hard metal sculpture, but felt that this would be out of place in the forest of eucalyptus trees there, which had a life of its own, separate from the history of European and American sculpture. Being aware of this contrast, he decided to fabricate standardized hard-edge steel sheets, paint them a bright yellow, and fasten them to the trunks of the old trees. This man-made "forest within the forest" formed a powerful mysterious contrast to the organic woods. An interplay of forms began to occur: the shadows of the leaves and the branches of the trees were reflected in the hard metal sheets and lent some of their changing, organic life to the metal, while the mysterious presence of metallic rectangles, in turn, heightened the perambulating visitor's perception of nature. For Kadishman, the forest had become a living picture plane.

A year later, he recreated his forest on the edge of Central Park for the Jewish Museum exhibition. Here the yellow rectangles found an unexpected echo in the yellow traffic lights, taxicabs, and yellow lines running down Fifth Avenue. In 1972 in Krefeld he added pieces of glass to the metallic sheets. The transparent glass registered the changes of color and climatic conditions. These glass sheets collected dust and snow and the condensation of water and ice, and appeared at times like a forest of frozen glass. While all of these projects were temporary in duration, Kadishman was also able to create a permanent forest in 1970 on the grounds of Jerome Stern's estate in Westhampton, Long Island. This piece is circular in its pattern, "like a necklace on the forest," the artist says.

For his 1975 exhibition at the Israel Museum Kadishman created another kind of forest, one made from cut-out sheets of gray canvas which were hung from lines like laundry out to dry. This "forest" gave people the feeling of branches floating in the wind. According to one visitor, "it looked like a forest

upside down"; another seemed to hear the noises of the wind through trees. People became an active part of the artist's environment as they walked under and through his fluttering "laundry." For the same show he painted a yellow square in the park in the Valley of the Cross near the Museum to change the color of the earth, the way a farmer does when he plows the ground. And, instead of painting a tree onto canvas in the fashion of landscape painters, he painted a fabricated metal tree and planted it in the actual landscape. People were outraged by the blue metal tree and the yellow dyed earth. They frequently object to Kadishman's work (he is considered an avant-garde extremist in his country). People prefer to see comprehensible monuments, not mysterious sculptures. They never did have much use for alchemists.

Now Kadishman would like to cast a part of the cracked earth of the desert and place it in the urban center of Tel Aviv. He wants to make a mountain with painted trees; he would, in fact, like to grow metal and glass trees or plant real trees in the salt water of the sea. He talks about making X-rays of the roots of great trees so that they might become transparent, and he would like to see a tree planted upside down in order for us to see the strength of its roots. Inside becomes outside. Man intervenes in nature and comes closer to its meaning. The artist relates to the landscape and metal trees begin to grow.

The Coloratura of Colette

Decade by decade artists have increasingly blurred the distinction between reality and illusion (art). Did it begin with Picasso's *Still Life with Chair Caning* or with earlier trompe-l'oeil painting? But then, like birds pecking at the grapes in the legendary Greek painting, these were still pictures on a wall—distinct and separate parts of our environment. But others have gone further in breaking down the barriers between art and life. The Symbolists were intent on making their lives works of art. We think of des Esseintes, of M. Swann, living in their rarified world, carefully observing their own sensations, creating a *Gesamtkunstwerk* of every situation and action, or rather lack of action.

In 1877 James McNeill Whistler created his *Harmony in Blue and Gold*, perhaps the first "Environment" consciously designed by a modern painter. Known as the "Peacock Room," this space has every single detail carefully appointed to create a total ambience. Toward the end of the century, Henry van de Velde gave up a career in painting because he felt that the artist has the social responsibility to build a better aesthetic environment. He built his own house and designed not only every spoon, plate, and chair to go into it, but also the costumes of his wife so as not to destroy the sense of totality of the experience.

Later, Giacomo Balla covered the walls of his apartment in Rome with bright colors and lozenge-shaped designs, including the furniture, rugs, and clothes of his own making. He had created a total Futurist ambience in which he and his family lived and worked, and opened it to the public in 1918-1920. The Futurists also took their dynamic and aggressive messages into the street to give a highly visible reality to their manifestoes. In Zurich and Berlin the Dadas involved an astounded and often angry public in their controversial and anarchist performances, while the street served for more directed political demonstrations of agitational propaganda in the young Soviet Union. Vast Agit-Props were erected on the streets and squares of Moscow and Leningrad to exhort the masses to join the Revolutionary forces. Vladimir Mayakovsky announced, "Let us make the streets our brushes, the square our palette."

Instead of the communal effort on the part of the Futurists, Dadas, and

Constructivists, environmental and performance artists ever since the Happenings of the early '60s have a more personal character. If there is any propagandistic aspect, it is to propound the artist's own ideas and concepts. But reality has been aestheticized for a long time by artists who prefer doing to making: the artist as actor, the artist whose own life is the work of art—Colette in her street pieces, her installations, performances, and, above all, in her environments.

Her own nest. In New York's Wall Street area with all its high-rise buildings that leave so little room for the light of the sun, between all those gigantic clean packages of glass and steel, in this modern ghetto which becomes desolate when the offices close, there are still a few old four-story houses left, run-down and ramshackle. In one of these small old buildings, up three flights of creaky stairs, you enter Colette's grotto of fantasy. It's a place of totally unexpected luxury, of abundance, of ambiguity and illusion. We see that it is made of silks and satins, there are mirrors, there are ropes which, like the stalactites of a cavern, come down from the billowing satin ceiling. There are her own boxes, clearly works of art, but these are almost indistinguishable from the artificial birds which seem to fly from rope to rope, the shells and plastic fish on the veiled lavender bathtub, and the pink paper roses. Voices are used for muted sounds. The floors are covered with soft material. The size of the space is difficult to determine; it is a mysterious place of soft and muted colors, off-whites, off-pinks, almost monochromatic, but hardly minimal. The light in the room which seems to come from an unknown source is used the way a painter uses color, and we are aware that Colette indeed began her career as a painter. Perhaps she has simply expanded her realm from the canvas to the whole environment. The color is of paramount importance. Even when she painted little pictures in her childhood in France, she included pictures of a palette in her drawings. These little pictures of the eight-year-old girl are a key and it is interesting that she should have kept them. They include not only a palette, but also costumes, furniture, a whole world of fantasy; but now the fantasy has become reality. And it is the reality of fantasy.

Slowly we become aware that this environment is made of silk, salvaged from parachutes, and of pieces of satin. The lamps, chairs, bed—everything is enveloped into this total environment which suggests somehow a miniature Sagrada Familia; but whereas Antonio Gaudí based his fantasies on the Spanish Gothic, Colette's environment recalls the Orient. Then we remember that this artist was born in Tunisia and saw all the Islamic architecture when she was a small child: the white buildings and the colorful Mozarabic tiles and carvings covering floors and walls. She also recalls the beaches, the sea, sky, and sand— and it is above all the color of sand which we experience in her environment.

But unlike Gaudí or Balla, Van de Velde, or Schwitters, Colette has included herself as an essential part of her environment. It is not just the nest, but the bird

in the nest. She is part of the mysterious surrounding, truly unifying art and life. Her body is in touch with outer reality. She is the center and the activating agent, even when (as she has done in so much of her work) she is passive and asleep. Perhaps she is related to other Body Artists: but rather than the hazardous and sometimes destructive antics of some, she uses her body to blend softly with its surroundings, much like the pet chameleon she remembers admiring when she was a child. Her work strives toward a unity of the organic with the woman-made. "My obsession with totality in my work," she wrote, "is analogous to the desire for unity in my life. If my work has strong emotional, physical, as well as cerebral qualities, it is because I feel that the struggle for achieving the balance of these three parts of ourselves is essential for the development of the self—which is ultimately what I am seeking."[1]

In her late teen-age years in New York, Colette made a series of interesting paintings in which figures were placed against brightly colored stripes, stripes that could be associated with the kind of academic abstract "color-field" painting which was so popular in New York at the time. But Colette's stripes could also be associated with jail cells. Indeed, the people in her paintings always seem to be enclosed, and when, around 1969, the stripes disappear in her work and her paintings become softer and more fluid in character, her figures become confined in spheres or globes. Closure is an essential part of much of her work. But in order to move out from the inner space of the rooms, she took to the outer space of the street almost simultaneously.

It is her own persona that gives unity to her work, whether she does environments, performances, or street pieces. Her first indoor performance was called *Homage to Delacroix*, done first privately in 1970 and publicly in 1972. Delacroix had a special appeal to Colette because he endowed art with emotion and also because he had spent some time in Tunisia. Then there was the image of Liberty as a woman. Colette, equipped with a white towel tacked to a broomstick with the words "red-white-blue" written on it, portrays Liberty Leading the People. Though this is perhaps still a naive work, a certain naiveté remains with her and she is determined to retain this simplicity. There was Liberty—Marianne—La France. Frequently, over the years, Colette would personify women in the history of art, literature, or mythology. There are Persephone, Camille, Mme. Récamier, Ophelia, Justine—most of them figures of a tragic cast. But there are also *tableaux vivants* from works of art: Michelangelo's *David*, Miró's *Dog Barking at the Moon*, Rousseau's *Sleeping Gypsy* (but this one without the lion).

It was called *The Transformation of the Sleeping Gypsy without the Lion* (1973). The office of Stefanotty Gallery was transformed into a totally different space which could no longer be measured or defined by the eye. The wall looked like a waterfall and was made of silk, pleated by small folds. The space was accessible through a gateway that had the appearance of underground

archaeological remains. Colette herself, dressed in a puffed satin costume, was recumbent on a bed and looked like a puppet. The tableau had little resemblance to Rousseau's painting, but she explains that artists like Rousseau, Delacroix, or David have stimulated her more by their lives and their spirit than by their actual paintings. In an adjoining room Colette placed large individual wall pieces (7½ feet tall) of nude women. These paintings were made of canvas, resin, and stuffing and were painted in acrylics. Called "sand women," they were frontal and austere, but their embedded environments also gave them a soft, sensual, feminine appearance. There was also the additional paradox of the tragic and comic aspect of these women, all set rigidly in a row, and all of them somehow resemblances of the artist.

Colette's street pieces began around 1970 when she decided to make her mark or code on the sidewalks of Soho, enigmatic messages to be read from above. She performed these ritualistic actions in a harlequin's costume and had them documented on film. These mysterious traces were soon followed by anatomical drawings: Colette painted largely schematic diagrams in broken outlines of lips, ears, eyes, noses, or hearts on the surface of the street.

In 1974 in Florence she emerged from her hotel room in white evening gown and gloves and proceeded to make her marks on the pavement below a baroque statue at the Piazza S.S. Anunziata. On the pavement of the Piazza Michelangelo she drew a diagram of a room with white traffic paint. Into this schematic environment, which appeared like a giant blueprint, she moved various bits of actual furniture and posed a young man to look like Michelangelo's "David," whose greatly enlarged replica loomed across the roadway. Her real-life David, however, played "There's No Place Like Home" on the harmonica. Later that summer in Copenhagen Colette illustrated Hans Christian Andersen's story of the Little Mermaid with a series of performances, using her own person to illustrate and recreate the well-known fairy tale.

Each place has different vibrations and evokes different sensations, resulting in varied responses on the part of the artist. These performances also have their ceremonial aspects for Colette, who writes: "...I conduct these pieces as performances or rituals. I dress up for them in whatever costume may feel appropriate at the time, usually execute them at dawn not only to avoid traffic or police harassment but also because of the associations attached to those particular hours of the day—the hours when most people are just about waking from their dreams or, in other words, those hours when everything that is real appears to be unreal."[2]

The inner space of her rooms continues to take different shapes at different times and locations. They often include her own person, frequently asleep, as in *Rag Doll*, done in the window of the Rizzoli book shop on Fifth Avenue in December 1975. A window, of course, is an opening to be looked into as well as out of, and Colette, aware of the dialectic of this simultaneity, was also intrigued

by the paradox of converting a public space into a private room. For this occasion the artist was dressed in a white parachute-silk skirt, a laced corset, ribbons and cording, Victorian boots, and was decorated with artificial flowers. The costume is an essential part of Colette's work; her own dresses, worn on all occasions, are an intrinsic part of her environments and are a constant reminder of the unity of art and life.

For the "Rooms" exhibition at P.S. 1 in New York in 1976, Colette was assigned a space in the attic. Somehow, the area suggested a memorable historic event to her and she proceeded to make *David's Wraith*. First she covered the room with golden-brown satin and white parachute silk. The wind from the open window animated the scene and the natural light illuminated the apparition, the wraith of Marat in his bathtub, while tapes in the closet make ghostlike noises.

In 1977 Colette participated in the Berlin Festival of Contemporary Art. In Berlin's Akademie der Künste she recreated a room very much like her own. This was a long rectangular space, visible through mirrors placed above the main staircase and visible also from the garden of the Academy through small openings. The visitor had to go into the room to see the total environment with Colette, nude, asleep on a coffin-like bed and to hear the sound of the water and the tape of Hamlet's soliloquy. This important work was entitled *In Memory of Ophelia and All Those Who Die of Love and Madness*.

Colette's environments and her street pieces have come closer together over the years. In spring of 1977 on the occasion of the opening of her one-woman show at the Cucalon Gallery in New York, her *Femme Fatale* was a small replica of her own living space, placed in a large blue satin-covered box. This was eventually moved from the gallery into the street where Colette lay asleep for three hours amid her personal objects, while popular love songs emerged from the large box. In regard to another piece, *The Wake of Madame Récamier*, Colette wrote: "... the woman is enclosed, and that is my interpretation of being always in an enclosure, of being repressed. I made an environment where I become part of the box that has something to do with the human condition and specifically with the condition of women in our age. To create means to think and develop oneself in order to become free."[3] But in addition, her pieces are exceedingly sensuous, erotic, and directly evocative of women's sexuality. Above all, they are autobiographical works of art.

Following an installation and performance at the Paris Biennial of 1977, Colette had a *Clearance Sale* at the Gillesbie-De Laage Gallery in Paris. She moved into Nancy Gillesbie's bedroom with her clothes, jewelry, and a variety of personal effects. Many remnants of her life were put in small satin boxes. Colette's own living space was intermingled with the space of an art gallery and assumed the appearance of a fashionable Paris boutique where her life was offered to the public for sale.

One of the most extraordinary performances was *Justine and the Victorian*

Punks, which I witnessed at P.S. 1 in New York in March of 1978. Here Colette turned to Punk Rock, a destructive form of music generally simply ignored by artists. Punk, a product of contemporary culture in England and the U.S., is a musical manifestation with strong political undertones: with all its noise it denotes hopelessness, frustration, and nihilism. Somehow, it seems like the final loud gasp of an overwrought consumer society bent on its own gluttonous destruction. Colette as Justine finds herself in the midst of the "Victorian Punks" with the Sex Pistols playing "Anarchy." As a woman and an artist she is no longer able to create in this deadly environment. In vehement response she breaks her cooking utensils, throws everything around and kicks it, tears up issues of *Artforum* and her copy of *The Little Prince,* and shatters her replica of Michelangelo's *David*—everything that at one time stood for hope. Dreams are broken and now she smashes the empty shells. There are no more beautiful visions. The struggle for individuality and creativity is rewarded only by exploitation and loneliness. It was a very angry piece which ended, however, with a vision of an oracle: as the punks move away we hear Bob Dylan's "It's All Over Now, Baby Blue" and Colette appears holding the broken light-blue statue of the *David* with blue light projected on her person. Briefly, she looks like the Madonna in a Pietà.

This piece, above all, had dramatic presence; it was filled with action and had a sense of theater. It was an enormous relief from the tedious, pointless, redundant performance pieces put on by do-it-yourself thespians. These pseudo-erotic performances that could never hold their own in the theater seem to be acceptable to the art world, where judgment has been suspended by ignorance of the performance media, which often passes for tolerance of artistic expression. Colette knows that if performance art will work as a significant new art form, it "should convey its message in a medium in a way that Painting and other more traditional art forms have not been able to achieve ... this I am afraid has been forgotten ... and neglected, and I am afraid some of the results have been more boring even than Painting."[4]

Colette succeeds in involving the viewer, perhaps because she has something of importance to communicate. She continues to make compelling and erotic tabernacles and provocations for participation. The philosophical-aesthetic question, the never-ending debate as to whether we can still speak of "art" when its distinction from life becomes less defined, seems somehow immaterial. Colette's art belongs in the subject-object paradox that Christian Metz talks about. As she permits us to enter her spaces of illusion, we become participants in her artful distillations and share her aesthetic-life experiences.

Notes

1. Colette, "My Life is a Backdrop for Me," *The Arts in Ireland,* June 1975, p. 60.

2. Ibid., p. 50.

3. Colette, *Flash Art,* No. 78/79, November-December 1977, p. 33.

4. Colette, Letter to Peter Selz, March 1978 (n.d.).

Roger Herman: The Past Recaptured

Many of Roger Herman's big paintings and woodcuts are remembrances of things past: his parents, the mountains, the industrial areas of the Saar where he was born, the heroes he admired as a youth. Although his work—vehement and agitated—differs completely from the meticulous precision with which Marcel Proust, the French novelist, formulated his sense impressions, Herman would agree with Proust that the deeper levels of expression can be understood only in recollection. The men of the past whom Herman admires and paints are mostly tragic heroes who sacrificed their being to their cause. Men like Marat and Artaud, Van Gogh and Vladimir Mayakovsky or the vanquished Indian chief, whom Herman derived from the reading of Karl May. All, as Herman said, "are defeated heroes rather than victorious ones."

Roger Herman belongs to a generation which no longer has the faith of previous modernists who committed themselves to pure painting and felt, somehow, that the act of painting, in Barnett Newman's words, is "an act of defiance against man's fall and an assertion that he return to...the Garden of Eden." Some of the German artists of Herman's generation have a saying which translates as "you haven't got a chance—so use it." Their orientation is toward the here and now. He once remarked, "We look back and we look forward but always with a consciousness of the present." But when a painter like Herman looks forward, it is no longer the optimistic attitude of "What is next?" It is, rather, to hope to continue, and perhaps "to get better as we get worse." In their utilization of old styles and old images he and his contemporaries look into the past not unlike the Italian Mannerists.

Roger Herman, who came to painting relatively late after having studied philosophy and law, has a particularly acute sense of history and tradition which becomes apparent both in his imagery and his style. On one of his paintings, an emotionally charged picture of the ocean, he has scribbled the names of Albert Pinkham Ryder and Marsden Hartley onto the canvas. This painting also recalls an early seascape by Jackson Pollock, itself indebted to Ryder—as well as Emil Nolde's close-up views of tempestuous and ominous waves. Roger Herman

speaks with admiration of Courbet, also a marine painter—and de Kooning, whose "Women" must have had a great impact. Some of Herman's series of Industry seem to pay a tribute to Franz Kline. When he first came to the United States, he went to San Francisco, attracted by the simple and robust block-like figures of David Park—to find only that art in Northern California had moved far away from the "Bay Area Figurative." All these influences are absorbed and the former conflict between abstraction and realism has ceased to be an issue.

The vehement brushwork of the German Expressionists and of the Abstract Expressionists has become almost a cliché by this time, but it is infused with new vigor and conviction by Roger Herman. He works with blunt, thick slashes of paint, which appear to be slapped on with house-painter's brushes. His canvases consist of many layers of pigment, with image painted upon image, resulting in a densely textured picture of great physical weight. The thickness seems intrinsic to the work, carrying with it all the underpainted and scraped-away pictures. The voyage of the muscular process is preserved in the final rendering. But this version itself is only a study for the next one to come.

The physical aspect of the work is very important to Herman, which is one reason for his turning to the woodcut—the technique so dear to his German Expressionist predecessors. Creating prints of enormous size, he gouges his images in 8' x 4' plywood panels which are generally printed onto the sheets in two contrasting colors. He enjoys the physical process of working in the wood and often spends his nights with paint and brush after an arduous day with the chisel. The woodcut is often a trial proof for the painting which follows. It is a device which helps determine the configuration.

The paintings are usually severely limited in color range. They are in red and black or yellow and black or simply in black, grey and white. Like the early Cubists, Herman at this time is too much preoccupied with structuring the canvas to admit a great variation of color. *Nude Drinking*, 1983, is basically a painting in red and black. The heavy action of the brushstroke recalls de Kooning's women, but Herman no longer feels it necessary to dismember and reassemble the big-breasted figure, which is almost as sensuous as a Rubens nude. One of his most successful paintings to date is *Woman with Raised Arm*, 1982. The acute angle of the arm, pointing upward like an arrow, consists of heavy brushstrokes of ocher, grey, and white. The woman appears to be dreaming in this highly romantic depiction on which the artist has inscribed the words "Brynhilde Firedance." Wotan's ring of fire, in which his heroic daughter was to remain banished, came to the painter's mind during the rapid working process. In the painting *Van Gogh*, 1983, transformed from a reproduction of the master's famous 1888 *Self-Portrait*, his right eye is turned inward like that of Wotan in Northern mythology. The blue left eye is the painter's eye turned outward toward the visible world. The ghostly green in the original self-portrait has been replaced by a fiery red in Herman's rendition so that the skull-like head

of the troubled artist appears to be surrounded by flames.

Van Gogh, of course, has become the myth symbol of the artist as saint. Herman can admire Vincent's total commitment and self-sacrifice, knowing that this stance is no longer possible. It was Albert Camus who, quite some time ago now, perhaps best understood the position of the artist in this time. Like Sisyphus, he pushes the stone toward the height, knowing that there is no avoidance of it rolling down again. No victory is possible: the struggle itself is the only affirmation and memory of past experience which helps to focus its meaning.

Helen and Newton Harrison: Art as Survival Instruction

After a long period of cool indifference, art has reentered the realm of immediate human concern. Some time in the late sixties many artists began once again to try consciously to influence society and provide pertinent effectual political and social change.

Newton and Helen Harrison, who presented the far-reaching *Meditations on the Condition of the Sacramento River, the Delta and the Bays of San Francisco*, relate to a long tradition of artists as mapmakers. In the Renaissance, artists set out to depict views of cities and oceans and often added their interpretations of the world around them. The cartographers of the Renaissance created splendidly drawn projections of land and sea as an essential part of the exploration of space and a requisite for the bold expansion into areas heretofore unknown. The Harrisons relate historically to artists like Jacopo de Barbari, who in 1514 completed a huge mural-size view of Venice, 26 feet wide, seen from a height of about 5000 feet. It not only explores every alley and canal of the great lagoon city, but does so with the free imagination of the artist, who believed that he delineated the most magnificent city in the world. The Harrisons, like Jacopo, use descriptions, but now their maps, done in our time, focus on the destruction which man has brought to the land. Instead of the image of Mercury "shining favorably over this fabulous emporium" and Neptune "smoothing the waters of its port," the Harrisons' meditations make us acutely aware of the abuse of land and water. But even this has an interesting precedent, as in Francesco Roselli's less known but similar bird's-eye view of Rome, 1482, which shows the great monuments of antiquity in ruin with the caption "How Great I Was, Only Ruins Show" and the inscription of a poem that ends with:

> What I am today shows that no ground is eternal
> and human passions never change.

The Harrisons' graffiti—part of their presentation in San Francisco—stated similar foreboding warnings:

He who builds a house on landfill is living on sinking land,
When the desert is made to flourish, the forests wither
and the rivers die.

In our time, artists have turned to maps for a variety of reasons. For Jasper Johns they were subjects for the identification of the picture plane. Robert Morris, Jeremy Anderson, and William Wiley map out imaginary terrains in which often ambiguous words add to the visual poetry. Agnes Denes' projections of the globe into forms of nature and geometry yield new and unexpected insights. And maps are an essential component for the often gigantic projects of Smithson, Heizer, and Christo. Like that of the Harrisons, the system aesthetic of these artists deals with an interpretation of the natural environment, but the Harrisons differ from many of their colleagues in their much stronger orientation toward social, economic, and political structures. Aware of the emotional connotation of maps, they know that many battles have been fought for a place on the map, never seen or experienced by the warring sides. To Newton Harrison "a map is one of the most powerful political statements."

The *Meditations on the Condition of the Sacramento River, etc.* is actually part of a series entitled *Meditations and Survival Pieces,* which are continuing comments on the ecological environment. Many of these works are on view at the San Francisco Art Institute with large maps and huge blow-ups of aerial photographs. There was, for example, a document from the *Meditations on the Conditions of the River Seine and the Excavation at Les Halles,* exhibited at Ronald Feldman Fine Arts in New York in 1974. Here Newton Harrison proposed to fill the big hole of Les Halles with water pumped from the Seine, which would create a viable ecosystem with good fish and plants for them to feed on. The new public lake would by itself have been a great pleasure to experience in the center of Paris, and it could also have acted as an ecological preserve for a cleaned-up Seine. I also recall, further back, Newton's *Portable Fish Farm* at the Hayward Gallery in London and its sequel at the Palais des Beaux Arts in Brussels in 1972. Here Harrison nurtured catfish in a 50-ton tank; at the appropriate time the fish were killed, fried, and fed to some 500 invited guests in the setting of the gallery, turned into an elegant dining room. This ritual revealed the critical elements of the chain of life to the art public, which felt rather uneasy about the whole thing. Art has frequently dealt with life and death, but rarely so visibly or edibly.

Before turning to *Survival Pieces,* Newton Harrison worked as a minimal artist in the sixties and then became interested in the science and technology of glow discharges, producing stunning works in which light acted as color in space. In the large Art and Technology exhibition at the Los Angeles County Museum of Art in 1971 he exhibited plexiglas cylinders, 12 feet high, in which electrified gases made colors appear as magically disembodied from any support. But

outside the building and a part of the same exhibition, Harrison also installed the miniature *Brine Shrimp Farm*, his first ecological piece. With this work he began to concern himself with the problems of survival both as an artist and as a citizen and increasingly the two aspects of his personality have merged. "I thought one day," Newton explained, "what if everything went away? My teaching job, all modern conveniences. How would I survive? It was then I decided to become a farmer and became interested in the land and how to use it." The Harrisons soon will be moving to a small one-acre land farm a few miles inland from their present place facing the Pacific Ocean.

As the implications of Newton's *Survival Pieces*, dealing with whole ecological systems, became too broad to be dealt with by a single person, he was soon joined by Helen, whose own background is in the fields of psychology and social anthropology. The effectiveness of their collaboration comes about as a result of shared basic assumptions about the nature of things which they hold in common. Their operational procedures, however, are highly different, with Newton's attitudes being much more stationary and Helen's more ambulant: they compare his position to that of farming and hers to the hunter-gatherer. "The most difficult thing to resolve," Helen said, "was learning to be silent, when one or the other was thinking deeply." Their working process typically begins with an almost accidental encounter of a problem, as in the case of the Sacramento River, the irrigation system in California's Central Valley. They gathered material and did a truly astonishing amount of research, collecting all kinds of historical data about California, the use of land by the Indians, farming in the Central Valley, dam building, feasibility studies of the building of more dams and their impact on the ecology. They investigated the fate of vast stretches of land that have been overirrigated in the past such as the valleys of the Nile and the Tigris and Euphrates. They studied flow and growth charts of population, economic reports on the value of California agribusiness, and the amount of hydro-electric energy, fertilizers, pesticides, etc., it takes to keep it going in California.

After saturating themselves with all this information and, they point out, meditating on its meaning, they derived from it statistics which become the first sets of forms. These numbers and the anomalies they signify are then a new subject to ponder. Eventually the information was allowed to sink into the background and they began to work as visual artists, in this case by applying the information to large demonstrative maps, inscriptions, and in the form of poems. These deal with the domination of the land, with events in nature, and with the acts of people, government and business. Concerned as they are with the anomalies and problems, they are still working in the art context, but, like other politically oriented artists—Christo, Haacke, Hershman, Levine, etc.—they are deeply involved in the working process. I like Kim Levin's definition of the Harrisons' projects as "visionary earthworks on an epic scale with moral

overtones." We must look at these maps as works of art with a political message, not as well-designed political statements.

The ten mural-size maps—political, topographical, satellite—themselves and in relation to each other evoke rapid recognition of some of the problems in an almost subliminal way before the viewer begins to read the inscriptions. In color-field painting, which Newton Harrison practiced with some success in the sixties, instant recognition was essential and this strategy has here found a new function. The Harrisons explain that "for us, after the map is blown up, hand-colored and assigned with captions, it eventually stops being a map and becomes a large field." Yet the color is used not for its own decorative sake or for chromatic brilliance. It is employed for a variety of purposes: symbolically as when water is indicated by blue, didactically to indicate specific irrigation areas or the separation of private and public land, and by analogue as when brown is used for the field of California.

Each map is accompanied by a lengthy text, hand-written on school-book lines. Often this text is rather poetic; to enhance this effect, the Harrisons held an effective reading during the course of the exhibitions. The inscriptions explain that the world's largest irrigation system in man's history and its eight-billion-dollar industry is actually self-canceling because the dams become useless through silting: the pumping system will soon require more energy than it creates. They point out that the present irrigation ruins land and water and destroys precious topsoil. They indicate that the technocratic planners have helped agribusiness to prosper at great public expense. Collective survival is threatened. They juxtapose the socio-economic paradigm of "exploit-consume-transform into capital" to the biological imperative of survival of the species and, in the last map, they direct our thinking toward the necessity that all resources be held in communal public trust "either through legal or revolutionary means in order to avoid virtual extinction of the land." This is a rather radical point of view. Seldom do contemporary artists suggest such extreme political alternatives to specific issues.

But the medium is by no means the message here, because the various mediums of the projects are in a constant state of change and development. But then, even the politics of water distribution in California is being questioned seriously and the building of additional dams may indeed be halted. The Harrisons' *Meditations* increase the viewer's awareness of the limitation of this resource, once taken for granted. As artists they look at the present *Meditations on the Conditions of the Sacramento River...* not as a single project, but as part of their ambition to restore the waterways throughout the globe. It is an art of visionaries with political and human implication. They propose to "stop masterplanning nature and to begin masterplanning technology."

Index

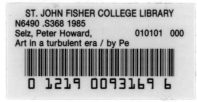